Digital Photography Workbook

FOR DUMMIES®

by Doug Sahlin

WILEY

Wiley Publishing, Inc.

Digital Photography Workbook For Dummies®

Published by
Wiley Publishing, Inc.
111 River Street
Hoboken, NJ 07030-5774

www.wiley.com

Copyright © 2008 by Wiley Publishing, Inc., Indianapolis, Indiana

Published by Wiley Publishing, Inc., Indianapolis, Indiana

Published simultaneously in Canada

For general information on our other products and services, please contact our Customer Care Department within the U.S. at 800-762-2974, outside the U.S. at 317-572-3993, or fax 317-572-4002.

For technical support, please visit www.wiley.com/techsupport.

Wiley also publishes its books in a variety of electronic formats. Some content that appears in print may not be available in electronic books.

Library of Congress Control Number: 2008923596

ISBN: 978-0-470-25933-7

Manufactured in the United States of America

10 9 8 7 6 5 4 3 2

WILEY

Digital Photography Workbook For Dummies®

Cheat Sheet

Digital Photography Terms

- **ISO:** The camera's sensitivity to light. Increasing the ISO rating makes it possible to take pictures in low light conditions without using a tripod. However, increasing the ISO also increases the amount of digital noise that's visible in the resulting photograph.

- **depth of field:** The distance in front of and behind the subject that appears to be in focus. When you shoot portraits, try to capture a shallow depth of field where your subject is in focus but the foreground and background are blurred. When you shoot landscapes, try to capture a large depth of field where the entire scene is in focus.

- **f/stop:** The diameter of the opening of the lens relative to the focal length. A small f/stop value lets a lot of light into the camera, whereas a large f/stop lets a small amount of light into the camera.

- **Aperture Priority mode:** Noted as AV (Aperture Value) or A (Aperture) on the camera shooting mode dial. When you set the aperture, the camera automatically chooses the shutter speed for a properly exposed image. Choose a large aperture (small f/stop value) to achieve a shallow depth of field, and a small aperture (large f/stop value) to achieve a large depth of field. You achieve the shallowest depth of field when using a large aperture with a telephoto lens, and the largest depth of field when using a small aperture with a wide-angle lens. Use this shooting mode when your primary objective is to control depth of field.

- **Shutter Priority mode:** Noted as TV (Time Value) or S (Shutter) on the camera shooting mode dial. When you set the shutter speed (the amount of time the shutter stays open), the camera automatically chooses the aperture for a properly exposed image. Shutter speeds can range from a very fast $\frac{1}{4000}$ of a second to as long as 15 seconds or more. The range of shutter speeds varies depending on the cost of the camera and on the manufacturer. Choose a fast shutter speed to freeze action, and a slow shutter speed when you want to blur an object in motion. Use this shooting mode when your subject is moving.

Digital Photography Workbook For Dummies®

Cheat Sheet

Elements You Find in Photoshop Elements 6.0 Edit Mode

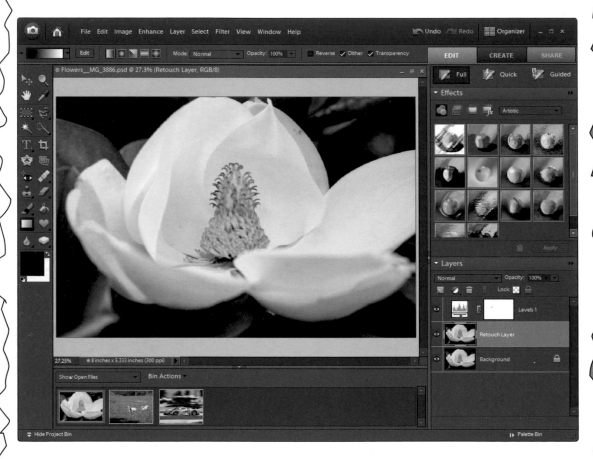

- **Toolbox:** You can access all tools when working in Full Edit mode. A tool with a black triangle in the lower right corner has additional tools nested with the currently displayed tool. Click the triangle to reveal a flyout displaying all nested tools.

- **Tool keyboard shortcuts:** Pause your cursor over a tool to reveal its keyboard shortcut.

- **menu bar:** Contains menu groups that are organized by topic. Click a menu group name to reveal commands in that group.

- **Options bar:** Displays available options for the selected tool.

- **Project Bin:** Displays thumbnails of all images open in the editor.

- **Layers palette:** Shows thumbnails of all layers used in the current image. You can modify the effect a layer has on underlying layers by changing its blend mode and opacity.

- **Effects palette:** Shows thumbnails of effects you can use to modify images. Effects can be used to make images look like paintings, pencil sketches, and more. There are also effects you can add to text and much more.

For Dummies: Bestselling Book Series for Beginners

About the Author

Doug Sahlin is an author, a photographer, and a Web designer living in central Florida. His clients include attorneys, authors, artists, doctors, and musicians. He has written and coauthored over 16 books on office applications, Web design applications, and digital photography. His books have been translated into five foreign languages. When he's not busy writing, photographing clients, or designing Web sites, he enjoys playing the guitar and dabbling in watercolor painting.

Dedication

Dedicated to the memory of Dr. Winston O'Boogie.

Give peace a chance.

Author's Acknowledgments

Publishing a book is a huge project. Without teamwork, a book would go no further than the author's fervent imagination. This book is no different. Thanks to Steve Hayes for making this project possible. Thanks to my literary agent Margot Hutchison (a.k.a. "Ollie") for her role in making this project possible. Thanks to Project Editor Becky Huehls for keeping my inbox full and providing editorial support. Thanks to technical editor Michael Sullivan for his contribution to this project. Kudos to the rest of the publishing team at Wiley for their role in this project.

Thanks to Tampa's Lowry Park Zoo (www.lowryparkzoo.com) for providing access to that wonderful facility. Thanks to Craig and staff at Lensbabies (www.lensbabies.com) for creating an awesome lens and providing suggestions used in Chapter 8. Thanks to my friends and business associates who smiled (and did not say "cheese") when I took their pictures.

Thanks to fellow authors Bonnie Blake, Joyce Evans, and Ken Milburn for their friendship and creative inspiration. Thanks to my friends and mentors. Many thanks to my family for their continued support, with special thanks to my cousin Ted and sister Karen. Thanks to my loving mother, Inez, for inspiring me to be creative and think outside of the box and for paying to have my film (remember film?) processed when I was a kid.

I wish you were here to see this.

Publisher's Acknowledgments

We're proud of this book; please send us your comments through our online registration form located at www.dummies.com/register/.

Some of the people who helped bring this book to market include the following:

Acquisitions and Editorial

Project Editor: Rebecca Huehls

Executive Editor: Steve Hayes

Copy Editor: Linda Morris

Technical Editor: Michael Sullivan

Editorial Manager: Leah P. Cameron

Editorial Assistant: Amanda Foxworth

Sr. Editorial Assistant: Cherie Case

Cartoons: Rich Tennant (www.the5thwave.com)

Composition Services

Project Coordinator: Erin Smith

Layout and Graphics: Stephanie D. Jumper

Proofreaders: Melissa Buddendeck, Jessica Kramer

Indexer: Valerie Haynes Perry

Special Help: Linda Morris

Publishing and Editorial for Technology Dummies

Richard Swadley, Vice President and Executive Group Publisher

Andy Cummings, Vice President and Publisher

Mary Bednarek, Executive Acquisitions Director

Mary C. Corder, Editorial Director

Publishing for Consumer Dummies

Diane Graves Steele, Vice President and Publisher

Joyce Pepple, Acquisitions Director

Composition Services

Gerry Fahey, Vice President of Production Services

Debbie Stailey, Director of Composition Services

Contents at a Glance

Table of Contents

Introduction

Digital cameras come in lots of different shapes and sizes and are used by people from all walks of life. Soccer moms use digital cameras to photograph their kids, real estate agents use digital cameras to photograph their clients' homes, and professional photographers use digital cameras to photograph everything under the sun — and moon. All digital cameras come with manuals. I've heard many groans and seen foreheads furrowed as beginning and intermediate photographers try to make sense of the manuals for their newly acquired cameras. Coming to grips with all of the menu options, camera dials, and shooting modes is daunting for many people.

Then there's the matter of what to do with your photos. Most people download them to their computer and look at them every now and again. They may print them out with their own printer or order prints online. In a couple of years, they have hundreds or thousands of pictures on their computer and have no idea how to find the photos of Aunt June at their son's first birthday party. Does this sound vaguely familiar? In addition to organizing photos, you may want to edit the photos to make them look better and perform other tasks like getting rid of the telephone pole that's mysteriously growing out of your husband's head. You also have to be prepared for the unthinkable: a hard drive crash that destroys your precious collection of photos. Such crashes do happen, and usually at the worst moment. Fortunately, software is available that can be used to organize your photo collection, edit photos, and much more. In this book, I cover the basics of photography, including composition, exposure, and shooting subjects, such as landscapes and people. I also cover one of the most popular packages for editing and organizing digital images: Photoshop Elements.

About This Book

Photography is supposed to be fun, not rocket science. Whether you're just getting started in digital photography or you've owned a digital camera for a while, the task of creating a compelling picture can be somewhat daunting. Many photographers always leave their digital cameras in Automatic mode (the big A on most camera shooting mode dials). If you take pictures without exploring the different shooting modes, you're not utilizing your camera to its fullest. After all, all those menus and dials and buttons are not there just to make the camera look high-tech. They have a purpose. My goal when creating this book was to put the fun back in digital photography and demystify the menu settings, shooting modes, and so on. The exercises in this book are designed to help you master your camera and its controls, whether you're photographing your son playing quarterback, wildlife at a nearby lake, or a stunning landscape. There are also exercises that show you how to deal with specific situations such as taking a picture of a moving vehicle, photographing sunrises, and much more.

Many beginning digital photographers download their photos to their computers and then have the photos printed online or at a local drugstore. If this describes your typical workflow, you're not getting the most out of your photos. In the latter part of this book, you can find exercises that show you how to organize and edit your photos. I also show you how to add a little pizzazz to your photos with special effects. I show you how to accomplish these tasks with Photoshop Elements 6.0.

Foolish Assumptions

If you're thumbing through this book at your friendly bookstore or reading these words in the comfort of your living room — or wherever you have your home library — you should have a few things before delving into the exercises in this book. First and foremost, you should own a digital camera. After all, taking digital photos with a film camera is, like, impossible. You can benefit from the exercises in this book with any digital camera with the exception of a disposable digital camera.

If you're going to get the most from the second half of this book, you should have Photoshop Elements installed on your computer. The exercises for organizing and editing your photos are all based on Photoshop Elements 6.0, the most current version as of this writing. Many of the exercises can also be done with Photoshop Elements 5.0. For those of you who own a computer with a Macintosh operating system, the current version is Photoshop Elements 4.0. Many of the exercises in the last half of the book will not work with Photoshop Elements 4.0.

How This Book Is Organized

This book is organized, I promise: My publisher insisted that it be so. The book is neatly divided into four parts. Hey, I'd appreciate it if you'd read the book from cover to cover because I spent considerable time on each section. But if you're a busy person and you need to cut to the chase and find specific information, you can do so by letting your fingers do the walking through the table of contents or the index. Most of the chapters of this book can be read as standalone sections, and they don't need to be read in any particular order. When information from another chapter or section will benefit you, I give you a cross-reference to the applicable section or chapter.

Part 1: Essentials for (Almost) Every Photo

In this part of the book, I present exercises that are designed to help you understand all of those pesky menu options, and what the different shooting modes do for you. I also present exercises that show how to take pictures with camera flash, set depth of field, and shoot photos for eBay. Chapter 3 is all about composition. Many beginning photographers just point the camera at the subject and press the shutter button. The exercises

in Chapter 3 are designed to make you think before you shoot and then compose the picture in your viewfinder or LCD monitor to create an interesting photo that your viewers will give more than just a cursory glance.

Part II: Taking Compelling Shots of Common Subjects

The exercises in Part II are designed to make you a better photographer. Whether you're taking pictures of your daughter playing soccer or the Grand Canyon, there's an exercise in this part to address that specific picture-taking situation. If you like to take pictures of people and pets, Chapter 5 is right up your alley. The exercises in Chapter 6 are for those of you who like to take pictures of the towns you visit and the breathtaking landscapes that dot the countryside. If you take pictures of moving objects like runners and race-cars, or if you photograph sporting events, you'll find the exercises in Chapter 7 useful. Chapter 8 is for those of you who like to stretch the envelope and get creative with your camera

Part III: Working with Photos in Photoshop Elements

Back in the old days of film photography, you got your photos developed by a local pharmacy or supermarket. If you returned from a three-week vacation, you had several rolls of film to develop, which cost a considerable amount to process. In return for your money, you got a nice envelope with the photos and negatives. The good photos ended up in a photo album, and the negatives ended up in a shoebox or desk drawer. Digital photography is different. You get instant gratification a few seconds after you take the picture. Then when you get home, you download the images to your computer. If you don't organize your photos, your hard drive becomes the equivalent of the desk drawer or shoebox cluttered with negatives — you can't find a thing. The exercises in Part III show you how to organize your prized photo collection. I also show you how to edit and retouch your pictures using Photoshop Elements. If you like artsy fartsy stuff, you'll love the exercises in Chapter 12, which show you how to work with text, special effects filters, and much more.

Part IV: The Part of Tens

Every *For Dummies* book has a Part of Tens. It's a law. In this part of the book, you find two chapters that have ten sections. Chapter 13 has ten exercises that show you ten different ways to share your photos. The exercises in Chapter 14 explore ten Web sites that are useful to digital photographers.

Icons Used in This Book

The book is liberally sprinkled with tips that the author learned the hard way. I pass the tips along to show you an easier way to achieve a desirable outcome.

This icon indicates a tidbit of info that you should file away for future reference.

The Warning icon indicates a danger that you ignore at your peril.

When you see a Practice icon, it's your invitation to delve into the topic in more detail. You know what they say about practice: It's true.

I've uploaded several images that you can use when working through the exercises in Part III of the book. When you see the On the Web icon, you can download the images for that chapter from www.dummies.com/go/digitalphotoworkbook.

Part I
Essentials for (Almost) Every Photo

In this part . . .

Digital camera technology is a wonderful thing. I mean, talk about your instant gratification: Point the camera at something, press the shutter button, and almost momentarily you see the image on your camera LCD monitor. But there's a lot more to digital photography than point and shoot. That's why your camera has dials with funny looking icons and a camera menu with more choices than your local Chinese restaurant. The exercises in this part of the book are designed to familiarize you with some of the features of your camera that previously seemed daunting. In addition, you'll work through several exercises in Chapter 3 that are designed to make you think more creatively when composing a photograph.

Chapter 1

Getting Chummy with Your Camera

*1*n some respects, digital cameras are like cars. You can put them on automatic so that all you have to do is guide them down the road. On the other hand, if you own a modern car you can take advantage of the car's advanced features by controlling when the engine upshifts, changing the settings for the suspension when driving on winding mountain roads, and so on. Most digital cameras come with a plethora of menu options, and they have dials and buttons as well. You take control of your photography and the quality of your pictures when you master menu controls and know when to switch settings for a specific subject. In this chapter, I present exercises that familiarize you with some basic settings on your camera. I have to include a caveat: No two digital cameras have the same settings, even when made by the same manufacturer. Throughout this chapter, I direct you to your camera manual to find out exactly what part of the menu or on which camera dial the settings to which I refer can be found. I show you which menu option to use to achieve an end result. Your job is to find out where it is on your camera.

Setting Image Size and Quality

Image size and quality determine many things about the picture you download from camera to computer. For example, size and quality determine how much room the images take up on your memory card and computer. They also determine what you can do with the images. If you're shooting a picture to send via e-mail, you choose one set of options. If you're printing the images, you choose different options. Before you decide which image size and format to specify, you must first ask yourself a few questions. The answer to these questions will determine what settings you choose. The following exercise helps you examine what you must consider before choosing the settings that best suit your needs.

Exercise 1-1: Setting Image Size and Quality

1. **Power on your camera.**

You turn your camera on by either pressing a button or flipping a switch. Your camera may also be equipped with a feature that powers down the camera when you haven't taken a picture or used the menu in a while. If this is the case, you generally push the shutter button halfway to "wake up" the camera.

2. **Format your memory card.**

It's always a good idea to format your memory cards after you download images to your computer and back up the images to an external source such as a DVD disc or a USB hard drive. Formatting cards is especially important if you use a card that has already has some images on it, but is not full. Your camera lets you shoot until you fill up the card. If you've already downloaded the previous shots, you end up downloading them again and wasting valuable space on your hard drive. When you start with a formatted card, you're starting with a clean slate and don't download the same image twice. Formatting a memory card is similar to formatting a hard drive on a computer: When you format a memory card, you erase all data (photos), and you can start filling up the card again. To format the memory card, you use a camera menu setting. The exact location of the Format command varies depending on the camera and manufacturer. Most cameras warn you that you're erasing all data from the card when formatting. If you're sure that you downloaded the images to your computer, click Yes to format the card.

Even though you can format a card with your computer after downloading images, you should always use the camera menu command to format a memory card.

3. **Determine how many pictures you can fit on your memory card.**

The number of images you can fit on a memory card is directly proportional to the image size and quality currently specified. When you specify a large image size, with the highest quality, you won't be able to fit as many pictures on your memory card.

4. **Consider the following questions before choosing a setting:**

- *Will you be printing the images (or ordering prints)?*

 If so, you must specify an image quality that is high enough to support the size media on which the image will be printed. For example, if the native resolution of your camera is 180 PPI (pixels per inch), and you want an 8 x 10 print of the picture you are shooting, the image size must be larger than 1440 x 1800 pixels. If you want a really sharp image with a resolution of 300 PPI, your image must have dimensions of 2400 (8 inches x 300) x 3000 (10 inches x 300) pixels. You'll find more information on image dimensions and the relationship of resolution to image size in Chapter 10.

- *Will you display the images on a Web site rather than print them?*

 If so, you can specify your smallest image size and quality, which on most cameras is still more than you need to display the image on a Web page or send it via e-mail. For more information on optimizing images for the Web, see Chapter 10.

• *Are you running out of room on your memory card?*

Every time you take a picture, you decrease the number of images you can add to the memory card. Your camera lists the remaining number of images in the LCD viewfinder, or in a window on the camera body. If you're running out of room on your memory card and don't have a spare memory card or a device to which you can download the pictures before taking more pictures, you can switch to a smaller image size and quality, which increases the number of images you can fit on the card. Another alternative is to delete some of the images that are obviously of poor quality or poorly composed.

You can purchase battery-powered portable hard drives that are specifically made for downloading images from digital camera memory cards. The units accept most popular memory cards. Power on the unit, insert your memory card, and then press a button to download the contents of the card to the hard drive. After successfully downloading the images, you can reformat the card and continue taking pictures. Many of the portable hard drives also come with a monitor you can use to preview your images. You can also purchase portable CD/DVD burners, which enable you to copy images from your memory cards to a CD or DVD. Either device is a great alternative if you shoot lots of pictures while you travel. They're lighter and smaller than a laptop computer and alleviate the need for purchasing more memory cards than you would ordinarily need.

When you purchase additional memory cards, refrain from purchasing memory cards larger than 2 GB. A memory card is an electrical device. The most common cause for memory card failure is loss of power when the card is being read or written to. In accordance with Murphy's law, a memory card will fail at the least opportune time. When a memory card fails, I'd rather lose 1 or 2 gigabytes of images instead of 4 or 8 gigabytes of images.

5. **Open your camera menu and navigate to the image size and quality settings.**

Your camera's menu may be subdivided into sections. Some camera manufacturers divide settings into tabs of related commands. For example, my Canon ProShot 1 has one tab for camera settings such as shutter sounds, startup sounds, and so on; a second tab for other camera settings such as LCD brightness, power saving, and so on; plus a third tab for settings related to picture taking. However, on my camera, a different button (Func) is used to change the image size and quality settings. The choices on my ProShot 1 (8.0 megapixels) range from S (an image with dimensions of 640 x 480 pixels) to L (an image with dimensions of 3264 x 2448 pixels). The quality settings are Normal, Fine, and Superfine. My Canon EOS 5D (12.8 megapixels) has the image size and resolution settings on the menu. The options for this camera range from S (2496 x 1664 pixels) to L (4368 x 2912 pixels) with quality settings of Normal and Fine. You get the most detail when you choose the highest image quality, which also creates the largest file size and uses more space on your memory card. To give you an idea of the impact file size and quality have on space, consider the following fact: When I use a 256 MB card in my PowerShot Pro 1, it holds 2720 images when I choose S for the image size and Normal for the quality. It holds 72 images when I choose L (largest image dimension in pixels) for the image size and Superfine (least compression, best image quality, and largest file size) for the quality. Quality determines how much the image is compressed. If you're shooting images that you plan to print, you should always choose your camera's highest quality setting, as shown in Figure 1-1, which shows the image size menu for a digital SLR (single-lens reflex) camera.

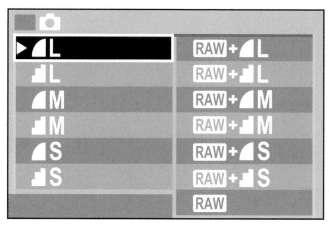

Figure 1-1: A digital SLR image size menu.

6. **Choose the setting that best suits your immediate picture-taking needs.**

 Exactly how you select image size and quality varies from camera to camera. Refer to your camera manual for the button or dial used to toggle through menu options. On many cameras, it's self-explanatory.

7. **Press the shutter button halfway to achieve focus.**

 Most cameras give you visual representation on the LCD monitor or in the viewfinder that the camera has focused the scene. You may also hear a beep. Some cameras also lock focus when you press the shutter button halfway. Other cameras have a button to lock focus. Refer to your camera manual for additional information.

8. **Take the picture.**

 You can continue shooting with the current settings until your needs change. That's the beauty of digital cameras. You can change image size and quality settings on the fly. However, unless memory card capacity is an issue, your best bet is to shoot at the largest image size and the best image-quality setting. You can always optimize the image for an intended destination such as the Web or e-mail later in an application like Photoshop Elements. Remember, if you take pictures with smaller image dimensions at lower-quality settings, there's really no way to increase the image size and quality after you download the images to your computer. The only exception to that rule is when you shoot using your camera's RAW format. The Camera Raw dialog box in Photoshop CS2 and CS3, and in recent versions of Photoshop Elements, gives you the option of increasing the image size of a RAW file when processing it.

Shooting with Your Camera's RAW Format

If your camera has an option for capturing images using a RAW format, you capture exactly what the camera sensor captures. Think of this as working with the equivalent of a digital negative. When you shoot in any mode other than RAW, the camera processes the image. Most modern cameras process images into the JPEG format. The disadvantage to shooting images in the JPEG format is that you're limited to how much you can

manipulate the photo in an image-editing program like Photoshop Elements. If the image is slightly underexposed or overexposed, there's not a whole lot you can do with it, unless the image was captured using the RAW format. When you shoot RAW, however, you can correct exposure problems, and even enhance the image while you process it. (And just think of how much fun you can have telling your friends you shoot in the RAW.) There's a downside to shooting RAW images, however: You must process them. All camera manufacturers provide a software application that enables you to process the images after you download them to your computer. These applications work with the images from your camera. As you may have guessed, each camera manufacturer has a proprietary RAW format. In fact, some have multiple RAW formats, such as Canon, which has .CRW and .CR2 RAW formats. However, the Adobe engineers have been working with all camera manufacturers and have created a nifty application called Camera Raw, which ships with Photoshop CS3 and Photoshop Elements 6.0. Camera Raw recognizes all the popular RAW formats and has features not found with the application shipped with your camera. In Chapter 10, I show you how to process images with the version of Camera Raw for Photoshop Elements. In the following exercise, I show you how to take pictures using your camera's RAW format.

Exercise 1-2: Shooting Photos in RAW Format

1. **Power on your camera.**

2. **Format your memory card.**

 Refer to Exercise 1-1 for details.

3. **Open your camera menu and navigate to the image size and quality settings.**

 Your camera should show several settings that relate to image size. The option you need should be called something like RAW, R, or RAWCCD, depending on your camera manufacturer. The option to shoot RAW should be readily identifiable. When you shoot in the RAW format, you capture all the data your camera sensor records.

4. **Choose your camera's option for shooting in the RAW format.**

 Most cameras use a wheel or dial to navigate from menu item to menu item. Figure 1-2 shows the RAW format menu from my Canon EOS 5D. The Canon EOS 5D and many other cameras on the market give you the option of saving a RAW file and a JPEG image each time you take a picture.

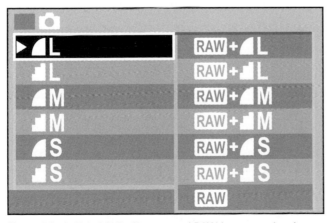

Figure 1-2: A digital SLR offers several RAW formats and options.

5. **Press the shutter button halfway to achieve focus.**

 Inside your viewfinder or on your LCD monitor, a focus point changes color, which signifies that the camera has focused on an object that intersects that focus point. Your camera may also beep when it has focused on an object.

6. **Compose the scene and take the picture.**

 The camera transfers the information from its sensor to your memory card with no processing. Figure 1-3 shows a photograph captured using Canon's .CR2 RAW format as processed using the Adobe Photoshop CS3 Camera Raw application.

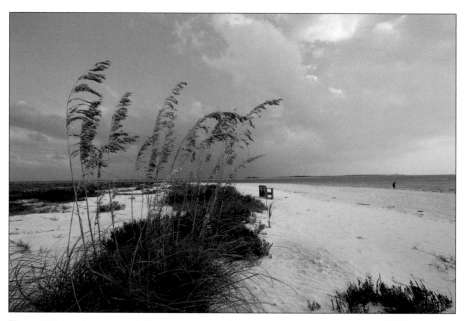

Figure 1-3: You have more latitude when you shoot photos using your camera's RAW format.

Setting the Focal Length

Point-and-shoot digital cameras are marvels of engineering. Realize that the pint-sized camera you can fit in a purse or your pocket captures the photograph and processes it as well. In addition, it's equipped with a motorized lens that enables you to zoom in or zoom out. Talk about having everything in a teeny-weeny little package! Typical point-and-shoot cameras have a lens that can zoom to four times (4X) the minimal focal length of the lens. An example of this type of camera is the minuscule Canon PowerShot SD850 IS, which is just a little larger than the classic iPod, and has an optical zoom of 4X, which is the 35mm equivalent of a focal range from 35mm to 140mm. If your camera isn't quite pint size, it may have a more powerful zoom. Some cameras on the market can zoom up to 12X. An example of a camera with this zoom range is the Canon S5 IS, which has a 12X optical zoom, which is the 35mm equivalent of 36mm to 432mm.

Digital cameras also have what is known as digital zoom. In essence, *digital zoom* crops to a portion of the image that can be captured at the largest optical zoom, and then resizes to fill the frame. This means that the camera is redrawing pixels, which inevitably leads to image distortion. I strongly advise against using digital zoom. If you need to zoom in really close, your best bet is always a camera with a high rate of optical zoom.

Many beginning photographers don't understand *focal length,* the distance in millimeters from the optical center of the lens to the camera sensor or film. A long focal length gives you a narrow field of view, which in effect zooms in or magnifies the subject. A short focal length gives a wide field of view; hence the name, wide angle. Beginning photographers tend to just stand wherever they happen to be, and then zoom in or out to compose the photo. This can lead to some undesirable results. For example, if you're capturing a head and shoulders portrait of a person with a wide-angle lens, the features closest to the camera appear distorted. (Can you say "large nose?" I thought you could.) The following exercise is designed to help you understand the difference between wide-angle focal lengths and telephoto focal lengths. If you're doing this exercise with a digital SLR, use a wide angle to telephoto zoom lens with a range of about 28mm to 105mm, if you have one.

Exercise 1-3: Setting the Focal Length

1. **Find a building you'd like to photograph.**

 You can take a snapshot of your own house or a photogenic building in your neighborhood

2. **Zoom out to the widest focal length.**

 The actual device used to zoom in and out varies. Some cameras have a circle with a detent outside of the shutter button. Move the detent left to zoom out, right to zoom in. Other cameras have a collar on the lens barrel that you twist to change focal length. This is similar to zooming in and out with a 35mm telephoto lens. Move the collar left to zoom out; right to zoom in.

3. **Walk toward the building until it almost fills the viewfinder.**

4. **Press the shutter button halfway to focus, and then fully to snap the picture.**

 The image appears in your camera LCD monitor shortly after you take the photo. Figure 1-4 is a photograph of a Frank Lloyd Wright building a few miles from my home It was shot with the 7.2 mm focal length on my Canon PowerShot 1, which is the 35mm equivalent of a 28mm focal length.

 When you shoot a building with a wide-angle lens, do not tilt the lens up to fill the lens with your subject. Doing so results in the distortion of vertical lines. The lines appear as though they are converging together. This is known as *keystoning*. Of course, all rules are meant to be broken. If you *want* to exaggerate the height of a tall building, get up close and personal, choose the widest focal length on your camera, and then tilt the camera to fill the viewfinder with the skyscraper.

Figure 1-4: Photographing a building with a wide-angle lens.

5. **Zoom in the middle focal length of your lens.**

 Some camera lenses are marked with the 35mm equivalent and the actual focal length of the lens. If your camera has this feature, you can accurately zoom to the middle focal length of the lens. If your camera is not marked, experiment with the zoom control until you get a good feel for it, and then approximate the middle focal length. If your camera has a 3X optical zoom, your middle focal length will be the 35mm equivalent of a 50mm lens, which is close to the range of the human eye. If your camera has a 4X or higher optical zoom, you're in the telephoto category.

6. **Walk away from the building until it almost fills the viewfinder.**

7. **Press the shutter button halfway to focus, and then fully to take the picture.**

 You'll see the image in your LCD monitor in a few seconds. Figure 1-5 is the same building in Figure 1-4 at the middle focal length of my Canon PowerShot Pro 1, which is the 35mm equivalent of a 100mm lens. Notice the difference between this image and the photo in Figure 1-4.

Figure 1-5: Photographing a building with the equivalent of a medium telephoto lens.

8. **Zoom in to the longest focal length of your lens.**

The focal length depends on the amount of optical zoom your camera has. If you have a camera with 6X optical zoom or higher, you're shooting with a relatively long telephoto lens. A lens with the 35mm equivalent of 180mm and greater lets you zoom in on your subject from afar, an excellent and very safe alternative when you're trying to photograph a grizzly bear catching a salmon.

9. **Walk away from the building until it almost fills the viewfinder.**

10. **Press the shutter button halfway to achieve focus, and then fully to take the picture.**

You see the image in your LCD monitor shortly after you snap the picture. Figure 1-6 is the same building in Figure 1-4 at the maximum focal length of my Canon PowerShot Pro 1, which is the 35mm equivalent of a 200mm lens. Notice the difference between this image and the photos in Figures 1-4 and 1-5, especially the building in the background. When you use a telephoto lens, it brings everything closer to you, including the distant buildings. When you photograph a busy city street with lots of buildings, the buildings seem like they are closer together in the photo than they are when you see them in real life. It's a pretty cool effect. Try it. You'll like it.

11. **Download the images to your computer and compare them on-screen.**

When you compare the images on-screen, you'll see the difference between the different focal lengths you have available. This gives you a better idea of which focal length to use when photographing a particular subject. I expand on the topic of focal lengths during exercises on how to shoot different subjects.

Figure 1-6: Photographing a building with the equivalent of a long telephoto lens.

On a Saturday afternoon when you have an hour or so to spare, take a walk around your neighborhood and photograph objects with several focal lengths. Practice quickly zooming from one focal length to another and pay attention to the different types of pictures you can take just by changing the focal length with the same subject. For example, if you get close to an SUV and photograph it with a wide-angle focal length, the grille will look huge, almost comical.

Changing Lenses on a Digital SLR

If you own a digital SLR (single-lens reflex) camera, you change your focal length by switching to a different lens. Each camera manufacturer has a wide variety of lenses from which to choose. You can purchase wide-angle lenses that enable you to capture the broad expanse of a majestic vista like Yosemite Valley, or telephoto lenses that you use to zoom in on distant subjects such as wildlife without getting dangerously close to them. You can purchase a prime lens, which has a single focal length, or a zoom lens, which gives you a wide variety of focal lengths from which to choose. The beauty of a zoom lens is that you can compose a picture by zooming in or out. If you've used 35mm SLRs in the past, you may think you can change lenses whenever you want. However, if you switch one lens with another and don't take some precautions, you end up with dust on your sensor. The following exercise shows you techniques for changing lenses on your digital SLR that minimize the chance of dust fouling the camera sensor.

Exercise 1-4: Swapping Lenses on a Digital SLR

1. **Replace the front lens cap of the lens currently mounted on the camera.**

 This protects the lens from damage. You can also set the lens on a solid surface, lens cap side down after removing it from the camera.

 Consider purchasing a skylight filter for each lens you own. A skylight filter "warms" the picture by removing the bluish cast of daylight. Leave the filter on the lens at all times. It's also cheap insurance against dust, moisture, or scratches on your expensive lens. Remember that you get what you pay for. If you buy a cheap skylight filter, it may degrade the quality of your image.

2. **Decide which lens is best suited for the picture you want to take.**

 Wide-angle lenses are great for shooting wide-open landscapes; lenses with a 35mm equivalent of 50mm are great for photographing groups of people and trees; and telephoto lenses are great when you need to zoom in on a subject.

3. **Turn the camera off.**

 The camera sensor uses camera power to capture images. When you turn the camera off, you minimize the risk of dust particles being attracted to the sensor's electrical charge.

4. **Point the camera down and away from any prevailing wind.**

 This prevents dust from blowing into the camera during the brief amount of time when the lens is off the camera. If you're taking photographs in a dusty or windy environment, it's advisable to changes lenses in a building or your car.

5. **Remove the current lens and gently set it down on a solid surface.**

 If the only solid surface is dirt or wet grass, place the lens between your thighs and clamp them around the lens. Practice this a few times before actually doing it outdoors.

6. **Remove the rear lens cap from the lens you're going to mount on the camera.**

 When you remove the lens, note where the lens mounting dot is. There is also a dot on the body of your camera.

7. **Align the lens mounting dot with the mounting dot on the camera body.**

 You'll have to turn the camera body up slightly to see the mounting dot on the camera.

8. **Mount the lens to the camera body and turn it clockwise or counterclockwise (depending on the manufacturer of your camera) until you feel it lock into place.**

 With practice, you'll be able to dismount and mount a lens quickly, minimizing the chance of dust fouling your camera sensor. When I purchased my first digital SLR, I knew nothing about dust spots on the sensor and learned the hard way when reviewing some pictures I had taken during a San Francisco vacation. The cerulean blue sky in the photo was speckled with dots. Figure 1-7 shows a close-up of a photo that was marred due to dust on the sensor. If you notice black specks on areas of solid color, such as a clear blue sky, your camera sensor has dust specks. The dust spots can be removed in an image-editing program. However, if you follow the steps in this exercise, you'll minimize the chances of dust adhering to your sensor, which will save you a ton of time when editing your photos.

Figure 1-7: Change lenses with the camera power off to avoid the risk of dust fouling your camera sensor.

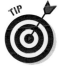

If you do notice dust specks on your pictures, you can clean your sensor by following the instructions in your camera manual. Digital SLRs have a menu command for sensor cleaning, which, when invoked, flips up the camera mirror. You then use a blower to dislodge the dust from the camera sensor. Do not use a blower with a CO_2 cartridge as the cartridge contains oil, which fouls the sensor. You can purchase a powerful hand-held blower (there are many available with the generic name of "hurricane blower") from your local camera store. Do not touch the sensor with the blower. Turn the camera off to complete the task. After cleaning the sensor, immediately replace the body cap or put a lens on the camera. Some newer digital SLRs have built-in dust removal, which shakes the sensor when the camera is turned on or off and thus dislodging any dirt.

Understanding the 35mm Equivalent

If you used a film SLR camera prior to converting to digital, you're probably familiar with the different focal lengths typically used to shoot landscapes, portraits, or close-ups, for example. The focal lengths on a point-and-shoot lens are different than those commonly associated with 35mm film cameras. The reason is that your digital camera's sensor is smaller than the frame size of a 35mm negative or slide. If you study the specifications of a digital point-and-shoot camera, you'll see that the lens has a focal length with a range of something like 5.8mm to 17.4mm. The camera manufacturer lists the 35mm equivalent in the specs, which is great information for photographers who previously used 35mm film cameras. For example, the 35mm equivalent of the lens previously mentioned is 35mm to 105mm, which, by the way, is 3X zoom.

If you purchased a digital SLR, your sensor is probably also smaller than the frame size of 35mm film. There are only a few cameras on the market that have what is known as a *full frame sensor*: a sensor that is the same size as a frame of 35mm film (24 x 36mm). If you own a camera with a sensor that is not full frame, you're dealing with a focal length multiplication factor. The focal multiplier determines the 35mm equivalent of a lens you mount on a digital SLR that does not have a full frame sensor. In essence, the smaller sensor has a smaller field of view. For example, if your camera has a lens multiplication factor of 1.5, and you mount a 50mm lens on the camera, it's the equivalent of mounting a 75mm (50 x 1.5) lens on a 35mm film camera. This information is useful if you're a 35mm film convert and want to purchase additional lenses for your camera.

Focusing on Your Subject

Digital cameras relieve you from needing razor-sharp eyesight when composing your photo. Gone are the old days when you had to manually focus on your subject and then shoot the picture. But auto-focus is not infallible, so that's why you have options. On the other hand, options without knowledge can be confusing. The following exercise familiarizes you with how your digital camera thinks when it focuses on a subject, and how you can stay one step ahead of your camera.

Exercise 1-5: Focusing on Your Subject

1. **Compose the photograph.**

2. **Choose the proper AF point.**

 The AF (auto-focus) point is the spot in the frame from which your camera focuses the scene. Your camera may have multiple AF points. To determine how many AF points your camera has, point it at an object, press the shutter button halfway, and look in the viewfinder. If you see a single square as shown in Figure 1-8, your camera uses a center AF point to focus the scene. When the AF point changes color, and the camera beeps, the scene is in focus.

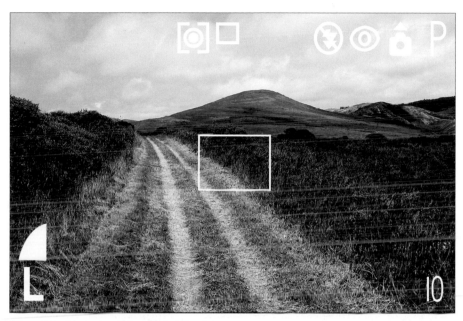

Figure 1-8: A camera with a single AF point.

If you see multiple points, such as shown in Figure 1-9, the camera focuses on an object that intersects with one of these focus points. In fact, your camera may detect many points on which it can focus. This is a good thing when you're photographing landscapes; however, when you're photographing people, the camera can be fooled, especially if one of the auto-focus points intersects with something that has a lot of contrast, such as window blinds. If your subject is the bride walking down the aisle, and your camera focuses on the blinds, the end result is an out-of-focus bride. In this case, choose the camera option to switch to a single focus point. Refer to your camera manual to discover which menu command or dial you need to use to switch to a different AF point if indeed your camera has multiple focus points.

Your camera may also have an option known as Face Detect. Use this option if you're photographing a scene with people in it. In addition to focusing on the right subject, this mode may also choose the proper exposure and flash setting for photographing people. If your camera is equipped with this feature, refer to your camera manual to determine the proper menu command or dial that you use to switch to this option.

3. **Press the shutter button halfway to achieve focus.**

The AF point changes color and your camera may beep.

4. **Press the shutter button fully to take the picture.**

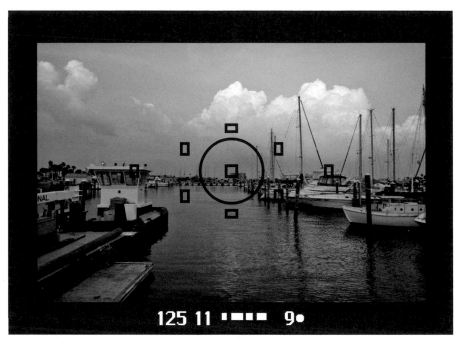

Figure 1-9: A camera with multiple AF points.

Focusing On Off-Center Subjects

Many photographers prefer to compose their photographs in such a way that the main subject (also known as center of interest) is not smack-dab in the middle of the photo. In fact, this often makes for a more interesting photograph. (For more information on composing a photo, see Chapter 3.) When your subject is not in the center of the scene, you can ensure that it's in focus by following the steps in this exercise.

Exercise 1-6: Focusing on an Off-Center Subject

1. **Switch to Single AF (auto-focus) mode. Your camera may also refer to this mode as One-Shot.**

 If your camera is in Continuous AF mode, it continually focuses on whatever intersects the AF point.

2. **If your camera is equipped with multiple AF points, switch to the AF point in the center of the viewfinder.**

3. **Aim the camera so that the AF point is over your subject.**

4. **Press the shutter button halfway to achieve focus.**

 When focus is achieved, the AF point changes color, and your camera may beep.

5. **With the shutter button depressed halfway, compose the scene.**

 Move the camera until you see the photo you envisioned in the viewfinder or on your LCD monitor. As long as you're in Single AF mode, and the shutter button is depressed halfway, the camera is focused on the subject you aimed at in Step 4.

6. **Press the shutter button fully to take the picture.**

 Figure 1-10 shows an example of a scene where a single AF point was aimed at an off-center subject, the man painting the Golden Gate Bridge.

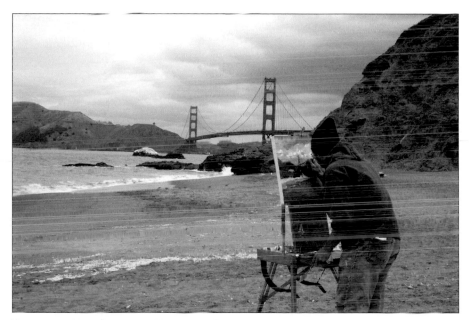

Figure 1-10: Focusing on an off-center subject.

Zen and the Art of Photography

If you're going to become a good photographer, you must learn to see photo opportunities. And when you see them, you need to make the best of the "Kodak Moment" and capture some keeper photos on your memory card. To recognize a scene that will make a good or perhaps great photograph, you must be observant, or as they say, "in the moment." Just taking a quick glance into the viewfinder or LCD monitor and then pressing the shutter is not being observant. Many people go through life with blinders on. They drive to and from work without observing the beauty around them and the changes in their own neighborhood or hometown, and they always take the same route whenever they go somewhere. Armed with a digital camera, a creative spirit, and the ability to see a photo opportunity, you can capture some wonderful photographs of the town in which you live. Here are some suggestions for capturing interesting photos:

✔ **Always carry your digital camera with you.** You never know when you'll see an interesting scene, or when a glorious rainbow (with or without the obligatory pot of gold at its end) will appear after a storm.

If you own an expensive digital SLR, you may be hesitant to carry it with you wherever you go. I'm hesitant to carry *my* digital SLR with me wherever I go. I purchased a relatively inexpensive 8.1 megapixel point-and-shoot digital for my everyday camera. I carry it in the glove box and am ready whenever I see something that would make an interesting photo.

✔ **Leave a half-hour early for work and take a route you've never traveled.** Morning light is wonderful for photographs. If you take a route to work that's off the beaten path, you're bound to find interesting subjects to photograph. Taking a different route also makes you more aware of your surroundings.

✔ **Take a different route home from work.** If you leave work in the late afternoon, you'll have golden light for your photographs.

✔ **See the big picture.** Many beginning photographers snap the picture and move on. But if the scene or person is worthy of a photograph, you should take the best picture you can. If you're photographing a landscape or building, take a few moments to slow down and analyze the scene. This helps you figure out the best vantage point from which to photograph the scene. It will also make you aware of items that will distract from the picture such as telephone poles, garbage cans, street signs, and so on. If you're photographing a person, make sure you don't have a telephone pole growing out of her head. If you really see the big picture, you'll find the vantage point that will give you a great shot, without background clutter or other distracting elements.

✔ **Think outside of the box.** Photograph the scene the same way you've photographed similar scenes, and then put your creative muse to work and think of ways you could take a better picture. Try turning the camera diagonally, or using a different zoom setting. If you're photographing a person, give him a prop and ask him to ham it up a bit.

✔ **Walk around the scene.** When you see something worth photographing, take the picture you imagined, but don't put the camera away. Not yet, anyway. Walk around the scene and envision shots from different angles. Crouch down on your belly for a snail's-eye view, or climb up some steps to get a higher vantage point, or, if you're agile, climb a tree. When you see something that looks good, analyze the scene through your viewfinder or LCD. If it still looks good, take the picture.

✔ **Take photographs of everyday objects, like pots and pans, road signs, and billboards, but photograph them in unusual ways.** Look for the patterns in common objects. A close-up of a stucco wall with peeling paint can be the basis for a wonderful abstract photograph. Figure 1-11 is a photograph of painted plywood that serves as a gate for an alley in Ybor City, Florida. The painted lock draws your eye into the photograph.

Figure 1-11: Explore your world through the camera lens.

Face it: We live in a world that's moving at a breakneck pace. By creatively exploring the world around you through your camera lens, you get a chance to really see the beauty in your world. It's also a wonderful way to slow down and relieve stress.

Chapter 2

Lights! Camera! Exposure!

Menu choices, camera modes, dials, buttons, and other digital camera delights can leave the beginning photographer in a state of mental stress. When my sister got her first digital camera for Christmas, she opened the box, looked at the camera and started reading the manual. A few minutes later, she looked at me and said, "This is way too complex for a simple point-and-shoot camera." I felt the same way when I first made the switch to digital. But I persevered and learned what I needed to know. As I became more comfortable with the camera, I expanded my knowledge base and learned how to use the other functions and options. The exercises in this chapter show you how to grasp the menus and dials by the nape of the neck and train them to cooperate with your creative vision.

Selecting the Right Preset Mode

Somewhere on the right side of your camera, you'll find a dial with all kinds of cool and groovy icons that designate the different shooting modes you have available. You may have lots of icons if you have a high-end camera, or just a few if you've got a basic point-and-shoot camera. When you move the dial, you switch to a different camera mode, which is tailor-made to shoot specific images. Most beginning photographers don't try the different modes and wonder why the shots of their kids playing soccer are blurry. Well, there's not an icon of a soccer ball, Pele, or any other reference to soccer on your camera dial, but there probably is an icon that looks like a runner. Switch your dial to that icon and you can create great stop-action shots of sports like baseball, soccer, and so on. When you leave the soccer game and see a stunning landscape just begging to be photographed — you guessed it — there's a mode for that as well. The following exercise will familiarize you with the different shooting modes available on most digital cameras.

Exercise 2-1: Choosing a Shooting Mode

1. **Locate the shooting mode dial on your camera.**

Figure 2-1 shows the shooting mode dial on my Canon PowerShot Pro1. Notice the icons. Your camera should have a similar dial. However, if your camera has more shooting modes than there are Smiths in New York City, you may have an icon marked SCN, which is used to access the shooting modes on your camera menu.

Figure 2-1: Accessing your camera's shooting modes.

2. **When you first use your digital camera, it is set to Auto mode.**

Auto is essentially a no-brainer. You point the camera at the subject and press the shutter. But by moving the dial, you can access different modes for specific picture-taking situations.

3. **Move the dial to Portrait mode.**

This mode is usually designated by an icon that looks like a person's head. As you may have guessed, this mode is used when you want to shoot a portrait of someone. When you take photographs in this mode, the resulting photo highlights your subject, and the background is a soft out-of-focus blur.

4. **Move the dial to Landscape mode.**

This mode is designated by an icon that looks like mountains with a teardrop-shaped cloud. Use this mode when you want everything to be in focus. This mode works great for photographing scenes like the Grand Canyon. Note that your camera may end up choosing a slow shutter speed when you shoot in this mode. It's advisable to use a tripod when you're photographing in Landscape mode to ensure a sharp photograph.

5. **Move the dial to Night Scene mode.**

This mode is designated by an icon of a person with a star overhead. When you choose this mode, the camera flash records the image of the person, and the shutter stays open longer to accurately expose the background. Depending on the amount of available light, the camera lens may be open for a long time, therefore it's advisable to use a tripod to minimize blurring that occurs when the operator (that would be you) moves while holding the camera. (Unless of course, you'd like a blurred background to create an abstract, special-effect photo.)

6. **Move the dial to Movie mode.**

This icon looks like an old-fashioned Hollywood movie camera. You can use this mode to shoot video. It's no substitute for a camcorder, but you can get some decent video in good lighting conditions. If your camera has a Movie mode, there may also be a menu command to change the dimensions of the video. Typical dimensions are 640 x 480 pixels, which is good for monitor viewing; 320 x 240 pixels, which can be used for Web sites, and 160 x 120 pixels, which is good for sending short clips via e-mail. You may also have the option of choosing the video frame rate. The most common frame rates for digital cameras are 15 fps (frames per second) and 30 fps. A higher frame rate gives you better-quality video, but takes up more room on your memory card. Note that if you have a digital SLR, your camera will not have a Movie mode.

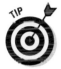

If you don't have a camcorder, but you want to post some video on YouTube, use your camera's Movie mode, and then edit the video using Movie Maker (Windows) or iMovie (Macintosh). For more information on editing video clips for YouTube, consider picking up a copy of *YouTube For Dummies* by Doug Sahlin and Chris Botello (Wiley Publishing).

7. **Move the dial to Macro mode.**

The icon for this mode is usually a blooming flower. The mode enables you to take close up photos of flowers and other small objects. If you've got a really good digital camera, you can shoot close-ups of small items for eBay auctions. If your camera manipulates the image digitally to get a close-up of an object, the icon usually has a capital D or S in the middle of the flower. If you own a digital SLR, your camera does not have this mode, so you'll have to purchase a macro lens that fits your camera in order to shoot a close-up.

Your camera may have additional shooting modes. Some cameras have a Beach mode, which accurately exposes people in the scene. Without Beach mode, the people in the scene appear dark because of the bright sand. Other modes you may have on your camera are Foliage, which enhances the color of fall foliage; Snow, which removes the blue color cast normally associated with winter photos and properly exposes people in spite of the brightness of the snow; Fireworks, which creates the optimal exposure for fireworks in a night sky; or Aquarium, which optimizes the camera settings for photographing aquatic critters in a public or home aquarium. There are undoubtedly more shooting modes, and I'm sure more will be introduced as new digital cameras are introduced to the market.

In addition to the modes previously listed, your camera may have additional modes that enable you to manually set exposure, shutter speed, or the size of the aperture. These modes are covered in the following steps.

8. **Move the dial to P mode.**

This mode is similar to full automatic, yet you can make adjustments to the following: exposure, white balance, and ISO. In addition you can bracket exposure, enable second shutter flash, and so on. (These terms may seem foreign to you right now, but the exercises in upcoming sections and chapters show you how to use these options to get better photographs.)

9. **Move the dial to TV or S mode.**

This is Shutter Priority mode. You select the shutter speed and the camera automatically chooses the aperture to properly expose the photo in the current lighting conditions. Digital cameras have a range of shutter speeds, which vary depending on the model of your camera. For example, my Canon PowerShot Pro 1 has a range of shutter speeds from 15 seconds to 1/4000 second. The faster shutter speeds are used for stopping action, whereas longer shutter speeds are used for capturing photographs in low light situations. You can also use slow shutter speeds to creatively blur an object in motion. When you choose shutter speeds slower than 1 second, you may notice more digital noise in the photograph. Digital noise shows up as random specks and smudges of color that appear in the shadow areas of an image.

Unless your camera has image stabilization, the slowest shutter speed at which you can hand-hold the camera is the reciprocal of the 35mm equivalent of the focal length with which you're shooting the photo. For example, if you photograph a scene with the 35mm equivalent of a 28mm lens, you'll need a tripod if you choose a shutter speed below 1/30 second. If you're photographing a scene using the 35mm equivalent of a 200mm lens, you'll need a tripod when using a shutter speed slower than 1/200 second. If your camera has image stabilization, experiment with using slower shutter speeds. Download the images to your computer and zoom in to see the shutter speed at which blurry edges are apparent.

10. **Move the dial to AV or A mode.**

This is Aperture Priority mode. You select the aperture and the camera automatically selects the shutter speed to properly expose the photograph in the current lighting conditions. Lenses have a range or apertures that vary depending on the lens. If you're using a point-and-shoot digital camera, your lens probably has a range of aperture from f/2.4 to f/8.0, whereas if you have a lens for a digital SLR it may have a range from f2/0 to f/22. This number is known as an *f/stop* number. The smallest f/stop number lets in the most amount of light. This is known as shooting wide-open. The largest aperture value lets in the smallest amount of light. When you choose large aperture (small f/stop number), the camera chooses a faster shutter speed, which enables you to freeze action. When you choose a small aperture (large f/stop number), the camera chooses a slower shutter speed, which leaves the lens open longer to compensate for the smaller amount of light filtering in through the aperture. You'll see the shutter speed in the LCD monitor or in your viewfinder. Use this information to determine whether you need to steady the camera with a tripod. The aperture also affects the depth of field (how much of the scene is in apparent focus). Refer to the section on "Controlling Depth of Field" for more information.

11. **Switch to M mode.**

This setting enables you to manually adjust the shutter speed and aperture. This option is useful when shooting photos under tricky lighting conditions. For example, if you're photographing your local Fourth of July fireworks show, your camera may have a tendency to overexpose the scene because the ambient light is low. The fireworks in the resulting photo will have little or no detail. To solve this problem, you can use a smaller aperture (larger f/stop value) to ensure a longer exposure and mount your camera on a tripod. You may also have to use exposure compensation to increase exposure time if the photo still lacks detail.

Choosing the Right Metering Mode

When you shoot a photo using a mode other than manual, the camera light meter determines the proper exposure for the scene. *Exposure* is the shutter speed (the amount of time the shutter is open) combined with the f/stop (diameter of the aperture). If you've ever watched a professional photographer at work in a studio situation, you may have noticed that he walks up to the subject with a hand-held doohickey, points it at the light source, and pushes a button. The photographer is using a hand-held light meter to determine the exposure. He may take a meter reading from other areas of the subject, such as her hair and clothing. When he meters several areas, he determines the aperture and shutter speed by averaging the readings of the light meter, or he may take one reading to determine the exposure. Your digital camera has metering modes that do the same thing as the light-meter-wielding professional photographer. The following exercise explores the metering modes available on most digital cameras and when to use them.

Exercise 2-2: Choosing a Metering Mode

1. **Power on your camera.**

When you turn on your camera, it reverts to the previously used settings. If you have not changed the metering mode when you last used the camera, the default metering mode is used to determine the exposure when you take a picture. The default metering mode for most digital cameras is known as *evaluative*, or, depending on the camera manufacturer, *matrix* or *multi-pattern*. This metering mode works well for most picture-taking scenarios, including backlight lighting (the subject has her back to the light source). This metering mode divides the scene into several zones, and evaluates each zone to determine the proper exposure for the scene.

2. **Switch to Center Weighted Average metering mode.**

Some cameras have a button or switch that is used to switch between modes; others use a menu or function setting to switch metering modes. If the method for switching metering modes isn't readily apparent, consult your camera manual.

When you switch to Center Weighted Average mode, your camera averages the light metered from the entire frame, but gives greater weight to the objects in the center of the scene. This metering mode is good if the background is significantly brighter than the subject in the center of the scene.

3. **Switch to Spot metering mode.**

Some camera manufacturers refer to this as Partial metering. This mode is ideal when your subject is in the center of the scene. The camera meters the entire scene, but weighs heavily on a small area in the center of the scene. Your camera may also have an option to meter a single AF (auto-focus) point. If this is the case, the spot metering takes place around the auto-focus point, and the light from the rest of the scene is average, and is weighed heavily toward a small area around the AF point.

Controlling Depth of Field

Depth of field determines how much of the scene you photograph is in apparent focus. Depth of field is an important concept to master if you want to take your skills beyond those of the digital camera owner who uses her camera to shoot the occasional snapshot of her child's birthday or Aunt Clementine and Uncle Joe arriving for Thanksgiving dinner. When you shoot a portrait of somebody, you want a shallow depth of field: Your subject is the center of interest. When you photograph a breathtaking landscape, you want a large depth of field. In other words, you want as much of the scene to be in apparent focus as possible. The following exercises familiarize you with how to achieve a shallow depth of field and an almost infinite depth of field.

Exercise 2-3: Achieving Maximum Depth of Field

1. **On a bright sunny day, go outside to the front of your house or the building where you live.**

2. **Walk away from your house, power on your camera, and compose the picture.**

 You should be far enough from your house that it is still a prominent feature in the picture, but not the only object in the picture. Make sure that you can get a good portion of the yard on either side of the house in your viewfinder.

3. **Zoom out to your shortest focal length.**

 You get maximum depth of field when you photograph with a wide angle lens.

4. **Switch to Aperture Priority mode.**

 Your camera mode dial or menu setting will be either Av or A. If your camera doesn't have a way to manually choose the aperture, switch to Landscape mode.

5. **Select your smallest aperture.**

 The smallest aperture is the largest f/stop number. On a bright day, you should be able to shoot at your smallest aperture. If the sky is slightly overcast, you may have to switch to a higher ISO setting to shoot with a small aperture. When you increase the ISO setting, you increase your camera's sensitivity to light, which means you can shoot with a faster shutter speed. For more information on ISO settings refer to "Adjusting Your Camera's Sensitivity to Light" section of this chapter. If the shutter speed is too slow to hand-hold the camera, set the camera on a tripod.

 You won't do this step if you're shooting in Landscape shooting mode. Your camera will automatically select the smallest possible aperture for the lighting conditions.

6. **Press the shutter button halfway.**

 If the camera is focusing on nearby objects, switch to a single AF point and focus on a distant object. Even when you shoot with a small aperture, the distant objects won't be in clear focus if the camera focuses on a nearby object. Your goal is to have as much of your scene in apparent focus as possible.

7. **Press the shutter button fully to take the picture.**

When the picture appears in the LCD monitor, the objects in the front of the scene and your house will be in focus. Figure 2-2 was photographed with a wide-angle lens and a small aperture. Notice how everything is in focus from the blades of grass to the distant art deco hotel.

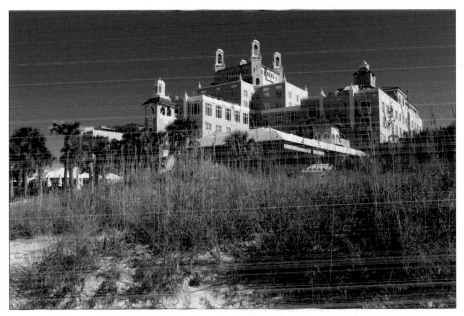

Figure 2-2: Use a short focal length and small aperture to achieve the broad depth of field.

Exercise 2-4: Achieving a Shallow Depth of Field

1. **On a cloudy afternoon, ask your significant other or a friend to assist you.**

2. **Go outdoors and position your friend a few feet in front of some foliage.**

3. **Power on your camera and switch to Aperture Priority mode.**

Your camera dial or shooting mode menu will list this option as AV, or A. If you don't have the option to shoot in Aperture Priority mode, select your camera's Portrait mode.

4. **Zoom to your longest focal length and compose the photo so your subject's head and shoulders are visible in the viewfinder. Make sure some of the background foliage is visible as well.**

Your longest focal length may be the 35mm equivalent of a lens with a focal length of 160mm or greater, depending on how much optical zoom your camera has. Resist the temptation to use digital zoom.

5. **Choose the largest aperture.**

This will be the smallest f/stop number that's available for your camera's maximum focal length. Unless you have a very expensive digital SLR zoom lens that has the same f/stop throughout its focal length range, the aperture will be slightly smaller

(larger f/stop number) as you increase your focal length. Even with a slightly smaller aperture, shooting wide open at your longest focal length ensures a minimum depth of field. Note that if you have a digital point-and-shoot camera whose longest focal length is less than the 35mm equivalent of 150 mm, you'll still have a relatively large depth of field, even when you use the largest aperture. This is due to the fact that point-and-shoot cameras have smaller sensors.

This step is not necessary if you choose Portrait mode. In Portrait mode, the camera chooses the largest possible aperture for lighting conditions.

6. **Press the shutter button halfway to achieve focus.**

 Make sure your camera focuses on your subject and not something in the background. If your camera doesn't focus on your subject, switch to a single AF point, position it over your subject, and then press the shutter button halfway. If you don't want your subject in the middle of the photo, move the camera to achieve the desired composition with the shutter button still pressed halfway.

7. **Press the shutter button fully to take the picture.**

 Examine the photo when it appears in the viewfinder. The background should be a soft, out-of-focus blur similar to the background in Figure 2-3.

Figure 2-3: Achieve a shallow depth of field by shooting wide open with a long focal length or telephoto lens.

Manually Setting Camera Exposure

Cameras are engineered by human beings, who, so far at least, can't create a camera that properly exposes a scene under difficult lighting conditions. You know what these are. You take the picture and when it appears in the LCD monitor, it's either too dark, or the highlight areas of the image such as the sun and sky are overexposed. When this happens, you have no choice but to press the button to trash the picture and try again. But if the camera goofed the first time, the second time won't get any better. When your camera has a temporary bout of bad judgment, follow these steps:

Exercise 2-5: Manually Setting Camera Exposure

1. **Take a photograph in difficult lighting conditions.**

 Before you fully press the shutter button, note the shutter speed and f/stop as determined by the camera.

 Carry a small memo pad that fits in your pocket and a small writing instrument that fits easily in your pocket or camera bag. They don't take up much room, and are handy when you need to jot down camera settings or information about an image you photographed.

2. **Examine the image when it appears on your LCD monitor.**

 You'll know in an instant whether the camera captured the scene as you see it

3. **Examine the histogram to determine whether your image is underexposed or overexposed.**

 Most advanced point-and-shoot cameras and all digital SLRs have the option to display a histogram along with the images you're reviewing. The histogram is a graph that displays the distribution of pixels from shadows to highlights. Figure 2-4 shows three histograms. The histogram on the left is that of an underexposed image. Notice the flat part on the right side of the histogram. That indicates there are no pixels in the highlight region, a clear clue that the image is underexposed. You may also see a large spike on the left side of the histogram, which indicates that shadows will be totally black in the resulting image. The histogram on the right shows an image that has been overexposed. Notice the spike on the right side of the histogram. This indicates that all detail in these pixels are lost and show up as white in your image. The center histogram shows a properly exposed image. There are no spikes on either end of the histogram. You may have a histogram that has a relatively flat line on the highlight side of the histogram. Even though no detail is blown out to white, the image is dark in comparison to the actual scene; in other words, underexposed. If there is a flat area on the shadow side of the histogram, this indicates that the image is brighter than the actual scene.

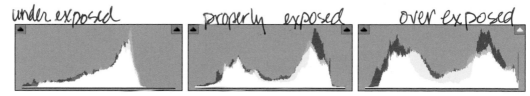

Figure 2-4: A tale of three histograms.

4. **Switch to Manual mode.**

 Your camera may have a shooting mode dial, which will be marked with an M to indicate the Manual exposure mode.

5. **Increase or decrease the exposure settings.**

 You can do this by changing the shutter speed, the aperture, or both. To increase exposure, choose a wider aperture (smaller f/stop number) or slower shutter speed. To decrease the exposure, choose a smaller aperture (larger f/stop number) or faster shutter speed. Remember that exposure is a combination of how long the lens is open (shutter speed) and how much light is let into the camera (the size of your aperture, the f/stop).

 Your camera may also have an option to adjust exposure using a menu setting. This is referred to as *exposure compensation*. If you're shooting images in a given set of lighting conditions and they are either too dark or too light, you can increase or decrease the exposure as metered by the camera using either a menu command or a dial on your camera. Most cameras measure exposure compensation by 1/3 f/stop. The only drawback to exposure compensation is that you may forget to change back to the default settings when you're shooting in different lighting conditions.

6. **Take the picture.**

 When the image appears in the LCD monitor, examine it to make sure it is properly exposed with the new settings. If not, change the settings and take the picture again. Remember to change the settings, or switch back to some form of auto-exposure when you want to shoot more photos in different lighting conditions.

Bracketing Your Exposures

When you take pictures that are really important, it pays to hedge your bet and do everything possible to capture a properly exposed image. Professional photographers often bracket their exposures when shooting in tricky lighting conditions. When you bracket exposures, you take one photo using the camera's recommended settings, one photo that is overexposed, and one that is underexposed. If your camera has this feature, you use a menu setting to determine the exposure compensation for the shots that are overexposed and underexposed. When you download the images to your computer, you can choose the one you like best. The following exercise gives general instructions on how to bracket exposures.

Exercise 2-6: Bracketing Exposures

1. **Switch to a shooting mode that supports AEB (auto exposure bracketing).**

 With most digital cameras, you can bracket exposure when shooting in P, Aperture Priority (AV or A), or Shutter Priority (Tv or S) mode.

2. **Access your camera menu and navigate to the section for bracketing exposures.**

 Each camera manufacturer uses different menu settings. Refer to your camera manual for detailed instructions on how to bracket exposures.

3. **Specify the amount by which each shot will be overexposed and underexposed.**

 Most camera manufacturers enable you to change the exposure compensation by −2 to +2 EV (exposure value), in 1/3 step increments. Typically, you use a dial or a multifunction button that enables you to increase and decrease values.

4. **Take the picture.**

 When you take a photograph using auto exposure bracketing, the camera captures three images. Most cameras take the photos in this sequence: standard exposure, underexposed, or overexposed. Figure 2-5 shows a sequence of images captured with auto exposure bracketing. Auto exposure bracketing takes up more room on your memory card, and also increases the amount of time it takes to photograph a scene. Remember to disable auto exposure bracketing after you have captured the scenes that need to be bracketed.

After enabling auto exposure bracketing, you can use exposure compensation to increase or decrease the standard exposure value.

Figure 2-5: Use auto exposure bracketing to hedge your bets.

Setting White Balance

The human eye and mind work in synchronicity. When you view a scene under lights with different color temperatures, white always looks white. The mind automatically compensates for the different color temperatures of fluorescent light, incandescent light, firelight, and daylight. Your digital camera does the same thing by automatically compensating for different color temperatures by setting the white balance. The camera, however, can sometimes be fooled when you're taking pictures in mixed lighting. If your subject is under a fluorescent lamp, and she looks a little green around the gills, you can manually set the white balance on your camera to eliminate the problem. The following exercise explores the different white balance settings available on most digital cameras.

Exercise 2-7: Manually Setting White Balance

1. **Power on your camera.**

2. **Take a photograph.**

 If you notice that the image has a tint, or white objects look blue, or orange, the camera white balance settings are not correct.

3. **Access your camera menu and navigate to the white balance settings.**

 Alternatively, your camera may have a dial or button with a WB icon. If this is the case, click the button or spot on the dial that enables you to change white balance settings.

4. **Choose the white balance setting that best suits the current lighting conditions.**

 Table 2-1 shows the white balance icons you're likely to find on your camera and gives you a brief description of the type of lighting conditions.

5. **Take the photos in conditions that match the selected white balance setting.**

 Most of the time you'll be shooting with the AWB setting. When you do come across difficult lighting conditions and notice that the photo you've just taken has an odd color cast, you should consider switching to one of the preset white balance settings. Remember to switch back to automatic white balance, or a different setting, when you shoot photos under different lighting conditions.

Table 2-1	Digital Camera White Balance Settings	
Setting Icon	*Name*	*Description*
AWB	Automatic White Balance	Automatically sets the white balance for the existing light conditions.
☀	Daylight	Use this setting for outdoor picture-taking on a bright, sunny day.
☁	Cloudy	Use this setting for outdoor picture-taking on a cloudy day, when shooting in the shade, or when shooting at dusk.
💡	Tungsten	Use this setting for taking pictures indoors under tungsten light bulbs, or bulb-type three-wavelength fluorescent lighting.
🔆	Fluorescent	Use this setting for taking pictures indoors under warm-white, cool-white, or warm-white (three-wavelength) fluorescent lighting.
	Fluorescent H	Use this setting for taking pictures indoors under daylight fluorescent or daylight fluorescent-type three-wavelength fluorescent lighting.
◁●▷	Custom	If your camera has this mode, you aim the camera at a sheet of pure white paper under the current lighting conditions and push a button, or actually photograph the white object. The camera adjusts the white balance to render the paper pure white.

Setting Icon	Name	Description
K	K	Some digital SLRs have this mode, which enables you to set white balance by selecting the color temperature that best matches the scene lighting. Color temperature is designated in degrees Kelvin. For example, the color temperature of tungsten lighting is approximately 3200 degrees.

Adjusting Your Camera's Sensitivity to Light

If you remember back to the dark ages of photography when the majority of photographers actually used film, you may remember that you could buy different speeds of film for different lighting conditions. If you were shooting slides (remember those?) when all the world was a sunny day, you used Kodachrome. If you wanted to shoot black and white pictures in dim lighting conditions, you used Tri-X film. Film speed and digital cameras have one thing in common, the ISO rating. The ISO (International Organization for Standardation) rating determines how sensitive the camera or film is to light. This is similar to the ASA rating used in the Jurrasic period of film photography. At higher ISO ratings, a digital camera is more sensitive to light, just like the film you used to use. The beauty of a digital camera ISO setting is that you can change it as needed. The following exercise shows you how to increase your camera's sensitivity to light.

Exercise 2-0: Increasing Your Camera's Sensitivity to Light

1. **Power on your camera and check the currently selected ISO setting.**

It's a good idea to get in the habit of checking the ISO setting when you begin taking pictures. The last used setting will still be in effect, which may or may not suit the current lighting conditions. You should always shoot with the lowest ISO setting that will give you the desired result. Shooting at the lowest possible ISO setting minimizes digital noise in the image.

2. **Access your camera's ISO settings.**

If you own a digital SLR, you probably use a button and/or dial to change ISO settings. If you own a point-and-shoot camera, you probably use a Menu or Function setting.

3. **Choose the ISO setting that best suits the current lighting conditions.**

Most digital cameras have ISO settings in a range from 100 to 400 ISO. If you own a digital SLR, your camera may have an ISO range from 100 to 1600. In addition, some digital SLRs have a function called ISO Expansion, which further increases your camera's sensitivity to light, or enables you to select a lower-than-normal ISO setting. Be forewarned: When you use the highest ISO settings available for your

camera, you run the risk of introducing *luminance noise*, which shows up as specks of color in the darkest areas of the photo. The amount of noise in images shot with high ISO settings is also determined by the size of the camera sensor. If you've got a small point-and-shoot camera that fits in your pocket, your images have digital noise when you shoot above ISO 200. However, if you've got a digital SLR that has a sensor that is half the size of a 35mm film frame, or the same size as a 35 mm frame, you can shoot at much higher ISO settings and your images are still relatively crisp and noise-free.

4. **Shoot your photos.**

 Remember to switch to a lower ISO rating when you encounter brighter lighting conditions. The ISO rating is listed in your camera viewfinder or is displayed on a window on the camera body. Get in the habit of checking your camera's settings when you're shooting a new batch of photos. For example, if you're shooting photos at dusk and you increase the ISO rating, the same rating is still in effect when you use your camera to shoot pictures of your gardenias at midmorning.

If your camera has an Auto ISO setting, do not use it. The camera may end up selecting a higher ISO than you actually need, which adds digital noise to the image. It's always better to know what ISO setting the camera is using, which means you're in control of the picture-taking process. For example, if you leave your camera on automatic, and it chooses your highest ISO settings because of low light, you'll end up with an image that has digital noise. You're better off choosing a lower ISO setting and using a tripod to steady the camera due to the slow shutter speed.

Using Image Stabilization

If your camera features image stabilization, you can hand-hold your camera when shooting at slower shutter speeds. Some cameras feature vertical and horizontal image stabilization, which enables you to track fast-moving objects (also known as *panning*) at slower shutter speeds. Image stabilization is also useful when you're taking photos in low light situations without flash. Some of the newer digital SLRs have built in image stabilization while others have image stabilization built into certain lenses. The following exercise familiarizes you with the types of image stabilization that may be available on your camera.

Exercise 2-9: Using Image Stabilization

1. **Access your camera record menu.**

2. **Navigate to the Image Stabilization section of the menu.**

3. **Choose the desired setting.**

 Many cameras only give you the option of enabling or disabling image stabilization. If you have an advanced point-and-shoot digital camera, or one of the digital SLR cameras that features images stabilization, you may have options like the

following:

- **Continuous:** This is the default mode on many cameras. Image stabilization is functional whenever you use the camera. In other words, the image stabilization mechanism is at work whenever you turn the camera on. This mode optimizes your chances of taking a sharp photo when shooting with slow shutter speeds. This mode does, however, take the biggest toll on battery life. The biggest benefit of using continuous image stabilization is when you're zooming in on distant objects. You can see the effects of image stabilization in the viewfinder, or on your camera LCD monitor.

- **Shoot Only:** When you choose this mode, image stabilization functions when you press the shutter. Choose this mode to maximize battery life while still benefiting from image stabilization.

- **Panning:** This image stabilization mode compensates for up-and-down camera movement when you're panning objects that are moving horizontally.

Taking Flash Photos

With the exception of high-end professional digital SLRs, most digital cameras come with a built-in flash. The flash pops up whenever lighting conditions are too low to take a photo with natural light. If you have one of the compact point-and-shoot cameras, the flash is mounted in front of the camera. Either flash can cause red-eye — the disease that made digital image-editing programs famous. Note that on-camera flash is relatively weak and only has a range of about 10 feet. If you need to exceed this range, the only alternative is to invest in an auxiliary flash unit that fits your camera. The following exercise shows you some of the options available on most digital cameras for taking flash photos.

Exercise 2-10: Using On-camera Flash

1. **On a relatively dark day, find a friend or family member willing to pose for an indoor photo.**

2. **Choose your lowest ISO setting.**

3. **Aim the camera at your subject and press the shutter button halfway.**

 Your camera flash should automatically pop up if it's mounted on the top of the camera. If you have a tiny point-and-shoot camera, you won't notice any difference. The camera sends out a small beam of light, which is used by the camera to determine the proper amount of flash to use and the exposure settings. Your camera also displays an icon similar to a lightning bolt to let you know that camera flash will be used to augment the ambient light.

4. **Press the shutter button fully to take the picture.**

 The image appears on your LCD monitor a second or so after you take the picture.

5. **Examine the photo.**

 You may notice that your subject's eyes appear red. You may also notice harsh

shadows behind your subject.

6. **Access your camera menu and navigate to the Red-Eye section.**

7. **Enable Red-Eye reduction.**

 Your camera has a dial or button that is used to navigate the camera menu and choose a setting.

8. **Place a piece of tissue paper or medical tape over the flash window.**

 This diffuses the light and helps minimize dark shadows. Note that this reduces the output of your flash. To compensate, your camera selects a slower shutter speed and possibly a wider aperture. You may also need to move closer to your subject to compensate for the diminished output.

9. **Take another picture.**

 Compare the two shots. The second photo should be a marked improvement. You may, however, notice that your subject appears to be squinting. When you use camera red-eye reduction systems, the camera fires one or more low-power flashes, which cause the subject's iris to contract, minimizing the red-eye effect. If your subject has small pupils, the end result doesn't look natural. If you want a natural-looking photo, your best bet is to disable red-eye reduction and use an image-editing program like Photoshop Elements to get the red out. Another way you can minimize red-eye is to increase the ambient lighting in the room.

10. **Look for a button on your camera body that has a lightning bolt icon.**

 This button is used to disable camera flash. Disabling camera flash is useful when you want to create special-effect photos such as time exposures of night scenes. Figure 2-6 shows a Canon PowerShot Pro 1, which has a button to disable on-camera flash. I show you how to create special effects without camera flash in several exercises in upcoming chapters.

Figure 2-6: Press this button to disable camera flash.

Using Auxiliary Flash

If your camera has a hot shoe, or a connection for a PC (patch cord), you can use a more powerful flash than the one built into your camera. You can purchase a dedicated auxiliary flash manufactured by the same company as your camera, or purchase a third-party flash that is designed to fit your camera. The advantage of using a flash unit that was created by your camera manufacturer is that the camera and flash work as a team, automatically choosing the proper exposure settings for the scene you are photographing. To use an auxiliary flash unit with your camera, follow the steps in this exercise.

Exercise 2-11: Using Auxiliary Flash

1. **Slide the auxiliary flash unit into the camera hot shoe.**

2. **Turn the thumbscrew to snugly seat the flash unit in the hot shoe.**

Be careful not to overtighten the thumbscrew, which may damage the unit and make it harder to remove. If your flash unit doesn't have a thumbscrew, refer to the flash manual for information on properly mating the flash unit with the camera.

3. **Take the desired photographs.**

The camera automatically detects the auxiliary flash unit when you mount it on the camera. You can also press the button with the lightning bolt icon to disable the auxiliary flash unit. If the flash unit is designed to work with your camera, the exposure and flash settings are automatically calculated for you. All you have to do is aim and shoot.

 If you use an advanced auxiliary flash that is dedicated to your camera, you may have the option to bracket flash. Some camera manufacturers have the option to bracket flash built into the camera menu. With this option, you can hedge your bets when you're photographing a special event like your son's first birthday by bracketing flash. If your flash unit has this option, you take three photographs when you press the shutter button: one using the recommended flash setting, one with more flash power, and one with less flash power. After you download the shots to your computer, you get to decide which one is the keeper.

Using Bounce Flash

Many professional photographers use a technique known as *bounce flash* to mimic a large, diffuse light source. Bounce flash minimizes the harsh shadows that show up in a photo that's shot with an on-camera flash pointed straight at the subject. If you have an auxiliary flash with a rotating head, you can take advantage of bounce flash. The following exercise shows you how to use bounce flash.

Exercise 2-12: Using Bounce Flash

1. **Mount an auxiliary flash with a swivel head on your camera.**

2. **Compose your scene.**

 When you take a photo with bounce flash, you need to distance yourself from your subject. Imagine a 45-degree angle from your flash to the ceiling. The flash bounces off the ceiling and onto your subject. Your goal is to aim the flash so that the subject is bathed in the diffuse light. If you're too far from your subject, the flash fills the foreground. If you're too close to your subject, the flash illuminates the area behind her.

3. **Rotate the flash head to a 45-degree angle.**

 Your flash unit may have a built-in *detent* (an indentation that resists movement at a given point) that you use for bounce flash. When you feel the detent, the flash is at the optimum angle for bounce flash as determined by the flash manufacturer. Figure 2-7 shows a flash with swivel head aimed to bounce off the ceiling. This technique works best when the ceiling is pure white or off-white. If you bounce the flash off a ceiling that's painted a different color, you bathe your subject in that color light.

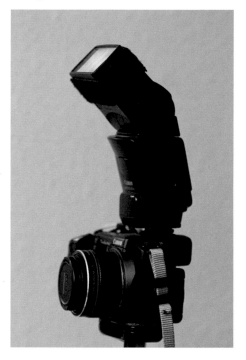

Figure 2-7: Bouncing an auxiliary flash off a white ceiling

4. **Take the picture.**

 You see the results in your LCD monitor a second or two after you take the picture. If your subject is not properly illuminated, move forward or backward until you get the desired results.

Creating a Makeshift Reflector

Sometimes flash is just too harsh. At other times, all you need to do is bounce a little light into the shadows. When you need just a bit of auxiliary light, a reflector is just what the doctor ordered. Professional photographers carry a reflector with them when they're shooting outdoors. Reflectors also come in handy when you're shooting indoors. However, even the smallest reflector collapsed into its carrying case is cumbersome.

A reflector is an investment that an amateur photographer may not be willing to make. Not to worry. When you have a lighting situation that calls for a reflector, get creative and follow the steps in this exercise.

Exercise 2-13: Creating a Makeshift Reflector

1. **Position an object on a table near a window facing north or south.**

 A large painted vase or basket would be ideal for this exercise.

2. **Turn off any other lighting in the room and disable your camera flash.**

3. **Take a picture of the object.**

 Notice the deep shadows on the side of the object that does not receive direct light.

4. **Have a friend or family member hold a reflective object on the shadow side of the object and angle it toward the object to reflect light into the shadows.**

 Your goal is to intercept the light shining in through the windows and bounce it back into the shadow side of your object. The following is a list of objects you can use as makeshift reflectors:

 - **Your car sunshade:** Car sunshades make excellent reflectors. They're big enough to use when taking head and shoulders portraits in shaded areas outdoors, or by the diffuse light from a window facing north or south. Most sunshields have a silver and gold side. The gold side of the sunshield bounces warm light on your subject, similar to the light in early morning or late afternoon.

 - **A large white T-shirt:** Hold a T-shirt under your subject's face to bounce light on him when his back is to the main light source.

 - **A white blanket or sheet:** A white sheet or blanket can be hand-held, or placed on the ground to bounce light up to your subject.

 - **A white sheet of Styrofoam:** This is another object that is lightweight. Styrofoam makes an excellent reflector as long as you're not taking pictures outdoors in windy conditions.

 - **A piece of foamcore or white poster board can be pressed into use as a reflector.** They're large enough to use when you're photographing a head and shoulders portrait of your favorite family member.

Using a Neutral Density Filter

Say you're photographing somebody in bright light and you want to minimize depth of field in order to render the background and foreground as colorful, out-of-focus blurs. However, the light is so bright that even at the lowest ISO setting, your camera chooses an aperture that maximizes depth of field, which is the polar opposite of what you want

to achieve. Fear not, intrepid shutterbug: There is a solution for the problem. It's known as a *neutral density filter*. A neutral density filter attaches to the front of your camera lens. A neutral density filter is gray in color and reduces the amount of light that reaches the camera sensor, without adding a color cast to the photo. Some advanced digital point-and-shoot cameras have a menu command to access an ND filter, which also reduces the amount of light reaching the camera sensor. When you want to photograph a scene with a smaller aperture, or slower shutter speed than current lighting conditions allow, follow the steps in this exercise.

Exercise 2-14: Using a Neutral Density Filter

1. **Take your camera outside when the light is very bright.**

This exercise works better if you're photographing a person. If possible, ask a friend or family member to pose for you.

2. **Switch to your lowest ISO setting.**

3. **Switch to Portrait or Aperture Priority mode.**

4. **If you switched to Aperture Priority mode, choose the largest aperture (smallest f/stop number) that will properly expose the scene.**

Choose an aperture that enables you to hand-hold the camera. Depending on how bright the day is, you'll probably end up with an aperture of f/8.0 with a point-and-shoot camera or higher if you're using a digital SLR. Either way, you'll have a huge depth of field.

5. **Attach the neutral density filter to the front of your lens.**

Most lenses have threads on the front of the lens. Carefully twist the filter into the threads, being careful not to cross-thread the filter. If your camera has a menu setting for a neutral density filter, enable the option.

6. **Choose the smallest largest aperture (smallest f/stop number) that will properly expose the scene.**

The amount by which you can increase the aperture opening is related to the strength of the neutral density filter you are using. If you use a 2X neutral density filter, you can reduce exposure by 1 f/stop; a 4X filter lets you reduce exposure by 2 f/stops; and a 8X filter lets you reduce exposure by 3 f/stops. Figure 2-8 was photographed at a slow shutter speed (1/20 second). It was a bright day, so I used a neutral density filter and the camera's smallest aperture. Without the neutral density filter, the shutter speed would have been so fast, you'd be able to see the individual droplets of water instead of the nice, soft, misty look. I also enabled image stabilization to compensate for photographer movement during the exposure.

When you use a strong neutral density filter, your camera may have a problem focusing. If this is the case, switch to a single AF point and aim it at a spot on your subject that has high contrast, such as a tie or shirt collar. Press the shutter button halfway to achieve focus, and then compose your picture. Alternatively, you can switch to Manual focus.

You can also use neutral density filters to shoot the same scene with a slower shutter speed. This is useful when you're photographing subjects like waterfalls. The slower shutter speed accentuates the feeling of motion by rendering the waterfall as a soft blur instead of individual streams of water frozen in time.

Figure 2-8. Using a neutral density filter to enable a slow shutter speed.

Minimizing Reflections with a Polarizing Filter

Reflections are a wonderful thing, and you can use them to good effect in photography. For example, if you have a building in your town with mirror glass windows, you can create wonderful photos of the building with clouds reflected in the windows and so on. But there are other times when reflections just don't cut it. For example, if you're photographing a lush garden with a koi pond, you want to see the fish, not reflections of the overhead clouds, or — yikes — the photographer in baggy shorts. Another example is when you're photographing the bride and groom as they look at you from the back seat of their car. If you're not carrying the right equipment, you'll barely see the happy couple because of all the reflections on the rear window. In this case, all you need to do is grab a polarizing filter and follow the steps in this exercise.

Exercise 2-15: Using a Polarizing Filter

1. **Mount the filter on your camera lens.**

 Notice that the filter has an outer ring.

2. **Aim the camera at your subject.**

3. **Twist the outer ring until the reflections disappear.**

4. **Take the picture.**

 Polarizing filters are also great for photographing scenes with blue skies and puffy white clouds. Twist the polarizing filter until the sky turns a deeper shade of blue. This works best when you're pointing the camera 90 degrees from the path of the sun. Figure 2-9 shows a sky with distant billowing thunderheads that was photographed with a polarizing filter attached to the lens.

Figure 2-9: Using a polarizing filter to enhance a photograph with clouds.

Lighting Still-Life Photos for eBay Photos and More

If you're going to sell something on eBay, you'll need one or more photos that clearly show the object you're putting up for auction. If you use eBay picture hosting, the price is right, but the images are small. Therefore, you'll have to take several shots from front, back, and side. You may also need to take a photo from above and a close-up. The following exercise points out what you'll need to do to create effective images for your eBay auction.

Exercise 2-16: Creating Photos for eBay Auctions

1. **Disable your camera flash.**

 Flash creates hot spots and reflections that obscure important details.

2. **Choose the location in which you'll photograph the object.**

 Your best bet is to use the light from a north-facing window. Alternatively, you can shoot outdoors on an overcast day, or shoot in a shaded area. If you're photographing a relatively small item, another option is to set up two reflectors with 100-watt incandescent bulbs on either side of the object. You can purchase clamp-on reflectors for less than $10 at your local hardware or home improvement store. Place a piece of sheer white cloth over each reflector to diffuse the light source.

3. **Set up a backdrop.**

 The best backdrop for most eBay photos is a piece of curved white poster board. You can purchase a sheet of poster board at your local office supply store.

 If you do a lot of business on eBay, you can purchase a small light tent or light cube. The light cube is surrounded by fabric, which diffuses the light that enters the cube. You can use a light cube outdoors, or position lamps of equal intensity on either side of the cube. Position your object inside the cube, aim the camera at it, and take the picture. To purchase one, you can do a Google search for "light tent" or find them on eBay. Go figure.

4. **Position the object on the backdrop.**

 Move the object forward to minimize the shadow.

5. **Place your camera on a tripod.**

 Placing your camera on a tripod minimizes any loss of detail from camera or operator movement.

6. **If you're shooting close-ups, or a small object, switch to your camera's Macro mode.**

7. **Analyze the scene through your viewfinder.**

 If you're using window light for illumination and one side of the object is in heavy shade, position a piece of white poster board on the shadow side and angle it to bounce light into the shadows.

8. **Focus on the object.**

 Switch to a single focus point if your camera has this option. Make sure the camera focuses accurately. Blurry shots defeat the purpose of including a photo with an eBay auction.

9. **Take the picture.**

 After you shoot the picture, it appears almost instantaneously on your LCD monitor. Examine the photo to make sure it is correctly exposed and in focus. Your camera's automatic-exposure function may be fooled by the white poster board and underexpose the object. If this is the case, increase the exposure in ⅓-stop increments until the object is properly exposed. The background will be overexposed, but who cares? You're selling the object, not the backdrop.

10. **Take additional photos from different angles and close-ups as needed.**

 It's always better to take more photos than you need. You never know when someone who is interested in your item will ask for a view you haven't posted with your auction.

Chapter 3

Creative Composition

· ·

In This Chapter

▶ Composing your photo using the Rule of Thirds

▶ Using geometric forms and patterns

▶ Framing your center of interest

▶ Composing a still life

· ·

*W*hen you see a photograph created by a master photographer, the photo does something to you. You're compelled to look at the photo, even though you may have seen the identical landscape or subject matter in other photos. Compare Ansel Adams's photographs of Yosemite to those of casual photographers who don't think and just snap the shutter. Many elements contribute to a great photo: lighting, subject matter, and composition, which is the subject of this chapter. Average photographers snap the picture and move on. Good photographers examine the elements of a scene and then determine the best way to create a compelling photo. Great photographers go out and search for the perfect scene or perfect elements. Good and great photographers go the extra mile when composing their photos. The exercises in this chapter are designed to make you think about composition before you shoot. With repeated practice, composing a good photo becomes second nature.

Using the Rule of Thirds

Have you ever looked at a photo of a person, place, or thing and yawned? Maybe you then looked at another photo of the same person, place, or thing and then spent some time examining the photograph. The most boring type of photograph is one in which the subject is smack-dab in the center of the photo. If you begin to think of the area inside your camera viewfinder as a special room in which you direct and compose the objects in your photo, you're on your way to making great pictures. The following exercise introduces you to the *Rule of Thirds*, which helps you divide your imaginary room into three zones and use these zones to place your center of interest.

Exercise 3-1: Composing a Photo Using the Rule of Thirds

1. **Take your camera to a nearby park with trees and interesting buildings.**

2. **Walk around the park until you find a scene that piques your interest.**

 Choose a scene that has some prominent features, such as a building or a tree with an interesting shape.

3. **Look through your camera viewfinder and imagine that the viewfinder is divided into thirds, vertically and horizontally.**

 Figure 3-1 shows a rectangle with the same aspect ratio (the ratio between the width and height of the photo) as most digital cameras. The grid is divided into thirds vertically and horizontally, which creates nine equally sized rectangles. Notice the four points where the lines that define the grids intersect. When you compose a photo using the Rule of Thirds, you place a center of interest on one of these intersection points, which are also known as *power points*.

Figure 3-1: Imagine your camera viewfinder is divided into thirds.

4. **Move around the scene, or move the camera until a center of interest aligns with one of the intersection points.**

5. **Take a picture.**

 Figure 3-2 shows a nice scene that is not composed according to the Rule of Thirds. I've placed an overlay on the photo to help you visualize the imaginary grid in the viewfinder. Figure 3-3 is the same scene composed according to the Rule of Thirds. The setting sun is now a center of interest, almost perfectly aligned on a grid inter-section point.

6. **Recompose the scene so that your center of interest intersects another imaginary grid point.**

 You'll get a slightly different photo. When you compose a scene using the Rule of Thirds, you have to decide which grid point best suits the scene. Figure 3-4 shows the scene in Figures 3-2 and 3-3. This time the sun intersects the lower right grid intersection point. The composition of the second photo emphasizes the broad expanse of wet sand, and the third photo highlights the moody sky. I like the com-position that emphasizes the sky.

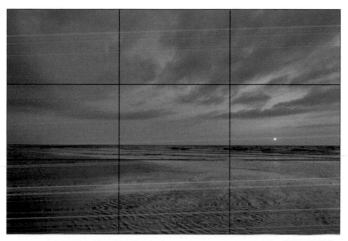

Figure 3-2: A scene that is not composed according to the Rule of Thirds.

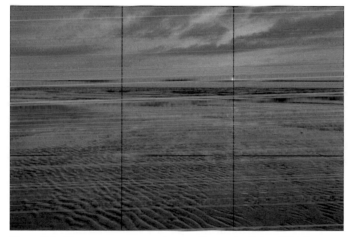

Figure 3-3: The scene composed according to the Rule of Thirds.

Don't knock yourself out trying to align your center of interest on a power point, especially in a quickly changing scene. If you've got a powerful center of interest such as the sun or moon and you get close, you've still got a compelling photo.

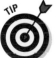

Unless you're photographing a landscape, make sure the foreground and background of the photo don't draw attention from your center of interest. You can achieve this by limiting the depth of field as discussed in Chapter 2.

Figure 3-4: The same scene also composed according to the Rule of Thirds.

Drawing Your Viewer into the Photo

Why do people take pictures? Lots of people just shoot a photo so that they remember a time or place. The fact that you're reading this book probably means that photography is more important to you than just recording an event in time. You're probably a creative person who likes to use that creativity in your photography as well. If you use elements in a scene and some artful composition, you can draw your viewer into a photo. The following exercise is a photography field trip in which you look for elements that can draw your viewer into a photo.

Exercise 3-2: Use Natural Elements to Draw Your Viewer into a Photo

1. **Take your camera to your favorite local park.**

 This exercise involves noticing things that can be used as elements in a photograph. Do this exercise on a Saturday morning or afternoon when you have a few spare hours to relax and enjoy the scenery.

2. **Look for natural curves that can be used to draw your viewer into a picture.**

 Curves take many forms. A curve in the road can pose the question, "What's on the other side?" S-curves are also great compositional elements. Notice how the curving road in Figure 3-5 draws your eye to the rolling hills, which are also curves.

3. **Look for diagonal lines that can be used to guide your viewer to the photo's center of interest.**

 Diagonal lines can be natural or manmade. The bowsprit in Figure 3-6 draws the viewer's eye to the tall ship *Balclutha* near San Francisco's Fisherman's Wharf. Another way you can use diagonals for composition is to make sure that all main elements of the picture align diagonally. When a river or highway is in your photo, align it diagonally for a more interesting picture.

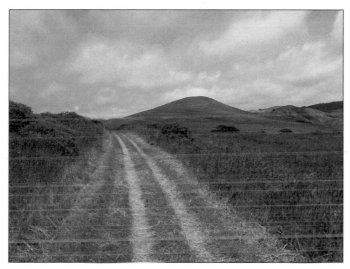

Figure 3-5: Using curves to draw your viewer into a photo.

4. **Look for contrasting elements.**

 You can use a yin-yang approach to composing a photo if you've got areas of light and dark, small objects leading to tall objects, contrasting colors, and so on.

5. **Notice strong horizontal and vertical elements.**

 Horizontal or vertical lines can be used to draw your viewer into an image, and either can be the subject of your composition. Sailboat masts in your local marina can be used to create an interesting photo.

6. **Look for vertical or horizontal lines.**

 Crouch down on your belly to take a photograph of a long pier that disappears into the distance. Another possibility is a street lined with tall, stately palm trees or an abandoned set of railroad tracks. Photograph either scene using a wide-angle lens to exaggerate the feeling of distance in the photo.

Figure 3-6: Using diagonal elements to draw your viewer into a photo.

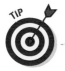

Have only one center of interest in a photo. If you have too many objects in a photo, your viewer is distracted. Ask yourself why you are taking the picture and then move around the scene until you've found a vantage point that highlights your center of interest while minimizing other visual clutter. Remember that you can use a limited depth of field to render distracting elements as out-of-focus blurs while drawing attention to your center of interest.

When you take a picture, decide which rule of composition should be used to get the most dynamic photo possible. Then step back and think of ways you can improve the photo by combining composition rules. For example, if you're using a diagonal line or curve to draw your viewer into a photo, walk around the scene until the line or curve points to a center of interest that is aligned according to the Rule of Thirds.

Composing a Photo Using Geometric Forms and Patterns

Geometry is a fact of life. We live in rectangular spaces, use circular vessels to hold fluid, and have triangular shapes in the buildings in our cities. Repeating geometric forms can be the basis for an interesting photograph. The following exercise helps open your eyes to the additional variety you can add to your photography by being on the lookout for geometric forms and patterns.

Exercise 3-3: Using Geometric Forms and Patterns in your Photography

1. **Take your camera to a local school, college campus, or shopping mall.**

Choose a locale that has some interesting and varied architecture. One of my favorite photography haunts is Florida Southern College, which has a large collection of Frank Lloyd Wright-designed buildings on campus. (If you're not familiar with Frank Lloyd Wright, Google his name to see examples of his buildings.)

2. **Take a leisurely stroll and be on the lookout for the following:**

- *Circular patterns:* You'll find circular patterns in nature and in architecture. Figure 3-7 is a photo of a koi pond. The floating lily pads are an interesting pattern, which give the viewer plenty to explore. Notice that the photograph was composed according to the Rule of Thirds so that the purple flowers are a center of interest.

- *Contrasting patterns:* Look for repeating shapes that have contrasting colors, such as black and white. Checkerboard patterns can be found on many art deco buildings. If you compose the photo so that the checkerboard patterns are diagonal, it makes the area you're photographing appear larger.

If you're photographing an opulent building with marble floors, be sure to crouch down low or lie on the floor. Switch to a wide-angle lens and shoot in Landscape or Aperture Priority mode. If you shoot in Aperture Priority mode, choose a small aperture (with a large f/stop number) for maximum depth of field. If the shutter speed is too slow to hand-hold the camera and still get a sharp picture, place the camera on the floor and compose the scene using your LCD monitor. Enable the camera self-timer and press the shutter button, and the camera will take the photograph a few seconds later.

- *Repeating geometric patterns:* You can find repeating geometric patterns in fences and architecture. A photo of a lattice fence intertwined with colorful flowers can be the basis for an interesting photo. Buildings on a college campus can also be sources for good photographs. Look for repeating patterns such as the rectangles in Figure 3-8. The image was photographed with a medium telephoto lens, which makes the building in the background

appear as though it's closer to the foreground building. When you find something you like, walk around until you see some symmetry or an interesting arrangement. Your goal is to find a composition that will cause your viewers to take a close look at the photo. The lines and rectangles should draw them to different parts of the photo. Remember that the eye tends to move from dark to light and from big to small.

Figure 3-7: Circular objects can be the basis for interesting photographs.

- *Abstract patterns:* You can find abstract patterns on the sides of weathered buildings, old signs, and so on. Natural objects have wonderful patterns. A profile of a stately old oak tree with majestic, curving branches can be the subject of an interesting photograph. The tree in Figure 3-9 presents the viewer with a cacophony of abstract patterns. The gently curving trunk leads the viewers to an abstract yet graceful array of branches. The yellow and green foliage at the top of the tree also provides a point of interest. In other words, someone who likes nature will give this photo more than just a casual glance.

Figure 3-8: Rectangles rule.

3. **As you continue your exploration, take a photo of anything with a pattern that piques your interest or curiosity.**

 If it gets your attention, chances are you can turn the scene into a photograph worth framing. Remember to walk around the scene and look for a center of interest. Use the Rule of Thirds to compose your photo, or use one of the elements in the scene to draw your viewer into the photo. If your subject has an interesting pattern, it may be hard to find one clear center of interest. In this case, just move around the scene until you see a composition that catches your attention and then take the picture. Chances are that if it captured your attention, it will interest viewers of the photo as well.

Figure 3-9: Abstract patterns lead the viewer's eye around the photo.

Framing Your Center of Interest

In a sense, photographers frame photos long before we hang them on our walls. You can create interesting photos if you look for natural frames when you photograph objects. While you're out and about with your camera, look for the following:

- Shadows can be very effective frames for wildlife photos.

- Use trees or foliage to frame people, wildlife, or buildings.

- Use arches to frame your subjects. You can find natural arches in canyons or man-made arches in train stations, hotels, and other buildings you frequent.

- Use windows or doorways to frame people.

- Use silhouetted shapes such as tall trees and buildings to frame sunsets.

- Use arching tree branches to frame photos of wildlife, buildings, and people.

- Use wagon wheel spokes to frame a subject such as a horse or someone wearing western garb.

- Use wheel spokes to frame an object or a person at an automobile race, such as the image in Figure 3-10. Notice that the subject's head is perfectly aligned according to the Rule of Thirds. This picture was taken with a medium telephoto lens, which was the 35 mm equivalent of 90 mm and a relatively large aperture. The combination created a shallow depth of field, which blurred the spokes and kept my subject in sharp focus.

Figure 3-10: Use shapes to frame your center of interest.

Take a walk in a local park with a photogenic friend and your camera. As you walk through the park, look for natural frames, ask your friend to step into the frame, and then take a picture. You can also use manmade frames such as arches and doorways. The purpose of this exercise is to make you aware of frames. They're everywhere and can be used effectively to create compelling photos. If you practice looking for frames a couple of times, you'll soon be able to quickly spot natural and manmade frames and use them to add interest to your photos.

Using Vantage Points to Compose Your Photos

When you photograph a scene or subject, the first choice you make is how to hold your camera, which determines whether the picture mode is Landscape (wider than it is tall) or Portrait (taller than it is wide). Your subject matter determines which way you should hold the camera. Another choice you have to make is vantage point. Many amateur photographers always shoot a scene from the same vantage point, and always stand up when they take a picture. Most beginning photographers would never think of kneeling or lying on the ground when they take a picture. If you're in this group, you're missing out on a lot of good photos. In addition to deciding whether you should shoot a scene from a snail's eye or bird's eye view, there's the decision of where to place the horizon line. Many beginning photographers place the horizon smack-dab in the center of the photo. Boring! Whether you place the horizon line above or below the center of the photo is dictated by the subject matter you are photographing. The following exercises illustrate the variety you can achieve in your photography by choosing a vantage point to suit your subject.

Exercise 3-4: How to Hold the Camera

1. **Ask a family member or friend to help you with this exercise.**

2. **Have your friend lie down on the living room sofa.**

3. **Take a picture of your friend while you hold the camera horizontally.**

 When your subject matter is longer than it is high, you should hold the camera horizontally. Photographing scenic vistas is another scenario when you should hold the camera horizontally, as shown in Figure 3-11.

Figure 3-11: Hold the camera horizontally when your subject is wider than it is tall.

4. **Ask your friend to stand up.**

5. **Rotate the camera 90 degrees and take a picture.**

 Cameras are made for righties, which means the shutter button is pressed with the forefinger of the right hand. The most comfortable way to shoot vertically is to rotate the camera 90 degrees counterclockwise, or anti-clockwise if you happen to be British. When you photograph a subject that is taller than it is wide, you should hold the camera vertically. This also applies to scenery. If you're photographing a waterfall, hold the camera vertically and you'll get a picture like the one in Figure 3-12.

Figure 3-12: Hold the camera vertically when your subject matter is taller than it is wide.

Exercise 3-5: Choosing a Snail's Eye or Bird's Eye View

1. **Find a friend or family member who is willing to be your guinea pig — er, I mean, *subject* for this exercise.**

2. **Ask your subject to stand in front of a wall.**

 Crouch low and photograph your subject. When you photograph a subject from a low vantage point, she appears to be taller. The effect is even greater if you can get your subject to climb a few steps up a flight of stairs. (See Figure 3-13.) Snail's eye views are also great for photographing mountain ranges, a lake, or waves crashing on a beach.

3. **Ask your subject to sit in a chair.**

4. **Stand on a stool and ask your subject to look at you.**

5. **Take a picture.**

 When you photograph someone from a bird's eye view, you get a totally different photo. (See Figure 3-14.) Bird's eye views are also great for shooting scenic vistas. (If you ever visit Yosemite, make sure you take pictures in the valley, and then take the scenic drive up to Glacier Point, which is more than 7,000 feet above sea level. From this altitude, you get a totally different viewpoint of the valley.)

Figure 3-13: Taking a photo from a snail's eye view.

Figure 3-14: Taking a photo from a bird's eye view.

Exercise 3-6: Positioning the Horizon

1. **Take a field trip with your camera to a nearby lake or beach on a partly cloudy day.**

2. **Take a photograph of the lake with the horizon line positioned about one-third of the way from the top of the frame.**

When you're taking a photograph and the water is the main subject, placing the horizon line in the upper third of the picture draws your viewer's attention to the water and the sand (see Figure 3-15). I composed the scene and waited until the runner intersected a power point according to the Rule of Thirds.

3. **Take another photograph with the horizon line positioned about one-third of the way from the bottom of the frame.**

When you position the horizon line in the lower third of the frame, you draw your viewer's attention to the sky (see Figure 3-16). This is also the ideal horizon when you're photographing mountains.

Figure 3-15: Placing the horizon line in the upper third of the frame.

Figure 3-16: Placing the horizon line in the bottom third of the frame.

Now that you know some techniques to create compelling photos, review some pictures you've taken recently. Look for elements in the photo that could have been be used for composition. Does the scene have elements that could draw your viewer into the picture? Would the shot look better if the horizon were placed differently? Would the photo be more interesting if composed according to the Rule of Thirds? Could any elements in the photo act as natural frames? After examining the photos, you'll know your strengths and weaknesses regarding composition. If possible, take additional photos of the same subjects or scenes armed with your newly gained knowledge of composition.

Photographing a Still Life

It's the middle of winter, the snow is falling, it's 15 below zero, and you want to take pictures. Well, you could photograph your family or pets, but they've probably got a bad case of cabin fever and their smiles won't come easy. The best alternative is to do a scavenger hunt around the house and come up with some objects for a still life. A *still life* is basically a photograph of anything that doesn't move. The possibilities are endless. You can take artistic photos of objects like books, watches, flowers, and so on. Or you can raid your refrigerator for subjects. Fruit is a wonderful basis for a still life. So before you start the next exercise, find some objects that would make the basis for a good still life.

Exercise 3-7: Photographing a Still Life

1. **Find a table near a window.**

This is your studio. Because objects in a still life are relatively small, all you need is soft, diffuse light through a window. A window facing north or south is best. However, as long as you don't have bright sunlight shining directly into the window, any location will do.

2. **Place a white cloth on the table.**

This serves as your base for your still life. Unless you are photographing the still life from above, you should also drape a white backdrop behind the table. If the white cloth is long enough, you can drape it over a tall chair or tack it to the wall behind the table.

3. **Arrange the elements that are the basis of your still life.**

If you're photographing fruit, arrange it in a nice wooden bowl. Place flowers in a colorful vase. The possibilities are endless. Remember the rules of composition I covered earlier in this chapter. A still life photograph is more interesting if you photograph an odd number of elements.

4. **Fasten your camera to a tripod.**

If you're not familiar with using tripods, refer to the section on stabilizing your camera in Chapter 4.

5. **Switch to Portrait mode or switch to Aperture Priority mode.**

If you choose Aperture Priority mode, choose a large aperture (with a small f/stop number). Either choice blurs the foreground and background.

6. **Zoom in until the subject almost fills the viewfinder.**

If you're photographing small elements, you may have to switch to Macro mode with a point-and-shoot camera or use a macro lens if you're taking the picture with a digital SLR. Your camera's Macro mode or a digital SLR macro lens enables you to capture close-ups of small objects. For more information on Macro photography, see the section in Chapter 6 about getting close-up shots of flowers.

7. **Examine the scene through the viewfinder.**

If you notice heavy areas of shadow, you may need to use a piece of poster board to reflect light into the shadows. Remember that you can control the amount of light being bounced into the shadows by moving the reflector closer to or farther from the subject.

8. **Take the picture.**

The picture appears a few seconds later in your LCD monitor. Don't just settle for one photo. Rearrange the elements and take another photo. For that matter, while you've got your mini-studio set up, create some other still life photos. Figure 3-17 shows a still life photographed on my dining room table using the techniques in this exercise.

Figure 3-17: Call any still life, and the chances are good that the still life will not respond to you.

Composition: No Rules, Just Right

To quote master landscape photographer Ansel Adams: "There are no rules for good photographs, there are only good photographs." The exercises in this chapter have stressed that you should use rules when composing a photograph. But rules are made to be broken. Here are some of the rules that are drilled into every photographer's head and examples of when you can break them:

✓ **Don't center your subject:** This is directly related to the Rule of Thirds. You can break this rule when your subject is so powerful and occupies most of the frame that it demands to be on center stage. When in doubt, use the Rule of Thirds to compose the picture, and then take another picture with your subject matter in the center of the photograph. When you examine them side-by-side, you'll know which one is best.

✔ **Don't tilt the camera to fit a tall object in the frame:** Tilting the camera would be disastrous if you're photographing a tall person. The resulting photo would look as if the person were falling over backward. However, when you have a unique piece of architecture whose height you want to exaggerate, tilting the camera is just what the doctor ordered. Figure 3-18 is a photograph of a monument on a college campus near my home. If I had backed up until the monument filled the frame, the monument would be lost in a wide expanse of trees and other buildings. Tilting the camera allowed me to get the monument in a single picture without other distractions. It also emphasizes the height of the structure.

Figure 3-18: Tilt the camera to exaggerate the height of a structure.

✔ **Don't shoot a close-up with a wide-angle lens:** When you shoot a close-up with a wide-angle lens, you distort the objects closest to the camera. However, in some cases, you can use the distortion for comic effect or to emphasize a characteristic of your subject. Vintage Jaguar XKE cars have hoods so long they seem to go on forever, especially for the nut behind the wheel. Figure 3-19 shows a vintage Jaguar photographed from a snail's eye view with the 35mm equivalent of a 28mm lens. The grille opening and headlights almost fill the frame, and you can see the car has a *very* long hood.

✔ **Don't have more than one center of interest:** As a rule, photographers avoid having multiple centers of interest. However, if you've got a wonderful scene with interesting elements, you can have multiple centers of interest. If you align the multiple centers of interest on power points according to the Rule of Thirds, your viewer's eye moves from one center of interest to the next. When done correctly, the multiple centers of interest direct the viewer's eye around the photo.

✔ **Keep the camera level:** You can break this rule when you've got a strong horizontal element in the scene. Align the camera so that the horizontal element is diagonal and take a picture (see Figure 3-20). Notice that the young woman's face is also perfectly positioned according to the Rule of Thirds.

Figure 3-19: Exaggerating a characteristic with a wide-angle lens.

Figure 3-20: Turn the camera diagonally when you have a strong horizontal element in the scene.

Developing Your Style

The exercises on composition in this chapter are designed to make you observe the subjects and objects you're photographing with more than just a casual glance. When you learn to see the subtle nuances when viewing a scene through the viewfinder, you become a better photographer. However, if every photographer interpreted every rule identically, photos of certain subjects and geographical icons would all look the same. What separates the photography of Ansel Adams from the casual picture-taker is that he had the ability to see a scene as being photo-worthy. He then analyzed the scene to find the best vantage point and then applied his knowledge of photography to capture the best possible photograph.

The fact that you are reading this book and doing the exercises means you want to be a better photographer. To be a good photographer, you must be familiar with your equipment and its limitations. But like everything else, practice makes perfect. When you take enough pictures, you start developing a style. Here are a few pointers on developing a style to suit the type of subjects you photograph:

- **Whose work do you admire the most?** If you're serious about being a better photographer and you're specializing in a genre of photography, you probably know one photographer whose work inspires you. Study her photographs to see what makes them stand out from the crowd. You'll probably notice she used some of the composition techniques presented in this chapter's exercises. Use this information you glean by studying works of the masters as a starting point. Ask yourself what you like and dislike about their work. When you photograph the same or similar subject matter, remember how the masters tackled the subject, but make the photograph your own by adding your own, unique touch to the photo.

- **Personal style is all about choices.** You choose certain lenses to photograph your subject matter, and you choose to photograph it from a distinct vantage point unlike that of other photographers.

- **Do you set up your shots or shoot spontaneously?** Do you photograph when the weather is good, or do you like the moody look that photographing in inclement weather adds to a photograph? Are there people in your photographs?

- **The key to developing a style is to photograph something you enjoy again and again.** Not only does practice make perfect, but the more you photograph something, the more you discover about it, which undoubtedly leads to better photographs. When you repeatedly photograph the same subject matter, whether it's birds in Florida or wildlife in Yosemite, you become more familiar with the subject matter and tend to observe it in your own, unique way. Your photographs will reflect that. After all, Ansel Adams didn't photograph Yosemite on one visit: He spent a good part of his life photographing his favorite subject matter.

Part II
Taking Compelling Shots of Common Subjects

The 5th Wave By Rich Tennant

"I've got the red—eye reduction, I'm just seeing if there's a button that'll fix your hair."

In this part . . .

A digital camera is a tool that you can use to create a photo journal of your life. You can use your camera to photograph your family, your vacation, your son's soccer games, and much more. Taking the camera with you is the first step in documenting the important events in your life. The second step is knowing what to do with the camera to create great photos of the events in your life. The exercises in this part of the book show you how to master the different camera modes and controls to photograph everything from your wife's prized azaleas to a sports car racing down the back straight of your favorite racecourse. The last chapter in this part shows you how to create special-effect photos using your camera.

Chapter 4

One Sun, Many Settings

*W*hen you look at a photograph, you see shadow and light. The ambient light source filters light into the scene you're photographing, and anything that blocks the light's path creates shadows. The quality of natural light changes during the course of the day. A few minutes before the sun rises, the sky and clouds are colored with giddy hues of pink and purple and the ground is dappled with long shadows. The midday sun is quite harsh and, because it's directly overhead, doesn't cast much of a shadow. Late in the afternoon, when the sun starts sinking low on the horizon, the quality of light again transforms. Now you've got very warm light, which paints the clouds in reddish-orange hues and casts interesting shadows. If there are clouds in the sky, a few minutes after sunset — dusk, to you technically minded folk — the clouds are tinted pink and purple, just as they are if you rise early to take photos at the crack of "dark-thirty" before the sun comes up. The exercises in this chapter will make you aware of the quality of light at different times of the day and the type of results you can expect when taking pictures in the morning or late afternoon.

Taking Photos in Golden Light

If you take the majority of your pictures outdoors, you've got to cope with Mother Nature. Sometimes Mother Nature cooperates and presents you with an absolutely gorgeous day with a cerulean blue sky and puffy clouds. These are ideal conditions for any photographer. However, even when you're taking pictures during a "Chamber of Commerce" day, there are still certain times of the day when you'll get your best shots. You can capture stunning photographs an hour after the sun rises and an hour before the sun sets. Some photographers refer to these times as *golden hours*. At these times of the day, the sun is low on the horizon, the light is a warm, golden hue, and the shadows are long. The following exercises give you an appreciation for the types of photographs you can capture at these times of day.

Exercise 4-1: Taking Pictures in the Early Morning

1. **Visit a garden or park shortly after sunrise.**

 Choose a nearby park that has some interesting flowers or foliage. If you have your own garden and the flowers are illuminated by early morning sunlight, this is an ideal place to capture some great photos.

2. **Switch to Macro mode.**

 On most point-and-shoot cameras, this mode is designated with an icon of a flower. If you own a digital SLR, mount a macro lens on your camera that is capable of taking extreme close-ups.

3. **Take some close-up shots of flowers.**

 If you shoot pictures of flowers in the summertime, the flowers will be dotted with dewdrops (see Figure 4-1).

 If there's no dew on the flowers, you can create your own. Carry a small spray bottle filled with water and spritz the flowers before photographing them.

Figure 4-1: Photographing flowers in golden light.

4. **Switch to Landscape mode and take some photos with your back to the sun.**

 Photos taken at this time of day have wonderfully abstract shadows. All objects in your scene are imbued with wonderfully warm tones of orange and gold. Figure 4-2 is a photograph of Berkeley Marina photographed in the early morning. Notice the saturated and warm colors in the photograph. If you photograph a similar scene, do so when there's little or no wind and you'll create a mirror reflection of the sailboats, just like the one shown in this figure.

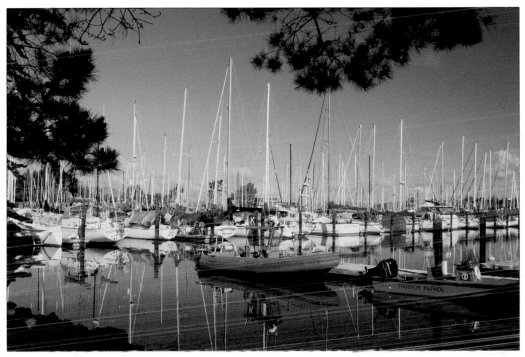

Figure 4-2: Photographing landscapes in the early morning.

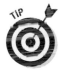

Morning light is also great for taking photographs of people outdoors. However, if your subject looks directly into the sun, he'll be squinting. A way to prevent this is to ask your subject to close his eyes and tell him to open them and smile at the count of three. Compose your photo, count to three, and then take the picture.

Exercise 4-2: Taking Pictures in the Late Afternoon

1. **Visit your favorite park about an hour before sunset.**

 One of my favorite spots for taking photos in the late afternoon is a nearby lake.

2. **Take some photographs of birds and other wildlife that may be lurking about.**

 Late afternoon light is wonderful for photographing wildlife (see Figure 4-3). (For more information on photographing wildlife, see Chapter 6.)

3. **Take photos of the scenery with your back to the sun.**

 The light in late afternoon is similar to early morning sunlight. However, there is usually less humidity in the afternoon so the light is not as diffused as early morning sunlight. The objects in the scenes you photograph are still illuminated by golden light (see Figure 4-4). Notice the warm tones on the Golden Gate Bridge and the San Francisco skyline.

4. **You can also take photos shooting directly into the sun.**

 If the sun isn't in the scene, the camera may overexpose the scene to compensate for the dark shadows. If this is the case, use exposure compensation to decrease the exposure until you capture photos that realistically depict the scene. You can use exposure compensation to decrease exposure by using menu commands or camera dials. Most camera manufacturers measure exposure compensation by ⅓ f/stop and enable you to increase or decrease exposure by as much as 2 stops. If you use exposure compensation, be sure to change back to the original settings after you take pictures that require exposure compensation.

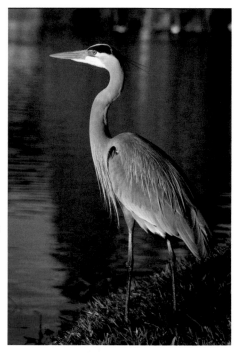

Figure 4-3: Photographing wildlife during the late afternoon.

 If the sun is visible in the scene, the dynamic range of a digital camera isn't sufficient to capture the dark shadows and bright light in the scene. Compose the photo so that the sun is hidden behind buildings or foliage. Your camera will probably still overexpose the scene. If this is the case, use your camera's exposure compensation feature to properly record the scene. If your point-and-shoot camera or digital SLR lens has a lens hood, place it on the lens when shooting directly into the sun to avoid lens flare (unless you want lens flare in the picture for artistic reasons).

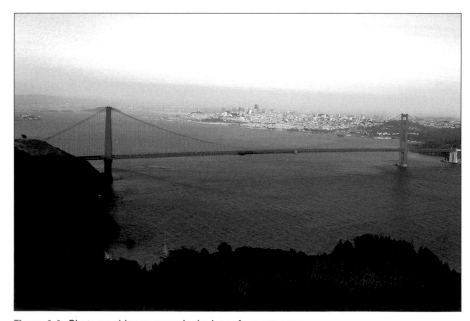

Figure 4-4: Photographing scenery in the late afternoon sun.

 Late afternoon sun is also great for photographing people outdoors, but your subjects will squint if they look directly into the sun. One way to thwart this problem is the afore-mentioned trick of asking your subjects to close their eyes and open them on the count of three, just as you snap the picture. Another alternative is to use fill flash, which I discuss in an upcoming section.

Taking Photographs at Midday

I avoid taking photographs in the middle of the day whenever possible. During the middle of the day, the sun is directly overhead. There are virtually no shadows and, if you're photographing a person, the harsh overhead light shows every pore and wrinkle.

However, you don't always have a choice. If you're on a tour or on vacation, you have to photograph what you can photograph when you're there. Unless you're on a photography tour, the tour guide won't hold up the tour so that you can get your photograph under ideal conditions. The following list shows a few techniques you can use to capture some acceptable photographs during the middle of the day:

- **Take photos in the shade.** When all else fails, you get nice, diffuse light when you photograph a scene or person that is shaded from the harsh light of the noonday sun. If you're taking photos in a city, tall buildings can provide shade an hour or so after high noon. Hotel balconies and overhangs also block the noonday sun.

- **Wait until a cloud passes overhead.** When a cloud passes overhead, the light is softer and diffused.

- **Use a polarizing filter.** Rotate the ring of the polarizing filter until the sky becomes a darker blue. As a bonus, any clouds in the sky stand out in sharp contrast to the sky. A neutral density filter can also help reduce harsh light. For more information on using polarizing and neutral density filters, see Chapter 2.

- **Use exposure compensation.** Decrease the exposure to make the scene appear darker than it actually is.

Stabilizing Your Camera When Shooting in Low Light

If you're going to take pictures in low light, or after dark, you need a camera with a fast lens (an aperture less than f/2.8) that has the capability of creating noise-free pictures at high ISO settings. If your camera doesn't measure up, your only choice is to stabilize your camera with a tripod or monopod. If you already own a tripod, follow the instructions in the following exercise to become familiar with the common features on most tripods. If you don't own a tripod and are considering purchasing one, read through the exercise and you'll discover what you need to know to purchase the tripod that is right for your camera.

Exercise 4-3: Stabilizing Your Camera with a Tripod

1. **Unpack your tripod and spread the legs from the center of the tripod.**

 Your tripod may have a locking mechanism on the center pole, which prevents the legs from opening. Unloosen the locking nut and then pull the legs from the center of the tripod.

 If your tripod doesn't have a carrying case, consider purchasing one from your camera store or online. The carrying case protects the tripod when you're traveling. Most carrying cases have a strap that enables you to sling the tripod and case over your shoulder while hiking.

2. **Extend and lock the tripod legs.**

 Most tripods have clamps that are used to unlock each leg. If you need to stabilize the camera on uneven ground, you can have each leg at a different height to level the head onto which you mount your camera. Your tripod legs are probably made with three sections and two locking clamps. Extend the middle sections first. Your tripod may also be equipped with a spirit level that you can use to be sure the tripod is level.

3. **If you're using the tripod on grass or dirt, retract the rubber feet.**

 With most tripods, you can retract each rubber foot by turning the foot clockwise several times. This reveals a pointed spike. Push the top of the tripod and the spikes dig into the earth, offering additional stability.

4. **Extend the center column to the desired height and then lock the center column.**

 Most tripods have a crank that is used to extend the center column. Your tripod also has a method by which you can lock the center column after you have raised it to the desired height.

5. **Mount the camera to the head of the tripod.**

 Some tripods have a thumbscrew that you use to fasten the tripod bolt to the thread in the base of your camera. Tripods like this also have a locking nut. The better tripods have a base at the top of the head that can be removed by moving a lever. Inside the base is a thumbscrew that is used to mount the camera to the head. After mounting the camera to the base, replace and lock it into position.

6. **Adjust the head of the tripod to shoot in Landscape or Portrait mode.**

 By default, your tripod is set up for you to shoot pictures in Landscape mode. However, if you want to shoot in Portrait mode, there is a thumbscrew on the left side of the tripod head. Turn the thumbscrew counterclockwise and then pivot the head 90 degrees. Tighten the thumbscrew to lock the tripod head for shooting in Portrait mode.

 When purchasing a tripod for a digital SLR, make sure it's sturdy enough to support your camera body and the heaviest and longest lens you own or anticipate purchasing in the future. The tripod manufacturer's spec sheet lists the weight the device can support. If in doubt, ask your retail camera salesperson how much weight the tripod you're considering purchasing supports.

7. **Adjust the angle of the head of the tripod.**

 Your tripod has a lever that can be used to rotate the tripod head vertically. Turn the end of the lever counterclockwise and move the lever forward or backward until the head is at the desired angle. Your tripod may also have a level mounted into the head of the tripod, which is helpful when you want the camera to be perfectly level.

8. **Lock the angle of the tripod head.**

 After adjusting the angle of the tripod head, turn the end of the lever clockwise to lock the head. Your tripod may also have a large thumbscrew that, when turned fully clockwise, makes it impossible to adjust the level of the tripod head. If your tripod has this feature, you can unloosen the thumbscrew and then move the lever to make minute changes to the angle of the tripod head.

9. **Pan the tripod head.**

 Move the lever from left to right to pan a camera mounted on a tripod head. Your tripod has a lever that can be used to lock the tripod head after you've panned to the desired position. If you are using your tripod to steady the camera while panning a moving object, don't lock the tripod head.

10. **Compose the scene and press the shutter button halfway to focus.**

 After you press the shutter button, make a note of the shutter speed. If you've got a very slow shutter speed of more than a second, it's possible to cause some movement when you press the shutter button, especially if you've got a smaller tripod. If this is the case, you can use your camera's self-timer to delay the shutter release, which gives the camera time to stabilize after you press the shutter button.

11. **Take the picture.**

 Figure 4-5 shows a digital SLR camera mounted on a heavy-duty tripod.

Figure 4-5: Supporting your camera with a tripod.

If you're purchasing a tripod and want to carry one with you when you travel, choose a compact tripod that's strong enough to support your camera and still fit in a piece of your luggage. Many tripods are small enough to fit in a suitcase.

Using a Monopod to Steady Your Camera

Sometimes you need just a bit of help steadying your camera. In this case, you use a monopod. A *monopod*, as the name implies, has one leg. Monopods work great for stabilizing small point-and-shoot cameras, or digital SLRs. (You won't be able to use a monopod to stabilize a digital SLR with a long lens. However, many long lenses feature a mount that can be used to attach the lens to a tripod or monopod. The lens mount is positioned so that the center of the mass of the camera and lens are evenly distributed.) The following exercise shows you how to support your camera with a monopod.

Exercise 4-4: Supporting Your Camera with a Monopod

1. **Extend the leg of your monopod to the desired height.**

 Most monopods have three telescoping tubes with locking collars. Twist each locking collar counterclockwise, extend each telescoping tube until the monopod is the desired height, and then twist the collars clockwise to lock the tubes.

2. **Extend the feet of the monopod.**

 Some monopods have small feet in the base of the unit. If your monopod has this feature, unscrew the cap at the bottom of the monopod, extend the feet, and then secure the cap.

3. **Mount the camera on the monopod.**

 The top of your monopod is threaded and mates with the tripod mount on the base of your camera. Be careful not to cross-thread the mount or overtighten it.

4. **Swivel the head to the desired position and then lock it.**

5. **Grab the strap on the monopod and pull down.**

6. **Spread your feet apart.**

 Your feet act as auxiliary support for the monopod. The key to success with a monopod is for the camera operator to be stable.

7. **Compose and take your picture.**

 Figure 4-6 shows a point-and-shoot camera mounted on a monopod with retractable feet.

Figure 4-6: Stabilizing a camera with a monopod.

Stabilizing Your Camera Sans Tripod

Sometimes it's not practical to carry a tripod, especially when you travel. It's also not fun to carry a tripod if you're doing a lot of walking, even if your tripod is light. So what do you do when faced with a situation where you need to stabilize your camera, but don't have a tripod in your hip pocket? Here are a few ideas:

- ✔ **Place the camera near the edge of a table.** If you see the table when you compose the picture, move the camera closer to the edge.

- ✔ **Stabilize yourself with a wall and then spread your legs slightly.** Take a breath and press the shutter as you exhale.

- ✔ **To stabilize the camera when taking a shot in Portrait mode, press the camera against a wall.**

- ✔ **Carry a small beanbag in your camera bag.** The beanbag can be molded to stabilize the camera in different positions.

- ✔ **Place some raw rice in a baggie.** Close the bag and place your camera on it. The bag molds to the shape of the camera as you move it to the desired position.

Set the camera self-timer to two seconds and use it whenever you're using a wall or horizontal surface to stabilize your camera. Using the self-timer gives the camera time to stabilize from any vibration that occurs when you press the shutter.

Shooting Photos at Dusk

Some people put their cameras away right after the sun goes down and seek out their favorite watering hole. If you're in this group, you're missing some wonderful photo opportunities, especially if there are any clouds in the sky. If you hang around a photogenic location such as a lake and wait patiently, the city lights will wink on one by one. The following exercise shows some techniques for capturing wonderful photographs at dusk.

Exercise 4-5: Taking Pictures at Dusk

1. **Go to your favorite park or lake half an hour before sunset.**

 Pick a location that doesn't have a lot of foreground clutter. A wide expanse of open field with tall trees and buildings at the perimeter is ideal. Another ideal location for photos at dusk is a lake, which provides wonderful reflections of the city lights.

2. **Notice the cloud formations to the west.**

 If there are no clouds in the sky, pack it up and plan to try another day, as the resulting pictures won't be very interesting.

3. **Switch to Landscape mode.**

Alternatively, you can switch to Aperture Priority mode and choose a small aperture (large f/stop number). When you shoot in Landscape mode or choose a small aperture, you'll have a large depth of field.

4. **Switch to a higher ISO setting.**

Switch to the highest ISO setting on your camera that does not add visible noise to the picture.

5. **Steady the camera.**

Even though you've switched to a higher ISO setting, you may still have to use a tripod or monopod to steady the camera. If your shutter speed is too low to hand-hold the camera, enable image stabilization if your camera is so equipped. Remember that the rule of thumb for the slowest shutter speed you can use while hand-holding the camera is the reciprocal of the 35mm equivalent focal length you are using. For example, if you're using a focal length that is the 35mm equivalent of a 28mm focal length, your shutter speed should be 1/30 second or faster.

6. **Take the picture.**

You have a small window of opportunity at dusk before the sky becomes completely dark. If there are clouds in the sky, you'll still see reflections from the sun, even though the sun has set 15 or 20 minutes earlier. You'll get your best pictures at dusk when there are clouds in the sky (see Figure 4-7).

Figure 4-7: Taking pictures at dusk.

Capturing Images at Night

If you've taken pictures at dusk, and the weather is nice, there's no real reason to seek the solace of your humble abode or hotel room if you're traveling. Armed with a tripod and a good eye, you can capture some great photos at night. Many beginning photographers think that they'll be able to use their on-camera flash to pierce through the darkness. Well that's like trying to carve a turkey with a butter knife. It just doesn't work. You can, however, get some great pictures at night with the aid of a tripod. If you capture a photograph at night in a busy city, you've got cars and people walking in your picture. You could take the photo at a high ISO and attempt to freeze action. However, you won't be able to do this unless you've got a camera with an ISO of 1600 and an incredibly fast lens. And, if your camera can capture at ISO 1600, it had better be a digital SLR with a CMOS sensor; otherwise, you have lots of digital noise, which looks even worse when you take a picture of a scene with lots of shadows. If you don't have a high ISO, that's not a bad thing. In fact, if you go the other way and use a long exposure to capture night scenes, you'll get stunning photos that show the hustle and bustle of city life with a graceful stream of red and white light streaks where cars traveled through the scene. If people are walking through the scene while your lens is open, they'll be rendered as a soft blur. So grab your camera and get ready to venture out at night. The following exercise shows you the steps to creating compelling images at night.

Exercise 4-6: Taking Pictures at Night

1. **Grab your camera and tripod, and then take a field trip to a nearby city or town.**

 Make your trip on a night where there will be some vehicular traffic. It's a bonus if you travel to a place with outdoor cafés. Friday night is generally a good night. People are going to dinner and the movies to recover from their 40-plus-hour work week.

2. **Find an intersection with a traffic light.**

3. **Mount your camera on a tripod.**

 For more information on using tripods, see the "Stabilizing Your Camera When Shooting in Low Light" section of this chapter.

4. **Watch the flow of traffic for a few seconds and then compose your picture.**

 When you compose the photo in the viewfinder or LCD monitor, notice how the vehicles are moving. Use the rules of composition to create a compelling photo. The resulting photo has abstract patterns of light from the headlights and taillights. Imagine the light patterns that will result as the cars round a corner.

 You can create an interesting night photo by photographing a busy intersection from the second story balcony of a hotel or office building.

5. **Switch to your lowest ISO setting.**

 Your goal is to keep the shutter open for several seconds.

6. **Switch to Landscape mode.**

 Alternatively, switch to Aperture Priority mode and choose a small aperture (large f/stop number). This gives you a good depth of field.

7. **Take the picture.**

 You'll see the results on your LCD monitor in a few seconds. You get your best results by taking several pictures from the same intersection. Doing so enables you to get different patterns from different-size vehicles. When you get a shot where a lot of traffic is traversing the intersection from different directions, you have a keeper (see Figure 4-8).

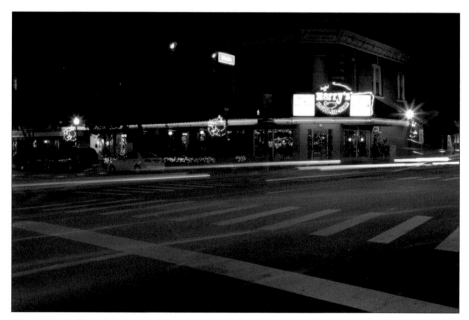

Figure 4-8: Taking pictures at night.

When taking pictures that require long exposures, use your camera's self-timer. This allows any camera movement that occurs when you press the shutter button to stabilize before the picture is taken.

To find out the highest ISO setting you can use to create acceptable pictures with minimal digital noise, take a night excursion with your camera. Travel to an area where there are some bright city lights on a moonless night. Mount your camera on a tripod and compose a picture with the bright lights and quite a bit of sky. Take several pictures using each of the ISO ratings available on your camera. When you get home, download the images to your computer and examine them at 200 percent magnification. Scroll to the dark areas of the photo and look for evidence of digital noise, which shows up as small specks and smudges of random color. When the digital noise is such that it degrades the image, note the ISO and always use the next-lowest ISO when you want images that are relatively noise free.

Using Fill Flash

Photographing a backlit subject is difficult. A subject is *backlit* when his back is to the main light source in the scene; for example, photographing someone at sunset with his back to the sun. When you photograph a backlit subject, your camera's exposure settings may render him as a silhouette, or in heavy shadow. You can use exposure compensation, or manually set exposure to properly expose your subject, but then the background winds up being overexposed. You typically run into these problems when photographing a person with their back to the setting sun. Is it possible to have your cake and eat it too? Yes. The following exercise shows you how to fill in the shadows using fill flash when your subject is backlit or in the shade.

Exercise 4-7: Using Fill Flash

1. **Ask a friend or family member to help you with this exercise.**

Go outdoors when the sun is low on the horizon. You can use fill flash when photographing a backlit subject in the early morning or late afternoon.

Fill flash is also useful when your subject is in shade, and the background is bright; for example, when you're taking a photograph of someone wearing a baseball cap on a bright day. His face is shaded by the bill of the cap, and will be dark in the photo. Fill flash fills in the shadow under the cap.

2 **Ask your subject to turn his back to the sun.**

3. **Switch to Landscape mode.**

Alternatively, you can switch to Aperture Priority mode and choose a small aperture (large f/stop number). Your goal is to have your subject and the background in focus.

4. **Press the button on your camera that pops up the on-camera flash.**

5. **Switch to a single auto-focus point if your camera has multiple focus points.**

6. **Move the camera until the auto-focus point is over your subject.**

7. **Press the shutter button halfway and then compose the picture.**

Even though this is an exercise in fill flash, there's no reason you can't practice the rules of composition as well. Position your subject so that he's a center of interest in the photo, remembering the Rule of Thirds.

8. **Take the picture.**

The image appears in your LCD monitor shortly after you take the picture. If your subject is still not properly exposed, use flash compensation to increase the output of the flash and take the picture again. You can also use fill flash when your subject is in heavy shadow. I used fill flash in the photo in Figure 4-9 to brighten my subject, whose face was in the shade.

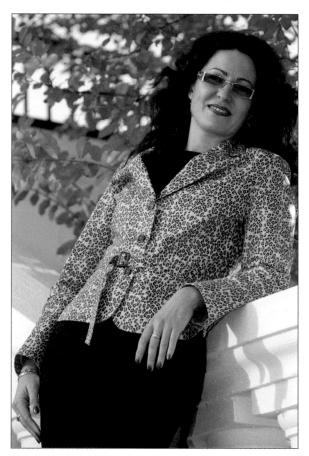

Figure 4-9: Using fill flash to brighten shadows.

Using Second Shutter Flash

When you're taking a photo of something in motion (your favorite car, a triathlon runner, your mother-in-law running away from your son playing his guitar) in a low light situation, the subject will be blurred unless you use flash and a shutter speed fast enough to freeze motion. On the other hand, you can create a photograph that captures the essence of motion if you use a slow shutter speed and flash with the Second Shutter Flash option enabled. Cameras with the Second Shutter Flash option fire the flash just before the shutter closes, which gives you a photo with a motion trail ending with your subject frozen in time by the flash. If you were to capture a photo like this with the flash set to its default of firing right after the shutter opens, your subject would be frozen and there would be a motion trail leading away from him, which would make it look like your subject was traveling in reverse. To get the knack of Second Shutter Flash, ask a friend or family member to assist you in the following exercise.

Exercise 4-8: Capturing Motion with Second Shutter Flash

1. **Grab your tripod, camera, and subject and go outside.**

 The best time to try this exercise is at dusk. The sky still has a bit of ambient light, but it's dark enough to ensure you've got a relatively long exposure.

2. **From your camera menu, enable the Second Shutter Flash option.**

 Your camera menu may refer to this as Flash Sync – Second Curtain. By default, most cameras have this option set to First Curtain or First Shutter.

3. **Choose the lowest ISO setting on your camera.**

 This minimizes noise and helps ensure a long exposure.

4. **Switch to Aperture Priority mode and choose an f/stop that gives you an exposure of about four seconds.**

 After choosing an f/stop, press the shutter button halfway. You'll see the duration of the exposure in the LCD monitor or viewfinder, whichever you are using to compose the scene. If the exposure is longer than four seconds, choose a larger aperture (smaller f/stop number) or higher ISO setting.

5. **Mount your camera on a tripod.**

 Mounting your camera on a tripod ensures you've got a level motion trail leading up to your subject. Alternatively, you can hand-hold the camera to get an uneven motion trail, which is also a desirable effect.

6. **Switch to a single auto-focus point.**

7. **Compose the picture.**

 Leave enough room for your subject to run into the frame. Your subject will be running from left to right. Your goal is for the flash to fire while there's space beyond your subject in the resulting picture. When you're capturing an action shot, always leave somewhere for your subject to go.

8. **Ask your subject to move to the place where you want the motion to be frozen and then press the shutter button halfway to establish focus.**

 In essence, you're prefocusing at the place where you want your subject to be in sharp focus.

9. **Ask your subject to move to your right and out of frame.**

 Make sure you're still pressing the shutter button halfway.

10. **Tell your subject to begin running and press the shutter.**

 If you've gauged everything correctly, your flash should fire when your subject is at the desired position. You may have to repeat this exercise with your subject running slower.

Shooting Photos in Night Scene Mode

When you take a photograph of someone at night with on-camera or auxiliary flash, your subject is properly exposed, but the background is underexposed. The flash simply doesn't have the horsepower — er, *candlepower* — to adequately light the scene. Most digital cameras have a feature known as Slow Synchro or Night Scene Mode that uses a combination of flash and ambient light to illuminate your subject and the surrounding scenery. The following exercise familiarizes you with how to use this mode.

Exercise 4-9: Taking Pictures Using Slow Synchro or Night Scene Mode

1. **Ask a friend, relative, or significant other to assist you in this exercise.**

Don't use the same person you used for the other exercises in this chapter. By this point, she may be ready to throw something at you or hide your camera.

2. **Grab your camera, tripod, and subject and go outside after dark.**

Choose an area where there is some ambient light sources such as streetlights, or lights from buildings.

3. **From your camera menu, access the Night Scene or Slow Synchro option.**

Now that there are more camera manufacturers than there are Smiths in the NYC phone book, it's impossible to predict what this option might be called on your camera. Canon calls this a function and names it Slow Synchro. You may also see this as Slow Synchro Flash.

4. **Tell your subject where you would like her to stand.**

For this exercise, have your subject stand on a walkway in front of your home's front door. For ambient light, turn on the porch light.

5. **Stabilize the camera.**

When you take pictures in this mode, the flash provides the illumination for your subject, and the camera lens remains open to faithfully record the background. This results in a long exposure. Alternatively, if you hand-hold the camera, your subject is sharp and the background is blurry. You'll also have a blurry ghost of your subject.

6. **Take the picture.**

Chapter 5

Creating Photos of People and Pets

· ·

· ·

Say you've got a digital camera and you just want to take a picture of something or somebody. What better place to begin than with your family, friends, and pets? Armed with a digital camera, sound techniques, and a bit of practice, you've got the necessary tools to create compelling photos of your family members: male, female, canine, and feline. However, just because you've got a point-and-shoot camera doesn't mean you can just point and shoot at any subject and expect to get a great picture. If it were that simple, you wouldn't have camera menus, buttons, and dials with all those funny icons. If you don't use the right settings for a specific photo opportunity, you won't get a good photo. And if you want a great photo, you've got to take more into account than just the camera settings. You have to contend with factors like the subject, the background, the composition, and the lighting, among others. When you take a good photo, your viewers give it more than just a casual glance. In this chapter, I show you exercises to make you a better people photographer.

Shooting Photos of People

When you photograph a person, or group of people, you need to do everything in your power to make your subject the center of interest in the photo. That doesn't mean they need to be smack-dab in the center of the photo. In fact, photos where the person is perfectly centered can be very boring indeed. In addition to thoughtful composition, you get your best photos of people by choosing the proper camera mode and focal length when using a point-and-shoot camera, or by choosing the proper lens and aperture when shooting portraits with a digital SLR. Here are some points to consider when preparing to shoot a portrait:

✔ **Choose the right camera mode.** Most digital point-and-shoot cameras have a Portrait mode, which is signified by the icon of a person's head on your camera dial. If you're using a digital SLR, or your camera is equipped with creative modes, choose the Aperture Priority mode (AV or A) and then select the largest aperture (lowest f/stop number). Either method gives you a limited depth of field. In other words, your subject will be in sharp focus, but the background and foreground will be blurred.

✔ **Select the right focal length.** If you're using a digital SLR, select a telephoto lens, or zoom lens that has a focal length that has a 35mm equivalent of between 85mm and 105mm. If you're using a point-and-shoot digital camera, zoom to a focal length that is the 35mm equivalent of between 85mm and 105mm. If your camera doesn't have any method of determining the 35mm equivalent, back away from your subject, and then zoom in. Your goal is to shoot a photo in which your subject's features that are closest to the lens are not exaggerated. For example, if you use a focal length with the 35mm equivalent of 28mm to shoot a head-and-shoulders portrait, your subject's nose ends up looking huge.

✔ **Illuminate the portrait carefully.** Use your on-camera flash if you have a way to diffuse the light. If you don't diffuse the light, you end up with harsh shadows behind your subject, and worse yet, red-eye. If your camera has a *hot shoe* (a slot into which you insert an auxiliary flash), use an auxiliary flash with a swivel head that you can bounce off a white ceiling. If you don't have a method for diffusing the flash, shoot outdoors on a cloudy day, or illuminate your portrait with the light from a window that is facing north.

You can purchase diffusers for many popular auxiliary flash units at your local camera store. When all else fails, place a piece of tissue paper, medical tape, or a piece of a white nylon stocking in front of the flash unit. If you have an auxiliary flash unit with a swivel head, you can make a bounce card to diffuse the flash as outlined in Chapter 2.

Taking a Formal Portrait

Before cameras were invented, the only way to get a formal portrait was to commission a painter. While the painter covered the canvas with paint, the subject had to endure long periods of sitting absolutely still, followed no doubt by a quick visit to "ye olde masseuse." The resulting portrait was largely influenced by the painter's talent, his interpretation of the subject, and what the subject wanted the finished portrait to look like. The painter could remove 20 pounds and all hints of wrinkles if that's what the subject wanted. Fortunately, these days, you can quickly create a portrait of a friend or family member with your digital camera. And if you need to remove wrinkles and slim your subject (he's so vain!), you can use Photoshop Elements to get that job done. An added bonus is that your subject doesn't need risk bodily harm from holding a pose for an agonizingly long period of time. The following exercise shows you the basics of creating a formal portrait.

Exercise 5-1: Shooting a Formal Portrait

1. **Position your subject a few feet in front of a neutral backdrop such as a white wall.**

In lieu of a white wall, you can suspend a white sheet from the ceiling. When you separate your subject from the background, you eliminate the possibility of a harsh shadow if you're using on-camera flash with no diffuser.

To remove wrinkles from a cloth backdrop, spray some wrinkle releaser on the cloth and then smooth it. You'll have to wait a few minutes for the backdrop to dry, but it's easier and quicker than trying to remove wrinkles using an iron or steamer.

2. **Switch to your camera's Portrait mode. Alternatively, you can shoot the portrait using your camera's Aperture Priority mode if so equipped.**

When shooting in Portrait mode, your subject remains in focus and the background is a blur. The amount by which the background is blurred depends on the distance between your subject and the background. If you shoot in Aperture Priority mode, choose a wide aperture (small f/stop number), which limits the depth of field.

3. **Pop your auxiliary flash into the hot shoe and bounce the flash off a white ceiling. Alternatively, use a bounce card (see Chapter 2 to discover how to make one), which gives you soft, diffuse light. If you're using an on-camera flash, use a diffuser. If you don't have a diffuser for your on camera flash, enable red-eye reduction if your camera has this feature.**

The red-eye reduction feature fires a preflash, which causes the subject's irises to narrow, which in turn prevents the camera from picking up the reflection of your subject's blood-filled retina (the cause of red-eye).

You can create a makeshift diffuser for an on-camera flash by placing tissue paper, wax paper, medical tape, or a piece of a white nylon stocking over the flash unit.

4. **Move away from your subject, and then zoom in. If you're shooting with a digital SLR, choose a lens with a focal length that is the 35mm equivalent of 85 to 105mm.**

If you are too close to your subject while taking a formal head and shoulders portrait, you end up using a focal length that is the 35mm equivalent of a wide-angle lens, which inevitably distorts the features closest to the camera, such as your subject's nose. A longer focal length also contributes to a shallower depth of field.

5. **Compose the photograph and press the shutter button halfway to focus on your subject.**

Accurate focusing is extremely important when you're photographing a portrait due to the limited depth of field. Many digital cameras have multiple focus points, which can be a problem if there are other objects in the scene such as flowers that are closer to the camera. If a nearby object intersects one of the focus points, and your camera focuses on it, your subject will be out of focus. If your camera has the option to switch to a single auto-focus point, I suggest you use it when shooting portraits. Aim the auto-focus point at your subject and press the shutter button halfway. The focus point changes color and some cameras beep when focus is achieved.

6. **Shoot the picture.**

After you shoot the photo, it appears on your camera's LCD monitor. Review the picture to make sure your subject looks relaxed and his eyes are not closed. Your best bet is to take several pictures in a row, and then review them. After you're satisfied that you've captured several good photos of your subject, you can shoot the next victim . . . er, I mean, *subject*. The portrait in Figure 5-1 was created in a spare bedroom with a clean sheet for a backdrop.

Some subjects have a hard time posing for the camera. If you tell your subject to smile, the result may not be natural. The best way to get your subject at ease is to talk to her while you're setting up the shot. This should relax your subject and give you better photos. Take several pictures and then review them. If you don't feel that you captured the true essence of your subject, have her take a break. When you resume, take several more shots until you're satisfied.

Figure 5-1: A formal portrait taken with a telephoto lens.

Creating a Natural Light Portrait

A natural light portrait looks more realistic than a portrait photographed with a artificial light, such as your camera's flash. The trick is to use soft, diffuse light, such as the light that shines through a window on a cloudy day. One side of your subject's face will be illuminated with soft, flattering light, and the other side will be in shadow. The following exercise shows you how to shoot a natural light portrait while filling in the shadow side of your subject's face using a reflector.

Exercise 5-2: Shooting a Natural Light Portrait

1. **Disable the camera flash and turn off any lights in the room.**

2. **Position your subject by a window from which soft, diffuse light is shining into the room.**

A window facing north with sheer curtains is ideal. If the window has no curtains and is not facing north, don't shoot your portrait if early morning light is cascading into the room through a window facing east, or during the late afternoon when the sun is shining into the room from a window facing west. Your goal is soft, diffuse light that won't create harsh shadows. You can also vary the amount and quality of light by moving your subject closer to or farther from the window.

3. **Switch your camera to Portrait, or if your camera has it, Aperture Priority mode.**

 When you shoot in Portrait mode, the camera chooses exposure settings that cause the background to be blurred. If you decide to use Aperture Priority mode, choose a large aperture (low f/stop number), which limits your depth of field.

4. **Move away from your subject and then zoom in.**

 If you're shooting with a digital SLR, choose a lens with a focal length that is the 35mm equivalent of 85mm to 105mm. This range of focal length results in a pleasing portrait, especially if you're shooting a head and shoulders portrait.

5. **Have a friend or family member stand on the other side of your subject, and hold a reflector to direct light into the shadow side of her face.**

 If you don't own a reflector, you can use a piece of white poster board, a sheet of Styrofoam, or a white bedsheet. You can vary the amount of fill light by having your assistant move the reflector closer to or farther from your subject. For more information on creating a makeshift reflector, see Chapter 2.

 Step 5 is optional if you're shooting the photograph in a relatively small room with white walls, which act as natural reflectors and fill in the shadow side of your subject's face.

6. **Compose the photograph and press the shutter button halfway to focus on your subject.**

 If your camera has the option to switch to a single auto-focus point in the center of the viewfinder, it's advisable to enable this option. With a single focus point, you're assured that the camera focuses on what you aim the focus point at.

 When shooting a natural light portrait, the camera shutter speed may be too slow to take a hand-held shot. If this is the case, mount your camera on a tripod.

 Zoom in until you just have your subject's face in the viewfinder. This is known as an extreme close-up. When you shoot an extreme close-up, it's okay to cut off the top of the person's head. Use one of the subject's eyes or mouth as a center of interest.

7. **Shoot the picture.**

 A few moments after you take the picture, it will appear on your camera's LCD monitor (or almost instantly if you have a newer camera). Review the picture to make sure it's in focus, and that your subject looks relaxed and natural. You may have to take several shots before you get a "keeper" that captures your subject at his best. Figure 5-2 shows a natural light portrait. Notice the pleasing quality of the shadows in the photo.

Figure 5-2: Shooting a portrait using available light.

You can also create a portrait without a person. Create a still life of a person's prized possessions. For example, if your subject is an avid reader, create a still life of his reading glasses on top of a book written by his favorite author. Toss in one of your subject's favorite writing instruments to complete the still life. Friends and relatives will immediately connect the photo with the person.

Shooting a Candlelit Portrait

Portraits photographed by the light of a single or even multiple candles can be stunning if done correctly. But this type of portrait photography also presents many challenges. First and foremost, you're dealing with low light, which means slow shutter speeds. Second, your camera may have difficulty focusing on your subject in the low light. The following exercise shows you how to create a candlelit portrait.

Exercise 5-3: Creating a Candlelit Portrait

1. **Dim the room lighting.**

When you take the photo, the only light source will be candles. However, it's easier to set up the scene if you have some ambient lighting. You should also be shooting in a very dark room, or at night.

2. **Pose your subject and set up the scene.**

The scene will vary depending on your creative muse. You may want to capture a moody candlelit portrait of your subject only. In this case, set up the candle(s) to cast light on one side of your subject. You also have to make a creative decision as to whether the candles should be visible in the photograph. You can also add props to suit your creative instinct and the subject you're photographing. For example, if you're photographing a friend who is a writer, an antique fountain pen, an inkwell, and parchment paper would be excellent props.

3. **Increase your camera's ISO.**

Increasing the ISO increases the sensitivity of the camera. However, you should not shoot at your camera's maximum ISO because the image will have too much digital noise to be useful. As a rule, don't exceed an ISO of 400. (Of course, unless your camera's maximum ISO is 400, in which case you shouldn't exceed ISO 200.) For more information on changing ISO, see the "Increasing Your Camera's Sensitivity to Light" exercise in Chapter 2.

When increasing the ISO, enable your camera's noise reduction option if your camera is equipped with this feature.

4. **Set your camera on a tripod.**

The shutter speed will be too slow to get a sharp picture if you hold your camera by hand.

The slowest shutter speed you can shoot a picture while supporting the camera by hand is the reciprocal of the 35mm equivalent of the lens focal length. For example, if you're photographing an image with a 35mm focal length equivalent of 105mm, the slowest shutter speed you can use to shoot a picture while holding the camera by hand is $1/125^{th}$ of a second, which is the closest shutter speed to the reciprocal of 105. If your camera has image stabilization, you can use this feature to shoot at a slightly slower shutter speed.

5. Set your camera in Portrait or Aperture Priority mode.

When you shoot a picture in Portrait mode, the camera uses a large aperture opening to limit the depth of field. When you shoot in Aperture Priority mode, choose a large aperture (small f/stop number), which also limits depth of field. For more information on depth of field, see Chapter 2.

6. If necessary, use a reflector or additional candles to bounce additional light on your subject's face.

A white tablecloth on a table reflects some light back to your subject. Alternatively, you can have an assistant hold a reflector on the shadow side of your subject's face and angle the reflector to fill in the shadows. You can also light a couple of candles and position them on the shadow side of your subject's face. The amount of light is determined by the number of candles and how far you place them from your subject. You can also use candles to determine the lighting ratio. For example, use half as many candles on the shadow side of your subject's face as you use on the other side of her face to achieve a 2 to 1 lighting ratio.

7. Turn out all the lights.

That is, of course, except for the candles, which are illuminating your brilliant subject.

8. Choose the largest aperture available on your camera if you're using a point-and-shoot digital camera, or lens if you're using a digital SLR.

Using the largest aperture is known as shooting wide-open. When you choose the smallest f/stop number, the lens aperture is fully open, which limits the depth of field.

9. Back away from your subject, and then zoom in to achieve the desired composition.

If you're using a digital SLR with a fast lens that has a 35mm equivalent of less than 85mm, leave enough distance between the lens and your subject so you don't distort features nearest the camera such as the subject's lips and nose. It's better to crop the image to the desired composition in your image-editing program than risk an unflattering portrait.

10. Focus on your subject's eyes.

If your camera is equipped with the option to use a single auto-focus point, enable it. Aim the focus point at one of your subject's eyes, and press the shutter halfway to achieve focus.

If your camera does not have an auto-focus assist beam, it may have a hard time focusing on a subject in low-light conditions. If your camera is having difficulty in achieving focus, switch to a single auto-focus point and then aim it at an area of high contrast, such as the edge of a black tie on a white shirt. Another alternative is your subject's eyebrows or eyelashes if she has dark hair. After you achieve focus, keep the shutter button depressed halfway, and move the camera to achieve the desired composition.

11. Shoot the picture.

After the picture appears in your LCD monitor, examine it to make sure your subject is in focus, and you've got a pleasing picture. I usually take several shots and then determine which ones are keepers after I download them to my computer and examine them on-screen.

Your camera shutter will be open for a long time, perhaps half a second or longer. If your subject blinks or takes a breath, your image may be blurred. Tell your subject to remain perfectly still while you're taking the picture.

Shooting Portraits Outdoors

You can also create stunning portraits of friends and family at natural locations, such as parks or historic landmarks. When shooting portraits outdoors, you use similar techniques as when shooting indoors. The limited depth of field adds a pleasing out-of-focus background to your image. In the following exercise, I offer some valuable tips about taking portraits in natural settings.

Exercise 5-4: Creating a Portrait Outdoors

1. Find a nearby park with interesting foliage, flowers, and other delights.

A park is a wonderful place to shoot an outdoor portrait, especially if there's lush green foliage in the background. The foliage appears as a colorful out-of-focus blur that contrasts nicely with your subject, who is in sharp focus.

2. Position your subject in an interesting area that is in full shade.

When you photograph a subject in the shade, she is bathed in soft, diffuse light. If you photograph someone in bright sunlight, you end up with harsh, unflattering shadows.

3. Choose Portrait or Aperture Priority mode.

When you shoot a picture in Portrait mode, the camera uses a large aperture opening to limit the depth of field. When you shoot in Aperture Priority mode, choose a large aperture (small f/stop number), which also limits depth of field.

4. Back away from your subject, and then zoom in to compose your picture.

If your camera lens marks the 35mm equivalent of popular focal lengths, choose a focal length that gives you the 35mm equivalent of a focal length between 85mm

and 105mm. If your camera doesn't signify 35mm equivalents, back far enough away from your subject so that the lens doesn't distort features like your subject's nose and lips.

5. **Focus the camera on your subject.**

 It's advisable to switch to a single focus point if your camera has this option. Center the focus point on your subject, and then press the shutter button halfway down to achieve focus.

6. **Shoot the picture.**

 When you're shooting in a nice location, move to several different areas to get a variety of shots. Your subject will loosen up as you take more shots. When I'm photographing a client, I generally get my best shots at the end of the shoot. Figure 5-3 shows a portrait photographed at the University of Tampa, which is bordered by Henry B. Plant Park and the Hillsborough River.

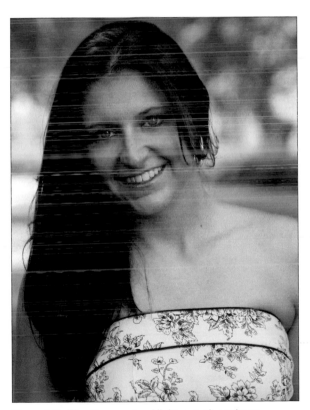

Figure 5-3: Shooting a natural light portrait outdoors.

If your subject is in heavy shadow, use fill flash to add some highlights and definition to the picture. For more information on fill flash, see Chapter 4.

Shooting an Outdoor Portrait in Direct Sunlight

If you can, avoid shooting portraits in direct sunlight. The resulting photo winds up looking like the shadows were etched on your subject's face and also exaggerates your subject's skin texture. Shots in direct sunlight may work well for subjects like Clint Eastwood, who has character fissures. However, this lighting scenario is not flattering for most subjects.

Sometimes, though, shooting in direct sunlight is unavoidable. If you're an avid photographer, you like to be prepared for most eventualities and carry a treasure trove of goodies in your camera bag. One such goodie that can save the day if you've got a photogenic subject at a photogenic location and the sun is shining brightly is a diffuser. You can purchase a 22- or 30-inch 5-in-1 reflector, which has four reflectors (white, black, silver, and gold) and a diffuser for less than $50. The following exercise shows how to utilize the diffuser when photographing a subject in direct sunlight. If you don't want to invest in a reflector, you can use a common object to create a makeshift reflector as described in Chapter 2.

Exercise 5-5: Shooting an Outdoor Portrait in Bright Sunlight

1. **Pose your subject.**

2. **Choose Portrait or Aperture Priority mode.**

Portrait mode gives you a limited the depth of field. If you choose Aperture Priority mode, select a large aperture (small f/stop number), which also limits depth of field.

3. **Back away from your subject, and then zoom in to compose your picture.**

Use a focal length that gives you a pleasing composition without distorting your subject's features that are nearest to the camera.

4. **Have a friend hold the diffuser over the subject's head.**

You'll have to direct your assistant in the proper positioning of the diffuser. Your subject should appear as if he is in the shade. If you see any streaks of bright light on any part of your subject, tell your assistant which way to move the diffuser to eliminate the light. Also make sure that no shadows cast by the diffuser are visible in the viewfinder.

5. **Focus on your subject.**

Switch to a single focus point if your camera has this option. Aim the focus point at your subject, and then press the shutter button halfway to achieve focus.

6. **Take the picture.**

The resulting photo should appear as though it were shot in the shade. Using the diffuser creates the added bonus that your subject won't be blinking. Figure 5-4 is a photo I shot of a young lady for her modeling portfolio. Her mother/manager/chaperone held the diffuser over her head while I composed and shot the photograph.

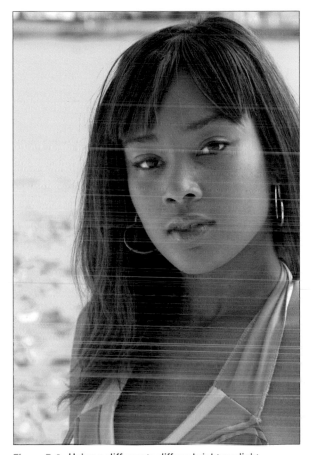

Figure 5-4: Using a diffuser to diffuse bright sunlight.

Taking Photos of Your Family

The opportunities for photographing your family are endless. Occasions like birthday parties, holiday dinners, and family gatherings can be once-in-a-lifetime occurrences. As the resident family photographer, it's your job to document these special occasions. You can later distribute the photos to all family members via e-mail after you download them to your computer, post a gallery on the Web, add the photos to a blog post, or order prints for the family. The photos will document the event and take on special meaning as family members come and go in years to come.

To cover each family photo opportunity would require a book longer than this one, but in the following list, I show you some techniques you can use to capture compelling photos of your family that you'll cherish for years to come:

✔ Take a group photo of a large family gathering outdoors if weather permits. Arrange the members of your family so that the tallest are in the back, and the children are in front. If necessary, one or two family members can lie horizontal in front of the children. Make sure that everyone's head is visible. Take several shots to ensure you've got a couple of shots where everyone is smiling, nobody is yawning, and no one has their eyes closed. For a more interesting photo, shoot from a vantage point that is lower than or higher than the group.

✔ If you're attending a family reunion at a venue that has stairs, have the tallest members of the family climb to the top step and then arrange the other family members on the lower steps. Back away from the building — after watching for traffic — and compose the photo so that the name of the venue is visible.

✔ When photographing a small group of people, it's okay to leave their legs out of the photograph. Get your subject's heads as close together as possible and then choose an interesting vantage point to avoid the police lineup–style photograph.

✔ Stand up on a stool to photograph a family feast such as Thanksgiving dinner. Make sure that everyone is facing the camera. One pose that works well is everyone raising their glasses to spread holiday cheer. Shoot the photograph at the beginning of the meal, before the youngest members of the family have decorated the tablecloth with gravy spills.

✔ Photograph the cook while he's preparing the meal and carving the poultry.

✔ Photograph the table prior to family members being seated. Take one photo of the setting, and another after the feast has been placed on the table.

✔ Park your camera while people are eating. Photographs of people with their mouths full are not flattering.

✔ Take candid photos of family members opening gifts, the birthday girl blowing out 60 candles without triggering the smoke alarm, and loved ones enjoying each other's company.

✔ Keep an eye on the family critters at holiday gatherings. Cats go crazy when they have crumpled-up paper and bows to play with. Your family pet's antics can be the source of wonderful photographs.

✔ When photographing a large family group, switch to Aperture Priority mode if your camera has the option, and choose a small aperture (large f/stop number), to maximize depth of field. This ensures that all family members are in focus. Alternatively, switch to your camera's mode for photographing landscapes. You may have to increase the ISO or use a tripod if the shutter speed is too slow.

✔ Photograph a family party from a second-story balcony if your home has one. You'll get great candid shots because nobody will be aware that their picture is being taken.

✔ Take nonposed shots of your family meeting a new baby for the first time. Use natural light if at all possible so you won't startle the baby with the harsh light of the camera flash.

✔ Take candid shots of your child's first birthday party. Pay particular attention to his first piece of cake. If your camera has a mode to enable continuous shots, use it. The record of your child's transformation from a relatively well-dressed 1-year-old to a child with frosting-streaked hair and gooey clothes are shots that you'll cherish for a lifetime, even if your child finds them embarrassing later.

🖝 When photographing the women in your family, avoid using direct flash when at all possible. If you use soft, natural light, or diffused flash, you'll minimize the possibility of any skin texture or character lines spoiling the photograph. (Why women? Well, guys are expected to have somewhat rougher skin than women. We shave. It's not a big deal with guys, but most women I photograph would cringe if I presented them a portrait that showed texture in their skin.)

Capturing Photos of Your Pet

Pets, especially the furry ones, are an important part of many families. But dogs are from Mars and cats are from Venus, which means they must be approached differently when you photograph them. (And be careful that your dog doesn't plant a wet tongue on your lens when you're posing him.) The following pointers prepare you for taking photos of your family friend:

🖝 **Find a good spot to photograph your pet.** Dogs move around a lot, whereas cats remain stationary for long periods When you choose a spot to photograph your pet, make sure the background is plain and contrasts well with his fur color. If you photograph a dark dog against a dark background, you'll have a hard time finding your pet in the resulting photograph. Animals with dark fur tend to soak up light like a dry sponge soaks up water.

🖝 **Shoot from the same level as your animal.** Lie prone on the floor to capture photos of your dog lounging on his favorite pillow.

🖝 **Move in close and then zoom in to catch your pet's expression.** This is similar to shooting an extreme close-up of a person's face. Figure 5-5 is a shot of my cat Niki (also known as "Queen of the Universe") meditating on yonder window. This is one case where early morning sunlight streaming in an east window works.

Figure 5-5: Shoot a close-up of your pet staring into the distance.

✔ **Disable the camera flash.** Animals can be frightened by camera flash. If you zap a shot of your pet cat with flash, she'll probably run away the next time she sees you with a camera around your neck.

✔ **If your pet is well trained, you may be able to get a formal portrait, such as a shot of your dog wearing a Santa cap.**

✔ **Cats are pretty independent and usually have their own agenda.** You can, however, catch your cat in a very Zen-like pose staring out the window. As an added bonus, the light is soft and diffuse, which is perfect for photographing your cat contemplating whatever cats contemplate.

✔ **When your pet is relaxing and staring off into space, contemplating the next doggie biscuit or catnip fix, aim your camera at your pet, compose the shot, and then call your pet's name.** Snap the picture as soon as she turns toward you and perks her ears.

✔ **Anticipate your pet's next move and be ready with your camera.** Most animals are creatures of habit. They do certain things at certain times of the day. In the midafternoon, my cat Niki runs up the circular staircase to my loft and then takes a well-deserved rest in a bean-bag chair, a scenario that has been the source of many memorable and amusing photos.

✔ **Catch your pet doing a "human trick."** One day I fixed lunch, put it on the table, and then went to the refrigerator to get a soft drink. When I returned, my cat was in my chair, paws on the table, surveying my feast. My camera was nearby and I captured a wonderful candid shot.

✔ **Toss your pet's favorite toy to him, grab your camera, and capture the action.** If your dog chases and catches a Frisbee, have a friend toss the Frisbee while you capture a photo of your pet in midair using the techniques to freeze motion as described in Chapter 7.

✔ **Ask a friend or family member who knows your pet to call the pet's name, bribe your pet with his favorite treat, or toss your pet's favorite toy.** While your assistant has your pet's attention, aim your viewfinder at the pet and have a field day taking great photos.

Photographing Young Children

Kids do the darnedest things. And sometimes if you're really lucky, they do them when you've got a camera pointed at them. Photos of your children are a wonderful way to document the various stages of their youth. But taking a formal photo of a child can be a trying experience. Getting the child to act natural and smile is difficult if you don't have an accomplice or two. The following exercise shows you some fundamentals for photographing your child.

Exercise 5-6: Taking Pictures of Children

1. **Find a good spot to photograph your child.**

 If you're photographing an older child, choose a spot such as a light-colored wall. Another alternative is to set up a backdrop such as a white sheet. If you're photographing a younger child who's apt to fidget and move around, sit the child on a sofa.

2. **Have some family members talk to the child to relax him.**

 It also helps to play the child's favorite music.

3. **If you're photographing a young child, disable the camera flash.**

 Young children may be distracted and possibly frightened when the flash goes off. If you photograph the child in a relatively well-lit room, lighting shouldn't pose a problem. If, however, you're photographing in a dark location, turn on some room lights, and, if necessary, increase the camera ISO. You may have to adjust the white balance in your image-editing program, but that's a small price to pay for a priceless photograph.

4. **Choose your camera's Portrait or Aperture Priority mode.**

 Portrait mode gives you a limited the depth of field, which nicely blurs the background. If you decide to use Aperture Priority mode, choose a large aperture (small f/stop number), which also blurs the background.

5. **Back away from the child, and then zoom in to compose your shot.**

 The distance you place between yourself and your subject depends on how tall your subject is. If you're shooting an extreme close-up of a young child, you'll probably have to zoom in all the way.

6. **Kneel so that the camera lens is at the same level as the child's face or slightly lower.**

 Don't use digital zoom when photographing people. When you use digital zoom, the camera crops in from the highest optical zoom, and then digitally enlarges the picture to fill the frame. This means your camera is redrawing pixels, which inevitably causes poor quality.

7. **Press the shutter button halfway to focus the camera on your subject.**

 Switch to a single auto-focus point if your camera has this feature, and aim the focus point at the child. When you're photographing a child, focusing can be a problem. Young children don't like to stay in one place for any length of time, and they have a lot of energy to burn off. If your subject isn't standing still, call to the child. You may need to have a family member stand behind you and start doing something silly that causes the child to look in your direction and smile.

8. **Take the picture.**

 With a moving target like a young child, you'll have to take a lot of pictures to get some keepers. Figure 5-6 was shot for a client. The boy's mother gave him a box of candy to keep him occupied while I set up the shot. She then stood behind me and called the child when I asked her to.

Figure 5-6: Kids do the darnedest things in front of your camera.

Taking Candid Photos

Some of the best photos you can take are unposed photos of people going about their daily business. You can capture candid photos around your hometown, on vacation, or of your loved ones. Unfortunately, shooting candid photos with a digital SLR is like trying to drive home a finishing nail with a sledgehammer. As soon as someone sees you point a big camera with a long lens at them, they turn the other way. The best way to capture candid photos is with an inconspicuous point-and-shoot digital camera. The following exercise shows how to be the next best thing to a fly on the wall.

Exercise 5-7: Shooting Candid Photographs

1. **Carry your camera with you wherever you go.**

My professional camera is a Canon EOS 5D, which is hardly inconspicuous, especially with a telephoto lens attached. I also own a smaller Canon point-and-shoot camera. I carry this camera with me to capture candid photos of friends and family. If you always have a camera with you, friends and relatives get used to it and are more natural when you point the camera at them.

2. **Turn off your camera's shutter sound and disable the flash.**

 Point-and-shoot cameras don't have shutters like digital SLRs, but most of them make a noise that sounds like a shutter when you take a picture. You can disable this using a camera menu option.

3. **Take the lens cap off your camera and be ready to photograph anything that interests you.**

 When you photograph your friends and family in public places, you have two options. The first is to distance yourself from your subject, and then zoom in. These shots, however, look sterile and lack interest. Your second option is to shoot with a wide-angle focal length. This involves anticipating your subject's action. If your subject sees the camera, he'll know that you're getting ready to take his picture and you won't get a natural expression. There are a couple of ways you can blend in and be the proverbial fly on the wall. You can sit at a corner café or other inconspicuous spot, take off the camera lens cap, rest your camera on the end of a table, and point your camera in the direction of your subject, or the area from which you anticipate you'll get good candid shots. Position your thumb on the shutter button and press it when your subject does something interesting. This works best when you use a wide-angle focal length (35mm equivalent of 28 to 35mm) and squeeze the trigger when your subject is close at hand. If your camera's LCD monitor is at the back of the camera, or you can flip it around, you'll see when your subject is in frame, and will know exactly when to squeeze the shutter button.

4. **Walk up to an interesting subject and ask if you can take his picture.**

 Use this technique with caution, especially if you're in a bad part of town and your subject has friends. If you're shooting photographs in a tourist area and you ask a street performer or someone promoting a tourist attraction for permission to take his photograph, chances are he'll smile and you'll get a good picture when you snap the shutter. It's not exactly candid, but street performers are used to having their picture taken and the result may look candid. Another option is to ask the person to go about his business after he's agreed to let you photograph him. Then you can take several shots and you're bound to end up with a keeper.

 If someone asks you not to take his picture, obey his request. It's better to lose a potentially good photograph than risk a confrontation.

5. **The possibilities for candid photos are endless. Here are a few examples:**

 - Shoot a photo of a friend in deep thought looking out the window.

 - Shoot a photo of your friends dancing, or conversing over a cup of coffee.

 - Capture a photo of fishermen on a pier. If you're alert, you may capture a photo of a fisherman landing a whopper. Fishermen on a pier are also a good subject when the sun is setting. Take a photo of them in silhouette with a telephoto lens. The warm light from the setting sun and silhouettes of the fisherman's poles will create an interesting pattern.

 - Take photos of people walking down a crowded sidewalk.

 - Shoot photos of storeowners in open-air markets.

- County fairs are another great place to shoot candid photos. You can get shots of cotton candy vendors, people waiting to board the Ferris wheel, and so on. You'll have to shoot at a high ISO rating if you're photographing the fair at night. However, a little bit of noise will give your photos an edgy feel, similar to the old black-and-white photos shot with fast film.

- Capture photographs of street performers. I've captured some great shots of the street performers in Key West celebrating the legendary tropical sunsets.

Figure 5-7 was photographed at Fisherman's Wharf in San Francisco. I liked the reflection of the neon signs on the counter. I placed my camera on the counter to stabilize the camera because of the long exposure needed for the low-light situation. Just then a worker came into view and started pouring something. Instinctively, I snapped the shutter and got an interesting photo as a result.

Figure 5-7: Taking a candid shot at night.

Chapter 6

Nature and Cityscapes

As a photographer with a digital camera and a creative mind, you can create visual logs of the important things and events in your life. You can capture the beauty of nature, the beauty in your hometown, and the magnificent variety of creatures that inhabit this wonderful planet of ours. You'd be surprised at how much raw material you have for photographs within a short drive from your home. You probably pass by wonderful opportunities for photographs every day. On the rare occasion when I venture out beyond the walls of my humble abode without a camera, I always pass something that would make a wonderful photograph, slap myself on the forehead, and utter, "Doh! Where's my camera?" The exercises in this chapter help you capture the moment when you *do* have your camera and see something you'd like to commit to a memory card. At the end of this chapter is an exercise that is designed to make you a better vacation photographer.

Photographing Landscapes

Lovely landscapes are everywhere. If you live in the suburbs, you've probably got some great landscapes within a few miles of your home. If you live in a city, you can find some wonderful landscapes in large parks. I've traveled from coast to coast and spent some time in Europe and have photographed everything from strawberry fields that go on forever to hills that are alive with the sound of music. In spite of the lovely landscapes I've photographed while away from home, I continue to marvel at the beauty that's within an hour's drive of my home. The trick is to be on the lookout for scenic vistas as you go about your day-to-day routine. And if you can break up the routine by taking a different route to your supermarket or hair salon, you'll continue to find great things to photograph. (It's kind of hard to photograph a landscape from within your home, unless you take a picture of a picture of a landscape, which would be redundant. That is, unless your son piles mountains of laundered clothes on his bed while deciding what to wear to school.) In lieu of a mountain of clothes, you'll have to travel to a nearby landscape to perform the following exercise.

Exercise 6-1: Photographing a Landscape

1. **Take your digital camera on a field trip to a local park.**

If you have mountains or hills near your home, either would be better than your local park. Remember to do this exercise at a time of day when you'll have golden light. Even though this is just an exercise, you should always practice good habits whenever you use your camera. I always get my best landscape photos in spring or fall when there's not as much humidity in the atmosphere. Whenever possible, I take my landscape photos before 10:00 a.m. and after 4:00 p.m. You also get a more interesting photo when there are some clouds in the sky.

Do an online search for state parks. You'll be surprised at how many photogenic landscapes you can find at state parks that are a short drive from your home.

2. **Walk around the area looking for an interesting composition.**

When you're looking for a scene to photograph, look for some small nearby objects. Flowers are excellent objects to draw a viewer into a scene. Small objects also give your viewer an idea of the scale of your scene.

When you're looking for an interesting landscape to photograph, refrain from photographing a scene that is predominantly green. The resulting photograph will be monotonous. If you find a scene with some red, orange, or yellow flowers, make them a predominant part of your photo. The warm colors will draw your viewer into the photo.

3. **Switch to Landscape or Aperture Priority mode.**

Landscape mode is designed to give you a large depth of field. However, if you're shooting in low light, the camera selects a combination of shutter speed and aperture to best suit the lighting conditions. The setting may not be optimal for getting the largest depth of field. Look in your viewfinder or LCD monitor to see the settings. If the f/stop is less than f/8.0 on a digital SLR, or less than f/4.5 on a digital point-and-shoot camera, increase your ISO rating. If you're familiar with shooting in Aperture Priority mode, you'll have better control over your results. Switch to the smallest aperture (largest f/stop number). If you're shooting in low light, you may have to increase the ISO rating or mount the camera on a tripod. An added bonus to shooting in Aperture Priority mode is that you can capture images with your camera's RAW format. Most cameras cannot capture in the RAW format when Landscape mode is selected.

4. **Choose the desired focal length.**

Most landscape photographers go for the kill and use the shortest focal length available. However, unless you've got scenery in the background that will occupy a large portion of the picture and you can see for miles and miles and miles, you're better off going with a focal length that is the 35mm equivalent of 50mm. This approximates the field of view of the human eye. But if you're photographing something truly magnificent, like the Rocky Mountains or the Grand Canyon, use the widest focal length you have.

5. **Choose the proper vantage point and compose the photo.**

 When I photograph a majestic landscape, I drop to one knee. Sometimes I even lie prone on the ground. When you set up the photo, remember the rules of composition. (Flip over to Chapter 3 if you need a refresher.) If you're photographing mountains with triangular peaks, use them to draw your viewer into the picture. If a tree is a predominant part of the landscape, make sure it intersects a power point according to the Rule of Thirds. Remember not to place the horizon line in the center of the picture.

 If you're using a point-and-shoot camera with an LCD monitor that swivels, swivel the LCD monitor toward you and lower the camera to the ground.

6. **Press the shutter button halfway to focus the scene.**

 If you're using multiple auto-focus points, pay careful attention to the object on which the camera is focusing. If the camera is focusing on an object near the camera that intersects an auto-focus point, objects in the distance may be out of focus. If this occurs, press the shutter button again until the camera focuses on a different object. In most instances, this won't be a problem and you'll see that the camera is actually using several auto-focus points to focus the scene.

 If you're using a digital SLR, switch to manual focus. When you focus, use the hyperfocal distance for your lens. The hyperfocal distance is the point of focus from which everything from half that distance to infinity falls within the depth of field. Most SLR lenses are marked with a focus index, which is a white mark on the lens barrel. With a prime lens (single focal length), you'll see a mark for each f/stop. Align the appropriate mark with the infinity symbol, and more of your scene will be in apparent focus. For example, if I focus in this manner with my 15mm fisheye lens at f/16, everything from about 1 foot to infinity is in the depth of field (see Figure 6-1). If I set the focus to infinity, the depth of field changes to from 4 feet to infinity.

Figure 6-1: Manually focusing to get the maximum depth of field.

7. **Take the picture.**

The image appears on your LCD monitor a few seconds after you press the shutter. Examine the photo to make sure you don't have any unwanted objects in the image such as vehicles, power lines, or anything else that would distract from your photo. If you're shooting the image in tricky lighting conditions, examine the camera histogram to make sure the image isn't overexposed or underexposed. Remember you can always use exposure compensation to adjust the settings when Mother Nature fools the camera. Figure 6-2 was photographed on the way home from a visit to my cousin who lives about 50 miles from me. I decided to take a different way home and explore the shoreline of Lake Istapoga, which is north of Sebring, Florida. I was rewarded with a shot of a stately line of cypress trees that was reflected in the almost-calm lake. The image was photographed with a 28mm lens, 1/60 second at f/14. Everything's in focus from the ripples of water foreground to the distant trees, thanks to the small aperture.

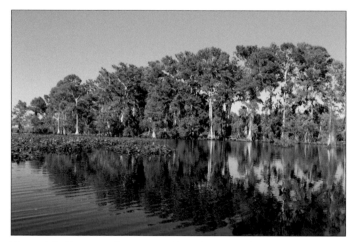

Figure 6-2: Use a small aperture when photographing landscapes.

Shooting Photos of Lakes, Rivers, and Oceans

Unless you're in a desert, you'll find one of Mother Nature's water features somewhere near your home. Rivers, lakes, and oceans have long been favorite subjects for photographers. But like every other subject, you need to know a few techniques to get good photos of water in motion, or for that matter, still water. You can create photos of the ocean with every particle of the spray from a wave crashing against the shore frozen in time, or you can create dreamy pictures of waterfalls in which the falling water appears to be a soft, gauzy mist. The following exercise shows you a couple of techniques for photographing moving water. It requires a digital camera and a garden hose.

Exercise 6-2: Photographing Moving Water

1. **Have a friend or significant other hook a garden hose to a water faucet and turn the water on.**

2. **Move a few feet away from the hose.**

 When photographing moving water, take precautions to make sure your equipment doesn't get wet.

3. **Mount your camera on a tripod.**

 One technique for photographing moving water requires using a slow shutter speed.

4. **Have your friend put his thumb over the end of the hose to release a forceful stream of water.**

 Call this a "faux" waterfall if you will. You'll get your best photograph if the background is dark, similar to the rock behind a waterfall.

5. **Switch to Shutter Priority mode.**

 Choose a slow shutter speed of 1/30 second or less. Make sure that you've also got a relatively small aperture to ensure a large depth of field. To get this combination in bright light, you may have to use a low ISO setting or mount a neutral density filter on your camera.

6. **Zoom in and compose your picture.**

7. **Press the shutter button halfway to achieve focus.**

 Some cameras may have a hard time focusing on a moving stream of water. If you experience this problem with your camera, switch to a single auto-focus point, move the auto-focus point over the hose, and then press the shutter button halfway to achieve focus. After you achieve focus, keep the shutter button depressed halfway and move the camera to achieve the desired composition.

8. **Take the picture.**

 The image appears on your LCD monitor a few seconds later. You should see a soft, dreamy mist of water. This is the desired result when you're photographing a waterfall (see Figure 6-3).

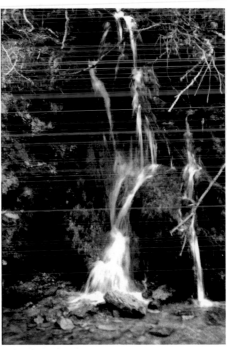

Figure 6-3: Use a slow shutter speed to photograph a waterfall.

9. **Choose a shutter speed of 1/500 second or faster.**

 Make sure you've still got a reasonably small aperture. When you freeze the motion of a wave, you still want a large depth of field. If you're photographing the ocean on an overcast day, you may have to increase your ISO to get the right combination of a relatively fast shutter speed and large depth of field. If desired, you can also take the camera off the tripod.

10. **Zoom in and compose your picture.**

 When photographing a tall waterfall like Yosemite Falls, turn the camera vertically.

 When composing a photograph of a lake, ocean, or waterfall, remember to put the horizon line in the top third of the picture, which makes the water the dominant feature in the photograph.

11. **Press the shutter button halfway to achieve focus.**

 If your camera has a hard time focusing on a moving stream of water, switch to a single auto-focus point, focus on the hose, and then move the camera to achieve the desired composition.

12. **Take the picture.**

 When you photograph moving water using a fast shutter speed, you freeze white-caps and can see the peak and valley of each wave (see Figure 6-4).

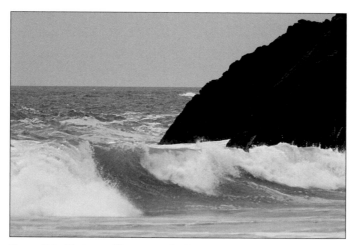

Figure 6-4: Photographing waves in the ocean.

Before you attempt to photograph a waterfall at a distant location, practice the techniques in the previous exercise by photographing a fountain outside a local shopping mall or at the entrance to a country club. Photograph the fountain using both slow and fast shutter speeds until you've got the knack of photographing moving water down pat.

Photographing still water is like photographing a landscape. Photograph a nearby lake on a windless day and the water will be flat as a pancake. When you photograph still water, use a wide-angle lens or a focal length that's the 35mm equivalent of 28mm or less. Switch to Aperture Priority mode and use the smallest aperture (large f/stop number) that lighting conditions will allow. You may have to mount your camera on a tripod or switch to a higher ISO setting if the shutter speed is too slow to hand-hold the camera. Using these settings gives you a photo with a lot of detail in the reflections that are cast on the water (see Figure 6-5).

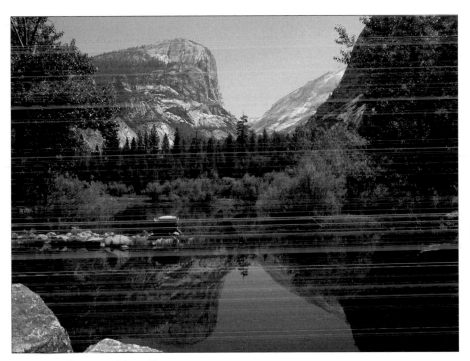

Figure 6-5: Photographing still water.

Shooting the Sunrise or Sunset

When you encounter a breathtaking landscape, your first instinct is to take a picture of it, regardless of the time of day. If the breathtaking vista faces east or west, you can capture a stunning photograph of the location at sunrise or sunset. Photographing a scene at sunrise or sunset presents a unique set of challenges, especially if the sun is in the picture, but the end result — a stunning photo — is worth it.

If you want to include the ocean in your photo, your location determines whether you're going to capture a sunrise or sunset. If you don't live near the ocean, lakes are great sources for sunrise and sunset pictures. In fact, a small lake gives you the best of both worlds. You can take photos of the sunrise from one side of the lake, and photos of the

sunset from the other side. The time of year also dictates the type of image you get. A photo of a sunrise or sunset reflected on a frozen lake is a recipe for a wonderful photograph. In some locales, you get morning fog, which adds another element to the finished photo. Have I piqued your curiosity? If so, grab your camera and follow the steps in this exercise.

Exercise 6-3: Photographing a Sunrise or Sunset

1. **Arrive at one of your favorite locations half an hour before sunrise or sunset.**

 You'll get your best photos when there are clouds in the sky. If you're photographing a sunrise, it's a roll of the dice. But with a sunset, you can look out the window and know whether you'll have some nice puffy clouds in your photos.

2. **Switch to Landscape mode.**

 Alternatively, switch to Aperture Priority mode and select a small aperture (large f/stop number). Either mode gives you a large depth of field, which is exactly what you want when photographing a sunrise or sunset.

 Some digital cameras have a Depth of Field Preview button. Press the button and the camera stops down to the selected f/stop. Look into the viewfinder to see how much of the scene is in focus.

3. **Switch your white balance setting to Daylight.**

 Some cameras overcompensate when you have white balance set to Automatic. You end up losing the saturated reds and oranges that dapple the landscape and clouds when you shoot at sunrise or sunset.

4. **Decide which focal length you'll use to photograph the picture.**

 If you want a small sun and lots of landscape — or skyscape — choose a wide-angle focal length that is the 35mm equivalent of 28 or 35mm. If you want the sun to loom large in your photograph, choose a focal length that is the 35mm equivalent of 100mm or greater. Some camera sensors may be damaged when exposed to the sun, especially when you use a telephoto focal length, which magnifies the sun.

5. **Compose the photograph.**

 When you compose a sunrise or sunset photo, apply the rules of composition that suit the scenario. You can align the sun on a power point according to the Rule of Thirds. Placing the horizon line is also important. If the foreground is the highlight of your photo (a sunset reflection in a lake), the horizon line should be in the upper third of the picture. If you have billowing clouds in the scene, the horizon line should be in the lower third of the picture.

 If you're using a point-and-shoot camera with an electronic viewfinder, the scene may be difficult to compose. If so, use your LCD monitor to compose the scene. If it's a very bright day, you may have to shade the monitor in order to accurately compose the scene.

When you compose a sunrise or sunset picture, never look directly at the sun, and be sure to wear sunglasses. If you're taking the photo with a digital SLR, don't look in the viewfinder for long, and don't look directly at the sun in the viewfinder, especially if you're shooting with a telephoto lens.

6. **Take a picture.**

 The photo appears in your LCD monitor a few seconds later. Examine the photograph and histogram if your camera has this feature. The sun may be blown out to pure white, and the rest of the scene may be brighter than what you actually see. If this is the case, use exposure compensation to underexpose the camera setting and take another picture. You might have to make additional adjustments to exposure compensation until what you see in the LCD monitor matches the actual scene. Figure 6-6 was photographed with a 50mm lens, 1/30 second at f/14. The camera was mounted on a tripod.

Unless you want lens flare in the picture for artistic effect, use a lens hood when the sun is within the angle of view of your lens. If the lens doesn't come with a hood, compose the picture so that the sun is behind an object and no lens flare appears on your LCD monitor or in your viewfinder.

Figure 6-6: Photographing a sunset.

7. **Continue taking pictures.**

 Hey, it's digital: If you don't like it, erase it. If you're shooting a sunrise, the sky gradually gets brighter, and the colors continue to change. When you photograph a sunset, the colors get more intense and saturated as the sun sinks lower on the horizon. If you're shooting a sunset, wait for the mythical "Flash of Green." Pay attention to the photos on your LCD and the histogram. As the sun rises or sets, you'll have to make additional exposure compensations to accurately record the scene.

8. **Take some pictures with your back to the sun.**

 The scenery and clouds will be bathed in golden light.

9. **If you're shooting a sunset, wait a few minutes after the sun sinks below the horizon.**

 If you have a lot of clouds in the scene, the rays of the sun will still reach them. The colors may get more intense if you're patient. Figure 6-7 was photographed a few minutes after the sunset. I turned around and saw this wonderful cloud formation painted a giddy shade of reddish-orange and instinctively composed and snapped the picture.

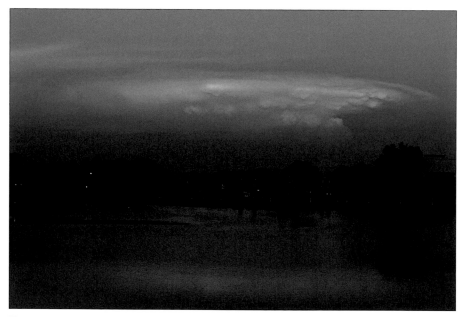

Figure 6-7: Waiting until after the sun sets to take a picture.

Taking Photos in Stormy Weather

Sometimes, you're at the right place at the wrong time. You're in a beautiful place, but the weather isn't cooperating. You may think it's time to pack up and head back home, or to the hotel if you're traveling. But as long as the conditions are not dangerous, you can get some great photos when the weather's not great. (I don't have an exercise for this one: The only exercise I can think of would be to take pictures in your shower, which would make my publisher question my sanity if I included it.) In lieu of picture-taking in the shower, here's a list of useful tips for taking pictures in stormy weather:

✔ **Protect your camera:** Your camera has sensitive electronic circuits that can be damaged if the camera gets wet. Unless you own one of the new waterproof cameras, you should protect your camera with a Ziploc plastic bag. Cut a hole for the lens and secure the bag to the lens with a rubber band. You can also cut holes for the camera straps and tape the bag to the camera straps. If your camera has an LCD monitor, you'll be able to see it through the plastic bag. If you take pictures with a digital SLR, cut a small hole for the viewfinder, and then use tape to prevent water from entering the hole. A weatherproof camera case is another handy option if you're hiking on a trail five miles from shelter and you get caught in a rainstorm.

✔ **Get closer to your subject:** Take close-up shots of flowers and other natural objects when they're wet. The colors will be more saturated.

✔ **Photograph a thunderstorm from a distance:** Bolts of lightning popping out of the bottom of a cloud make interesting photos. However, be careful: If you're too close to the storm, you'll put yourself in danger. You can get some great shots of distant lightning storms at night. Take photos of thunderstorms in areas where there's not a lot of ambient light from street lamps and so on. You may have to drive a few miles, but the results will be worth it. Switch to Aperture Priority mode, switch to your lowest ISO setting, and choose a small aperture. This ensures a long exposure. Put your camera on a tripod. Press the shutter button and hope for the best. If there's an active thunderstorm in the distance, you may capture a couple of streaks of lightning in a single exposure. If you don't, erase the exposure and try again. If you really get into photographing lightning storms, you can purchase the Lightning Trigger, a device that opens the camera shutter when it senses lightning.

✔ **Photograph your city at night after a rainstorm:** While the roads are still slick with moisture, you'll get some wonderful reflections from the streetlights and neon signs. Choose a small aperture to ensure maximum depth of field and a long exposure. Mount your camera on a tripod and start taking pictures. If any vehicles drive by, the light patterns from their headlights will be in your picture as well. Place the camera closer to the pavement to get the maximum amount of reflections in your picture.

✔ **Leave the sky out of the composition on a bleak, overcast day:** The sky will be a monochrome gray, but the colors of other objects will be saturated. If you're in a forest with a canopy of tree branches overhead, you'll get some wonderful pictures.

✔ **Take photographs when a distant thunderstorm is clearing:** When the sun starts peeking through the clouds, you'll get dramatic photos. For example, Ansel Adams created "Clearing Winter Storm," his award-winning photo of the Yosemite Valley, while a winter storm was clearing.

Capturing Winter Wonderlands

If you live in a climate or travel to areas where it snows, you can create some wonderful pictures. However, you do have a couple of factors that are working against you. Snow is bright. Very bright. But when faced with snow on a day with bright sunshine, your camera may not be so bright. On top of that, your winter wonderlands are generally very cold. Cameras perform just fine in cold weather, but you do need to take some precautions. If you live in a warm climate with no intention of traveling to snow country, skip this exercise and photograph a sunset instead. If you do live in a cold climate, or will soon travel to one, read on.

Exercise 6-4: Photographing Snow Scenes

1. **Bundle up in your favorite winter garb, grab your camera, and venture outside. (Oh, yeah: It helps if there's snow on the ground.)**

2. **Wait several minutes before taking the lens cap off your camera.**

Your camera needs a few minutes to acclimate to conditions. If you just pop the lens cap off the camera, the lens will fog over with condensation. You may also see some condensation on the outside of your camera. Be patient and it will dissipate as well.

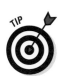

Your camera batteries won't last as long in cold weather. Keep a set of spare batteries on your coat pocket.

3. **When the camera has acclimated to the ambient temperature, take off the lens cap.**

You may still see a bit of condensation. If you try to remove it with a lens-cleaning cloth, it will reappear. Be patient and the condensation will soon dissipate.

4. **Find an interesting scene.**

Photo opportunities are everywhere after a freshly fallen silent shroud of snow dusts the ground. You can take photos of the snow plow sending a wall of snow onto the driveway you shoveled three hours ago, pictures of trees, close-ups of icicles, and so on.

5. **Switch to Landscape or Aperture Priority mode.**

When you photograph a snow-shrouded landscape, you want maximum depth of field. If you choose Aperture Priority mode, choose a small aperture (large f/stop number). If you're taking pictures on a gloomy day, you may have to increase the ISO rating or mount the camera on a tripod. If you do use a tripod, remember to keep your gloves on while setting up the tripod. Bare flesh can stick to cold metal.

Switch to Macro mode to shoot close-ups of icicles, Frosty's nose, and so on.

6. **Choose the desired focal length.**

If you're photographing a winter scene with tall majestic mountains in the background, choose a short focal length with a 35mm equivalent of 35mm or less. If you're photographing objects like snowmen or trees, choose a focal length with a 35mm equivalent of 50mm.

7. **Compose your photograph.**

Remember your rules of composition from Chapter 3.

Do not open the camera to change batteries or memory cards until the camera is fully acclimated to the temperature. Even though the exterior of your camera has no condensation, the internal parts of your camera may be warmer. Opening the camera may create condensation on the inside, which will damage the sensitive circuitry in the camera.

Use fillflash when you're photographing people in the snow. This reduces the contrast and will give you a better picture.

8. **Take the picture.**

The image appears on your LCD monitor in a few seconds. Examine the picture closely. Digital cameras can be fooled by the brightness of snow, especially when the sun is shining. If the picture looks a little dark, use exposure compensation to increase the camera's recommended settings and then take another picture to faithfully record the scene. Figure 6-8 is a photo of trees with bare branches dusted with snow.

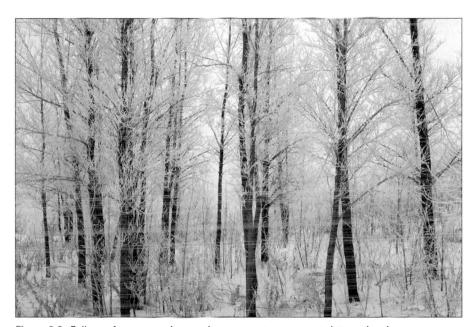

Figure 6-8: Follow a few precautions and you can get some great pictures in winter

When you go inside to warm up or grab a hot toddy, condensation appears on your camera. Make sure you give the condensation a chance to completely evaporate before going outside again. In fact, you should wait several minutes after the condensation on the outside of the camera dissipates to make sure the inside of the camera is also acclimated to the warmer temperature. After the camera is the same relative temperature as the room you're in, you can go outside and shoot more pictures. If you go outside when there is still condensation on or in the camera, it can freeze and severely damage your camera.

Shooting Panoramas

Panoramas are photographs that capture wide, expansive scenes. The resulting photos are much wider than they are tall. To capture a panorama, you take several pictures in which common elements in each successive photo overlap the same element in the previous photo. Software is then used to stitch the images together. Many digital cameras come with software that can be used to stitch panoramas. Photoshop CS3 and Photoshop Elements also have menu commands that you can use to stitch photos together in this way. Creating a panorama isn't rocket science, but you do have to follow a few steps to ensure that the stitched-together panorama looks like the real thing. In the following exercise, you create a panorama of your home and the surrounding scenery.

Exercise 6-5: Creating a Panorama

1. **Go to the front of your home and mount your camera on a tripod.**

 The best time to shoot a panorama is on a cloudy day. You'll get nice, even diffuse lighting. If the sun is shining, shoot the panorama in the late afternoon if the front of your house faces west, and in the early morning if your house faces east.

 Make sure the camera is level. If the camera's not level, it will look like your panorama is sliding downhill. Most tripods have a small bubble level built into the tripod that makes it easy for you to level the camera after you mount it on the tripod.

2. **Use tripod controls to flip the camera 90 degrees into a vertical position.**

 For more information on mounting a camera on a tripod, see Chapter 4.

3. **Pan your camera to the brightest part of the scene and press the shutter button halfway.**

 Note the shutter speed and aperture your camera selected.

4. **Switch to Manual mode and change the aperture and shutter speed to the values you recorded in Step 3.**

 If you let the camera automatically set exposure, it changes when you shoot the images needed to create your panorama.

5. **Change the camera focal length to the 35mm equivalent of 50mm.**

 At this focal length, you get a realistic-looking panorama without the distortion that can be present when you photograph with a wide-angle focal length. The resulting photos also have more prominent features, which makes it easier for the stitching software to recognize like elements in the overlapping portions of each photo.

6. **Switch the white balance setting to the appropriate mode.**

 If you don't manually set white balance, the camera may choose a slightly different setting as you shoot the different images needed to create your panorama. With different white balance settings, each image would look slightly different, which would make it almost impossible to create a convincing panorama.

 Focus must be consistent when you're shooting a panorama. If your camera focuses on the foreground in one shot, and the background in another shot, the stitched panorama looks pretty awful. Lock the exposure if your camera has this option, and manually focus on the important part of your scene.

7. **Pan the camera to the position that will capture the scenery you want at the beginning of your panorama.**

8. **Take a picture.**

 If you're creating several panoramas, take one picture with your finger in front of the lens. When you see the picture with your finger, you know the subsequent images are part of the next panorama.

9. **Pan the tripod head to the position required to capture the next image of your panorama.**

Make sure that each subsequent picture in the panorama captures 30 to 50 percent of the objects in the previous frame. The stitching software uses the overlapping elements to align the photos to create the panorama.

 Try not to include any moving objects in the scene. The resulting panorama will not look realistic if the same person or vehicle appears in several places.

10. **Take the remaining pictures required to complete your panorama.**

Remember to overlap each picture by 30 to 50 percent. Do not change the camera height or anything on the tripod. In order for the stitching software to properly do its job, the images must be photographed at the same height and level. Take four or five pictures to create your panorama. You can crop out unwanted elements in your image-editing application. Figure 6-9 shows an image that was created using the techniques in this exercise. The image was stitched together using Photoshop Elements. For information on creating a panorama in Photoshop Elements, see Chapter 10.

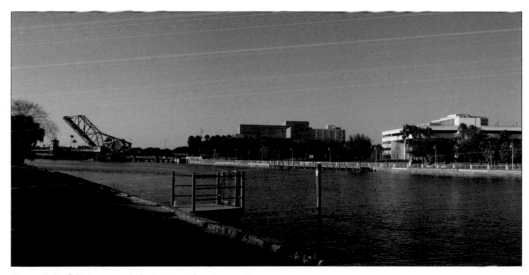

Figure 6-9: Stitch several photos together to create a panorama.

Photographing Animals in the Wild

There are many places where you can get fairly close to wild animals. If you visit national parks in Yosemite or the Rocky Mountains at the right time of year, you're almost certain to see animals roaming around. If you've got a digital camera with a high degree of optical zoom, or a digital SLR with a long lens, you have the necessary ingredients for some great photos. There are even opportunities to shoot photos of wildlife in many towns. A lake about three miles from my home is home to a wide variety of birds, some of them on the endangered species list. If you have wildlife near the vicinity of your house, you can practice the following exercise when an interesting critter stops by for a visit.

Exercise 6-6: Photographing Wildlife

1. **Switch to Aperture Priority mode.**

If you're taking close-ups of wildlife, your goal is to have a limited depth of field. You can achieve this by choosing a large aperture (small f/stop number). If you're photographing a herd of animals, or a large flock of birds, choose a small aperture (large f/stop number) for a greater depth of field, which gives viewers an idea of what type of habitat the animal lives in.

2. **Zoom in before you approach the animal you're going to photograph.**

Most animals are wary of human beings. If you zoom in ahead of time, you won't have to fumble with the camera when the animal's in range.

3. **Approach the animal slowly.**

If you get excited and rush the animal, it will flee and you won't get your shot. Of course, sometimes you get lucky. Once, I was hiking on a wilderness trail with my camera. A couple and their young boy were the only other people on the trail, roughly 300 feet behind me. Every time the boy saw some wildlife, he started running, which would send the animals in my direction, a happy accident that enabled me to get lots of great shots.

If you're photographing wildlife with a point-and-shoot camera, disable the shutter noise, which might spook the animal when you press the shutter. With no shutter noise, you might get several shots before the animal decides he's had enough of the silly human with the weird-looking thing tethered to his neck.

4. **Compose your shot while you're still walking toward the animal.**

If your camera has a Continuous Focus mode, enable it when you're photographing wildlife. When your camera focuses on the animal, it continues to change focus as you move closer.

If possible, take your photograph from the animal's level. This may involve a bit of gymnastics, especially if you're photographing a groundchuck, a squirrel, or something really low to the ground, like a snake.

5. **Press the shutter button to take the picture.**

 If your camera has a Burst mode, enable it. When you take pictures in Burst mode, the camera takes pictures as long as the shutter button is fully depressed. The amount of frames per second your camera can shoot in Burst mode depends on the image size and quality, how quickly the camera can process photos, and the size of the camera buffer. Refer to your camera manual to determine if your camera has a Burst mode or continuous shooting mode option.

6. **Move in closer.**

 After you take a couple of shots, try to move in closer and take a few more. (That is, unless you're photographing a potentially dangerous animal. If this is the case, get as close as you think is safe.) When you're photographing a large animal, you don't really need to fill the frame.

 Don't try to lure a wild animal closer with food. You're putting yourself as well as future visitors in danger. When animals are fed by humans, they lose their fear of us and become more aggressive.

7. **Anticipate the animal's next move.**

 When an animal is getting ready to make a move, it may give you a clue. Some birds stretch their neck and move one foot in the direction they're going to move. I was once videotaping a herd of tule elk while on vacation at Point Reyes, California. The elk became wary as I got closer. One elk tilted his antlers and began to move slowly. I raised my camcorder, zoomed in, panned, and got some great footage as they ran downhill in the same direction the elk tilted his antlers

8. **Focus on the animal's eyes.**

 If the animal's eyes are in sharp focus, it will enhance the photograph. If you're photographing a large animal like an elephant in low light conditions, you may be forced to use a large aperture, which gives you a limited depth of field. If the elephant's eyes are in focus, the entire image seems to be in focus. Figure 6-10 was photographed on a cloudy day. The duck was sleeping. I zoomed in and focused on the bird's eye.

 Never use camera flash when photographing an animal. If the animal is far away, the flash won't illuminate them. If they're close, the flash will startle or anger the animal, both of which are bad scenarios.

9. **If you're photographing moving animals, switch to Shutter Priority mode.**

 Choose a shutter speed of 1/250 second or faster and pan the camera with the animal as it runs. You can also go the other way and choose a slow shutter speed of 1/60 second or less. As you pan the camera to follow the animal's movement, the shutter speed will be slow enough to blur the animal's moving legs, but the body will be in sharper focus because you're panning the camera at the same relative speed at which the animal is running.

Figure 6-10: Focus on the animal's eye.

If you're photographing animals in the wild, stay downwind. Most animals have a sharp sense of smell, which alerts them to potential danger. If you're upwind, the animals will catch your scent and flee.

10. Be alert.

In addition to anticipating the animal's next move, you also need to anticipate potential danger. When photographing potentially dangerous wildlife like bears, keep your distance and use your longest focal length to zoom in on the animals. If you notice any cubs frolicking about, quietly retreat. Animals ferociously protect their young. You should also plan an escape route to nearby shelter if the animals you are photographing start making threatening moves.

Photograph wildlife on a cloudy day. This eliminates the harsh shadows that appear from afternoon sunlight. If the sun is out, take your wildlife photos in the morning or late afternoon when the light is not harsh.

11. Notice what's around you.

You may have stopped to photograph a blue heron, but you may also notice a magnificent monarch butterfly perched on a nearby plant.

12. Use natural elements to frame the animal.

For example, you can use palm trees to frame a flock of flamingos.

For those of you who visit South Florida, do not confuse the hideous pink lawn ornaments with real flamingos.

TIP

If you're photographing wildlife in a park, talk with one of the park rangers. They'll be able to tell you how to safely photograph the animals, and give you information about the animal's habits and where you're likely to find them.

13. **If the animal is not dangerous and does not flee as you get closer, move around until you get a natural background.**

This is especially important if you're photographing birds like herons. They have been known to walk across people's lawns when going from point A to B. A photo of a heron wouldn't look natural with a car or house as a backdrop. For example, a pair of sandhill cranes hangs around my neighborhood. I've patiently waited for the right opportunity to capture a natural-looking photograph of one of the critters. A recent rainstorm left a couple of inches of water in a nearby retention pond. I heard the crane squawking, grabbed my camera, and slowly approached the bird. I took several photographs and finally got one that looked like the bird was in his natural habitat (see Figure 6-11).

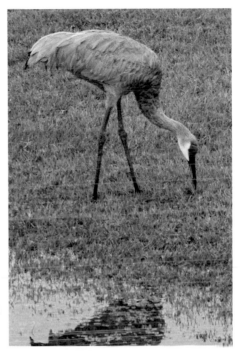

Figure 6-11: Photographing wild birds.

14. **When you're in an area full of wildlife, take enough pictures to fill up a memory card or two.**

Taking lots of pictures is always a good way to make sure that you capture compelling photos of your subject matter.

Getting Close-Up Shots of Flowers

Flowers are colorful, and many of them are fragrant. Scratch-and-sniff digital photography hasn't been invented yet, but you can capture the beauty of flowers if you have a digital camera with a Macro mode, or a digital SLR with a macro lens. You can do the following exercise with a floral arrangement inside your home, or with flowers in your yard.

Exercise 6-7: Photographing Flowers

1. **Switch the camera to Macro mode.**

Your camera may have a button with an icon that looks like a flower. Click the button to switch to Macro mode. Alternatively, your camera may use a menu command to shoot close-ups. If you're using a digital SLR, switch to a macro lens.

Photograph flowers early in the morning, late in the afternoon, or on a cloudy day. If you photograph flowers at noon on a sunny day, the light is harsh and doesn't do a good job of showing the subtle details of the flower.

2. **Switch to Aperture Priority mode and choose the smallest aperture you can use to take a picture hand-holding your camera.**

 When you're photographing in Macro mode, you've got a limited depth of field. In addition, the slightest camera movement is magnified, which results in a blurry picture. It's advisable to mount your camera on a tripod when shooting close-ups.

3. **Press the shutter button halfway to achieve focus.**

 The image should be crystal-clear in the viewfinder or LCD monitor. If it's not clear, you may be too close to the subject. Some cameras flash a warning when you're too close to a subject when photographing in Macro mode. Your camera auto-focus point should change color when you achieve focus. You may also hear a beep.

4. **Compose your picture.**

 When you're taking pictures of flowers, you can use elements of the flower as points of interest. You can use the curved petals to draw your viewer's attention to certain points of the flower. You can compose the picture so that a point of interest such as the flower stamen aligns on a power point according to the Rule of Thirds. (Refer to Chapter 3 for more composition tips.)

Don't shoot pictures of flowers on a windy day. The breeze will cause them to move around, making it difficult for your camera to achieve focus. If you're dead set on taking pictures of flowers on a windy day, or you're on vacation and can't come back at another time, have someone crouch between the flower and the direction of the prevailing wind. Alternatively, you can place a solid object such as a piece of wood upwind from the flower. Do not pick the flower and take the picture behind shelter unless you intend to keep the flower and put it in a vase when you return home.

5. **Take the picture.**

 Figure 6-12 was photographed using the techniques in this exercise. The stamen is the center of interest, and the entire photo is relatively sharp because I used a small aperture and the flower was sheltered from the wind.

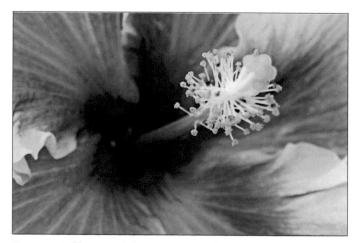

Figure 6-12: Photograph flowers on a windless day.

Pick some flowers from your garden and arrange them in a vase on a clean, white tablecloth. Take several photographs of just the flowers using different compositions. Then back up and include the vase and sprinkle a few petals around the vase. Combine your macro photography techniques with those from the still life exercise to create a picture suitable for framing.

Photographing Your Hometown

Most people take their hometown for granted. They see it almost every day of their life and fall into routines and patterns. Many people who own a digital camera don't use it until they want to photograph a special occasion, or until they go on vacation. If you fall into this group, you're missing a lot of photo opportunities in your own town. The following exercise is designed to get you to wake up and smell the roses in your own home town.

Exercise 6-8: Photographing Your Hometown

1. **Grab your camera and take a trip.**

Drive down the roads you normally travel, and then take some side streets you don't normally frequent.

2. **Look for interesting things to photograph. When you see something that piques your interest, stop and take a picture of it.**

Signs in businesses can be interesting subjects for photographs. Your town may have old buildings, historic sites, and so on. When you see something you like, drink the scene in and find the most compelling composition. Derelict buildings have a unique character; many of them have old faded advertisements in the bricks. A broken window inside an abandoned building can be used as a frame for the scenery outside the building.

3. **Photograph landmarks that are associated with your town.**

The minarets at the University of Tampa are associated with Tampa, Florida (see Figure 6-13). Put your own spin on your town's landmarks to come up with a unique photo. Notice how the palm frond leads your eye toward the building.

4. **Keep an eye out for celebrations and events that are unique to your town.**

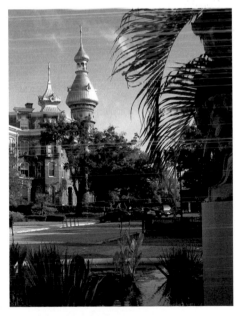

Figure 6-13: Use your creative muse when photographing town landmarks.

5. **Search out flowers and trees that are unique to your town.**

 For example, if you live near Fort Myers, Florida, make it a point to visit the Edison Museum. Thomas Edison planted a banyan tree that he used in his experiment to perfect rubber. The tree is now huge and a worthy subject for a photograph.

6. **Continue the exploration of your town through a photographer's eyes and document anything that captures your attention.**

 Be sure to keep your eyes on the road. You may want to try this exercise with a friend or loved one behind the wheel.

Many local newspapers have blogs that you can use to post your photos. Other publications sponsor amateur photography competitions. Post some unique pictures of your hometown and you'll get some notoriety. You might also win a prize.

Shooting a Day at the Zoo

You don't have to go on safari to Africa to capture photos of wild animals. If you've got a nearby zoo, or animal tourist attraction, you can get some great shots. It's also a heck of a lot safer to photograph a lion in a zoo than it is in the wild. Modern zoos don't have cages; they have habitats for the animals. The habitats are designed to look quite a bit like the animal's natural habitat, but you will still have challenges. The zoo still has fences, and some of the animals are behind glass. The following exercise presents some tips for capturing realistic pictures of animals at the zoo.

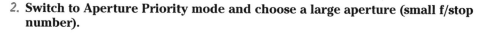

Exercise 6-9: Photographing Animals at the Zoo

1. **Visit the zoo on a weekday morning.**

 Zoos are not as crowded during the week and the animals are more active in the morning.

 Before you visit, go to the zoo's Web site to learn more about the zoo and the animals you'll see there. You'll also find information about special events that may be good photo opportunities.

 Call the zoo before your visit and ask it if there are any photography restrictions.

2. **Switch to Aperture Priority mode and choose a large aperture (small f/stop number).**

 This limits your depth of field and blurs the background.

 If you're shooting an animal habitat that has a large overhang, switch to a higher ISO. If it's permitted by the zoo, bring a tripod or monopod to stabilize the camera during long exposures.

3. **If you're dealing with chain link fence, choose a long focal length and position your lens so that it's in the middle of the link.**

 The combination of a large aperture and long focal length gives you a close-up of the animal. If you can't press your camera against the fence, get as close as possible and manually focus on the animal. When you're shooting with a shallow depth of field, the links of the fence may be so blurry that they'll essentially be invisible.

4. **Be patient.**

 Zoo animals lead a pretty mundane existence and often look quite bored. If you're patient, you'll catch an interesting or comical expression on the animal's face. If there are several animals in a habitat, you can get interesting pictures of them interacting with each other. As Simon and Garfunkel sang, "Zebras are reactionaries, antelopes are missionaries, visions locked in secrecy. . . ."

5. **If you are dealing with crowds, hold the camera over your head and use the LCD monitor to compose the picture.**

 This is difficult to do on a bright sunny day, but if there are clouds overhead, or it's overcast, you should be able to see the monitor.

 When you increase the brightness, you use more battery power. Make sure that you have an extra battery if you brighten the monitor.

6. **If you're dealing with glass, press the camera to the glass and then take your picture.**

 If the glass is clean, you'll get a good shot. Patience will be your best ally. Figure 6-14 was photographed at a local zoo. I placed my camera against the glass and took several pictures of the white tiger and her cub.

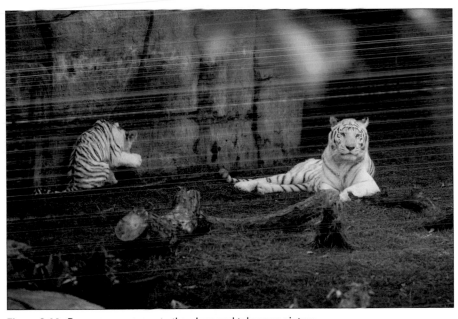

Figure 6-14: Press your camera to the glass and take your picture.

7. **When you see an animal you want to photograph in a realistic habitat, move around until you find the most photogenic part of the habitat. Then wait patiently until your animal moves into position and take your shot.**

 This is another instance where patience pays off. You may have to visit the zoo more than once to get your shot. If you go to the zoo on a day of the week when it has relatively few visitors, you stand a better chance of getting a "keeper" picture.

If you see any zoo employees, ask them about the animals and their habits. They may give you information that helps you get a better shot. Ask them when the lions or tigers are fed and arrive at their habitat half an hour before feeding. The animals will be active, anticipating their upcoming meal.

Creating a Photo Diary of Your Vacation

Vacations are wonderful. They give you a chance to get away from the hustle and bustle of your daily existence, recharge your batteries, and see some wonderful sights at some wonderful places. As the family photographer, it's your job to document the vacation and preserve it for posterity. Photography is creative and spontaneous. You take a photo when you see a scene or something that piques your interest. However, when you travel to a faraway place that you may not visit again, a bit of planning is necessary. In addition to planning your vacation, you should plan your photo opportunities as well. Do the following exercise before you go on your next vacation.

Exercise 6-10: Photographing Your Vacation

1. **Visit some Web sites for the area you are visiting.**

 There may be many Web sites for the area you are visiting. Start with the official tourism Web sites. If you've never visited the area before, you'll find lots of helpful information such as average temperatures, places to visit, and so on. Pay attention to the photographs on the site. Doing so starts planting some seeds as to which places you absolutely must visit and how you can photograph them. While you're perusing the Web site, look for areas of interest that are nearby.

2. **Visit the Web sites of local photographers in the area you're visiting.**

 If you find the Web sites of a couple of talented photographers who specialize in taking landscape photos of the area you're visiting, you'll get other ideas on how you can photograph the area. You may also find some areas not mentioned in the Chamber of Commerce Web sites.

3. **If you're planning side trips to a state park, visit its Web site.**

 In addition to finding out the price of admission and other facts, you may be able to request an information packet, which, if available, will be sent to you by postal mail. While you're visiting the site, take note of when the park is open and when certain areas or exhibits are open. I didn't do this when I made my first visit to Point Reyes National Seashore in California. As luck would have it, I went on the day when the lighthouse was closed. I didn't make that mistake the second time I visited the park and got a nice shot of the lighthouse (see Figure 6-15).

You can find traveler's guides to many popular locations at your local bookstore. I picked one up on my last trip to San Francisco and followed the guide's recommendation to tour the alleys in Chinatown. I was rewarded with some wonderful photo opportunities.

Figure 6-15. Don't visit a park on a day when exhibits you want to photograph are closed.

Visit the Web site of any attraction you plan to visit. Photography restrictions are generally listed on the attraction's Web site. For example, some indoor attractions such as art museums prohibit flash photography. If no photography restrictions are listed, call or e-mail the attraction before visiting to be on the safe side.

4. **If you're traveling by air, check the carry-on regulations.**

 Packing your camera equipment with your regular luggage is a recipe for disaster. Baggage handlers don't always handle your luggage with TLC, and there's a chance that your camera gear may mysteriously turn up missing when you reach your destination. Pack your camera in your carry-on luggage. You'll spend a while longer in airport security, but getting your equipment to your destination undamaged is well worth the extra hassle at the airport.

Don't travel with an expensive camera bag. Thieves will immediately know what's in the bag. Pack your camera gear in a nondescript bag. Some photographers I know pack their camera gear in a diaper bag when they travel. What thief in his right mind would steal a bag full of diapers?

5. **Plan your trip.**

 After you've surfed the Web sites and read the travel guides, you'll know which points of interest you want to visit. Unless you're visiting someplace that's noted for being foggy or overcast for a good part of the day, plan your photo excursions for early in the morning and late afternoon. In the interim, you can visit the indoor exhibitions or do some shopping.

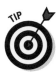

If you're traveling to a foreign country, make sure you bring a voltage converter if needed. If you don't, you won't be able to recharge your camera batteries.

6. **Pack your camera gear.**

 If you've got lots of photography gear, you'll have to figure out which gear is absolutely essential. If you're going to take lots of pictures, make sure you pack enough memory cards, or purchase extras. Make sure you have at least one set of additional batteries for your camera.

 You might also want to consider purchasing a portable hard drive if you travel a lot and take lots of pictures when you travel. Portable hard drives for digital photographers have built-in card readers. Many of them have monitors you can use to preview your work. After you've downloaded the images to the hard drive, you can reformat the memory card and use it again. If you have two cards, you can download your images to the hard drive while taking pictures with the other card. Carrying a portable hard drive is a lot easier than carrying a laptop computer.

7. **Take lots of pictures on your trip.**

 Use the highest resolution setting available for your camera. Memory cards are cheap. Vacations are not cheap. Great pictures of your vacation are priceless. The following list has some tips you should consider when photographing your next vacation:

 - *Take pictures of your family while traveling to your destination.* Photos of loved ones napping while waiting to board the next flight are priceless.

 - *Take some photos of the airplane before boarding.* To get an interesting shot of the plane, switch to your shortest focal length and press your camera against the glass wall in the airport terminal for an "up close and personal" shot of the plane.

 - *Avoid taking clichéd shots.* For example, don't take the standard police lineup shot of your family at the base of the Statue of Liberty, or at the Fisherman's Wharf pier with Alcatraz in the background.

 - *Do take candid pictures of your family looking up at the Statue of Liberty, or staring across the bay to Alcatraz.* These shots can be funny, or just plain old photos depending on your mood.

 - *Be creative.* You can have fun with focal lengths. For example, if you visit the Leaning Tower of Pisa, compose a shot where a member of your family appears to be holding up the tower.

 - *Take pictures of your family doing things on their vacation.* Take candid photos of your son pitching the tent on a camping vacation or your dripping-wet daughter after getting caught in a downpour.

 - *Remember that great vacation pictures are not staged.* Great vacation pictures are spontaneous photos of people enjoying themselves.

 - *Think before you shoot.* That may seem totally contradictory to the last tip. However, if you think for a second or two, you'll know which focal length to use, whether to use a small or large aperture, whether to kneel, stand up, or climb up the steps when taking the photo, and so on.

- *Take pictures that have meaning to you.* Different things appeal to different people. You want to take shots that show where you were, but you also want to take pictures of the things that interested you most while touring your destination.

- *Practice, practice, and then practice some more.* Getting to know your camera *while* you're on vacation guarantees that you end up with more bad shots than good. You should be able to change camera settings without thinking and find the right dial for your needs without having to drag out the camera manual.

Before you go on vacation, answer the questions in this list:

1. What are the URLs of some Web sites that will give me information about the places I'm visiting?

2. Which locations do I want to photograph in the morning?

 (Unless you want the sun in your picture, these locations will be facing west.)

3. Which locations do I want to photograph in the afternoon?

 (Unless you're taking sunset pictures, these locations will be facing east.)

4. Are any of the attractions I want to visit or photograph closed on a particular day of the week?

 List the day of the week followed by the location:

5. Which items on this photography equipment checklist do I need?

 ❑ Camera:

 ❑ Extra batteries

 ❑ Battery charger

 ❑ External flash unit

 ❑ Auxiliary lenses

 ❑ Lens cleaning equipment

 ❑ Tripod or monopod

 ❑ Extra memory cards

 ❑ Nondescript camera bag

 ❑ Portable hard drive

 ❑ Plastic bags to protect the camera in foul weather

 ❑ Voltage converters if needed

 ❑ Camera manual

 If your camera manual is big and bulky, visit www.photocheatsheets.com/ to see whether the site has a cheat sheet for your camera. The cheat sheets sold at this site list pertinent information from the original camera manuals on laminated cards that fit most camera bags.

Chapter 7

Capturing Movement

. .

In This Chapter

▶ Photographing moving objects

▶ Photographing fast-moving vehicles

▶ Freezing motion

▶ Photographing a local sporting event

. .

Motion is everywhere. We live on a planet that is spinning in space. Football players move from one end of the field to the other. If they're good, they even score. Triathletes swim, bike, and then finish up on the run. Racecar drivers travel at unbelievably high rates of speed — and their fuel consumption is unbelievable, too. Yet we take pictures of moving objects with still cameras. Isn't that an oxymoron? A good photograph of a moving object captures the essence of speed, whether the subject is a triathlete running at 5 miles per hour, or a racecar traveling at 200 MPH. The exercises in this chapter show you how to capture movement with your still camera.

Composing Action Photos

When you photograph a moving object, your point of view and the composition of the photo are extremely important. An object in motion needs someplace to go. You need to take this principle into consideration when photographing a moving object. The following exercise shows how to compose a photograph of a moving object.

Exercise 7-1: Composing an Action Photo

1. **Grab the fittest member of your family and tell her to put on her biking shorts.**

2. **Go outside and ask your subject to ride her bike past you.**

 Your subject is *perpendicular* to you when she passes.

3. **Pan your camera with your subject as she rides toward you.**

 When you pan a moving subject, cradle the lens of your camera in your left hand and grip the right side of your camera with your right hand. Move the camera so that your moving subject is centered in the viewfinder. Square your shoulders with your subject and pivot your body from the waist.

4. **Zoom in or out until there's space in the frame in front of your subject.**

 Don't zoom in too tight. You want to leave a visible space for your subject to travel into. Figure 7-1 was composed using the techniques in this exercise. I intentionally used a slow shutter speed to enhance the feeling of motion, a technique I demonstrate in the next exercise.

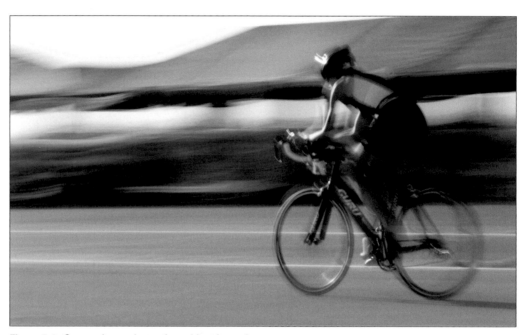

Figure 7-1: Composing a photo of an object in motion.

Accentuating Movement in Photos of Slow-Moving Objects

When you photograph something moving slowly — you know, something moving slightly faster than a snail — it's hard to get a feeling of motion. When you pan the camera with the subject at a normal shutter speed, you stop motion. If you shoot with a high shutter speed and snap the shutter as soon as the subject comes into frame, the photo looks like the subject is stopped in his tracks. When photographing a slow-moving object, the trick is to accentuate motion by panning at a slow shutter speed. The motion of the camera relative to the background and the motion of the subject creates a very blurry photo that is an artistic portrayal of motion. The following exercise explains how to achieve this effect.

Exercise 7-2: Photographing a Slow-Moving Object

1. **Ask a fit friend to help you in this exercise. This time, he'll be running.**

 Switch to Shutter Priority mode and choose a very slow shutter speed.

2. **Choose a shutter speed of less than ⅟₁₅ second.**

 If you get a warning that the image will be overexposed, switch to your lowest ISO setting. If you're taking the picture in bright sunlight, you may have to use a neutral density filter to get a properly exposed photo with a shutter speed of less than ⅟₁₅ second.

3. **Move into a position where you are perpendicular to your subject when he is directly in front of your camera.**

4. **Switch to Continuous Focus mode.**

 In this mode, the camera continues to focus on your subject as he moves toward you.

5. **Tell your subject to start running from left to right.**

6. **Pan the camera with your subject, compose the picture, and then press the shutter button halfway to achieve focus.**

 Leave some space in the front of the frame for your subject to move into. Keep your shoulders square with your subject when panning. Pivot your body from the waist to keep the camera level while you pan.

7. **Press the shutter button to take the picture.**

 Don't stop panning when you press the shutter button. Continue panning with the subject. This is similar to a batter's follow through in baseball.

8. **Review the picture.**

 When you try this technique for the first time, you might not get the desired result. Practice makes perfect. Try this technique a couple of times until you've got the knack of panning with a slow-moving object. When you photograph a runner using this technique, you end up with a photo similar to the one shown in Figure 7-2.

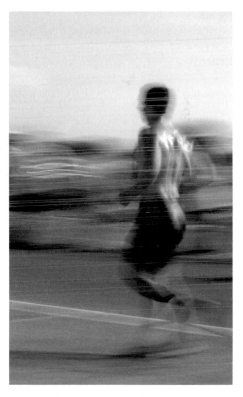

Figure 7-2: Accentuating movement when photographing a slow-moving object.

To get the knack of photographing slow-moving objects, follow the steps in the previous exercise while photographing kids in your neighborhood riding their bikes.

Photographing Fast-Moving Vehicles

When you photograph a fast-moving vehicle, you also want to accentuate the vehicle's motion. The trick is to render the vehicle sharply, with a blurry background. If you've ever seen a professional photo that shows a side view of a racecar at full speed, you notice that the background and the wheels are a blur but you can see every detail on the car, including the driver's names and the details on the driver's helmet. Accomplishing this feat requires a bit of practice. But if you're a diehard racing fan who wants to photograph the next race you attend, or if you just want to create realistic pictures of fast-moving cars, follow the steps in the next exercise.

Exercise 7-3: Photographing Fast-Moving Vehicles

1. **Travel to a parking lot that borders a busy road.**

 When photographing fast-moving vehicles from the side, first make sure you're in a safe place. The purpose of this exercise is to prepare you for photographing cars or motorcycles at a race. When you photograph at a race, you're in a protected spectator area, out of harm's way.

2. **Zoom in.**

 Your goal is to almost fill the frame with the vehicle. Remember to leave some space in front of the frame when composing a photograph of a moving vehicle.

3. **Switch to Shutter Priority mode and choose a shutter of about $\frac{1}{125}$ second.**

 If you're using a really long lens, you may have to choose a higher shutter speed or mount your camera on a tripod.

4. **Switch to Continuous Focus mode.**

 You're going to pan the camera with the vehicle you're photographing. The distance from camera to vehicle changes as you pan. When you switch to Continuous Focus mode, the camera updates focus as the vehicle moves closer to or farther from the camera.

5. **Stand comfortably with your feet spread slightly.**

6. **Cradle the lens with your left hand and place your right forefinger on the shutter button.**

 If your camera is a miniscule point-and-shoot camera, place the body of the camera in the palm of your left hand. Your goal is to provide a stable and level platform for the camera. Essentially, your hands act like the base of a tripod and your legs further stabilize the camera. Square your shoulders with your subject and pivot from the waist to keep the camera level as you pan.

7. **Aim your camera at a vehicle you want to photograph.**

8. **Pan the camera with the vehicle to keep it within the frame.**

 If you're photographing a vehicle at a race, you have to anticipate when the vehicle is accelerating or decelerating. This takes some practice. When I photograph a race, I concentrate on one vehicle at a time. I take a couple of dry runs to see how the driver approaches the particular part of the track where I'm taking pictures. When I think I have the driver's habits down pat, I start taking pictures.

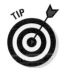

If you want to take several pictures of a vehicle, switch to Continuous Shooting or Burst mode.

9. **Press the shutter button halfway to achieve focus.**

10. **Take the picture.**

Remember to keep panning with the car after you press the shutter. If you don't, the vehicle will be slightly blurred. I suggest that you try this exercise several times with ordinary street vehicles before attempting to photograph a very fast moving vehicle such as a racecar. When you photograph a vehicle traveling 50 MPH or faster, the results from this exercise convey the feeling of motion to the viewer. When you photograph a vehicle moving slower than that, you need to pan with a slower shutter speed. When panning with low shutter speeds, you also need a tripod, unless of course, you want the end result to be a blurry depiction of motion. I first tried this technique with an old box camera when I was a kid. I photographed an orange truck traveling down Highway 301. My mother, who paid for developing my film, told me not to waste film. I told her I wasn't wasting film — a fact that was proven when she got the prints back. I've now graduated to photographing vehicles moving at speeds well in excess of 100 MPH (see Figure 7-3).

Figure 7-3: Pan with the vehicle using a slow shutter speed to capture the essence of motion.

Freezing Motion

There are occasions when you do want to freeze motion. When you photograph a batter connecting with a pitcher's fastball, you want the motion of the bat frozen, as well as the ball frozen just inches from the bat. Another example of a frozen action shot is that of a football player catching a ball in midair with a tackle from the other team ready to

pounce when his opponent touches the ground. To capture this kind of action requires a good eye, knowledge of the sport, and the right settings on your camera. There are plenty of other instances when you want to freeze action: a skier shushing down a twisting trail with flakes of snow flying from the tips of his skis, a figure skater in midpirouette, your dog catching a Frisbee, and so on. The next exercise shows you the settings you can use to freeze action.

Exercise 7-4: Freezing Motion

1. **Ask a friend or family member to assist you in this exercise.**

2. **Grab a tennis ball, or any ball that bounces, and go outside.**

3. **As your assistant to move to a position with a nondescript, evenly colored background.**

 A garage door or concrete wall is an ideal backdrop. Your assistant should also be on a hard surface. Balls don't bounce very well on grass.

4. **Switch to Shutter Priority mode and choose a shutter speed of $\frac{1}{1000}$ second.**

 This is a higher shutter speed than needed to freeze the motion of a bouncing ball. However, you may need an even faster shutter speed to freeze a pitcher's 90 MPH fastball. When you use a fast shutter speed, a large aperture (small f/stop number) is required for proper exposure. If depth of field is important and you're photographing in overcast conditions, you may have to use a higher ISO to achieve a large depth of field.

5. **Switch to Continuous Focus mode.**

 Continuous Focus mode isn't necessary for an object that remains the same distance from the camera. However, using this mode when photographing an object that moves closer to or away from the camera ensures that the focus is continually updated after the camera focuses on the moving object.

6. **Switch to Continuous Shooting or Burst mode.**

 This mode is useful when you want to take a sequence of photos of a moving object. For example, this mode is useful when you want to capture a sequence of images of your son doing tricks on his skateboard.

7. **Compose the photo.**

 For this exercise, drop to one knee and rotate your camera 90 degrees.

8. **Press the shutter button halfway to achieve focus.**

9. **Ask your subject to bounce the ball and then press the shutter button fully.**

 Your camera will take photos as long as you have your finger on the shutter button. The amount of frames your camera can capture per second varies depending on the image size and quality, your camera, and the speed of your memory card. Some digital cameras can capture as many as 9 frames per second when shooting in Burst mode. Your camera may designate the number of frames per second that can be captured on the LCD monitor. Refer to your camera manual for more information.

If you take a lot of photos using your camera's Burst mode, consider investing in one or more high-performance memory cards. High-performance memory cards have faster read/write speeds, which enable your camera to write images to the card quicker, which frees the camera *buffer* (the internal memory that stores the image before it's written to a memory card) to quickly capture other images. As an added bonus, when you use high-performance cards, you can download cards to your computer quicker.

10. **Release the shutter button to stop taking pictures.**

You need fast shutter speeds to freeze the motion of faster-moving objects. The herons shown in Figure 7-4 were frozen in midflight using the techniques in this exercise. A shutter speed of ⅟₈₀₀ second was used and the camera was set to Continuous Focus mode.

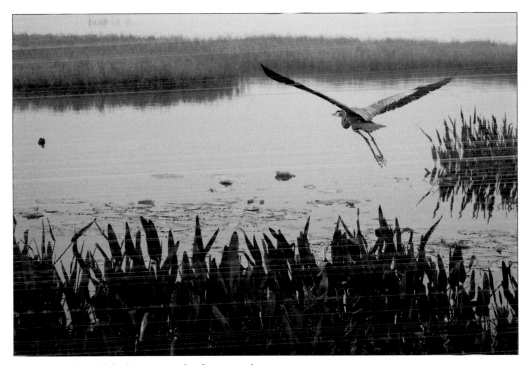

Figure 7-4: Use a high shutter speed to freeze motion.

Use the techniques in Exercise 7-4 to photograph different objects in motion. If you're a fan of drag racing, take a photo of your favorite dragster after the driver pops the chute at the end of a run. Take photos of your kids popping wheelies on their bikes. Take photos of birds in flight, or planes taking off and touching down at your local airport. When you want to freeze the motion of an object that's moving perpendicular to you and you want the background to be in sharp focus, pan with the object and use the combination of a high shutter speed and a relatively small aperture (large f/stop number). The shutter speed you use depends on what you're trying to achieve. Experiment with different shutter speeds for different subjects. When you're trying to freeze the motion of an object moving toward you, you can use a slower shutter speed.

Photographing a Local Sporting Event

Sports photography is fun, and sporting events are everywhere. Your children may play on a team at their school. A triathlon or foot race may be run near your hometown. If you're car-crazy like me, you probably know where all the local automobile races are held. When you photograph a sporting event, you can either be a casual picture-taker and snap pictures of whatever trips your trigger, or you can document the event from start to finish. The following exercises show you how to document a sporting event.

Exercise 7-5: Getting Ready to Photograph the Event

1. **Get to know the lay of the land.**

 If it's a local event, visit the venue before you actually photograph the event. If the event is in a stadium, get your seat ahead of time and try to get a seat where the action is. Make sure you've got a seat that enables you to get photos of the home team players. If you're photographing a marathon or triathlon, get a map of the course from the organizers. The same applies to an automobile racecourse. You may be able to get this information online.

2. **Find out if there are any limitations concerning photography.**

 The event organizers may prohibit flash photography. If the event is held in a stadium, you may not be allowed to carry a tripod or monopod into the stands.

3. **Find out how early you can arrive at the event.**

 To create a documentary-style journal of the event, you want to photograph every subtle nuance. When you arrive early, you can get great shots of the players practicing and so on.

4. **Find out what type of access to the event you will have.**

 For example, if you're attending an auto race, you generally have to purchase a ticket upgrade to gain access to the pits, or, as it is known in sports car racing, the *paddock*. At a football game, seats on the 50-yard line or in the end zone are more expensive than seats in the nosebleed section of the stadium. If you're attending a professional basketball or football game, forget about photographing the players in their locker rooms: Only the press gets that type of access. However, if you know the coach of your local football or basketball team and bribe him with 8-x-10 glossies of his team in action, you may be able to photograph the team in areas where you would not normally be allowed to go.

5. **Prepare your equipment.**

 Make sure your camera's batteries are charged and its memory cards are formatted. There's nothing more frustrating than putting a new memory card in your camera and finding out that it's full of pictures from your niece's birthday that you've already downloaded to your computer.

Keeping it clean

Cleaning your camera equipment is something you should get in the habit of doing regularly. Clean dust off the body of your camera with a brush. Never use a solvent on any part of your camera. Use a blower to remove stubborn dust particles on the body or lens. If there's any dirt that can't be removed with a brush, wet a soft cloth and gently rub it over the affected area, being careful not to get any moisture into the body of the camera. Clean the lens with a microfiber cloth that's designed for cleaning photography lenses. You can find cleaning equipment at your local camera store. You can order unique microfiber lens-cleaning cloths, like the one shown in the figure, from www. photosilk.com. One side of the cloth has a high-resolution image imprint, whereas the cleaning side is blank. You can even upload your own photos and have custom Photosilks created. The following figure shows the equipment I use to clean my camera and lenses.

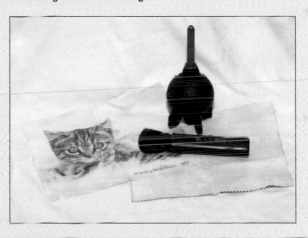

6. **Clean your equipment.**

 For tips on cleaning your equipment, see the nearby sidebar "Keeping it clean."

7. **Pack your equipment.**

 If you use a digital SLR, pack the lenses you think you'll need to cover the event in your camera bag. If you use a point-and-shoot digital camera, house your camera in a case. It's good protection for your camera. Most camera cases have pockets in which you can store extra memory cards, cleaning equipment, and so on. It's also a good idea to carry a plastic baggie big enough to cover your camera if you're photographing an outdoor event and the weatherman decides to rain on your parade.

Exercise 7-6: Photographing the Event

Automobile racing is my passion, so this exercise is illustrated with photos from automobile races I have attended and photographed, with one triathlon thrown in for good measure. I've had press passes at many events, but all of the photos that accompany this exercise were shot from spectator areas with a spectator pit pass.

1. **Arrive early.**

 When you arrive early, you can get some great pictures of the athletes preparing to do battle, the fans arriving, and so on. An added bonus to arriving early is being able to stake out a base. If you're photographing an event in a stadium or arena, bring a friend who can hold down the fort while you're out and about taking pictures of what interests you.

2. **Switch to Aperture Priority mode and choose the desired aperture.**

 When you photograph pre-event festivities, you can use a small aperture (large f/stop number) to create photographs with a large depth of field. A large depth of field is appropriate when you want to capture the full majesty of an event: a football stadium filled to capacity, the starting grid for the Indy 500, and so on. Use a large aperture (small f/stop number) when you want to create photographs with a limited depth of field, such as a close-up shot of a runner lacing up her shoes or a driver nestled in the cockpit of his race car (see Figure 7-5).

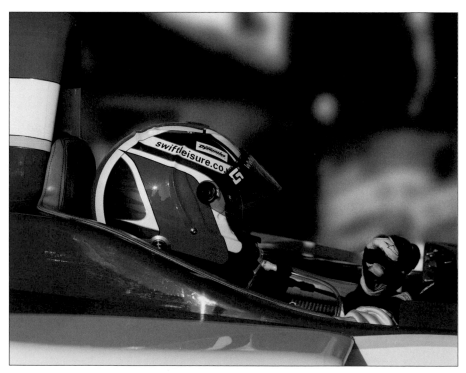

Figure 7-5: Choose the appropriate aperture for the job at hand.

3. **Photograph the athletes preparing for the event.**

 The type of photos you can get depends on your access. If you're photographing an event like a marathon or triathlon, you can get some shots of the athletes stretching, lacing up their running shoes, jogging to warm up, and so on. If you're photographing an auto race, and you have a pit pass, you can get some shots of the team preparing the car (see Figure 7-6).

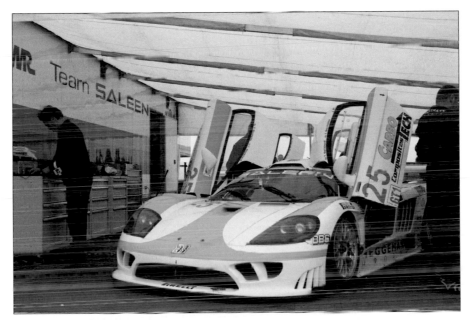

Figure 7-6: Photograph the teams and athletes preparing to do battle.

4. **Switch to Shutter Priority mode and choose the appropriate shutter speed.**

 The shutter speed you choose depends on the type of event you're photographing. If your intention is to stop action, use a high shutter speed. If you're going to pan with the athlete, use a slow shutter speed. Choose a very slow shutter speed if your goal is to accentuate the motion of a runner or biker, or a shutter speed of $\frac{1}{125}$ second if you're panning a fast-moving vehicle like a racecar.

5. **Switch to Continuous Focus mode.**

 This ensures that your camera continually focuses as your subject's distance from the camera changes. This mode uses more battery power, but sharp, in-focus shots are worth the price.

6. **Photograph the practice sessions.**

 During the practice sessions, the athletes warm up. This also gives you an opportunity to warm up and decide the ideal shutter speed to photograph the event. While you're photographing the practice sessions, take note of the competitors. You'll be able to determine which ones are the crème de la crème. These are the athletes you want to focus on during the competition: They'll be the ones worthy of many Kodak moments.

7. **Take candid shots of the athletes.**

After the practice session, the athletes relax. Keep an eye out for athletes giving each other high fives, laughing, smiling, and so on. If you have a friend or relative competing in the event, candid photos are wonderful keepsakes.

8. **Photograph the athletes performing pre-event rituals.**

After the athletes are suited up and ready to go, they often perform elaborate rituals. These vary depending on the type of event you're photographing. Be alert for anything that looks like it will be an interesting shot. Many athletes visualize the event in their mind's eye. Zoom in on the athlete from afar and switch to a large aperture for a wonderful photo of the athlete putting his game face on. If you're photographing an automobile race and you know where the driver's meeting is held, you can get some interesting shots. Figure 7-7 was photographed at a driver's meeting. The driver was in his own world, concentrating on the meeting and perhaps visualizing the event.

Figure 7-7: Photograph the athletes performing pre-event rituals..

9. **Photograph the players interacting with other team members and coaches.**

Before the event, the team and coach are making last-minute plans based on the information gleaned during the practice session. Athletes and coaches are very passionate about what they do, even on an amateur level. If you're prepared, you'll get some wonderful shots of highly focused individuals.

10. **Travel to the ideal place to photograph the start of the event.**

This is one of the reasons you should arrive early. Make sure you allow yourself enough time to get in position a few minutes before the start. If you've done your homework, you'll be in the right spot, ready to capture some compelling images of the start of the event.

11. **Take lots of pictures at the start of the event.**

If you're photographing a basketball game, get several shots of the tip-off. If you're photographing a football game, capture a close-up of the coin toss, and then zoom out to photograph the opening kick-off. If you're photographing an automobile race, a triathlon, marathon, or similar event, capture several photographs of the tightly packed field as it rushes past your vantage point.

Switch to Continuous Shooting or Burst mode when photographing the start of an event. The camera continues taking pictures as long as you have your finger on the shutter.

12. **Zoom in.**

After the event begins, get some close-ups of the athletes in action. Capture shots of a basketball player dribbling the ball down-court, a football quarterback with the ball cocked and ready to pass, or a close-up of a racecar zooming around a curve. If you're shooting close-ups of players, switch to a high shutter speed. If you're shooting close-ups of automobiles, switch to a relatively slow shutter speed and pan the camera with the car (see Figure 7-8).

Figure 7-8: Photograph close-ups of the athletes in action.

13. **Capture photos of the opponents in action.**

Take pictures of several athletes competing with each other. At a football game, you can get great shots of the running back being closely pursued by the opposing team's offense, a baseball player sliding into second base with the shortstop running toward the bag, several racecars rushing down a straightaway, and so on.

14. **Move around.**

If you take all of your pictures from the same vantage point, you'll quickly run out of interesting photo opportunities, and all of your photos will look similar. The amount of moving around you can do depends on the amount of access you're allowed by the event organizers and the ticket you purchased. If you're at an event where the grandstands are not filled to capacity, move to a different level or different part of the grandstands to photograph a different part of the field. If you're at a marathon or triathlon, you can freely move from point A to B to C. The same applies to an automobile race at a natural terrain road course or street course. You can capture a wide variety of photos by moving a few hundred feet at a road course.

15. **Photograph the end of the event.**

If you're photographing an automobile race, take a picture of the winner crossing the finish line. If you're photographing a football or basketball game, take a picture of the final play. If you're photographing a marathon or triathlon, take a picture of the winner, or your family member's winning time as she crosses the finish line (see Figure 7-9). The key is to be alert. If you're photographing a timed event, pay attention to the clock. If you're photographing an automobile race, you should know how many laps the event is before attending. Watch the scoreboard. It shows you how many laps have elapsed and the number of the leader. If the first few cars are close, you can get some great shots as they battle for position while approaching the finish line, and then take your own "photo finish" picture.

16. **Photograph the awards ceremony.**

Many events have award ceremonies. If you take photos of the winners, you've got start-to-finish documentation of the sporting event. If you take pictures of the winner's circle at an auto race, use your longest focal length and back up; otherwise, you and your camera may be doused with champagne.

Figure 7-9: Photographing the end of an event.

Photographing Your Children at a Park

Never venture to the park without your digital camera. You can capture some wonderful photos of your kids doing what they do best: being kids. Every kid does something different when they go to a park. You know what your child likes best. The following exercise gives you a few ideas for photographing your child playing on outdoor toys.

Exercise 7-7: Photographing Your Children Playing at the Park

1. **Grab your child, camera, spouse, and get ready to have some fun.**

It's always a good idea to bring your spouse. Some children are distracted when you point a camera at them, and other kids are just plain hams. Your spouse can play with your child while you capture some great pictures.

2. **When your child is playing on a swing set, switch to Sports mode or Shutter Priority mode.**

Your goal is to capture your child in midflight on the swings. If you choose Shutter Priority mode, choose a shutter speed of 1/500 second.

3. **Switch to Continuous Focus mode.**

 When you switch to Continuous Focus mode, the camera updates the focus as your subject moves toward or away from the camera.

4. **Ask your spouse to give your child a push to get him started.**

5. **Hold the camera vertically and zoom in on your child.**

 Your goal is to shoot a picture with your child tightly framed as he moves toward you.

6. **Push the shutter button halfway to achieve focus.**

7. **Take the picture.**

 Take several shots and you're bound to get a couple of winners. Figure 7-10 is a shot of a friend's son in midflight on a swing set.

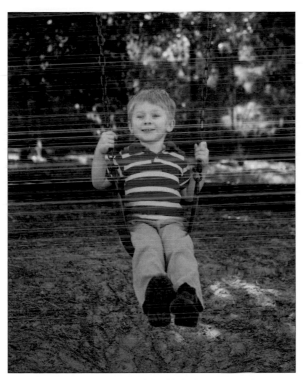

Figure 7-10: Freeze action with a high shutter speed.

8. **When your child has had his fill of the swings, ask your spouse to direct him to the slide.**

9. **Switch to Aperture Priority mode and choose a large aperture (small f/stop number).**

10. **Position yourself at the bottom of the slide.**

11. **Ask your child to climb the slide.**

12. **Zoom in on your child and take a picture.**

You'll get a tightly framed shot of him at the top of the slide.

13. **Zoom out to your widest focal length, choose a small aperture (large f/stop number), and take a picture.**

This time your photo will be quite different. If it's a tall slide, you'll have a lot of perspective and your viewers will get an idea of the trip your child is about to take.

14. **Ask your child and spouse to play on the monkey bars.**

15. **Climb to the top of the monkey bars and photograph your child looking up at you.**

For this photograph, use a relatively large aperture to get a small depth of field (see Figure 7-11). Experiment with different focal lengths and angles.

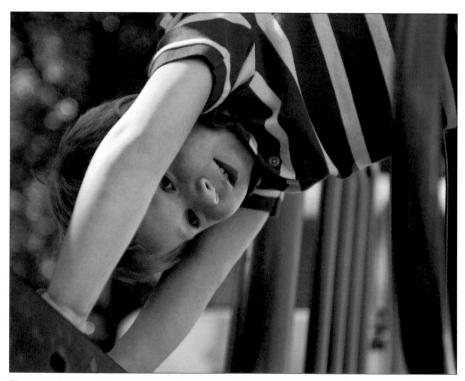

Figure 7-11: From high atop the monkey bars. . . .

16. **Ask your child to play on the top of the monkey bars while you photograph him from below.**

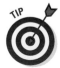

Use fill flash because the sky will be brighter than your son. If you don't, your child will be a silhouette, or heavily shadowed.

Chapter 8

Exploring Creative Effects

· ·

In This Chapter

▶ Using blur creatively

▶ Creating a zoom lens effect

▶ Creating a kaleidoscope photo

▶ Taking sepia and black and white photos

▶ Using photo filters

· ·

*M*any people think special effects in photos are created in a program like Photoshop. That's true in many cases, but before Photoshop was invented, photographers actually created special effects with the camera using photo filters, lenses, and ingenuity. You may be happy to know that many of the same techniques can be used with digital photography. The exercises in this chapter show you different ways you can use your equipment to create some very cool-looking pictures.

Using Blur Creatively

Many of today's digital cameras have razor-sharp lenses suitable for taking close-ups of very small objects. So why on earth would you want a blurry photo? Well, for one thing, because you *can* create one. More importantly, when you use blur creatively, you can depict motion in photos and create abstract photos. All you need is a slow shutter speed and some imagination. The next exercise gets your creative juices flowing. Try this technique next time you go shopping.

Exercise 8-1: Using Blur Creatively

1. **Before a trip to your local grocery store, switch to your lowest ISO rating.**

2. **Switch to Aperture Priority mode and choose a small aperture (large f/stop number).**

3. **At the store, place the camera on top of the shopping cart.**

 If your camera is deep enough, it should fit between the handle and the basket. If you've got a really miniscule camera, place a pad between the handle and the basket. If you've got some writing on it, your fellow shoppers will think it's your shopping list and won't look twice.

4. **Begin shopping.**

5. **When you start walking down a crowded aisle, press the shutter button to take a picture.**

 It will be a relatively long exposure and the people in the photo will look blurry.

 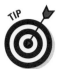

 Turn your camera shutter sound off and rest your thumb on the shutter button and people won't even realize you're taking pictures while shopping.

6. **When you see a group of shoppers walking toward you, stop and press the shutter button.**

 You'll get a different type of effect. Figure 8-1 was photographed in a shopping center during the holiday shopping season. I placed the camera on a table, set the self-timer, and pressed the shutter button when a group of people started walking toward me. The four-second exposure recorded the people walking toward me as a ghostly blur. Because the camera was mounted on a solid surface, the background isn't blurred.

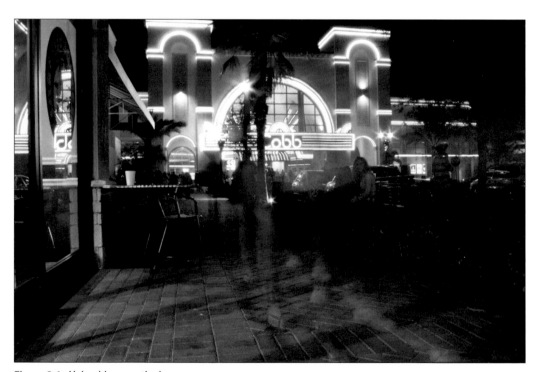

Figure 8-1: Using blur creatively.

7. **Experiment with different focal lengths.**

 With a wide-angle focal length, you get more of the surrounding aisle.

8. **If you're shopping at night, drape the camera around your neck and then push the shutter button as you walk into the parking lot.**

The lights will be blurred. The movement creates a surreal effect. Figure 8-2 was photographed while I was walking along the shoreline of a lake with lampposts evenly spaced.

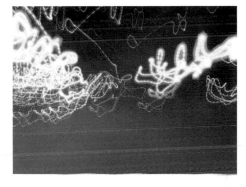

Mount your camera on a tripod in a busy place like an airport or a train or bus station. Choose your lowest ISO rating, switch to Aperture Priority mode and choose a small aperture (large f/stop number). Set the camera auto-

Figure 8-2: Using a slow shutter speed while walking.

timer for its shortest duration. When a crowd of people walks toward you, press the shutter button. Experiment with different focal lengths to include more or less of the background. After photographing the inside of the train station, take your camera and tripod outside. Place your camera on the platform next to the train and take a photo of the train leaving the station. If it's a sunny day, you may have to use a neutral density filter to get a slow-enough shutter speed for this technique.

Zoom Lens Effect

If you've got a digital SLR camera with a telephoto zoom lens, you can create some very cool abstract photos. This technique involves a long exposure. You can use this effect on objects, or at night to create abstract light patterns. The following exercise shows you the basics.

Exercise 8-2: Creating a Zoom Lens Effect

1. **Take your camera outside at night.**

 If you live in a neighborhood, you can do this from your driveway. If you live in a secluded area, turn on every light in your house and open the blinds.

2. **Place your camera on a tripod.**

3. **Choose your lowest ISO rating.**

4. **Switch to Aperture Priority mode and choose your smallest aperture (largest f/stop number).**

 This results in a long exposure, which is just what you want.

5. **Switch to your shortest focal length.**

6. **Press the shutter button halfway to achieve focus.**

 If your camera has a hard time focusing in the darkness, switch to manual focus. Alternatively, shine a flashlight at the edge of a window and focus on that.

7. **Press the shutter button fully while zooming in.**

 The resulting photo appears as if the lights are zooming toward you. If you have a long-enough exposure, you can stop the zoom at one focal length for a second or two, and then zoom to another focal length. If the exposure is long enough for you to do this with four or five focal lengths, you achieve a result similar to Figure 8-3.

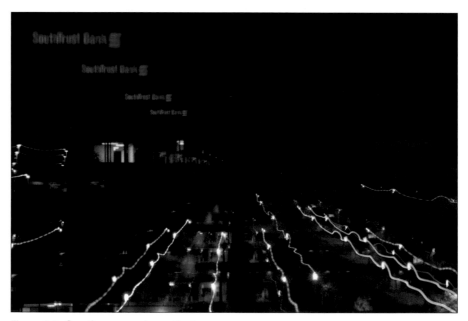

Figure 8-3: Creating a zoom lens effect.

If you have a neutral density filter, try this technique during the day on a stationary object, like a sports car. Take a photo of the front of the car while zooming from your shortest focal length to your longest. The resulting photo will look like the car is racing toward you.

Creating a Kaleidoscope Night Scene

At night, a city is vibrant with colorful lights. If you're a fan of abstract art, or a child of the '60s who attended rock concerts with psychedelic light shows, you'll love this technique. The cool thing about this technique is that you can do it any time you see a set of lights that look like they'd be the basis for an interesting abstract photograph. All you need is your camera and a slow shutter speed; no tripod required. Follow the steps in this exercise to create your own abstract "light painting" photos.

Exercise 8-3: Creating an Abstract Kaleidoscope Effect

1. At night, light a candle and put it on your dining room table.

2. Turn off any lights that are shining directly on the table.

 Your goal is to emulate a night city scene with a dark background and bright pinpoints of city lights.

3. Switch to your lowest ISO rating.

4. Switch to Aperture Priority mode and choose your smallest aperture (largest f/stop number).

 This ensures a long exposure.

5. Switch to a focal length that gives you a composition where the candle occupies a small part of the frame.

6. Point the camera auto-focus point at the candle and press the shutter button halfway to achieve focus.

7. Press the shutter button fully and then start turning the camera from side to side while moving the camera left and right.

8. Continue moving the camera until the exposure is complete.

 Your results appear in the LCD monitor a few seconds later (see Figure 8-4). Experiment with this technique at home until you start producing some results you like. Then try your hand at creating a "light painting" of some interesting city lights in a nearby city (see Figure 8-5).

Figure 8-4: Creating a "light painting" of a candle.

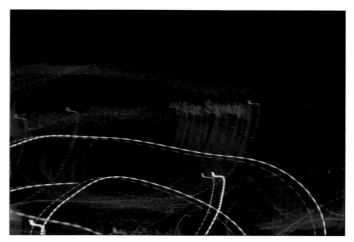

Figure 8-5: Creating a "light painting" of a city scene.

Creating a Digital Multiple Exposure

After you start experimenting with special effects, it becomes positively addictive. Another technique you can easily master with any digital camera is what appears to be a multiple exposure. All you need is a tripod, your camera, and a willing subject. Heck, you can even do a multiple exposure of yourself. Just make sure you're not overexposed. The following exercise shows you what you need to know to create a faux digital multiple exposure.

Exercise 8-4: Creating a Digital Multiple Exposure

1. **Turn on your porch light.**

 That's right: This technique is done at night.

2. **Mount your camera on a tripod.**

3. **Switch to a low ISO setting.**

4. **Switch to Aperture Priority mode and choose the smallest aperture (largest f/stop number).**

 The small aperture gives you the long exposure that is required for this technique.

5. **Zoom out to achieve the desired composition.**

 You want to allow enough room to move from one point to another and remain in frame.

6. **Set your camera self-timer for 10 seconds.**

 This gives you time to walk into frame. It also gives the camera time to stabilize from any jitter caused by pressing the shutter.

7. **Press the shutter button halfway to achieve focus.**

The camera may focus on an object in the background. However, if the background is close to where you'll be standing, the depth of field you achieve from using the small aperture should create a desirable picture. If the background is far from where you'll be standing, move the auto-focus point over an object that is the same distance from the camera and then use the tripod controls to move the camera and compose the picture.

8. **Press the shutter button fully and walk into the picture.**

 The timer starts counting down.

9. **After the timer finishes counting down, remain still for a few seconds.**

10. **Move to another part of the scene.**

 If you've got an exposure of 20 seconds or longer, you can move around a couple of times. Figure 8-6 was photographed by the light in the doorway of an elevator door atop a parking garage. The exposure was 20 seconds, which gave me time to move to a different spot and adopt a different pose.

The next time you and your family are at an attraction at night, try this technique. You can get some whimsical photos of your family members changing places, or a shot of a family member at a miniature golf course addressing the golf ball, and then moving toward the hole like she was coaxing the ball into the hole.

Figure 8-6: Creating a digital multiple exposure.

Taking a Self-Portrait with Special Effects

If you've worked your way through the previous two exercises, you know you can do some cool things with long exposures at night. But wait, there's more! How about creating a self-portrait complete with special effects? The following exercise explores a technique I stumbled on when looking at images in a book. A photo intrigued me, so I put on my thinking cap and tried to figure out how the photographer did it. The following exercise is my solution.

Exercise 8-5: Creating a Self-Portrait with Special Effects

1. **Turn on your porch light, grab a penlight, your camera, and tripod, and then go outside.**

2. **Mount your camera on a tripod.**

3. **Switch to your lowest ISO setting.**

4. **Switch to Aperture Priority mode and choose the smallest aperture (largest f/stop number).**

 This combination ensures a long exposure.

5. **Zoom in to achieve the desired composition.**

 Give yourself a bit of a fudge factor, and don't zoom in so tight that you end up chopping off body parts in the resulting image. If you want a head-and-shoulders portrait, zoom in tight but leave enough room for some space above your head.

 If your camera has an LCD monitor that flips to the side and can be rotated 180 degrees, you can walk into the picture area and see exactly how much of your body will be in the self-portrait.

6. **Set your camera self-timer for 10 seconds.**

 This gives you some time to walk into frame and for the camera to stabilize from any jitter caused by pressing the shutter.

7. **Press the shutter button halfway to achieve focus.**

 The camera may focus on an object in the background. However, using a small aperture should give you enough depth of field to create a desirable picture. Alternatively, you can move the auto-focus point over an object that is the same distance from the camera, achieve focus, and then use the tripod controls to move the camera and compose the picture.

8. **Press the shutter button fully and walk into the picture.**

 The timer starts counting down.

9. **Walk into the frame and remain still.**

10. **Shine your penlight at the camera and move it around to create an artistic swirl of light.**

 You can remain in the frame the entire duration of the exposure to create a conventional night self-portrait with the swirling light. Alternatively, you can walk out of the frame partway through the exposure to create a ghost-like effect (see Figure 8-7).

You can take a conventional self-portrait indoors or outdoors by following the same steps during the day. Use a large aperture (small f/stop number) to create a portrait with a blurry, out-of-focus background.

Shooting Black-and-White and Sepia Photos

If you like black-and-white and sepia-type photos, you'll be glad to know that most digital cameras have options for creating these types of photos. With most cameras, you just choose the desired photo type from a menu option and you're ready to rock and roll. Try the following exercise to explore the different options available for your camera.

Figure 8-7: Creating a self-portrait and light show in one fell swoop

Exercise 8-6: Creating Black-and-White and Sepia Photos

1. **Ask a family member to be your guinea pig . or, I mean** *subject* **for this exercise.**

You can take the photo indoors with flash or outside. You're taking a portrait, so take the photo in a shaded area if you're taking the photograph outdoors.

2. **Switch to Portrait mode.**

Alternatively, you can switch to Aperture Priority mode and choose a large aperture (small f/stop number).

3. **Compose and take a picture.**

A full color picture of your subject appears on your LCD monitor. Figure 8-8 is a photo of a street vendor's cart using the camera's default color mode.

4. **Access your camera menu and navigate to the section of the menu that gives you color options.**

Each camera is different. Refer to your camera manual for details.

5. **Choose the Black and White setting and take a picture of your subject.**

You'll get a picture that looks like the old days when people actually used black-and-white film. Figure 8-9 is the same street scene with the camera's Black and White mode.

Figure 8-8: Kodachrome gives us those nice, bright colors. . . .

Figure 8-9: Everything's the same in black and white, in my little town.

6. **Access your camera menu and choose the sepia setting.**

7. **Compose and take a picture.**

 Figure 8-10 shows the same street scene with a sepia setting. Your results may differ depending on how your camera renders sepia. Before you move to the next section, check to see if you have any other special color settings on your camera. One of my digital cameras, for example, has a setting to warm the color (add more red) or cool the color (add more blue).

Figure 8-10: You can create a sepia-type image using settings from your camera menu.

Using Photo Filters

Traditional film photographers use photo filters to create special effects. If your digital camera has threads at the end of the lens, you can purchase photo filters from your local camera store or online to create a plethora of effects. After you purchase a filter for your camera, you simply screw it on to the threads on the end of your camera. Before purchasing filters for your camera, consult your camera manual to see what the accessory filter thread size is for your camera, or take your camera to the camera store and ask the friendly salesperson for some help. Note that some of the smaller pocket-size point-and-shoot cameras don't have filter mounts to accept filters. Table 8-1 lists some popular filters and describes the results you can expect when using them.

Table 8-1	Photo Filters
Filter Type	*Effect*
Prism	Splits the image into multiple images. For example, a 6X prism filter creates an image with six prisms of the scene you're photographing. This filter works well with shots of people and objects.
Soft focus	Useful if you shoot a lot of head-and-shoulder portraits. The filter softens the sharp edge of the focus to create pleasing portraits. The filters are sold with different intensities for different age groups. For example, if you're taking portraits of older people, you should purchase a stronger soft focus filter. Soft focus filters soften an image without degrading it.
Cross screen	Works with point light sources to create an effect that makes the light source look like a star. A 6X cross screen filter produces a six-point star from light sources in the scene you're photographing.
Graduated	Useful when you need to add some color to a photograph. For example, if you're photographing a landscape with an anemic sky, you can use a graduated blue filter to add some blue to the sky. The filters have a color embedded in the glass over half of the filter. Most have a gradient at the transition zone from color to clear.
Warming	Adds an orange-reddish hue to a photograph. Use a warming filter when you're shooting a snow or cold-weather scene and you want to remove the blue color cast from the photo.
Cooling	Adds a blue hue to a photograph. Use a cooling filter to tame a wild sunrise or sunset.
Skylight	Removes the bluish tint from outdoor photos.
Ultraviolet	Removes ultraviolet rays from outdoor photos. An ultraviolet filter is useful when you're photographing a vast landscape. The filter removes some of the haze, which reveals distant details that might otherwise be lost.
Polarizing	Reduces reflections and works well for landscape photos. It enhances the blue sky and warms other colors in the image.

Lots of filters are available. Visit your local camera store or favorite online reseller to see which filters are available for your camera or lenses. Your camera manufacturer may also have filters available at its Web site. Figure 8-11 was taken with a polarizing filter on the lens. Notice the deep blue of the sky and sea.

If you own a digital SLR and have several lenses with different filter attachment sizes, buy the filters you need for the largest attachment size. Then you can buy a step-up ring, which adapts the larger filter to your other lenses.

Do not overtighten a filter when you attach it to your lens. If you do happen to overtighten a filter, your camera shop can sell you a filter wrench, which is a tool that is designed to loosen a filter from your camera lens.

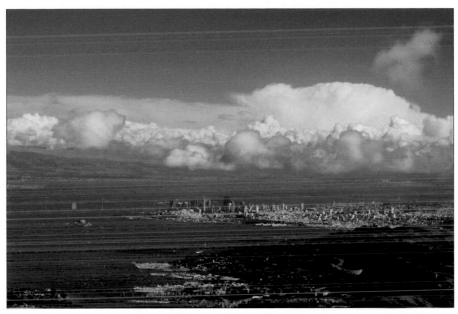

Figure 8-11: Enhancing images with filters.

 Purchase a UV or skylight filter for your camera, or, if you own a digital SLR, for each lens that you own. Leave the filter on the lens at all times. It's cheap insurance against scratches if you should accidentally bump the end of the lens against a sharp or abrasive surface.

Creating a Misty/Foggy Look on a Clear Day

A foggy scene evokes mystery. It's also very beautiful. The light is soft and diffuse, which makes a foggy landscape or seascape a thing of beauty. But somehow, there's never fog when you really need it. When you see a landscape that would look great in the fog, but it's not foggy, create your own fog as outlined in the following exercise.

Exercise 8-7: Adding Fog to a Landscape Shot

1. **Switch to Landscape or Aperture Priority mode.**

 If you choose the latter option, choose a small aperture (large f/stop number). Either method ensures you've got a large depth of field.

2. **Breathe on the lens.**

 Condensation appears on your lens. The amount of condensation depends on the humidity and the difference in your body temperature and ambient temperature. On warm days without a lot of humidity, you have to work quickly, before the condensation evaporates.

3. **Compose the picture and wait for the condensation to dissipate slightly.**

 If you're taking pictures on a warm day, skip this step. You'll be able to see the condensation dissipate in the viewfinder or LCD monitor.

4. **Take the picture.**

 If you're taking pictures on a very humid day, take several pictures with different amounts of condensation on the lens. This technique looks most realistic when you're taking pictures on an overcast day. Figure 8-12 was photographed using this effect.

Figure 8-12: Beautiful landscape: Just add fog.

Creating an Edge Diffusion Filter

If you shoot a lot of portraits, a filter that diffuses light at the edges of a photo is desirable. However, when you start buying specialized filters, you end up spending beaucoup bucks. If you like the soft look around the edges of a portrait, you can create your own edge diffusion filter by following the steps in the next exercise.

Exercise 8-8: Creating an Edge Diffusion Filter

1. **Purchase a skylight filter to fit your point-and-shoot camera, or if you're using a digital SLR, buy a filter that fits the lens you use for portraits.**

 You don't need to purchase the most expensive skylight filter as you'll be modifying it.

2. **Purchase a bottle of Sally Hansen Hard As Nails clear nail polish.**

 This nail polish dries perfectly clear.

3. **Paint a thin layer of nail polish on the filter, leaving a clear area about the size of a 50-cent piece in the middle.**

4. **Let the nail polish dry and take some test photos.**

 If you want more diffusion closer to the edge, paint a second thin layer on top of the first, and don't paint as close to the center this time. Figure 8-13 shows a photo without the homemade filter on the left, and a portrait taken with the filter on the right.

Figure 8-13: A portrait without the filter on the left and a portrait photographed with the homemade edge diffuser filter on the right.

Fun with specialty lenses

If you own a digital SLR, you can stuff a lot of lenses in your camera bag. If you shoot a lot of landscapes, consider investing in an ultra-wide-angle or fisheye lens. An ultra-wide-angle lens captures huge amounts of landscape. An ultra-wide-angle lens also has an incredible depth of field. When you use an ultra-wide-angle lens in conjunction with a small aperture (a large f/stop number), you can get very close to an object in your scene and still have distant objects appear to be in focus. The first figure was photographed with a 10–22mm lens with an aperture of f/13.0. Notice how everything is in focus from the foreground to the background. You can also purchase a *fish-eye* lens for your digital SLR. This type of lens is a wide-angle lens that has a 180-degree field of view.

If you like artistic or surreal images, you'll love the Lensbaby lens, at www.lensbabies. com. The Lensbaby 3G (see the second figure) is the newest iteration of the lens. The lens has a rubber bellows that connects the front and rear lens elements. It has a 50mm focal length, and you manually change apertures with a supplied tool. The aperture range is from f/2.0 to f/22. As with other lenses, when you choose a smaller aperture, the depth of field increases. With the Lensbaby, the size of the sweet spot of focus also increases when you use a smaller aperture. You manually focus the Lensbaby by pressing the outer ring closer to or farther from your camera's sensor. After focus has been achieved, you move the sweet spot of focus by tilting the lens plane. With the Lensbaby 3G, you can lock focus and then fine-tune it with another control. You may have to manually set the shutter speed depending on the model of

your camera. Using the lens is quite intuitive; with a little practice, you'll be taking artistic pictures in no time. The photo on the right was taken with Lensbaby and shows a koi pond at a hotel. The fish in the upper center of the image are in the sweet spot of focus. The rest of the image is a dreamy blur. The reflections of the hotel add to the surreal look of the image.

Part III
Working with Photos in Photoshop Elements

In this part . . .

After you fill up a memory card, you've got to do something with your photos. The obvious step is to download them to your computer. After you've accomplished that task, you have to figure out which photos you want to keep, and what to do with your keepers. The exercises in this part of the book show you how to download and organize your photos using Adobe Photoshop Elements 6.0. I also show you how to edit your images in Photoshop Elements. But wait, there's more. There are also exercises to retouch photos and add special effects. And you thought it was just point and shoot?

Chapter 9

Organizing Images

In This Chapter

▶ Getting images into your computer

▶ Sorting and rating images

▶ Archiving your photos

▶ Finding images

▶ Working with catalogs

Digital photography is a lot of fun. But unless you get the images out of your camera, you can't do much with them. Then after you've got the images in your computer, you've got to figure out a way to separate the wheat from the chaff. You know, you've got to banish from your hard drive the photos where your daughter closed her eyes and stuck out her tongue when you snapped the shutter. You can also make it easy to recognize the really great shots by rating them. Then there's the matter of organizing the several hundred — or thousand if you become a prolific shutterbug — photos. Come to think of it, that's pretty scary. If you've got a couple of years' worth of photos on your computer and your hard drive crashes . . . That's right, Virginia. You've got to back up your photos. The exercises in this chapter show you how to get the images into your computer and manage them after they're there.

Downloading Images to Your Computer

All digital cameras come with a means of connecting to your computer. At this point, computer software helps you with the download process, or you can take matters into your own hands and manually download images to the folder of your choice. The following exercise shows how to download images to your computer using Photoshop Elements 6.0 (Windows only).

Exercise 9-1: Downloading Images to Your Computer

1. **Connect your camera to your computer.**

Your camera ships with a cable that connects from your camera to the computer. The majority of cameras use a USB (Universal Serial Bus) connection. However, you can purchase a card reader for your camera media type. I recommend this option because it's faster and doesn't use your camera's resources. After you either connect your camera to the computer or insert camera media in a card reader attached to your computer, the Adobe Photoshop Elements 6.0 – Photo

Downloader dialog box appears (see Figure 9-1). You may also have alternative choices, depending on the software you have installed on your computer. These choices appear in a Windows dialog box. If this occurs, choose Adobe Photoshop Elements 6.0 – Photo Downloader.

Figure 9-1: Downloading photos to your computer.

2. **In the Import Settings section, accept the default download location (the My Pictures folder of your My Documents folder), or click the Browse button to navigate to and select a different folder.**

If you have more than one hard drive on your computer, it makes sense to store your images on the drive not used by your operating system, especially if you take lots of photos like I do. Windows needs a certain amount of empty hard drive space to function properly. If you use too much of your main hard drive for your photo collection, Windows won't function optimally. In fact, if you use too much of your hard drive, Windows can crash fatally and you'll have to hire an expert to put Humpty Dumpty back together again.

3. **By default, Photoshop Elements creates a subfolder with the date that the photo was shot in** yyyy mm dd **format. Accept the default option, or click the drop-down arrow to choose a different option.**

You can choose the day you download the photos as the folder name, choose a different format for the date the photo was shot, choose not to create a subfolder, or choose Custom Name. I recommend choosing Custom Name and giving the folder a unique name that you'll easily recognize.

4. **If you choose Custom Name, enter a folder name in the blank text field that appears.**

For example, you can name the folder with the name of the place where the photos were shot or the name of the event. If you shoot a lot of photos at the same location, append the name of the place with the date the photos were shot. For example, I shoot a lot of photos at a place I call No Name Lake. For photos that were shot on November 16, 2007, I call the folder NoNameLake_111607.

5. **Choose an option for renaming files.**

By default, Photoshop Elements doesn't rename the images and uses the camera filename. The camera *filename* is simply a group of letters followed by a number and the image file format extension. Click the drop-down arrow to choose a renaming option. You have several choices: the date you download the photos, the date the photos were shot, a custom name, a custom name combined with the date the photos were shot, or the subfolder name. If you choose the subfolder name, the new image name is appended with a number.

6. **If you choose Custom Name, type an image name in the blank text field that appears.**

 The custom name is appended with a number. For example, if the image name is NoNameLake and you're downloading JPEG images, the files will be renamed NoNameLake001.jpg, NoNameLake002.jpg, and so on.

7. **If desired, click the Preserve Current Filename in XMP.**

 All of the information about your images are stored in XMP *sidecar* files. These files contain all of the metadata about the photo such as the date the photo was taken, the type of camera used to take the photo, the focal length, and so on. If you preserve the current filename, the information is stored with the photo's XMP sidecar.

8. **Accept the default option to open the Organizer when the download is finished, or deselect the option.**

 If you accept the default option, the Photoshop Elements Organizer opens when the download finishes, which enables you to perform edits, sort and rate photos, and so on.

9. **Accept the default option to not delete the original files from your memory card when the download is complete, or choose another option from the drop-down menu.**

 I strongly urge you to accept the default option. You should always use the camera to format the memory card or delete photos. If a glitch occurs when the photos are downloaded and you tell Elements to delete the photos after download, you may end up losing a lot of precious photos.

10. **If desired, select the Automatic Download check box.**

 If you choose this option, Elements automatically downloads photos whenever you connect your camera to the computer or insert media in a card reader connected to the computer. However, If you choose this option, Elements names the images and downloads them into a folder specified in Preferences. I recommend taking the few extra seconds it takes to navigate the Photo Downloader dialog box to gain complete control over the download process.

11. **Click Get Photos.**

 Photoshop Elements begins downloading the images according to the choices you make in the Photo Downloader dialog box. Alternatively, you can click Advanced Dialog to expand the dialog box, as shown in Figure 9-2.

12. **If you choose the Advanced Dialog option, all photos on the card are selected by default.**

 You can choose the Uncheck All option and then select the photos you want to download. You also have the option to rotate photos to the right or left. The latter option is handy if you rotate the camera to a vertical position when taking pictures. You can use one of the rotate buttons on a selected thumbnail to have the images appear in the proper orientation when you view them in the Organizer.

13. **Choose the desired options in the Advanced Options section.**

 The options to open the organizer and automatically fix red-eye is selected by default. You also have the option to have Elements automatically suggest photo stacks and apply the custom name of the photos as a tag. (Tags and photo stacks are discussed in upcoming sections.)

Figure 9-2: Downloading photos using advanced options.

The option to automatically fix red-eye increases the amount of time it takes to download photos because Photoshop Elements checks each photo for red eyes, even when all of the photos were taken with natural light. Disable this option unless you know that the majority of the images on the card are photos of people shot with on-camera flash.

14. **Choose the desired options in the Apply Metadata section.**

You can enter your name as the author and add a copyright notice to the metadata of each photo that is downloaded. I do this for each photo I take, especially when I photograph a wedding for hire. In fact, I've had photo-processing firms refuse to print photographs until I gave the client written permission to print them. The processing company was able to detect my copyright information by viewing the image metadata.

15. **Click Get Photos.**

Photoshop Elements downloads the images to your computer. If you're downloading a large card, this may take some time. The Copying dialog box appears while images are being downloaded. The dialog box shows a progress bar, the percentage completed, and a thumbnail of the image being downloaded. After the images have downloaded to your computer, the Photoshop Elements Organizer opens (if you accepted the default option) and you can begin organizing the downloaded photos and others in your catalog.

If you downloaded photos to your computer before purchasing Photoshop Elements, you can add them to the Organizer by opening Windows Explorer and then dragging the folder directly into the Organizer.

Sorting, Rating, and Tagging Images

The Photoshop Elements Organizer is your way of bringing order to potential chaos. In the old days, casual and amateur photographers kept their best images in albums and filed the negatives and other photos in — pick the category that applies to you — shoeboxes, desk drawers, closets, coffee table drawers, and so on. Then when it came time to order a reprint for a relative, you had to sift through the envelopes the photo lab gave you to find the image that you wanted to enlarge. Not a fun prospect if you're not organized. Fortunately, you can get very organized with the Organizer. Sometimes, there is truth in advertising. If you do a few simple things to stay organized after you download images to your computer, you'll be able to quickly find images in the future. The following exercise is your first line of defense in organizing images on your computer.

Exercise 9-2: Sorting, Rating, and Tagging Images

1. **After you download a memory card of images to your computer, they are displayed in the Organizer.**

This display occurs if you accept the default option to open the Organizer after you download the images. I suggest you get in the habit of organizing your images immediately after you download them. This saves you a lot of work down the road. Can you imagine trying to sort through several hundred photos? The default view of the Organizer, which is also known as the Photo Browser, displays the images as thumbnails (see Figure 9-3).

After you download a memory card to your computer, a message appears and tells you that the thumbnails are the images you just downloaded. If you want to see the entire catalog, click Show All. You can prevent this message from showing up in the future by clicking the appropriate check box.

2. **Drag the thumbnail size slider to the right to increase the size of the thumbnails.**

When you increase the size of the thumbnails, it's easier to see the images you've just downloaded. This makes it easier to pick your favorites and delete the images that are out of focus, poorly composed, and so on. I like to view a single image at a time. Therefore, I drag the thumbnail slider until only one image appears in the Organizer. Alternatively, you can double-click a thumbnail to display one thumbnail at a time in the Organizer.

3. **Press the right-arrow key to navigate through the downloaded images.**

Alternatively, you can drag the scroll bar to the right of the image. As you look at each image, decide how the image ranks on a scale of 1 to 5.

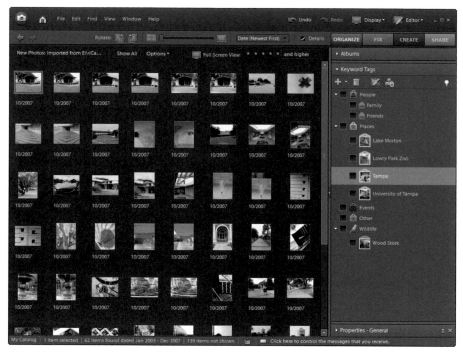

Figure 9-3: The Organizer is a digital photographer's best friend.

4. **Rate each image.**

 You can rate the image by clicking one of the stars in the lower-left corner of the workspace. Or if you prefer, you can simply press the applicable number from your computer keyboard. When I review images, I generally make three passes. On the first pass, I assign the images I want to keep a rating of 3 (see Figure 9-4). When I make the second pass, I use the rating filter to display images with 3 stars or higher. To filter images, click the desired star number on the rating filter, and only images with that rating or higher are displayed. On the second pass, I assign the better images a 4-star rating and then use the rating filter to display 4-star-rated images and higher. On the last pass, I assign a 5-star rating to the best of the lot. These are the images I process and print. I use the 3- and 4-star images for collages and montages.

5. **Press Delete to remove any images that you don't want to keep.**

 Delete the images that are out of focus or poorly composed, or those you just don't like. When you delete an image, a dialog box appears asking you to confirm deletion from the catalog. You can also select a check box that removes the image from your hard drive at the same time (see Figure 9-5).

6. **Continue rating images.**

 Making three passes may seem like a lot of work. Remember that you can also use these ratings later when you're searching through a catalog to find images to e-mail to friends, create photo albums, and so on. The ability to quickly find your 5-star images winds up saving you a lot of time.

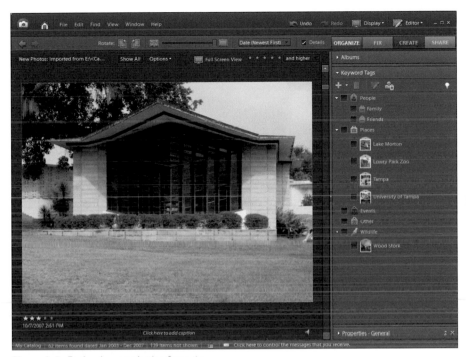

Figure 9-4: Rating images in the Organizer.

If any of the photos is not properly oriented, click the Rotate Left or Rotate Right icon.

7. **After rating the images, decrease the size of the thumbnails so that you can see multiple images.**

Now you're going to add tags to the images. Tags are metadata that can be used when searching images.

You can further organize your images by selecting similar images and then choosing Edit➪Stack➪Stack Selected Photos. After you invoke the command, Photoshop Elements shows the stack as a single thumbnail with an icon that looks like

Figure 9-5: Deleting images from a catalog and hard drive.

blue playing cards in — you guessed it — a stack. You can click the arrow to the right of the icon to display thumbnails of all images in the stack. When you're done working with the images in the stack, click the arrow to the right of the last image to restack the images.

8. **Click the Keyword Tags drop-down arrow to display the Keyword Tags panel.**

9. **Select the category that best describes the type of keyword you're going to create.**

If you're creating a tag for a photo of a person, click People. You can fine-tune the keyword by clicking a subcategory such as Family or Friends.

10. **Click the down arrow next to the green plus sign and choose an option.**

The Keyword Tags drop-down menu appears (see Figure 9-6). From this menu you can create a new keyword, a subcategory for the selected category, or a new category.

11. **To create a new keyword tag, select New Keyword Tag from the drop-down menu, or click the green plus sign. Alternatively, you can use the keyboard shortcut, Ctrl+N.**

Figure 9-6: Tag, you're it!

The Create Keyword Tag dialog box appears (see Figure 9-7).

If you choose the wrong category for your keyword, choose the desired category from the Category drop-down menu.

12. **Enter the desired keyword in the Name text box.**

Choose a keyword that makes sense to you. You don't have to add everything about the place or thing to the keyword. You can apply multiple tags to a photo. For example, you might apply one tag that is the name of the actual place, another that is the town in which the place can be found, and another for the state. For example, when I apply keyword tags to a photo shot at the University of Tampa, I apply three keyword tags: University of Tampa, Tampa, and Florida.

13. **You can also map the photo on Yahoo's mapping service by clicking Place On Map.**

This step opens the Keyword Tag Location on Map dialog box (see Figure 9-8). This option is useful if you plan to upload the photo to Panoramio, which lets you map the photo on Google Earth (see Chapter 14).

14. **Enter the address in the text field and then click Find.**

This opens the Look Up Address dialog box.

Figure 9-7: Keywords help you organize and find photos.

Figure 9-8: A keyword in search of a location.

15. **Click OK.**

The latitude and longitude of the place are added to the keyword metadata.

16. **If desired, add some comments to the Note field.**

This is optional. Think of a note as a digital piece of string around your finger. It can help you remember information about the photos associated with the tag.

To create tags for friends and family, select a group of photos, and then choose Find⇨Find Faces for Tagging. After invoking the command, the Organizer searches for faces in the selected photos. The faces appear in a new window with a miniature version of the Keyword Tags panel. From within the window, you can create tags for the photos and apply them to the applicable photos.

17. **Click OK to create the tag.**

The keyword tag is added to the Keyword Tags panel.

18. **Select the photo to which you want to apply the tag.**

You can also select multiple photos and apply the same tag to all.

19. **Drag the tag from the Keyword Tags panel and drop it on the images.**

The keyword is applied to the images. Figure 9-9 shows images from a memory card that have been sorted and tagged. Notice the yellow tag icon in the right-hand corner of each thumbnail. Pause your cursor over the icon and you'll see the keywords that have been applied to the image.

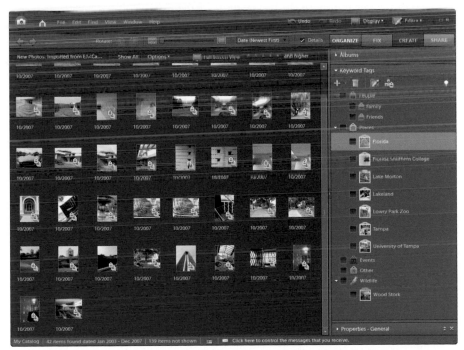

Figure 9-9: Inspected, rated, tagged, signed, sealed, and delivered: They're your images.

Viewing Properties, Renaming, and Captioning Images

Every digital picture you take is stamped with metadata. Your camera does this for you free of charge. You can add additional metadata when you create tags. Metadata tells you everything you ever wanted to know about an image and more; information such as the camera model used to take the picture, the focal length of the lens, f/stop, whether the flash fired correctly, and the date the photo was taken. You can summon this information by viewing a photo's properties. The following exercise shows you how to mine metadata from a photo's properties and more.

Exercise 9-3: Examining a Photo's Properties

1. **Select a photo in the Organizer.**

 You can only view properties for one image at a time.

2. **Choose Window⇨Properties.**

 The Properties panel appears (see Figure 9-10). Notice that the following is listed: the name of the image, the rating you gave the image, the file size and dimensions of the image, the date and time the image was photographed, and its location on your computer.

 The camera automatically adds the date and time the picture was taken to the metadata. There's no need for you to use a camera menu command to stamp the date and time over the top of the picture. If you later forget when you took the picture, you can always find out when the photo was taken by examining the image's properties.

3. **If desired, type a caption for the image in the Caption field.**

 You can search for photos by the information in this field. You can also use a caption when creating items such as calendars.

4. **If desired, type information in the Notes field.**

 You can add anything you want here and it's added to the metadata. You can also search for an image based on the information you enter.

5. **If desired, type a different name in the Name field.**

 You can even overwrite the image extension. Elements remembers the extension and it appears the next time you check the image's properties.

 You can also rename a photo by selecting its thumbnail and choosing File⇨Rename.

Figure 9-10: Properties that are not listed with your local Realtor.

6. **Click the Metadata icon that looks like a blue circle with an information symbol.**

The Properties panel refreshes and displays the camera EXIF (Exchangeable Image File Format) metadata (see Figure 9-11). The EXIF data tells you the make and model of the camera used to take the picture, the ISO rating, shutter speed and f/stop, focal length, and whether the flash fired.

7. **Click the Keyword Tags icon.**

All the tags you apply to the image are displayed (see Figure 9-12).

Figure 9-11: Everything you wanted to know about the image but were afraid to ask.

Figure 9-12: Holy metadata, Batman! This image has been tagged.

8. **Click the History icon.**

The Properties panel refreshes and displays the date the image was created or modified, the date it was imported into Elements, the device it was imported from, and the name of the drive on which the image is stored.

Archiving Your Images

After you download a memory card full of images to your computer, you may be tempted to erase the card. To paraphrase Marvin Gaye: Baby, don't you do it, don't erase that card — at least not until you've backed your images up to an external device. Disaster can strike your computer at any moment. The hard drive on which you store your images spins at a dizzying rate of 5500 RPM (revolutions per minute) or faster. The new hard drives may be masters of going faster, but they still break, and often when you least expect or can afford it. To avoid losing your precious images, you should back them up immediately after taking care of your housekeeping chores such as sorting, rating, and tagging. The following exercise shows you how to archive your images.

Exercise 9-4: Archiving Your Images

1. **Enable the device to which you are going to archive your images.**

If you're archiving them on an external hard drive, connect the drive to your system. If you're backing up the images to a CD or DVD, insert blank media in your CD/RW or DVD/RW drive.

2. **Select all of the images you just downloaded to your computer.**

 Click the first image and then Shift+click the last image to select the entire group at once.

3. **Choose File⇨Copy/Move to Removable Disk.**

 The Copy/Move to Removable Disk Options dialog box appears (see Figure 9-13). From this dialog box, you can also move files to a different drive. If you choose this option, a preview of the image appears in the Organizer. If you attempt to edit the file, you are prompted to connect the external device to which you moved the file. You also have the option to include all files that are located within stacks in the selection.

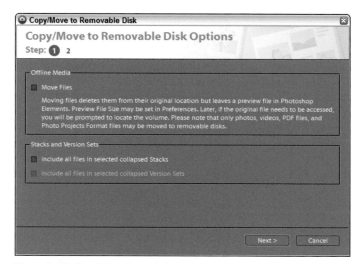

Figure 9-13: Copying selected photos to a removable disk.

4. **Click Next.**

 The dialog box refreshes and displays all external devices connected to your system.

5. **Select the device to which you are going to copy the images.**

 The size and estimated time to copy the images are displayed.

6. **Accept the default name for the backup, or type a different name in the Name field (see Figure 9-14).**

7. **Click Done.**

 Photoshop Elements copies the files to the specified destination.

When your photo collection reaches several hundred images, consider investing in backup software, like SynchBackSE (`http://2brightsparks.com/syncback/sbse-features.html`), and storing your backup on a large external hard drive. If you store all your images in one master folder, your first backup will contain the entire contents of the folder. This backup is stored as a task. When you add, delete, modify, or

make copies of images, run the application and choose the task for backing up your image folder. SynchBackSE compares the files on your hard drive to those on your external hard drive and then copies or deletes files to ensure that the two devices are synchronized — hence, the name of the application.

Figure 9-14: Naming the backup.

Finding Images

The beauty of digital photography is that you can take lots of pictures without buying film or paying for processing. The downfall of digital photography is that you have lots of pictures on your hard drive, and trying to find one is like looking for a needle in a haystack. That is, of course, unless you have the foresight to tag your images when you download them and harness the tools of the Organizer. The following exercise explores the many ways you can find images you've cataloged in the Organizer.

Exercise 9-5: Finding Images in the Organizer

1. **Launch the Organizer.**

The easiest way to open the Organizer is to click the Photoshop Elements desktop shortcut icon and then click the Organize icon.

2. **Choose Window⇨Timeline.**

A timeline appears at the top of the Organizer (see Figure 9-15). The timeline has blue rectangles that indicate the approximate number of photos taken during that month. A tall rectangle means you were very prolific during a month, and a short rectangle means you were busy doing other things, like trying to figure out what to do with your old film camera now that you're an expert at digital photography.

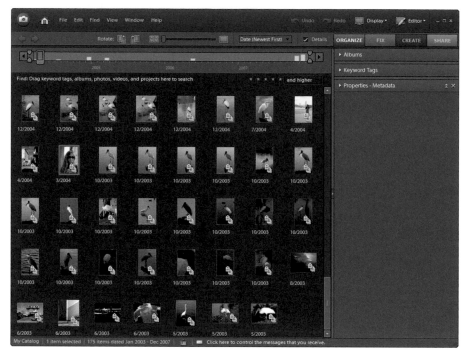

Figure 9-15: Using the Elements timeline to find photos.

3. **Drag the slider over a rectangle.**

 All photos taken during that month are displayed. That's one way to find photos, but there are more precise ways. Next step, please.

4. **Click the Keyword Tags drop-down arrow.**

 The Keywords panel opens.

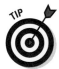

 If you have photos in your collection that are not tagged, choose Find➪Untagged Items. After the Organizer displays the untagged photos, you can apply the desired tags, which enables you to locate the photos in the future by their tags.

5. **Click the empty box to the left of the desired keyword tag icon.**

 All photos to which the tag has been applied are displayed in the Organizer. You can search for photos that have more than one tag by clicking more than one box (see Figure 9-16).

6. **Click Display and choose Date View.**

 The Organizer refreshes and displays a calendar of the earliest year in which photos in your catalog were photographed. Each date that contains photos is highlighted in blue. Click the date to display the first picture taken on that date in the preview window (see Figure 9-17).

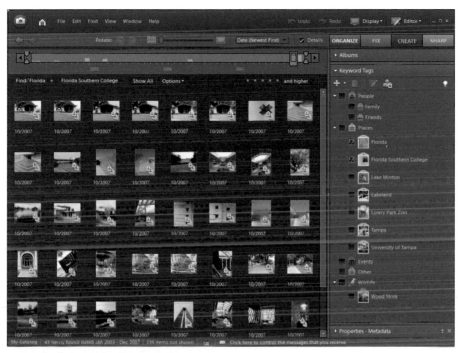

Figure 9-16: Searching for photos by their tags.

Figure 9-17: Displaying photos taken during a specific year.

7. **Click the Play Arrow button to start a slide show of images photographed on the selected date.**

 Alternatively, you can click the Next and Previous arrows to navigate through the pictures you took on the selected date.

8. **Click the Next or Previous arrows to navigate from year to year.**

9. **Click Month.**

 The Organizer refreshes and displays the selected month. A thumbnail of one image taken on a specific date is displayed. Click a date to display the first photo in the Preview window.

10. **Click the Play Arrow button to start a slide show of images photographed on the selected date.**

 Alternatively, you can click the Next and Previous arrows to navigate through the pictures you took on the selected date. The slide show plays in the upper-right corner of the calendar.

11. **Click the Next or Previous arrows to navigate from month to month.**

12. **Click Day.**

 The Organizer refreshes and displays all photos taken on the selected day.

13. **Click the Play arrow to start a slide show of images photographed on the selected day.**

 Alternatively, you can click the Next and Previous arrows to navigate through the pictures you took on the selected day. You can also use the scroll bar to the right of the vertical filmstrip to the right of the photo.

 Click the binoculars icon to find the photo in the Photo Browser.

14. **Click Photo Browser to return to the Photo Browser view of your catalog.**

 The Organizer refreshes and displays all of the photos in your catalog.

But wait, there's more. The techniques in the previous exercise are great for finding photos that you know have specific keyword tags or were taken on a specific date. But what do you do when you want to assemble a group of photos for a calendar or to create a Web gallery? The next exercise introduces you to the power of keyword tags, rating, and so on when you're looking for specific photos.

Exercise 9-6: Performing a Power Search by Metadata in the Organizer

1. **Launch the Organizer.**

 To open the Organizer, click the Photoshop Elements desktop shortcut icon, and then click the Organize icon.

2. **Click Find.**

 The different options for finding images in the Organizer are displayed (see Figure 9-18). As you can see, there is a myriad of ways to find your proverbial needle in the haystack.

3. **Choose the Find By Details (Metadata) command.**

 The Find By Details (Metadata) dialog box appears. The default search options use keyword tags and ratings. The minus and plus signs are used to delete or add criteria to the search. By clicking the applicable radio button, you can choose whether Organizer finds files that match *any* of the first criteria and following criteria or the first criteria *and* the following criteria. If you choose the second option, Organizer returns files that match all search criteria.

4. **Click the currently selected keyword tag.**

 A drop-down menu appears with all the keyword tags you've assigned to photos.

5. **Choose the desired keyword.**

Figure 9-18: Yikes. Which Find command do I want today?

 The second default search criterion is rating. If you haven't rated your photos, click the minus sign to delete this criterion from the search. Alternatively, you can change the star rating and change the search method from *is higher than* to *is*, *is not*, or *is lower than*.

6. **To add additional criteria to the search, click the plus button to the right of the last currently selected criterion.**

 The Organizer adds another criterion to the search parameters. The default parameter is Filename. However, if you click the parameter, a drop-down menu appears showing the other criteria you can use for a search (see Figure 9-19). As you can see, you can fine-tune a search to find exactly what you want. As you develop your photography skills, you'll have a lot of photos in your collection. You may end up buying a new camera or a second camera, and the camera make and model just happen to be search criteria. Searching by metadata will be a valuable ally when your photo collection reaches thousands of images.

Figure 9-19: Changing a search parameter.

7. **After choosing criteria for your search, click Search.**

Photoshop Elements searches through your catalog and displays thumbnails of the images that match your search criteria. After performing a search, you can organize the photos into an album, which is the subject of the next exercise.

Perform several searches by metadata. Instead of using the default parameter of keywords for your first criterion, choose a different parameter from the drop-down menu. When you're done exploring the different parameters, try some of the other commands from the Find menu group.

Organizing Your Photos into Albums

Think of your photo catalog as the Big Kahuna. It has every photo you ever downloaded or imported into the Organizer. If you worked through the previous exercise — and if you didn't, I know who you are — you know it's relatively easy to find what you want with a search by metadata. After you've searched for photos that match specific criteria, you can create an album of the photos. For example, you can create an album of your favorite landscapes and use them as the basis for a book or calendar. By default, the Organizer creates an album that includes all photos you've downloaded or imported in the last six months. The following exercise shows you how to create additional albums.

Exercise 9-7: Creating an Album of Photos

1. **Launch the Organizer.**

Click the Photoshop Elements desktop icon and then click the Organize icon from the splash screen.

2. **Click the Albums drop-down arrow.**

The Albums panel expands.

3. **Click the plus sign and then choose New Smart Album from the drop-down menu.**

The New Smart Album dialog box appears (see Figure 9-20). This dialog box may look similar to the Search By Details (Metadata) dialog box. Well, that's because it is.

New Smart Album

Search for all files that match the criteria entered below and save them as Smart Album. Smart Albums are albums that automatically collect files that match the criteria defined below. Use the Add button to enter additional criteria, and the Minus button to remove criteria.

Name: |

Search Criteria

Search for files which matches: ○ Any one of the following search criteria[OR]

○ All of the following search criteria[AND]

Filename ▼ | Is ▼ | | +

Photo's filename and/or file extension

OK Cancel

Figure 9-20: Creating a new album.

4. **Accept the default criteria (Filename), or click Filename and choose an option from the drop-down list.**

 You can use any photo metadata to create an album. You can change the default criteria from a filename to any metadata. Remember, you can add additional criteria to the Smart Album search by clicking the plus sign and then choosing the desired parameter.

5. **After selecting the criteria for your album, click OK.**

 The Organizer searches your catalog for images that match your search criteria. When the search concludes, the images are displayed in the Organizer and the album listing appears in the Albums panel. Figure 9-21 shows an album created with photos that matched my search criteria of various keywords associated with images I photographed at automobile races.

You can create a blank album (Albums⇨New Album) and then drop the desired photos from the Organizer into the album.

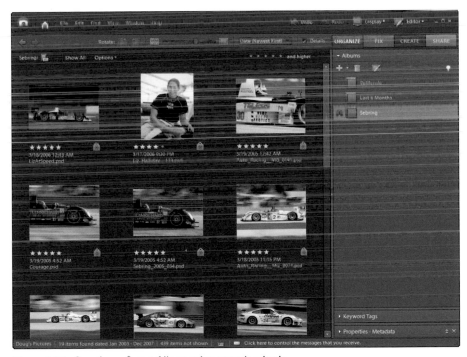

Figure 9-21: Creating a Smart Album using search criteria.

Working with Catalogs

When you download or import photographs into the Organizer, they are stored in a catalog. Many users use the default catalog for all their photos. However, if you have thousands of photos that encompass different subject matter, you may want to consider creating multiple catalogs. This is also a good option if you have more than one photographer in the family. You can create a catalog for each family member, which enables you to keep your classic car pictures separate from her pictures of flowers and hummingbirds. The following exercise shows you the options you have available with catalogs.

Exercise 9-8: Working with Catalogs

1. **Launch the Organizer.**

You can also launch the Organizer by choosing Start➪Programs➪Adobe Photoshop Elements 6.0 and then clicking the Organize icon from the splash screen.

2. **Choose File➪Catalog.**

The Catalog Manager dialog box appears (see Figure 9-22).

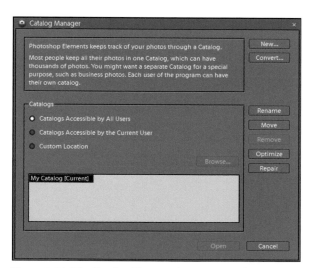

Figure 9-22: The Catalog Manager is at your service to whip things into shape.

3. **To modify your current catalog, select it and then choose one of the following options:**

- *Move:* Opens the Move Catalog dialog box. This gives you the option to change catalog accessibility to the current user.

- *Optimize:* Optimizes the selected catalog.

- *Repair:* Checks the selected catalog for errors and gives you the option to repair the catalog and reindex data that is visually similar.

- *Rename:* Opens the Enter the New Catalog Name dialog box, which has a blank text field into which you enter the desired catalog name. Click OK to rename the catalog.

- *Convert:* Enables you to convert a catalog created by a previous version of Photoshop Elements for the Photoshop Elements 6.0 version of the Organizer.

4. **To create a new catalog, click New.**

This opens the Enter a Name for the New Catalog dialog box. After typing the desired name in the blank text field, click OK to create the new catalog. After creating a new catalog, you can download or import photos to the catalog. To access your other catalogs, choose File⇨Catalog and then choose the desired catalog from the list in the Catalog Manager dialog box.

If you follow my advice and create copies of your photos on removable drives, CDs, or DVDs, you can re-create your catalog if disaster strikes and your computer hard drive grinds to a halt. However, you'll have to start from scratch and add keyword tags, rate photos, create albums, and so on. In other words, it's a lot of work. Your best bet is to back up your catalog(s) on a regular basis. That way, when disaster strikes, you can recover the catalog. The following exercise shows you how to back up a catalog.

Exercise 9-9: Backing Up Your Catalog

1. **Launch the Organizer.**

Choose Start⇨Programs⇨Adobe Photoshop Elements 6.0, and then click the Organize icon from the splash screen. Alternatively, you can click the Photoshop Element desktop shortcut and then click the Organize icon from the splash screen.

2. **Connect the removable drive to which you are backing up the catalog**

You can back your catalog up to an external hard drive, a CD, or a DVD. If you decide to back up the catalog to CD or DVD, insert a blank disc in your CD or DVD RW drive.

3. **Choose File⇨Backup Catalog to CD, DVD, or Hard Drive.**

The Backup Catalog to CD, DVD, or Hard Drive dialog box appears.

4. **Choose the desired option.**

If you're backing up the catalog for the first time, choose Full Backup. If you've already made a backup and want to update it with new and modified files, choose Incremental Backup.

5. **Click Next.**

The Destination Settings section of the dialog box appears (see Figure 9-23).

6. **Choose the destination drive.**

The available drives are listed in the dialog box along with the estimated time to accomplish the task. You also have the option to back up the catalog to a drive on your computer. However, such a backup is absolutely useless if the system hard drive crashes. Your best bet is to back up the catalog to an external hard drive or a DVD. If your catalog is less than 8GB, backing up to multiple DVDs is feasible. When your collection grows, your best bet is to back up to an external hard drive. My main collection of images is on another computer, and is approximately 250GB. An external hard drive is the only logical choice in a scenario like this.

Figure 9-23: You get to tell the backup where to go.

7. **Click Done.**

A dialog box appears that notes the percentage of the catalog that has been backed up. If you're using media like CD or DVD discs that will not store the entire catalog, you're prompted to insert a blank disc when necessary.

Chapter 10

Processing Images

· ·

In This Chapter

▶ Processing RAW images

▶ Cropping, rotating, and resizing photos

▶ Fixing underexposed and overexposed images

▶ Color-correcting images

▶ Printing images

· ·

*A*fter you download your images to your computer, the real fun begins. You get to edit your photos to pixel perfection and then share them with friends and relatives. If your camera didn't do its job properly, you may have to color-correct images, adjust the contrast, or tinker some more to get the image looking the way you want it. If you've got a photo-realistic inkjet printer, you can create prints suitable for framing and sharing with your relatives. The journey from snapping the picture to printing a great image is a long and winding road. The exercises in this chapter are designed to shorten and straighten the path.

To use the images created for the exercises in this chapter, download 259337ch10.zip from this book's companion Web site.

Processing RAW Images

Many photographers shy away from shooting images in their camera's RAW mode because they think it's too much work to process the images after shooting them. Shooting in RAW format does involve extra work, but the rewards are worth it. When you take pictures in your camera's RAW mode, you work with the data captured by your camera sensor. When you process a RAW image, you can modify the exposure, change white balance, change the brightness, and much more. In Photoshop Elements 6.0, you process RAW images using the Camera Raw application, which, as of this writing, is at Version 4.2. Adobe constantly updates Camera Raw when new cameras are introduced. If you've processed images using your camera manufacturer's RAW editing utility, you'll find that you have more control when using Adobe's Camera Raw. An added bonus is a slider called Vibrance, which makes the colors in your photo pop. If you have been taking pictures using your camera's RAW format, the following exercise introduces you to all of the options in Adobe's Camera Raw, which is part of Photoshop Elements. If you've never used your camera's RAW format, use the image I've included in this chapter's exercise files on the companion Web site and follow along with this exercise.

Exercise 10-1: Processing RAW Images

1. **Launch the Editor.**

 The easiest way to launch the Editor is to click the Photoshop Elements desktop icon and then click Edit. This opens the Edit Workspace.

2. **Choose File⇨Open.**

 This displays the Open dialog box.

3. **Navigate to the file ch10_01.cr2, select it, and then click Open.**

 This opens the Camera Raw dialog box (see Figure 10-1). The image you've opened is a high-resolution image captured with a Canon EOS 5D. Notice the histogram in the upper-right corner of the dialog box. The spikes at each end of the graph indicate that there are pixels that are clipped in the highlight and shadows. When a pixel is *clipped,* detail is missing in one or more color channels. For example, if you have a photo with a large area of puffy white clouds and you see a spike on the right side of the histogram, chances are you've lost a lot of detail in the cloud area of your photo, which appears as solid white. The area of the dialog box under the histogram tells you the focal length, shutter speed, f/stop, and ISO used to capture the image.

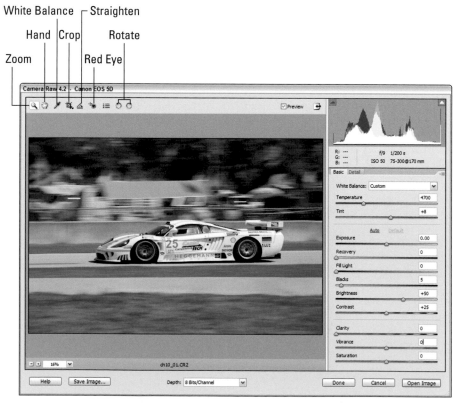

Figure 10-1: Processing a RAW image.

4. **Click Auto.**

 This option processes the image automatically. In many cases, the results are perfect. However, when they're not, you must manually process the image using the sliders in the Camera Raw dialog box.

5. **Click Default.**

 These are the default settings for the camera used to capture the picture.

6. **To adjust the white balance, choose a setting from the White Balance drop-down menu.**

 The default option, As Shot, is how your camera interpreted the white balance for the scene. The other options are the standard settings: Daylight, Cloudy, Shade, Tungsten, Fluorescent, or Flash. You can also manually modify the white balance settings by dragging the Temperature slider. Drag the slider to the right to warm the image (add red tones), or left to cool the image (add blue tones). Drag the Tint slider right to add a Magenta tint to the image, or left to add a Green tint to the image. White balance is highly subjective. You can either drag the sliders until you see something you like to create a Custom white balance or choose Auto to set the white balance automatically.

 Select the White Balance tool and click an area inside the image that you know should be a neutral gray. If the first click doesn't set the white balance to your liking, click different areas until you get a result you like. You can also click on an area that's supposed to be pure white. However, if you click on something that's a very bright white, an error message appears, telling you to select a different area of the image.

7. **Drag the Exposure slider to the right to increase the exposure, or to the left to decrease the exposure.**

 Hold the Alt key while dragging the slider, and a black overlay appears across the Preview window (see Figure 10-2). When you see a color, it means that highlights are clipped in that channel. For example, if you see red, the indicated pixels in the channel are clipped. If you see a color other than red, green, or blue, the color is highlights are clipped in two channels. If you see white, the highlights are clipped in all channels. If the image isn't too far out of whack, you can correct clipped highlights by dragging the Exposure slider left, or fix clipped shadows by dragging the Black slider right. The Recovery slider can also be used to recover clipped highlights.

8. **Drag the Recovery slider to the right.**

 The Recovery setting is used to recover clipped highlights. Hold the Alt key while dragging, and a black overlay appears in the Preview window. When you see a color, pixels are clipped in that channel. Drag the slider until the colors disappear. This setting does a good job of recovering clipped highlights. However, if you've got large areas of a photo with highlights that are clipped to pure white, you won't get satisfactory results. The best defense against clipped highlights is to properly expose the photo in the first place. The Recovery slider is not designed to fix a poorly exposed photo.

9. **Drag the Fill Light slider to the right.**

 This slider brightens the shadow areas of the image. It is useful when you're processing a picture of a backlit subject. However, if you add too much fill light, the image will appear milky and washed out. If you keep this setting at 20 or less, you'll get good results.

Figure 10-2: Adjusting the exposure.

10. **Drag the Blacks slider to set the shadow areas of the image.**

Your camera has a default setting for shadows. Drag the slider to the right to darken the shadow areas, or to the left to brighten them. Hold the Alt key while dragging the slider, and a white overlay appears on the image. A color indicates that details in the shadow area of that channel are clipped. Pure black indicates that all channels are clipped (see Figure 10-3).

11. **Drag the Brightness slider to adjust image brightness.**

Drag right to brighten the image, or left to darken it.

12. **Drag the Contrast slider to adjust image contrast.**

Drag the slider right to increase contrast, or left to decrease contrast.

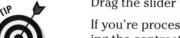

If you're processing an image that has detail clipped in the shadow areas, decreasing the contrast helps recover detail.

13. **Drag the Clarity slider to the right.**

This setting detects edges and effectively sharpens the image. This setting can help you recover a slightly out-of-focus picture. If your picture is in focus, increasing this setting reveals more detail, and as the name implies, increases the clarity of the photo.

14. **Drag the Vibrance slider to the right.**

This makes the colors in the image more vibrant. If you ever used slide film like Fuji Velvia, you'll like the results you get by increasing the vibrance. If you drag the slider left, it's the equivalent of desaturating the image to grayscale. Only the most vibrant colors still appear when you drag the slider all the way to the left.

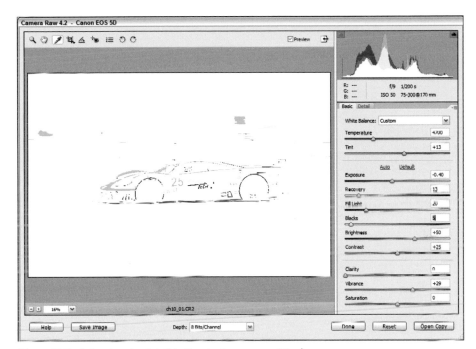

Figure 10-3: Adjusting the detail in the shadow areas of the image.

15. **Adjust the Saturation settings for the image.**

Drag the slider right to saturate image colors, or to the left to desaturate image colors. Don't go overboard with this setting. If you increase saturation too much, you'll induce colors that are out of gamut for many printers. When a color is *out of gamut*, it can't be printed properly and detail is lost. If you decrease saturation, you end up with a grayscale version of the image. However, there are commands in Photoshop Elements that will give you a much better grayscale (black and white) photo. I advise doing the majority of your color work with the Vibrance setting and, if desired, you can then slightly increase saturation.

16. **Click the Crop tool, and then click and drag inside the image to crop to a specific area of the image.**

By default, you can crop to any area of the image that you want. This poses problems, however, if you're going to print the image on a specific paper size. Click the drop-down list and choose an aspect ratio from the list. For example, if you're printing the image on 10-x-8 paper, choose the 4 to 5 option. Alternatively, you can click Custom and specify your own crop ratio or specify the crop size in inches. You can adjust the position of the crop rectangle by clicking inside it and then dragging to the desired position. You can adjust the size of the crop rectangle by dragging one of the corner handles.

17. **Select the Straighten tool.**

This tool is useful when the photo is not straight. Drag the tool along an edge that you know should be straight, and Camera Raw adjusts the crop rectangle to straighten the image. Figure 10-4 shows an image that has been cropped and straightened.

Figure 10-4: Straightening and cropping a RAW file.

You can also remove red-eye when processing a RAW image by clicking the Red Eye tool. When you select the tool, settings for Pupil and Darken appear. Adjust the settings and then click the subject's pupil to remove red-eye.

Click the Zoom tool and then click inside the Preview window to zoom to the next highest level of magnification. You can also click and drag around an area you want to examine in detail. Alternatively, you can choose a setting from the Select Zoom Level window in the lower left corner of the dialog box, press Ctrl++ (hold down the Ctrl key while pressing the plus sign) to zoom in to the next level of magnification, or press Ctrl+– (hold down the Ctrl key while pressing the minus sign) to zoom out.

18. **Click the Detail tab.**

The dialog box refreshes to show sharpening and noise reduction options (see Figure 10-5).

19. **Adjust the image sharpness.**

When you adjust image sharpness, first zoom to 100 percent (Ctrl+Alt+0) and examine an area with a well-defined edge. Drag the Amount slider right to increase sharpening, or left to decrease. Drag the Radius slider to determine the distance from each detected edge to which sharpening is applied. When you apply high levels of sharpening to an image, halos can appear around edges. The Detail setting suppresses halos. As you drag the slider to the right, sharpening is applied to smaller details, which may cause halos. If you leave the Detail setting at its default setting of 0 (zero), you'll be able to apply a larger sharpening value. The Masking value applies a mask to the image to determine which areas are sharpened. At its default value of 0 (zero), no mask is applied and sharpening is applied to the entire

image. When you drag the slider to the right, a mask is applied to the image and more areas are protected. To see the results of any sharpening control, hold down the Alt key while dragging the slider to display an overlay. Note that you must view the image at a magnification value of 100 percent or greater to see the overlay.

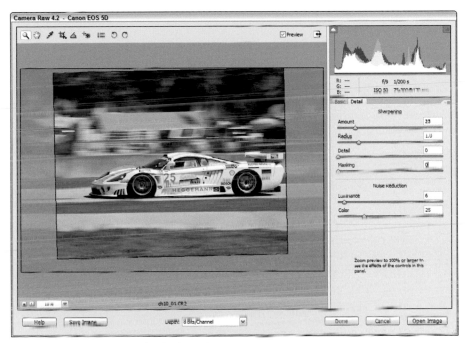

Figure 10-5. Sharpening and reducing noise.

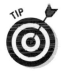

If you're sharpening an image that has large shadow areas, or large areas of solid color, such as a blue sky, hold down the Alt key and drag the slider until these areas become solid black. This indicates that no sharpening will be applied to these areas, which is typically where digital noise is most prevalent. After all, you don't want to sharpen noise.

20. **Adjust the noise-reduction settings.**

Drag the Luminance slider to the right to remove noise that looks like grain. Drag the Color slider to the right to remove noise that appears as colored specks in the image. Note that when you increase these settings, you lose some detail in the image. Zoom to 100 percent and then use the Hand tool to pan to a dark area of the image.

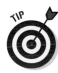

Press the spacebar to momentarily switch to the Hand tool. Release the spacebar to revert to the previously used tool.

21. **After processing the image, choose one of the following options:**

- *Done:* Click this button to save the settings you've applied to the image, but not perform any further editing in Photoshop Elements. The settings are saved in an .xmp sidecar file. When you next open the image in Camera Raw, all of the settings are applied to the image.

- *Cancel:* Click this button to revert to the previous settings.

- *Open Image:* Click this button to edit the image in Photoshop Elements.

- *Save Image:* Click this button to save the file as a DNG (digital negative) file. This file format is Adobe's answer to an open platform RAW file. If your camera's RAW format should ever become obsolete or the camera manufacturer stops supporting the format, you can use the DNG file in its place. Many photographers archive all of their RAW files as Adobe DNG files.

Experiment with different values for the Camera Raw settings to see the effect they have on an image. At first, the Camera Raw dialog box may seem a bit daunting. However, when you become familiar with the controls and their effects on an image, you can quickly process Camera Raw files.

Editing Images in Quick Fix Mode

When you're pressed for time but you want immediate gratification, you can edit images using the Quick Fix mode. In this mode, you can automatically fix a number of woes that are common to digital photographs. If you don't like the automatic settings, you can modify them to suit your personal taste. The following exercise explores the Quick Fixes you can apply to your images.

Exercise 10-2: Editing Images in Quick Fix Mode

1. **Launch the Organizer and then choose the image you want to edit.**

Remember, you can find the desired image by doing a search as outlined in Chapter 9.

2. **Click Fix.**

The Organizer refreshes to show the options you have for editing an image. Figure 10-6 shows a selected image at the maximum thumbnail size. Notice that there are options for automatic options (Auto Smart Fix, Auto Color, Auto Levels, for example) for fixing the photo within the Organizer. However, you have no options to change the settings. It's either the auto fix or no fix.

3. **Click Quick Fix.**

The Editor launches showing the Quick Fix Options. You can apply any or all of these fixes to an image.

4. **Choose an option from the View menu.**

I find it helpful to use the before-and-after mode (see Figure 10-7).

5. **Click the Auto button in the Smart Fix section.**

Photoshop Elements applies general corrections for color balance and enhances shadows and highlights if needed.

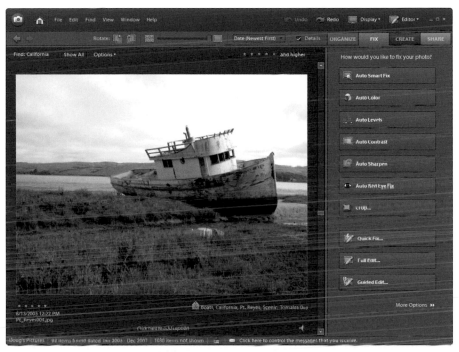

Figure 10-6: This image will be fixed.

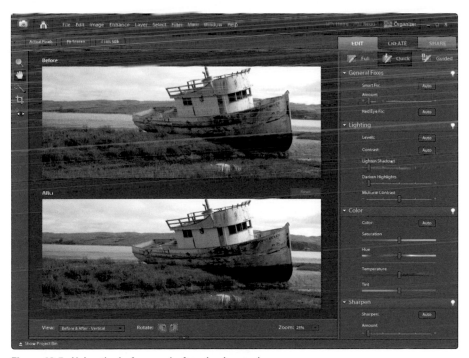

Figure 10-7: Using the before-and-after viewing mode.

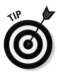

What you see on your monitor isn't necessarily what you see when you have your images printed. Consider calibrating your monitor to ensure you get consistent results. You can purchase a monitor calibration kit that consists of a device called a colorimeter and software. You attach the colorimeter to your monitor and then run the software program, which measures the light emitted by the colorimeter and then creates a profile. Update the profile regularly to compensate for changes in your monitor as it ages. You can purchase a calibration kit for as little as $79.95 as of this writing.

6. **Drag the slider to manually apply Smart Fix.**

 Use this option if the Auto Smart Fix didn't give you the desired results. Drag the slider to the right until you see something you like. When you drag the slider, you'll see a green check mark and a red circle with a line through it. To apply the change, click the check mark. To cancel the change, click the circle with the diagonal line.

7. **Click Red Eye Fix Auto.**

 Use this option if you're editing a flash photo of a person with red-eye.

8. **Click the Levels Auto button.**

 Photoshop Elements automatically adjusts the shadow, midtone, and contrast levels to improve the photo.

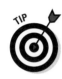

 If you don't like the results of the previously applied Smart Fix, click the Undo button.

9. **Click the Contrast Auto button.**

 Photoshop Elements automatically adjusts the image contrast.

10. **If you're not satisfied with the automatic contrast adjustment, do one of the following:**

 • Drag the Lighten Shadows slider to lighten the shadows. As you drag the slider, the image updates in real time.

 • Drag the Darken Highlights slider to darken the lightest tones in the image.

 • Drag the Midtone Contrast slider to increase midtone contrast.

 • When you drag any contrast slider, you'll see a green check mark and a red circle with a line through it. To apply the change(s), click the check mark. To cancel the change, click the circle with the diagonal line.

11. **Click the Color Auto button.**

 Photoshop Elements automatically adjusts the image contrast.

12. **If you're not satisfied with the automatic color adjustment, do one of the following:**

 • Drag the Saturation slider to increase the image saturation.

 • Drag the Hue slider to change the overall hue of the existing colors in the image. The colors under the slider give you an indication of the effect you'll get. The image updates in real time as you drag the slider.

 • Drag the Temperature slider to the right to make the colors warmer (more red), or to the left to make the colors cooler (more blue).

 • Drag the Tint slider to the left to make the colors greener, or to the right to make the colors more magenta.

- When you drag a color slider, you'll see a green check mark and a red circle with a line through it. To apply the change(s), click the check mark. To cancel the change, click the circle with the diagonal line.

13. **Click the Sharpen Auto slider.**

Photoshop Elements applies what it considers the optimum sharpening to the image.

You can also crop an image when working in Quick Fix mode. To crop the image, select the Crop tool from the left side of the workspace. For more information on cropping, see the "Cropping, Rotating, and Resizing Photos" section of this chapter.

14. **If you're not satisfied with the automatic sharpening, drag the Sharpen slider to the right to increase sharpening.**

Make sure you do your sharpening at 100 percent magnification (Ctrl+Alt+0). If you see any halos around the edges, you've applied too much sharpening. When you drag the slider, you'll see a green check mark and a red circle with a line through it. To apply the change(s), click the check mark. To cancel the change, click the circle with the diagonal line.

Click the Light Bulb icon to the right of each section to access help on the settings.

15. **Choose File⇨Save.**

The Save As dialog box appears (see Figure 10-8). The filename is appended with _edited and a number that indicates how many times the original has been edited. By default, the edited image is saved in the Organizer and is saved in a Version Set with the original. The edited file is stacked with the original. Photoshop Elements has a plethora of file formats in which you can save an image. The most commonly used format is JPEG (Joint Photographic Engineers Group), which compresses the image to reduce file size. For more information on the different file formats available in Photoshop Elements 6.0, see *Photoshop Elements 6 For Dummies,* by Barbara Obermeier and Ted Padova (Wiley Publishing).

Figure 10-8: Saving the edited file.

You can multitask by applying a Quick Fix to several photos. Shift+click the photos you want to fix in the Organizer, click Fix, and then select the desired adjustment from the How Would You Like to Fix Your Photo? list. The only fix you can't apply to multiple photos is Crop. After you apply a Quick Fix to multiple photos, Photoshop Elements saves a copy of the edited photo and stacks the photos in the Organizer. Your originals are not affected.

Editing Images in Full Edit Mode

When you have more to do than just fix an image, or if you want do some of the work manually, edit your images in Full Edit mode. When you work in Full Edit mode, you have access to more menu commands, can add layers to the image, and much more.

Exercise 10-3: Editing Images in Full Edit Mode

1. **Launch the Organizer and examine your photos.**

If you've just downloaded the photos to your computer, edit your "keepers." If you get in the habit of rating images as outlined in Chapter 9, you can filter the Organizer to show only 5-star rated images. After displaying your best images, change to Single Photo View (Ctrl+Shift+S) and then examine each photo. Look for the photos that are well composed and exposed correctly. You can then start editing your favorites. If you want to edit a photo you've previously downloaded, you can find the desired image by doing a search as outlined in Chapter 9.

2. **Choose the image you want to edit and then click Fix.**

The Organizer refreshes to show the options you have for editing an image.

3. **Click Full Edit.**

Photoshop Elements opens your image in the Edit workspace.

4. **Click Enhance.**

The available commands for enhancing your image are displayed (see Figure 10-9). The first group of commands is identical to what you find in Quick Fix mode. However, you also have other commands for adjusting lighting and color. You also have two powerful sharpening commands and a very effective way of converting an image to black and white.

Covering all of the image enhancement commands is beyond the scope of this book, but I show you how to use some of the commands in upcoming exercises. I encourage you to experiment with the commands. And if you want to learn just about everything you ever wanted to know about Photoshop Elements 6.0, but were afraid to ask, take a look at *Photoshop Elements 6 For Dummies,* by Barbara Obermeier and Ted Padova (Wiley Publishing).

5. **Move your cursor over the tools.**

The toolbar is located on the left side of the workspace. These tools are used for moving objects, selecting areas of the image, applying special effects, and so on. Notice that if you hover your mouse pointer over each tool, a tooltip appears that displays the name of the tool and the keyboard shortcut.

Move Zoom Crop

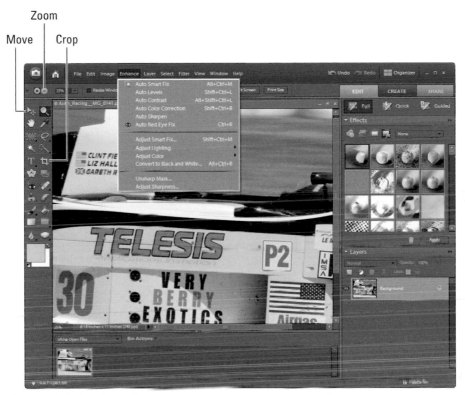

Figure 10-9: Enhancing an image.

6. **Click the Zoom tool.**

 This is the tool that looks like a magnifying glass.

7. **Click inside the image to zoom to the next level of magnification.**

 You can also use keyboard shortcuts to zoom in (Ctrl++, or Ctrl and the plus sign) or to zoom out (Ctrl+–, or Ctrl and the minus sign).

8. **Press Alt.**

 The Zoom tool icon changes to a magnifying glass around a minus sign (–), which means that when you click the image, you'll zoom to the next lowest level of magnification.

9. **Click the Hand tool.**

 This one is, you guessed it, shaped like a hand.

10. **Drag inside the image to pan to a different part of the image.**

 The Hand tool is extremely useful when you're working at high levels of magnification, or when you're working with an image whose dimensions exceed the workspace area.

 Press the space bar to momentarily activate the Hand tool. Release the space bar to revert to the previously used tool.

11. **Click the Hide Project Bin icon.**

 The Project Bin at the bottom of the workspace is hidden, which gives you more screen real estate. You can also hide the Palette bin by clicking the right arrow in the middle of the bin.

12. **Click the Show Project Bin icon.**

13. **Click the Organizer icon.**

 The Photoshop Elements Organizer is displayed.

14. **Select several images.**

15. **Choose Editor from the Windows Task Bar.**

 The Editor is displayed.

16. **Choose Show Files from Organizer from the Bin View drop-down menu.**

 The Project Bin displays all files you've selected from the Organizer (see Figure 10-10). You can double-click a file to begin editing it. You can work with multiple files in the Editor. The option to work with multiple files is handy if you're creating collages or just plain stretching the envelope to see what you can do when you stack several images together as layers. However, when you have several files open at once, your computer performance may suffer.

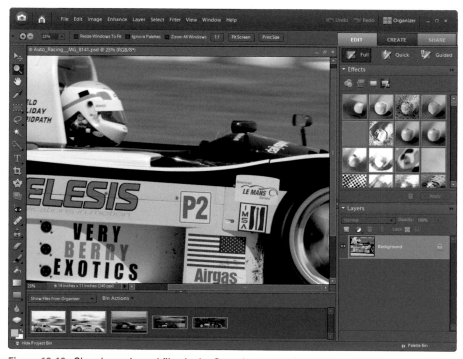

Figure 10-10: Showing selected files in the Organizer.

Color-Correcting Images

Tricky lighting conditions fool the best digital cameras. If you've got an image that has a color cast, the image needs to be color-corrected. For example, if your camera didn't get the white balance right when you photographed a scene with fluorescent lighting, the image probably wound up with a green color cast. The following exercise shows you how to remove a color cast using Photoshop Elements.

Exercise 10-4: Color-Correcting an Image

1. **Launch the Photoshop Elements Edit workspace.**

 The easiest way to launch the Editor is to click the Photoshop Elements desktop icon and then click Edit. This opens the Edit Workspace.

2. **Choose File⇨Open.**

 The Open dialog box appears. Navigate to the image 10-colorCast.jpg that you downloaded from the book's companion Web site. The image has a blue color cast.

3. **Choose Enhance⇨Adjust Color⇨Remove Color Cast.**

 The Remove Color Cast dialog box appears (see Figure 10-11).

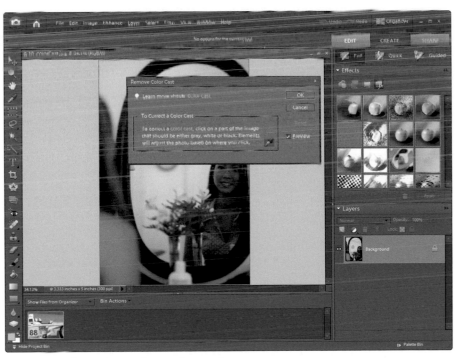

Figure 10-11: Removing a color cast from an image.

4. **Click an area inside the image that you know should be jet black, pure white, or neutral gray.**

 Photoshop Elements removes the color cast based on the area you clicked. In the case of this image, click the white bottle or the white flowers in the mirror. If the first click doesn't modify the image to your satisfaction, click a different area.

5. **Click OK in the Remove Color Cast dialog box to remove the color cast.**

Sharpening Photos

Images captured by a digital camera are a little *soft,* meaning that the edges of objects in the image are not razor sharp. This has nothing to do with the camera lens, but everything to do with the camera sensor. I could give you a long, detailed explanation about why this anomaly occurs, but you would probably fall asleep. But fortunately, you can sharpen your digital images using Photoshop Elements. The following exercises show you how to sharpen your images. Exercise 10-5 uses the Unsharp Mask command, which may seem like a misnomer. The command got its name back in the old days of film when photographers did darkroom sleight-of-hand to sharpen unsharp edges. With the Unsharp Mask command, you can achieve similar results in your digital darkroom. Exercise 10-6 shows you how to use the Adjust Sharpness command, and Exercise 10-7 demonstrates a technique that does a wonderful job of sharpening objects like flowers and close-up shots of jewelry and watches.

Exercise 10-5: Using the Unsharp Mask Command

1. **Launch the Photoshop Elements Edit workspace.**

 The easiest way to launch the Editor is to click the Photoshop Elements desktop icon and then click Edit. This opens the Edit Workspace.

2. **Choose File⇨Open.**

 The Open dialog box appears. Navigate to the image 10-sharpen.jpg that you downloaded from the book's companion Web site.

3. **Zoom to 100 percent magnification.**

 You can use the Zoom tool to zoom to 100 percent (see Figure 10-12), or the keyboard shortcut Ctrl+Alt+0. When you're sharpening an image, you should always do so at 100 percent magnification. This enables you to see halos that form around edges when you apply the Unsharp Mask command. A halo, which can be identified as a bright spot on an edge, means that you've oversharpened the image.

4. **Choose Enhance⇨Unsharp Mask.**

 This opens the Unsharp Mask dialog box (see Figure 10-13).

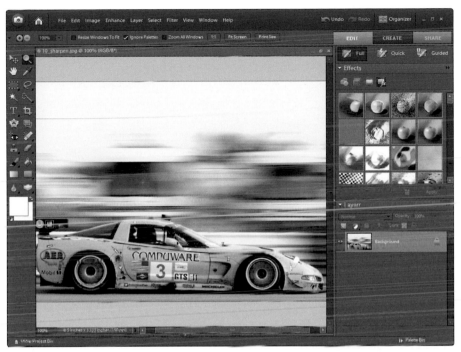

Figure 10-12: Zoom to 100 percent magnification when sharpening images.

5. **Specify the Amount, Radius, and Threshold values.**

The dialog box has three sliders that enable you to set each value. Alternatively, you can enter a value in each text box. The following explains what part each parameter plays in sharpening your image:

- *Amount:* This value determines how much contrast is added to each edge in the image. Drag the slider until you see halos start to form around the edges and then lower the value slightly until the halos disappear.

- *Radius:* This value determines the distance from each edge to which the sharpening is applied. The value you use is determined by the amount of contrast in the image. If you choose too low a value, the sharpening effect is hardly noticeable; too large a value, and halos appear around the edges.

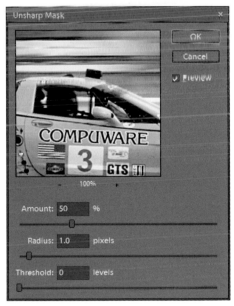

Figure 10-13: Using the Unsharp Mask command.

- *Threshold:* This value determines how many adjacent pixels must be the same hue to be considered an edge. If you set this value too low, incidental details (like digital noise) are sharpened.

6. **For this image, use the following values: Amount = 65, Radius = 4, and Threshold = 3.**

 These settings are for maximum sharpening when the subject is a bit out of focus yet there are well-defined edges.

7. **Click OK to apply the sharpening.**

Exercise 10-6: Using the Adjust Sharpness Command

Photoshop Elements has another trick up its sharpening sleeve: the Adjust Sharpness command. The Adjust Sharpness command does a better job of identifying edges than does the Unsharp Mask, which means you won't end up sharpening noise or random pixels that shouldn't be sharpened.

1. **Launch the Photoshop Elements Edit workspace.**

 The easiest way to launch the Editor is to click the Photoshop Elements desktop icon, and then click Edit. This opens the Edit Workspace.

2. **Choose File➪Open.**

 The Open dialog appears. Navigate to the image 10-adjustSharpness.jpg that you downloaded from the book's companion Web site.

3. **Zoom to 100 percent magnification.**

 You can use the Zoom tool's 1:1 button or the keyboard shortcut Ctrl+Alt+0 to zoom to 100 percent. When you sharpen an image, you should always view the image at 100 percent magnification.

4. **Choose Enhance➪Adjust Sharpness.**

 The Adjust Sharpness dialog box appears (see Figure 10-14).

5. **Specify the Amount value.**

 You can use the slider to select a value or enter the value in the text field. This value determines the amount of sharpening that's applied to the image. As you drag the slider, the image updates in real time. If any halos appear on the edges, you've oversharpened the image.

 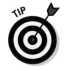

 Click the Preview check box to disable the preview of the command on your original image, which enables you to see the unsharpened image. Click the check box again to see the effects of the sharpening on your image.

6. **Specify the Radius value.**

 This value determines the distance from each edge to which the sharpening is applied. If you specify too low a value, the sharpening effect isn't noticeable; too large a value, and halos appear around the edges.

7. **Choose an option from the Remove drop-down menu.**

Your choices are Gaussian Blur, Lens Blur, and Motion Blur. Lens blur is the best option for digital photographs. However, you can use Motion Blur if you moved the camera while taking the picture. When you choose Motion Blur, you can specify the angle by dragging a slider. Drag the slider until you see the sharpest image possible. Use Gaussian Blur for close-ups.

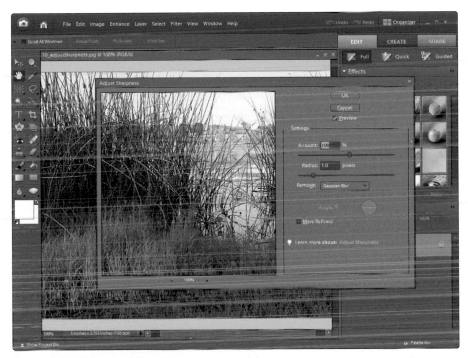

Figure 10-14: Using the Adjust Sharpness command.

8. **Click the More Refined check box.**

 This option processes the command more slowly for more accurate results.

9. **Click OK to sharpen the image.**

Exercise 10-7: Sharpening Details

When you're working with a photograph with a lot of minute details, such as a close-up of a flower or piece of jewelry, you can use an infrequently used command to get an incredibly sharp image. This exercise also introduces you to working with layers. It might help to think of a layer as either a clear sheet of plastic (blank layer) or a carbon copy of the original image stacked on top of the background. When you do your editing work on layers, the original image is still on the background layer — as good as new.

1. **Launch the Photoshop Elements Edit workspace.**

 The easiest way to launch the Editor is to click the Photoshop Elements desktop icon and then click Edit. This opens the Edit Workspace.

2. **Choose File⇨Open.**

 The Open dialog box appears. Navigate to the image 10-detailSharpness.jpg that you downloaded from the book's companion Web site.

3. **Press Ctrl+J.**

 This is the keyboard shortcut to duplicate the background layer. Alternatively, you can choose Layer⇨Duplicate Layer, which opens the Duplicate Layer dialog box in which you enter a name for the layer. Naming layers is useful when you're working with multiple layers. However, when you only duplicate one layer, the keyboard shortcut is a tremendous timesaver.

4. **Choose Filter⇨Other⇨High Pass.**

 The High Pass dialog box appears (see Figure 10-15). This filter detects the well-defined edges in the image.

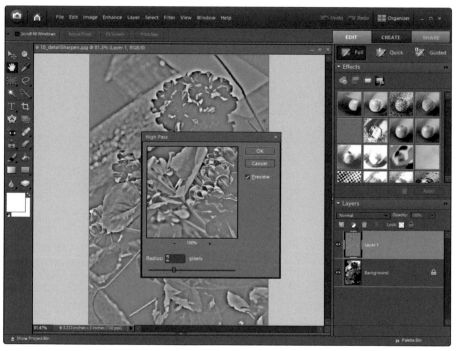

Figure 10-15: Sharpening details with the High Pass filter.

5. **Specify a Radius value.**

 Choose a value between 6 and 10 pixels. If you see a large bright halo appear around the edges in the dialog box, specify a lower value.

6. **Click OK to apply the filter.**

 The layer has a gray hue to it. To complete the technique, you need to change the layer blend mode and specify the layer opacity.

7. **Choose Overlay from the Layer Blend Mode pop-up menu (see Figure 10-16).**

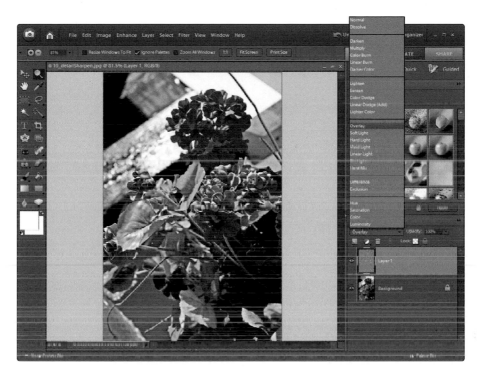

Figure 10-16: Changing the layer blend mode.

8. **If desired, change the layer opacity.**

 If the image appears oversharpened, you can let part of the underlying layer show through by changing the layer opacity. To change layer opacity, position your cursor over Opacity in the Layers palette. When the cursor changes to a pointing finger with two arrows (see Figure 10-17), drag left to lower the layer opacity. Alternatively, you can enter a value in the Opacity text field or click the down arrow to the right of the text field and drag the Opacity slider. The image updates in real time as you change layer opacity.

9. **Choose Layer⊏➪Flatten Image.**

 This command flattens the layers to a single image.

10. **Save the image.**

Use the three sharpening methods presented in this section on the flower image to get a better feel for image sharpening and the different results you get with each technique.

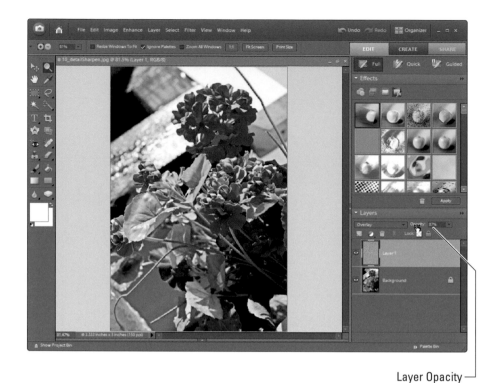

Layer Opacity

Figure 10-17: Changing layer opacity.

Straightening Photos

When you compose an image using your camera LCD monitor, you may have a hard time capturing a level picture. The same result can occur when you've been lugging around a digital SLR and a fully stocked camera bag for three or four hours. If you have a photograph that's well composed but not quite level, you can easily solve this problem with a Photoshop Elements menu command as outlined in the following exercise.

Exercise 10-8: Straightening Photos

1. **Launch the Photoshop Elements Edit workspace.**

The easiest way to launch the Editor is to click the Photoshop Elements desktop icon, and then click Edit. This opens the Edit Workspace.

2. **Choose File⊏>Open.**

The Open dialog box appears. Navigate to the image 10-straighten.jpg that you downloaded from the book's companion Web site. The photo shows nice reflections in a lake. However, the horizon is not level.

3. **Select the Straighten tool.**

 The options below the menu bar change (see Figure 10-18).

Figure 10-18: Straightening an Image.

4. **Select a canvas option.**

 This option determines how Photoshop Elements handles the canvas when the image is straightened. You have the following options:

 - *Grow or Shrink Canvas to Fit:* This option resizes the canvas so that no pixels are clipped. However, you will see areas of blank canvas beyond the border of the image.

 - *Crop to Remove Background:* This option crops the canvas to remove a blank background. You will lose part of the image. However, this is the best option if the image is only slightly askew.

 - *Crop to Original Size:* This option crops the image to its original size. However, areas of blank canvas appear on the sides of the image, and some pixels will be clipped.

5. **Drag the straighten tool along a line you know should be vertical or horizontal.**

 If you've got buildings in your image, drag the tool along the edge of a wall or the roofline. In the case of this image, drag the tool along the shoreline. When you release the tool, Photoshop Elements straightens the image.

Cropping, Rotating, and Resizing Photos

Sometimes you get it just right. The image is perfectly composed and all you have to do is some simple editing and print the image. Then there are those times when your instincts are not correct and you've got to get rid of unwanted background, for example. Then when you're done, you need to resize the photo for the media on which it will be printed. The following exercises explore cropping, rotating, and resizing images.

Exercise 10-9: Cropping and Rotating Photos

1. **Launch the Photoshop Elements Edit workspace.**

2. **Choose File⇨Open.**

 Navigate to the file you want to crop or rotate.

3. **Choose Image⇨Rotate, and then choose the desired rotation option.**

 Figure 10-19 shows the different menu commands available for rotating images. If you took a picture in Portrait mode and did not rotate it in the Organizer, you can rotate the image 90 degrees clockwise or counterclockwise. The last two commands, Straighten and Crop Image and Straighten Image, are automated. If you need to accurately straighten and crop an image, you're better off doing it manually as described in Exercise 10-8.

Figure 10-19: The available commands for rotating images and layers.

4. **Select the Crop tool.**

 The options below the menu bar change to reflect the options for the command.

5. **Select the desired aspect ratio from the drop-down menu.**

 The aspect ratio determines how the Crop tool is constrained. The drop-down menu lists popular print sizes, such as 4 x 6 and 8 x 10. If you need to crop the image to a different size, choose No Restriction and then type the desired values in the Width and Height field. Another option is Photo Ratio, which constrains the crop tool to the same aspect ratio of the photo. Choose an aspect ratio that will downsize the image when cropped. If you choose 8 x 10 from the drop-down menu and the current size of the image is 5 x 7, Photoshop Elements redraws pixels when enlarging it, which results in image degradation.

6. **Type the desired resolution in the Resolution field.**

 Choose the same resolution as the photo or lower. If you choose a higher resolution that results in a larger document size, Photoshop Elements redraws and creates pixels, which results in image degradation.

If you're not sure of the current image size, choose Image⇨Resize⇨Image Size. This opens the Image Size dialog box, which shows the width, height, and resolution of the image. After noting the information, click Cancel to close the dialog box without changing the image size.

7. **Drag the crop tool inside the image.**

 Photoshop Elements creates a cropping rectangle. This is the area to which the image is cropped (see Figure 10-20).

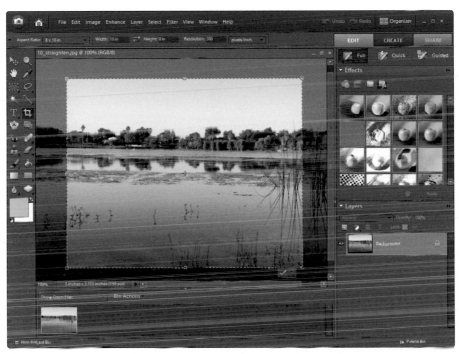

Figure 10-20: Cropping an image.

8. **If desired, resize, reposition, or rotate the cropping rectangle.**

 - To reposition the cropping rectangle, click inside it and drag it to the desired location.

 - To rotate the cropping rectangle, move the cursor toward any of the corner handles. When your cursor becomes a curved line with two arrowheads, drag to rotate the rectangle.

 - To resize the cropping rectangle, move your cursor over any of the handles until it becomes a diagonal line with two arrowheads. Drag to resize the cropping rectangle.

9. **Click the green check mark to crop the image.**

 Alternatively, you can click the red circle with the diagonal line to cancel the operation.

Exercise 10-10: Resizing Images

When you take a picture with your digital camera, you specify the image size and quality. Each digital camera has a native resolution, which, when combined with the pixel dimensions, determines the document size in inches. For example, if an image is 3000 x 2400 pixels with a resolution of 300 PPI, the document size is 10 x 8 inches (3000 x 2400/300). You can resample the image by changing the pixel dimensions or document size. You can also change the resolution without resampling the image, which has no effect on the pixel dimensions. For example, if you change the resolution of the aforementioned image to 150 PPI without resampling, the document size becomes 20 x 16 inches (3000 x 2400/150). The following exercise explores resizing images:

1. **Launch the Photoshop Elements Edit workspace.**

The easiest way to launch the Editor is to click the Photoshop Elements desktop icon and then click Edit. This opens the Edit Workspace.

2. **Choose File➪Open.**

The Open dialog box appears. Navigate to the image 10-resize.psd.

3. **Choose Image➪Size.**

The Image Size dialog box appears (see Figure 10-21). The image has pixel dimensions of 2100 x 1500 and an image resolution of 300 PPI (pixels per inch), which translates to a document size of 7 x 5 inches.

Figure 10-21: Resizing an image.

4. **Type a value of 1800 in the Pixel Dimensions: Width text field.**

The image is resized (also known as resampled) to 1800 x 1286 pixels: a document size of 6 x 4.287 inches. The image is resized proportionately. The default Constrain Proportions option automatically calculates the other dimension. If you disable this option, the image is not resized proportionately, which causes distortion.

5. **Click OK.**

 The change is applied to the image.

6. **Click the Undo button in the upper-right corner of the workspace.**

 The previous command is undone.

7. **Choose Image⇨Size.**

 The Image Size dialog box appears.

8. **Type a value of 4500 in the Height text field and then click OK.**

 Photoshop Elements enlarges the image to three times its original size.

9. **Zoom to 100 percent (Ctrl+Alt+0).**

 In spite of the fact that this photo began life as a high-resolution capture from a 12.8 megapixel camera, the image is not as sharp as it originally was. I don't advise increasing the pixel dimensions of an image for this reason.

10. **Click the Undo button.**

 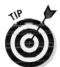

 Alternatively, you can choose Edit⇨Undo Image Size.

 To undo the previous command, press Ctrl+Z.

11. **Choose Image⇨Size.**

 The Image Size dialog box appears.

12. **Deselect the Resample Image option.**

13. **Type a value of 150 in the Resolution text field.**

 The Document Size is now 14 x 10 inches. A resolution of 150 pixels per inch still yields good results when printed on photo paper using a good inkjet printer. At this stage, you could click OK and then crop the document to the desired print size. For example, if you were going to print this image on 10 x 8 paper, select the crop tool and, for the tool options, type **10** for the width, **8** for the height, and **150** for the resolution.

14. **Click OK.**

 The image is resized.

Optimizing Images for the Web

Your digital camera is capable of capturing large, high-resolution images. If you take an image as captured by your camera and plop it in a Web page or send it via e-mail, the image takes a long time to download. When you place an image on the Web or send it via e-mail, you should always optimize the image first. Fortunately, Photoshop Elements has a command that makes optimizing child's play.

Exercise 10-11: Optimizing Images for the Web

1. **Launch the Photoshop Elements Edit workspace.**

2. **Choose File⇨Open.**

The Open dialog box appears. Navigate to the image 10-Web.psd and click Open.

3. **Choose File⇨Save for Web.**

The Save for Web dialog box appears (see Figure 10-22). The left side of the dialog box shows the original image, and the right side shows the image with the current optimization settings. The last preset used is chosen by default. Figure 10-22 shows one of the GIF presets. This file format is ideal for images like text banners with nothing but text. However, when you're working with a digital photograph, the best option is one of the JPEG formats.

Figure 10-22: Optimizing images for Web use.

4. **Choose JPEG High from the Preset drop-down menu.**

The Preset section of the dialog box refreshes to show the JPEG options. You can modify the settings by choosing an option. However, you won't see the true effect of your changes until you resize the image.

5. **Type a value in the New Size Width or Height dialog box.**

For the purpose of this exercise, type a value of **500** in the Height text field, which resizes the image to dimensions of 500 x 333 pixels. As a rule, you should not exceed 600 pixels for image width or 400 pixels for image height. If you choose larger dimensions, the file size increases and viewers with small desktop sizes won't be able to see the full image.

6. **Click Apply.**

 The image is resized to the new dimensions.

7. **Choose a setting from the Compression Quality drop-down menu.**

 Your choices are Maximum, Very High, High, Medium, or Low. Low gives you the smallest file size by applying maximum compression, and Maximum gives you the best-quality image by applying the least amount of compression, which results in an image with a large file size. After you choose a setting, the image in the right pane of the dialog box updates showing the new file size and the amount of time it will take to download the image with a 28.8 Kbps Internet connection.

8. **If the image quality still looks good, choose a lower quality.**

 Your goal is to save the best-looking image with the smallest possible file size. However, when you're displaying an image with large dimensions on a Web site, you can readily see the results of high compression. If you're working with a smaller image, the results of high compression are not as readily apparent.

9. **To further fine-tune the optimization, click the arrow to the right of the Quality setting and drag the slider.**

 This changes the preset to Custom. At this point in the Optimization process, change the Zoom setting to 200. The image for this exercise is high resolution, so it will take more compression without degrading. However, when you apply too much compression to any photo, image degradation inevitably results. Figure 10-23 shows the image with a Quality setting of 15. Notice the image degradation around the orange stamens. These gnarly-looking areas are known as *compression artifacts*. When you see artifacts like these, drag the Quality slider to a higher value until they disappear. For an image of this size, with this amount of detail, you'll need a quality value of about 50.

Figure 10-23: Fine-tuning the image quality.

10. **If desired, choose other options.**

You can add the following options when optimizing an image for the Web:

- *Progressive:* Choose this option if you're displaying a large image with high-quality settings on a Web site. When you choose this option, the image downloads in stages. The first stage reveals the image at low quality. The final stage reveals all image detail.

- *ICC Profile:* Choose this option, and Photoshop Elements automatically applies the proper ICC profile for images being displayed on the Web, regardless of the original image ICC profile.

- *Matte:* This option lets you choose a color that will be transparent. In other words, when you place an image with transparency on a Web page, the Web page background is shown, and not the color you specify as transparent. You don't need this option unless you're a Web designer who needs to display the image over another background.

11. **Click OK.**

The Save Optimized As dialog box opens.

12. **Navigate to the folder in which you want to store the file.**

13. **Accept the default filename or type a different name.**

14. **Click Save.**

The optimized image is saved.

15. **Close the original image.**

When you are prompted to save your changes, click No.

Fixing Underexposed Images

If your camera underexposes an image or you manually set the camera controls and capture an image that is underexposed in the JPEG format, you can rescue the image by doing the steps in the following exercise.

Exercise 10-12: Fixing Underexposed Images

1. **Launch the Photoshop Elements Edit workspace.**

The easiest way to launch the Editor is to click the Photoshop Elements desktop icon and then click Edit. This opens the Edit workspace.

2. **Choose File⇨Open.**

The Open dialog box appears. Navigate to the image 10-underexpose.jpg and open the file. The original image is too dark and details are lost on the young girl's face.

3. **Choose Layer⇨Duplicate Layer.**

Alternatively, you can press Ctrl+J.

4. **In the Layers Palette, change the duplicated layer's blend mode to Screen.**

 This brightens the image considerably. If the image still isn't bright enough, duplicate this layer. When you duplicate a layer, the blend mode of the original layer is inherited by the duplicate.

5. **If the image is too bright, lower the opacity of the uppermost layer until you achieve the desired results.**

 The image for this exercise only requires one duplicate layer (see Figure 10-24). Experiment with different opacity settings to see the results.

Figure 10-24: Fixing an underexposed image.

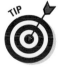

If the image has dark shadows but is otherwise properly exposed, choose Enhance⇨Adjust Lighting⇨Shadows and Highlights to open the Shadows/Highlights dialog box. From within the dialog box, you can lighten the shadows, and, if desired, increase contrast.

Fixing Overexposed Images

If your camera overexposes an image or you change camera settings and end up with a slightly overexposed image in the JPEG format, you can easily fix it with a duplicate layer and the proper blend mode. As long as none of the highlights is completely blown out to white, you can save the image by following the steps in the next exercise.

Exercise 10-13: Fixing Overexposed Images

1. **Launch the Photoshop Elements Edit workspace.**

 The easiest way to launch the Editor is to click the Photoshop Elements desktop icon and then click Edit. This opens the Edit Workspace.

2. **Choose File⇨Open.**

 The Open dialog box appears. Navigate to the image 10-overexpose.jpg and open the file. The original image is too light and details are lost in the sky.

3. **Choose Layer⇨Duplicate Layer.**

 Alternatively, you can press Ctrl+J.

4. **In the Layers Palette, change the duplicated layer's blend mode to Multiply.**

 This darkens the image considerably. If the image still isn't bright enough, duplicate this layer. A duplicated layer inherits the blend mode of the original layer.

5. **If the image is now too dark, lower the opacity of the uppermost layer until you achieve the desired results.**

 The image for this exercise only requires one duplicate layer (see Figure 10-25). Experiment with different opacity settings to see the results.

Figure 10-25: Fixing an overexposed image.

TIP

If the image has bright highlights but is otherwise properly exposed, choose Enhance⇨Adjust Lighting⇨Shadows and Highlights to open the Shadows/Highlights dialog box. From within the dialog box, you can darken the highlights, and, if desired, increase contrast.

Stitching a Panorama

If you worked through the exercise to photograph a panorama in Chapter 6, the following exercise shows you how to stitch the images together in Photoshop Elements.

Exercise 10-14: Stitching a Panorama

1. **Open the Organizer workspace.**

2. **Choose File⇨Get Photos and Videos⇨From File and Folders.**

In the Get Photos from Files and Folders dialog box, navigate to the folder in which you downloaded the photos for this chapter and select the following images that you downloaded from the book's companion Web site: pan_01.jpg, pan_02.jpg, pan_03.jpg, and pan_04.jpg.

3. **Click Get Photos.**

The images are imported into the Organizer.

4. **Select the images and then choose File⇨New⇨Photomerge Panorama.**

The files are opened in the Editor, and the Photomerge dialog box appears (see Figure 10-26).

Figure 10-26: Stitching a panorama.

5. **Click Add Open Files.**

Photoshop Elements displays a dialog box telling you that all files must be saved.

6. **Click OK.**

7. **Accept the default layout option of Auto and click OK.**

 Photoshop Elements starts working its magic. In a few seconds, the stitched panorama appears in the workspace (see Figure 10-27). Each image in the stitched panorama appears on its own layer.

Figure 10-27: The stitched panorama.

8. **Choose Layer➪Flatten Image.**

 Photoshop Elements flattens the layers to a single image.

9. **Select the Crop tool.**

 The tool's options are displayed under the menu groups.

10. **Select No Restriction from the Aspect Ratio drop-down menu.**

 Alternatively, you can set the options to match the size of the media on which you'll print the image. Many printer manufacturers offer panorama paper. For example, Epson makes panoramic paper that is 23.4 by 8.3 inches.

11. **Drag the Crop tool to define the area to which you want to crop the image.**

 A cropping rectangle with a green check mark and a red circle with a diagonal line through it appear.

12. **Adjust the cropping rectangle as needed, and then click the green check mark.**

 The image is cropped (see Figure 10-28). The seams match perfectly because the photos for this panorama were taken using the techniques in Chapter 6.

Figure 10-28: The finished panorama.

13. **Save the image.**

You have many different options when saving images. First to consider is the file format. The Photoshop Elements default file format is *PSD (Photoshop Document). When you choose this format, you can save layers and selections with the document file. Other popular formats are JPEG (Joint Photographic Engineering Group) and TIFF (Tagged Image File). The JPEG format is known as a lossy format, which means that color information is lost when the file is compressed while it's saved. Many online printing outlets require that you upload only JPEG images. When you save a JPEG image, you specify image quality on a scale from 0 (poor image quality, small file size) to 12 (high image quality, large file size). If you're saving JPEG images for online printing services, specify the highest possible image quality. Normally, it's 12. However, if the image file size exceeds the maximum upload, you have to specify a lower image-quality value.

When you save an image using the TIFF file format, you also have compression options. Unfortunately, the available options and the plethora of other file formats exceed the number of remaining pages in this chapter. For additional information on saving images, refer to *Photoshop Elements 6 For Dummies,* by Barbara Obermeier and Ted Padova (Wiley Publishing).

Printing Images

If you've got a photo printer and photo-quality paper, you can create prints of your favorite images. Photoshop Elements gives you many options for printing. You can create individual prints, create multiple prints on one page, or create a contact sheet of images. You can print images from the Edit or Organize workspace. The following exercise explores the different options you have for creating stunning prints of your favorite images.

Exercise 10-15: Printing an Image from the Editor

1. **Launch the Editor and then open the image you want to print.**

2. **Crop and/or resize the image to fit the dimensions of the media in your printer.**

Refer to information included with your photo paper to learn the dimensions of the printable area. Many photo papers enable you to print a photo with no border.

3. **If desired, sharpen the image.**

 You should always sharpen the image after you've resized it.

4. **Choose File⇨Print.**

 The Print dialog box appears (see Figure 10-29).

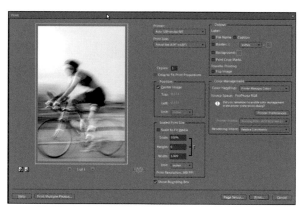

Figure 10-29: Printing the image.

5. **Choose the Orientation.**

 Click the Portrait (icon of a man standing) or Landscape (icon of a horizontal man) button to the lower left of the image. Click Portrait if your image is taller than it is wide, and Landscape if the image is wider than it is tall.

6. **Click Page Setup.**

 The Page Setup dialog box appears.

7. **Choose the paper size from the Size drop-down list.**

 The list contains all of the media available for your printer.

8. **Choose an option from the Source drop-down list.**

 This list contains the options available for the selected printer. For my Epson 1280, the choices are Sheet Feeder, Sheet (Borderless), Roll Paper, and Banner (Borderless).

9. **Click Printer.**

 The second Page Setup dialog box appears.

10. **Choose the desired printer from the Name drop-down list.**

 This list contains the names of all available printers connected to your computer and, if applicable, network.

11. Click Properties.

The selected printer's Property dialog box opens. Figure 10-30 shows the properties for an Epson 1280.

12. Choose the media type and set the other parameters for your printer.

Each printer is different. Your printer's Properties dialog box shows the media available from your printer manufacturer. If you're using third-party paper, you'll have to experiment with the settings or use those suggested by the paper manufacturer for your printer. Other options may include color settings, layout, and so on. Refer to your printer documentation for more information.

13. Click OK to close the Printer Properties dialog box, click OK to close the second Page Setup dialog box, and then click OK to close the first Page Setup dialog box.

Figure 10-30: Setting the printer properties.

14. Specify the number of copies to print.

15. If your image is not the same aspect ratio as the media, click the Crop to Fit Print Proportions check box.

This option crops the image to the proportions of the print media.

16. If your image is larger than the print media, click the Scale to Fit Media check box.

Do not choose this option if your image is significantly smaller than the print media. For example, if you choose this option with an image that is 4 x 6 inches and you're printing on 8½ x 11 media, the results won't be satisfactory.

17. Choose the desired options in the Output section.

In this section, you can add a label to the image, add a border, specify background color, add print crop marks, or flip the image if you're printing to transfer media, such as T-shirt iron-on media. Print crop marks are useful if you're going to trim the print to fit a matte.

18. Choose an option from the Color Handling drop-down list.

Your options are Printer Manages Color (the default), No Color Management, or Photoshop Elements Manages Colors. If you choose the latter option, a Printer Profile and Rendering Intent field appears. Printer profiles tell Photoshop Elements how to render the color for a specific paper used on a specific printer. If you're using third-party paper from a manufacturer like Hanamuhle or Ilford, you may be able to download a printer profile from its Web site for your printer. Most profiles come with instructions that show you how to install the profile, which media to choose from your printer properties dialog box, and which rendering intent to specify.

19. Click Print.

Photoshop Elements sends the information to your printing device.

Use your printer regularly. If you don't, the heads may clog and you'll get pretty dismal results when you try to print an image. Most printer manufacturers include a utility to clean printer heads, which, depending on the brand of printer you own, may or may not use copious amounts of ink. However, if you print something in color a couple of times a week, even on plain paper, you'll give your printer the exercise it needs.

Photoshop Elements 6.0 has many options for printing. Select several images from the Organizer and then choose File⇨Print. From within the Print Photos dialog box's Select Type of Print drop-down menu, you can choose Contact Sheet, which enables you to print all selected photos on a single sheet; Picture Package, which enables you to select a layout for printing multiple photos; Labels, which enables you to print the photos on label stock; or Individual Prints, which enables you to create individual prints of each selected photo. Unfortunately, complete exercises on each option are beyond the scope of this book. With the knowledge you gained from the previous exercise, you'll be able to create prints from the Organizer and take advantage of the options in the Print Photos dialog box.

Chapter 11

Sprucing Up Specific Spots

· ·

In This Chapter

▶ Fixing red-eye

▶ Using the Lasso tools

▶ Working with layers

▶ Retouching images

▶ Extracting subjects from the background

· ·

Digital cameras and the images they produce aren't perfect. That's why the lads and lasses at Adobe developed the Photoshop Elements Edit workspace. In Chapter 10, I introduce the basics of editing images in Photoshop Elements 6.0. In this chapter, I up the ante and present exercises to show you how to confine your edits to specific areas of the image. I also show you how to work with layers.

To use the accompanying images for the exercises in this chapter, download 259337_ch11.zip from the book's companion Web site.

Curing Red-Eye

Red-eye is a fact of life when you blast your victim — er, I mean *subject* with an on-camera flash. Red-eye occurs when the camera flash reflects off your subject's blood-filled retina. You can use camera red-eye reduction to cure this problem, but the results don't always look natural. You can also correct for red-eye as you're downloading an image into the Organizer. However, if a photo with red-eye slips past your radar, you can easily fix it later by following the steps in this exercise.

Exercise 11-1: Curing Red-Eye

1. **Launch the Photoshop Elements Edit workspace.**

 The easiest way to launch the Editor is to click the Photoshop Elements desktop icon and then click Edit. This opens the Edit Workspace.

2. **Choose File➪Open.**

 The Open dialog box appears. Navigate to the image 11-red-eye.psd that you down-loaded from this book's companion Web site.

3. **Select the Red-Eye tool.**

 The tool's options appear below the menu (see Figure 11-1).

Red Eye tool Tool options

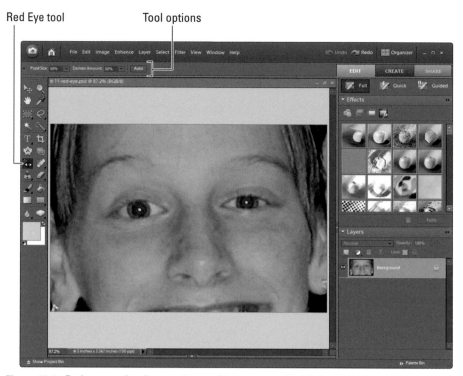

Figure 11-1: Red-eye — the disease that made on-camera flash infamous.

4. **Accept the default pupil size, or enter a different value.**

 To change the pupil size, type a different value in the Pupil Size text field.

5. **Accept the default Darken Amount value.**

 The default value of 50 percent works well in most cases. To change the darken value, type a different value in the Pupil Size text field.

6. **Click inside each pupil to remove red-eye.**

 The fixed image should look similar to Figure 11-2.

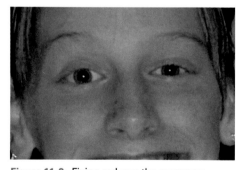

Figure 11-2: Fixing red-eye the easy way.

Creating Selections

When you use a tool or menu command to change an image, the entire image is modified, unless you make a selection to segregate your changes to a specific area of the photo. You can use one of several selection tools in Photoshop Elements to select part of an image. The following exercise shows you how to create rectangular and elliptical selections.

Exercise 11-2: Creating Rectangular and Elliptical Selections

1. **Launch the Photoshop Elements Edit workspace.**

The easiest way to launch the Editor is to click the Photoshop Elements desktop icon and then click Edit. This opens the Edit Workspace.

2. **Open an image.**

3. **Select the Rectangular Marquee tool.**

4. **Click and drag inside the image to define your selection.**

As you drag the tool, a bounding box appears that designates the current size and position.

Press the spacebar to move the selection while creating it.

5. **Release the mouse button to complete the selection.**

You can use the selection to create a new layer, a task I outline in Exercise 11-11. You can also confine a command or tool to the selected area. For example, if you want to darken the sky on a shot with a level horizon, create a rectangular selection, choose Enhance⇨Image⇨Brightness/Contrast, and then drag the Brightness slider left to darken the image. When you click OK, the command is applied only to the selected area.

6. **Select the Elliptical Marquee tool.**

The Elliptical Marquee tool occupies the same space in the toolbox as the Rectangular Marquee tool. To reveal the hidden tool, position your cursor over the down arrow below and to the right of the Rectangular Marquee tool (see Figure 11-3).

Figure 11-3: Selecting the Elliptical Marquee tool.

7. **Click and drag inside the image to define your selection.**

 As you drag the tool, a bounding box appears that designates the current size and position. Press the spacebar to move the selection while creating it.

8. **Release the mouse button to complete the selection.**

 You can use the selection to create a new layer, a task that I outline in Exercise 11-11. You can also confine a command or tool to the selected area.

Hold the Shift key while using the Elliptical or Rectangular Marquee tool to constrain the selection to a circle or a square.

Selecting a Specific Color

Selecting an area that is similar in color is a common task: for example, you may want to select a boring sky and replace it with a sky from another image; you select hues of the color blue. You can use one of two tools to select an area of similar color: the Magic Wand tool and the Magic Selection tool. The following two exercises show you how to select an area of color with each tool.

Exercise 11-3: Using the Magic Wand Tool

1. **Launch the Photoshop Elements Edit workspace.**

 The easiest way to launch the Editor is to click the Photoshop Elements desktop icon and then click Edit. This opens the Edit Workspace.

2. **Choose File⇨Open.**

 The Open dialog box appears. Navigate to the image 11-colorSelect.psd that you downloaded from the book's companion Web site.

3. **Select the Magic Wand tool.**

 The tool options below the menu change when you select this tool.

4. **Specify the tolerance and other options:**

 • *Tolerance:* When you specify a small Tolerance value, the tool selects a tighter band of colors that are close to the color value where you click the tool. A larger Tolerance value selects a wider band of colors. The default Tolerance value of 32 is good for this image. However, when you have several shades of the same color in close proximity to each other, the default value selects more than you need. Always start with a high value and whittle your way down to the right tolerance for the job at hand.

 • *Anti-alias:* This option smoothes the edges of the selection to avoid the jagged stair-step appearance of a selection that is not anti-aliased. You should always leave this default option selected.

 • *Contiguous:* This option selects only pixels that are next to each other. If you deselect this option, the tool selects pixels anywhere in the image that are similar to the color of the pixel upon which you click the tool. When you're selecting an area of color, like the blue in the sky, accept this default option.

5. **Click inside the blue sky area.**

The tool does a pretty good job of selecting the sky, but the area by the palm trees on the right side of the image is not selected (see Figure 11-4). If the tool selected too much, type a lower Tolerance value and click inside the image again until you select the desired area.

Magic Wand tool

Figure 11-4: Creating the selection.

6. **Hold the Shift key and then click the unselected area in the upper-right corner.**

When you press the Shift key, a plus sign (+) appears to the right of the tool, indicating you can add to the selection. If you press the Alt key, a minus sign appears to the right of the tool, indicating you can click and delete an area of similar color from the image.

7. **Hold the Shift key and click the area between the palm trees.**

The sky is selected. All you need to do is refine the selection, which is the topic of Exercise 11-8.

Exercise 11-4: Using the Quick Selection Tool

The Quick Selection tool is quite magical. The tool makes it possible to select a large area of contiguous color quickly, as the name implies.

1. **Launch the Photoshop Elements Edit workspace.**

The easiest way to launch the Editor is to click the Photoshop Elements desktop icon and then click Edit. This opens the Edit Workspace.

2. **Choose File⇨Open.**

 The Open dialog box appears. Navigate to the image 11-colorSelect.psd that you downloaded from the book's companion Web site.

3. **Select the Quick Selection tool.**

 This tool's options appear below the menu bar (see Figure 11-5).

Quick Selection tool

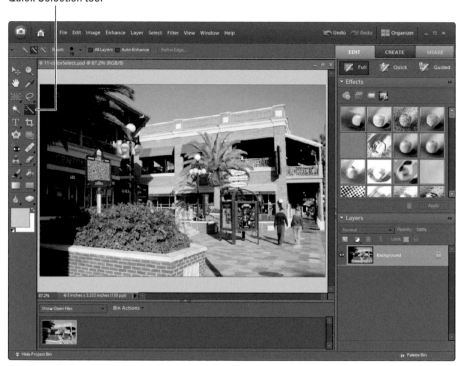

Figure 11-5: We're going to make a quick selection.

4. **Specify the following options:**

 • *Brush tip and size:* Specify the brush size and hardness from the drop-down menu, which is accessed by clicking the down arrow to the right (see Figure 11-6). A hard-edged brush (100 percent hardness) works well in most cases. If you have a digital tablet and stylus attached to your computer, you can choose to size the brush based on pen pressure or stylus wheel. If you don't have a digital tablet attached to your computer, choose Off for the Size option. You can also resize the brush by pressing the left bracket key ([) to decrease brush size, or the right bracket key (]) to increase brush size.

Figure 11-6: Specifying the brush size and hardness.

- *All Layers:* Include this option if you're working with multiple layers and you want the tool to create the selection based on the content of all layers.

- *Auto Enhance:* This option smooths the boundary of the selection and does some blending with the pixels surrounding the edge of the selection. Use this option when you require a selection with smooth edges.

5. **Click where the sky meets the palm trees and start dragging the tool across the sky.**

 As you drag the tool, a bounding box appears, indicating the current selection.

6. **Release the mouse button to create the selection.**

 A bounding box that looks like an army of marching ants indicates the selection, and a plus sign (+) appears in the brush, indicating you can add to the selection by dragging the tool over the desired area. Alternatively, you can click the icon with the minus sign (–) and delete areas from the selection by dragging over them.

7. **Refine the selection by adding to or subtracting from it.**

 At this point, you refine the selection edge, which is the topic of Exercise 11-8.

Using the Lasso Tools

The Lasso tools are a powerful trio used to round up pixels into nice, neat selections; hence the name Lasso. To create free-form selections, you use the Lasso tool. To create selections around objects that have defined shapes, there's the Polygonal Lasso tool. And last but not least, when you want to create a magnetic attraction to pixels that have well-defined edges, there's the Magnetic Lasso tool. The following exercises show you how to use each tool.

Exercise 11-5: Creating a Selection with the Lasso Tool

Use the Lasso tool when you need to make a free-form selection around an area. In the following exercise, you use the tool to create a selection around an eye.

1. **Launch the Photoshop Elements Edit workspace.**

 The easiest way to launch the Editor is to click the Photoshop Elements desktop icon and then click Edit. This opens the Edit workspace.

2. **Choose File⇨Open.**

 The Open dialog box appears. Navigate to the image 11-Lasso.psd that you down-loaded from the book's companion Web site.

3. **Select the Zoom tool and zoom in on the woman's eye.**

4. **Select the Lasso tool.**

 The Lasso tool looks, well, like a lasso.

5. **Drag around the perimeter of her eye to define the area of the selection.**

 As you drag the tool, a line appears that shows you the outline of your selection. The line may look a little ragged, especially if you're creating the selection with a mouse. Photoshop Elements smooths the selection after you create it.

6. **Release the mouse button to complete the selection.**

 Photoshop Elements surrounds the areas with a moving line, which is affection-ately called an *army of marching ants* by veteran Photoshop users (see Figure 11-7). If you select more than you want, you can delete pixels from the selection by hold-ing down Alt and dragging around the pixels you want to remove from the selec-tion. If you need to add pixels to the selection, hold down Shift and drag around the pixels you want to add to the selection. For example, if this portrait were pho-tographed from the front instead of the side, you'd hold down the Shift key and drag the tool around the subject's other eye.

Lasso tool

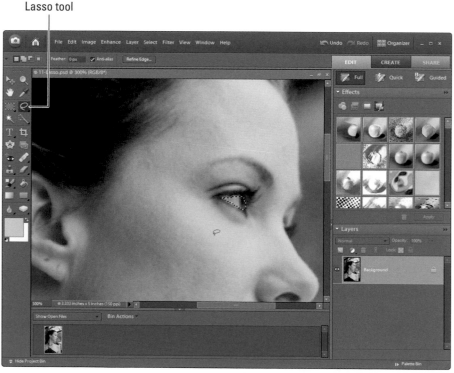

Figure 11-7: Creating the selection.

7. **Choose Select➪Save Selection.**

 The Save Selection dialog box appears (see Figure 11-8).

8. **Type a name for the selection.**

 Eye is as good a name as any.

9. **Click OK to save the selection.**

 When you save a selection, you can load it later when performing other edits to the image. When you save a selection, it is also saved with the image when the image (also known as a *document* in Adobe lingo) is saved.

Figure 11-8: Saving a selection.

Exercise 11-6: Creating a Selection with the Polygonal Lasso Tool

The Polygonal Lasso tool enables you to create point-by-point selections. It's the ideal tool for selecting rectangular shapes, also known as *polygons*. (I love truth in advertising, don't you?) The following exercise shows you how to create a selection with the Polygonal Lasso tool.

1. **Launch the Photoshop Elements Edit workspace.**

2. **Choose File➪Open.**

 The Open dialog box appears. Navigate to the image 11-polyLasso.psd that you downloaded from the book's companion Web site.

3. **Select the Zoom tool and zoom in on the restaurant windows.**

4. **Select the Polygonal Lasso tool.**

 The Lasso tool looks like a lasso. The Polygonal Lasso tool resides on a toolbar fly-out with his cousins Lasso and Magnetic Lasso (see Figure 11-9).

5. **Click in the upper-left corner of the first window.**

 This defines the first point of your polygonal selection.

Figure 11-9: Using the Polygonal Lasso tool.

6. **Click in the lower-left corner of the window where it intersects the red parking meter.**

 A dotted line appears between the two points.

7. **Continue clicking to add points to your selection.**

8. **After you create a point in the upper-left corner of the window, double-click to close the selection (see Figure 11-10).**

 If the selection isn't perfect, press Alt and create a selection around pixels you don't want to select, or press Shift and create a selection around pixels you want to add to the selection.

Figure 11-10: Creating a selection with the Polygonal Lasso tool.

9. **With the tool still selected, press Shift and add the other windows to the selection.**

The technique is the same. Click three corners of each window and then double-click to close the selection.

Exercise 11-7: Creating a Selection with the Magnetic Lasso Tool

The Magnetic Lasso tool does a great job of creating a selection along a well-defined edge. This exercise will show you how to develop a magnetic attraction to the tool and the results you can get from it.

1. **Launch the Photoshop Elements Edit workspace.**

The easiest way to launch the Editor is to click the Photoshop Elements desktop icon, and then click Edit. This opens the Edit workspace.

2. **Choose File⇨Open.**

The Open dialog box appears. Navigate to the image 11-magLasso.psd that you downloaded from the book's companion Web site. The file is a picture of Bridal Veil Falls in Yosemite. The sky is blown out to white and needs to be replaced. But before you can replace the sky, you need to select it. The well-defined edge at the rim of the canyon makes this job an obvious choice for the Magnetic Lasso tool.

3. **Select the Zoom tool, and zoom in on the area where the edge of the canyon meets the sky.**

The easiest way to zoom in on a specific area is to drag the tool around the perimeter of the area you want to edit.

4. **Select the Magnetic Lasso tool.**

 The tool options are displayed beneath the menu bar (see Figure 11-11).

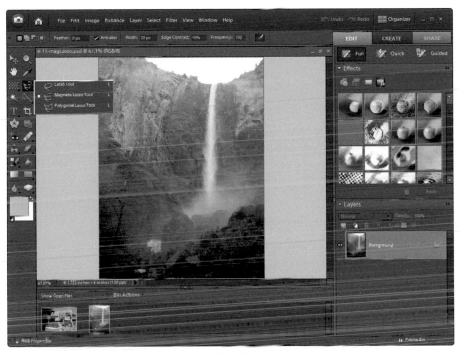

Figure 11-11: Creating a selection with the Magnetic Lasso tool.

5. **Set the following options:**

 - *Selection options:* The first four icons, which determine the type of selection. The choices are A: New; B: Add to; C: Subtract from; D: Intersect with. In this exercise, you're creating a new selection, which is the default option. If you were using the tool to modify an existing selection, you'd choose one of the other options.

 - *Feather:* Creates a gradual blend between the selection and surrounding pixels. The amount of feathering is determined by the size of the selection. You can specify feathering when creating the selection or after the fact. I suggest accepting the default value of 0 pixels, which creates a hard-edged selection, and applying feathering after the selection is created. You can always undo the feathering if you apply too much or too little and then apply it again. However, if you apply feathering when you create the selection, you need to re-create the selection if you specify too high or low a value.

 - *Anti-alias:* Smooths the edges of a selection. I suggest you accept this default option when you create selections with the Magnetic Lasso tool.

 - *Width:* Determines the distance from which the tool detects edges. In most cases, the default value of 10 pixels works well.

- *Edge Contrast:* Determines the tool's sensitivity when detecting edges. Specify a low value when the edge has low contrast; a high value when the edge has a lot of contrast. For this exercise, a value of 50 percent works well.

- *Frequency:* Determines how often the tool creates anchor points. Type a value between 0 and 100. A high value creates points frequently and a low value creates points infrequently.

- *Stylus Pressure:* Used when you're working with a digital tablet and stylus. When this option is enabled, increasing stylus pressure decreases the width of the edge.

6. **Click the point where the sky, rock, and edge of the image intersect.**

 This creates the first anchor point for your selection.

7. **Drag the tool along the edge of the rock.**

 As you drag along the edge, the tool creates anchor points.

 When creating a selection along a well-defined edge, specify a high value for width and edge contrast, and then loosely trace the edge. If you're dealing with an edge that has low contrast, specify a small value for width and edge contrast, and then precisely trace the edge.

8. **When you reach the edge of the first tree, click.**

 This creates an anchor point. When you reach an edge that needs to be included in the selection, creating an anchor point ensures it will be part of the final selection. Create additional anchor points around the tree to include it in the selection.

9. **Continue dragging the tool along the edge of the rock and creating anchor points when necessary.**

 If the tool creates points that are not along the edge, press Backspace and move the tool over the points to delete them from the selection. You can also momentarily select the Lasso tool by clicking and then pressing Alt, or momentarily select the Polygonal Lasso tool by pressing Alt and then clicking. Release the Alt key to revert to the Magnetic Lasso tool.

10. **When you reach the point where the rock and sky intersect the right side of the image, double-click to close the selection.**

 Photoshop Elements defines the selection with the world-famous army of marching ants.

Use the Lasso tools on your own photos to create selections. Create a selection whenever you need to confine a tool or menu command to a specific area. When you create a selection, the area outside of the selection is protected from the effects of any tool or menu command.

If you need to protect an area you selected, choose Select⇨Inverse to invert the selection.

Refining Selections

When you create a selection, you can use the Refine Edges button to refine the edges of your selection. This is a tremendous timesaver. In previous versions of Photoshop Elements, you had to use many different commands to achieve the results that are possible with the Refine Edges option. When you refine an edge, you can also feather the edge. This determines the amount by which the edge of the selection blends with the surrounding pixels. The following exercise explores the Refine Edges option, and feathering a selection.

Exercise 11-8: Refining Edges

1. **Create a selection with any of the selection tools.**

2. **Click the Refine Edge button.**

 The Refine Edge dialog box appears (see Figure 11-12).

3. **Specify a value for the Smooth option.**

 You can drag the slider, or type a value in the text box. This option smooths jagged edges in the selection. Use a high value if your selection has a lot of jagged edges.

4. **Specify a value for the Feather option.**

 You can drag the slider or type a value in the text box. This option blurs the selection edge to blend it with the surrounding pixels. The value you specify is determined by the size of your selection. If you're selecting a small object, like a person's teeth, specify a small value of 1 or 2 pixels. If you're feathering a large selection, specify a larger value. The value is determined by the size of the image compared to the selection. For a large selection on small photos, a value of 15 pixels is appropriate; for a large, high-resolution image, you might go as high as 100 pixels. It all depends on the effect you're trying to achieve.

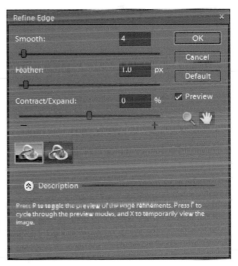

Figure 11-12: Refining the edges of a selection.

5. **Contract or expand the selection.**

 This option contracts or expands the selection by a given percentage. Contracting (shrinking) the selection is useful when you have a lot of detail in the selection edges and may have some stray pixels from outside the selection.

6. **Choose a preview option.**

 The default preview option shows the infamous army of marching ants border around the selection. Click the red button to display a red overlay on the selection. The Preview check box is selected by default, which means that when you change an option in the Refine Edge dialog box, the selection in your image updates in real time.

7. **When you're satisfied with the refined edge, click OK.**

 Photoshop Elements refines the selection just the way you want it.

If you use the Rectangular, Elliptical Marquee, or Magnetic Lasso tool, the Refine Edges button does not appear. These tools create a well-defined edge that does not need to be smoothed. You can, however, blend the selection with the surrounding pixels by choosing Select⇨Feather and then specifying the amount to feather the selection in the Feather dialog box.

To hide a selection, press Ctrl+H. If you use a tool and nothing happens, press Ctrl+H to unhide a selection, and then press Ctrl+D to deselect it.

Use the selection tools on your own images. Experiment with the different settings when you use the tools and then refine the edges. The only way to master these tools is to use them until they become second nature.

Using the Clone Stamp Tool

Did you ever take an attractive picture of a beautiful landscape, but right in the middle, you later spot a nasty patch of brown weeds? Or maybe you're a real estate agent and you took a photo of your client's humble abode before it was repaired and, to your dismay, you see a handprint on the wall? If you open either photo in Photoshop Elements, you can summon the Clone Stamp tool — also known as "Captain Clone Stamp: Here he is, to save the photo!" — to apply a bit of digital fertilizer or digital stucco. The following exercise explores the digital-fertilizer scenario.

Exercise 11-9: Using the Clone Stamp Tool

1. **Launch the Photoshop Elements Edit workspace.**

2. **Choose File⇨Open.**

 The Open dialog box appears. Navigate to the image 11-digitalFertilizer.psd that you downloaded from the book's companion Web site.

3. **Select the Clone Stamp tool.**

 The tool options below the menu change (see Figure 11-13).

4. **Adjust the tool options.**

 • *Brush tip:* Choose a brush tip from the drop-down menu. Choose a tip with a soft edge, which is designated by a solid center with a blurry outline. A soft-tipped brush hides the evidence of your digital sleight-of-hand.

 • *Size:* You can manually type a brush size in the Size field. Alternatively, you can press the right square bracket key (]) to increase brush size, or the left square bracket key ([) to decrease brush size. Specify a size that is appropriate for the features you are cloning. For this exercise, specify a brush size of 100 pixels.

Clone Stamp tool

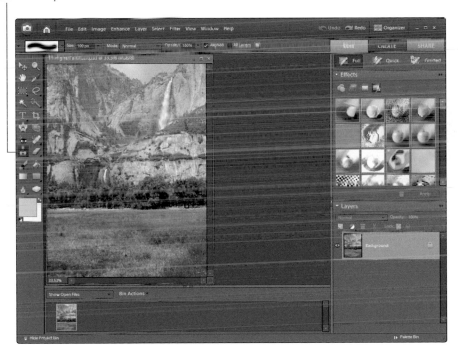

Figure 11-13: Getting ready to apply a heaping helping of digital fertilizer.

 • *Aligned:* This option is selected by default. It maintains the relative position of the clone source to the current brush position.

 • *All Layers:* Choose this option and the tool clones pixels from all layers.

5. **Alt+click the source pixels you want to clone.**

 For this exercise, click the area of thick green grass on the right side of the image.

6. **Drag inside the area to be repaired.**

 Start filling in the brown patch at the bottom of the image. Eventually, you'll start cloning brown weeds. When you drag the tool, you'll see a plus sign (+) that indicates the source pixels. When the icon gets close to where the weeds were, you need to sample another source.

7. **Alt+click a different area in the image.**

 The key to a successful clone job is to sample many areas so that the viewer doesn't see repeating patterns, which is a dead giveaway that the picture has been digitally manipulated.

8. **Continue cloning pixels into the brown grass.**

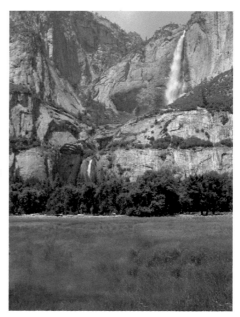

Figure 11-14: The repaired image.

For this exercise, you're repairing a large area. You'll have to change your source several times in order to get a realistic-looking result (see Figure 11-14).

Exercise 11-10: Cloning from Another Image

If you don't have pixels in your source image that you can clone, you can use a different image as a source and clone pixels from it. For example, if you've got a bright blue sky — boring! — you can replace it with the sky from another image. Follow these steps to clone pixels from one image to another.

1. **Launch the Photoshop Elements Edit workspace.**

 The easiest way to launch the Editor is to click the Photoshop Elements desktop icon and then click Edit. This opens the Edit Workspace.

2. **Choose File➪Open.**

 The Open dialog box appears. Navigate to the image 11-colorSelect.psd that you downloaded from the book's companion Web site.

3. **Use the Magic Wand tool to select the sky.**

 If you didn't work through Exercise 11-3 on using the Magic Wand tool, do so now. It uses the same image as in this lesson.

4. **Choose File➪Open.**

 The Open dialog box appears. Navigate to the image 11-replaceSky.psd that you downloaded from the book's companion Web site and then click Open.

5. **Choose Window⇨Images⇨Tile.**

 The images are displayed one on top of the other (see Figure 11-15).

6. **Select the Clone Stamp tool.**

 The tool's options are displayed below the menu bar.

7. **Accept the default settings, but change the brush diameter to 100.**

Figure 11-15: Tiling the images.

8. **Alt+click the areas to the left of the tallest cloud in the image 11-replaceSky.psd.**

9. **Drag the tool inside the selection in image 11-colorSelect.psd.**

 The selection prevents the clouds from being cloned on top of the buildings. Make sure you drag the tool to the bottom of the selection. If you don't like your first attempt, press Ctrl+Z to undo the change, and then sample a different area in your source image and drag the tool inside the target image.

10. **Choose Select⇨Deselect.**

 Alternatively, you can press Ctrl+D to remove the selection. Your finished image should resemble Figure 11-16.

Figure 11-16: The repaired image.

Working with Layers

Layers are powerful tools. When you create layers, you can confine your changes to individual layers. You can change the manner in which layers interact by changing layer opacity and the layer blend mode. The following three exercises show you how to create a layer, work with adjustment layers, and explore the popular blend modes.

Exercise 11-11: Creating a Layer

1. **Launch the Photoshop Elements Edit workspace.**

The easiest way to launch the Editor is to click the Photoshop Elements desktop icon and then click Edit. This opens the Edit Workspace.

2. **Open an image.**

3. **Choose Layer⇨Duplicate Layer.**

Photoshop Elements creates a duplicate of the background layer. Duplicating a background layer is useful when an image requires a lot of editing. Professional photographers use layers to nondestructively edit images, which means that when

you apply your edits to a layer and you don't get the desired result, you can just delete the duplicated layer. Your original photograph is still on the background layer, none the worse for wear. Alternatively, you can duplicate a layer by pressing Ctrl+J or, in the Layers palette, drag the background layer to the Create a New Layer icon.

4. **In the Layers palette, drag the duplicate layer to the Trash icon.**

The layer is deleted. Alternatively, you can select a layer and then press Delete.

5. **Use one of the selection tools to create a selection.**

6. **Choose New⊅Layer Via Copy.**

Photoshop Elements creates a copy of the selection on the new layer. This option is useful when you want to modify a specific area of your image, but don't want to change the original. You can choose New⊅Layer Via Cut, in which case Photoshop Elements cuts the selected area from the background layer and moves the cut pixels to a new layer.

Exercise 11-12: Using Adjustment Layers

Adjustment layers are a great way to apply changes to an image without destroying the original image. There are several adjustment layers in Photoshop Elements. A full-blown description of every Adjustment layer is beyond the scope of this book, but the following exercise explores a couple of them:

1. **Launch the Photoshop Elements Edit workspace.**

The easiest way to launch the Editor is to click the Photoshop Elements desktop icon and then click Edit. This opens the Edit workspace.

2. **Open an image.**

3. **In the Layers palette, click the diagonally divided black-and-white circle.**

A drop-down list displays the Photoshop Elements Adjustment layers (see Figure 11-17).

4. **Select the Hue/Saturation Adjustment layer.**

The Hue/Saturation dialog box appears (see Figure 11-18).

5. **Click the Colorize check box.**

The image is tinted a light blue.

6. **Drag the Hue and Saturation sliders.**

The image is tinted a different color.

7. **Click OK.**

The Hue/Saturation Adjustment layer is applied to the image (see Figure 11-19).

Adjustment Layer icon

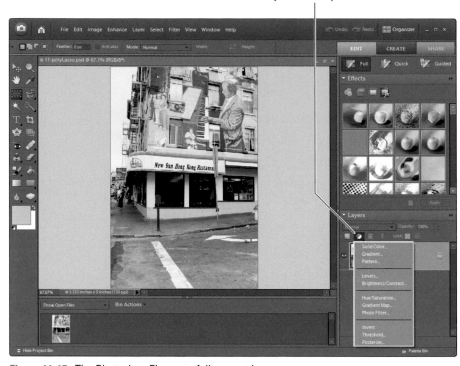

Figure 11-17: The Photoshop Elements Adjustment layers.

8. **Click the eyeball icon next to the adjustment layer.**

 The layer is temporarily hidden.

9. **Click the eyeball icon again.**

 The layer is revealed.

10. **Double-click the Hue/Saturation Adjustment Layer icon.**

 The Hue/Saturation dialog box is revealed. You can now change the original settings. That's the beauty of adjustment layers: You can change the settings at any time before you flatten the image.

11. **Click OK to close the Hue/Saturation Adjustment Layer dialog box.**

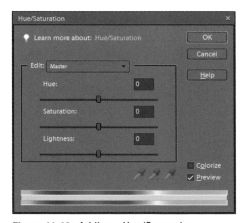

Figure 11-18: Adding a Hue/Saturation Adjustment Layer.

12. **Select the Hue/Saturation Adjustment layer, and then click the garbage can icon.**

 Like a street artist says, "Easel come, easel go." The adjustment layer is deleted.

13. **Click the Adjustment Layer icon and then choose Photo Filter.**

 The Photo Filter dialog box appears. The default filter is the digital equivalent of the 85 warming filters that photographers use to warm an image that has a blue color cast.

Click to edit

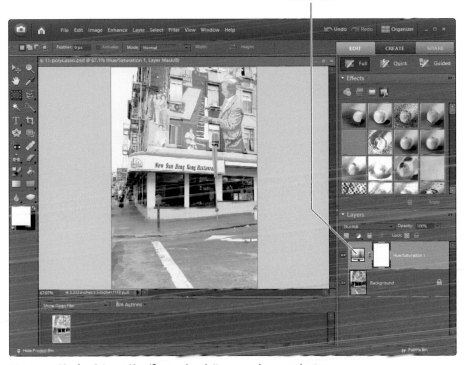

Figure 11-10: Applying a Hue/Saturation Adjustment layer to the image.

14. **Select a filter from the drop-down menu.**

 There are several photo filters from which to choose (see Figure 11-20). You can choose a filter that warms an image, cools it, or tints it.

15. **If you're editing your own image, you flatten the image (choose Layer ➪ Flatten Image) when you're done and then save it.**

While you still have the image open, experiment with other adjustment layers to see the effect they have on your photo.

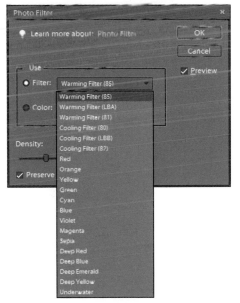

Figure 11-20: Using a Photo Filter Adjustment layer.

Exercise 11-13: Understanding Layer Blend Modes and Opacity

When you add a layer to your image, the uppermost layer eclipses those beneath it. However, if you apply a blend mode other than Normal, the pixels of the underlying layers interact with those of the uppermost layer. If you change layer opacity, you partially reveal the pixels from the underlying layer. This exercise introduces you to some of the blend modes and explores layer opacity.

1. **Launch the Photoshop Elements Edit workspace.**

2. **Open an image.**

3. **In the Layers palette, click the Layer Adjustment icon.**

 The Adjustment Layers icon is a black-and-white diagonally bisected circle.

4. **Select Solid Color.**

 The Solid Color dialog box opens.

5. **For this exercise, accept the default color and click OK.**

 A solid blue layer appears over your image.

6. **Position your cursor over the word Opacity. When it becomes a hand with a pointing finger and two arrows, click and drag left to lower the layer opacity.**

 The uppermost layer becomes partially opaque, revealing some of the underlying layer (see Figure 11-21).

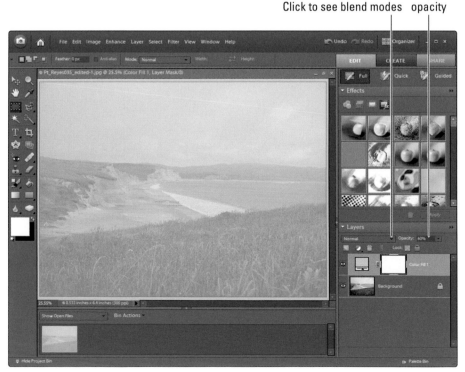

Figure 11-21: Lowering layer opacity.

7. **Change layer opacity back to 100 percent.**

8. **Click the down arrow to the right of the word Normal.**

 The list of blend modes appears.

9. **Choose Multiply.**

 This blend mode multiplies the colors in the underlying layer by the colors in the layer to which the blend mode is applied, which effectively darkens the image.

10. **Open the layer blend list and choose Screen.**

 This blend mode multiplies the inverse of the colors in the background layer with the inverse of colors in the layer to which the blend mode is applied, which effectively brightens the image.

11. **Open the layer blend list and choose Lighten.**

 This blend mode examines the colors from the underlying layer and the layer to which the blend mode is applied and chooses the lighter color.

12. **Open the layer blend list and choose Darken.**

 This blend mode examines the colors from the underlying layer and the layer to which the blend mode is applied and chooses the darker color.

13. **Continue experimenting with the other blend modes to see the effect they have on your image.**

 Blend modes are useful when you're creating special effects. After you experiment with blend modes for a while, you'll understand how to use them when editing your images.

Retouching Images

Even the simplest point-and-shoot digital camera captures an unbelievable amount of detail; sometimes more detail than is flattering to your subject. When you have a nice portrait of someone that needs a little touching up — to paraphrase Carly Simon, "You're so vain, I bet you think this sentence is about you" — you can easily touch up minor flaws with the Spot Healing Brush and Healing Brush tools. The following exercise shows how to retouch an image.

Exercise 11-14: Retouching Images

1. **Launch the Photoshop Elements Edit workspace.**

2. **Choose File➪Open.**

 The Open dialog box appears. Navigate to the image 11-retouch.psd and then click Open.

3. **Press Ctrl+J.**

 This creates a duplicate of the background layer. When you retouch an image, it's advisable to do your work on a duplicate layer. If the edits don't turn out as expected, you can delete the duplicated layer upon which you've applied your edits and your original image is untouched.

4. **Select the Zoom tool and drag the tool around the woman's chin.**

 This is the first area you'll touch up. You'll remove the texture on the skin below her mouth.

5. **Select the Healing Brush tool, which looks like a Band-Aid.**

 The Healing Brush tool repairs an image by examining pixels from the source you specify and then blending them with the area where you use the tool. The tool defaults are perfect for touching up blemishes on a person's face. The tool continually samples from the area you click. If you choose the aligned option for this task, the source area is aligned with the tool and moves as you retouch the image, which means you may end up sampling unwanted areas.

6. **Alt+click the smooth flesh to the right of her chin.**

7. **Click the areas on the skin with texture.**

 To repair large areas, click and drag over the area. To touch up a small area, click it. You may have to resize the tool brush tip as you work. You can increase the size of the tool brush tip by pressing the right bracket key (]), or decrease the brush size by pressing the left bracket key ([). After you touch up the chin, it should resemble Figure 11-22.

Healing Brush tool

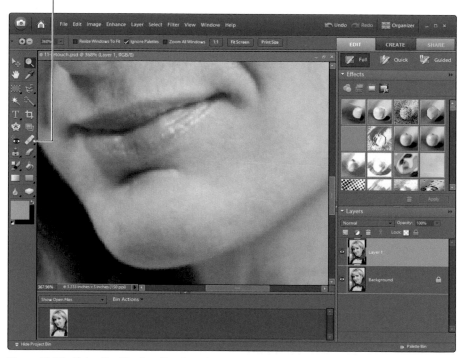

Figure 11-22: Using the Healing Brush tool.

8. **Press Ctrl+0 (zero).**

 This shortcut fits the entire image in the Photoshop Elements workspace. I suggest that you memorize the keyboard shortcuts for the commands and tools you use the most. This will save you a tremendous amount of time during image processing, which in turn gives you more time to take photographs.

9. **Press Z to select the Zoom tool and drag the tool around her eye and cheek.**

 The next area of the photo you'll retouch is her cheek.

10. **Press J.**

 This selects the Healing Brush tool. I told you keyboard shortcuts were powerful!

11. **Alt+click an area of smooth skin below her cheekbone.**

 Always sample an area of clean skin close to the area you're going to repair.

12. **Click the areas of skin with texture on her cheek.**

13. **Select the Spot Healing Brush tool.**

 This tool resides on a fly-out with its best buddy, the Healing Brush tool (see Figure 11-23).

Figure 11-23: Using the Spot Healing Brush tool.

14. **Click the dark spots on her right cheek.**

 The Spot Healing Brush tool repairs an area by sampling nearby pixels and blending them with the area where you click the tool. When you use this tool, it needs to be slightly larger than the area you're repairing. You can increase the size of the tool brush tip by pressing the right bracket key (]), or decrease the brush size by pressing the left bracket key ([). At this point, you could remove the character lines, also known as crow's feet. However, when people look at a photograph of a mature person, they expect to see some character lines. You'll deal with those lines in the following steps.

15. **Select the duplicated layer and press Ctrl+J.**

 Yep, you're creating a duplicate of the duplicate.

16. **Select the Healing Brush tool.**

17. **Alt+click an area of smooth skin below the character line under her right eye.**

18. **Drag the tool over the character lines under her right eye.**

19. **Alt+click an area of smooth skin below the character line under her left eye.**

20. **Drag the tool over the character lines on her left eye.**

 Now you've removed all character lines, but the photo looks *too* perfect.

21. **Lower the opacity of the uppermost layer until the character lines begin to appear.**

 For this image, an opacity of 60 percent is perfect.

22. **Choose Layer⇨Flatten Image.**

 Photoshop Elements merges all layers. Your retouched photograph should resemble Figure 11-24.

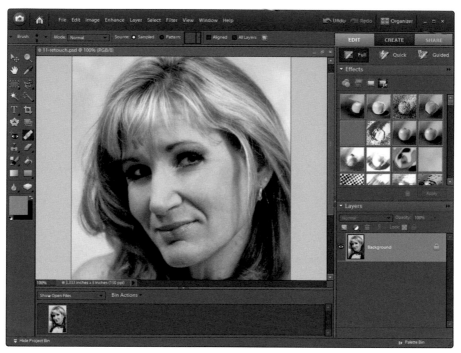

Figure 11-24: The retouched image.

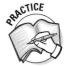

The Spot Healing Brush and Healing Brush tools are also useful when you want to restore old photographs. Scan into Photoshop Elements an old photograph that is creased and discolored. Use the Healing Brush tool to repair areas where the photo is creased. Use the Spot Healing Brush tool to repair spots on the image. After you repair the image, use some of the auto-fixes from the Enhance menu to color-correct the image, adjust levels, sharpen, and so on. With a bit of patience, you can restore to their former glory photos that are creased, tattered, and discolored.

Extracting a Subject from the Background

Have you ever taken a photo of someone that turned out great, but the background was awful? If so, you can extract the subject from the background and replace the background. The following exercise shows you how to accomplish this task in Photoshop Elements.

Exercise 11-15: Extracting a Subject from the Background

1. **Launch the Photoshop Elements Edit workspace.**

The easiest way to launch the Editor is to click the Photoshop Elements desktop icon and then click Edit. This opens the Edit workspace.

2. **Choose File➪Open.**

 The Open dialog box appears. Navigate to the image 11-extract.psd.

3. **Press Ctrl+J.**

 You've created a duplicate of the background layer. After you extract the subject from the duplicate layer, you'll modify the background layer.

4. **Choose Image➪Magic Extractor.**

 The Magic Extractor dialog box opens.

5. **Select the Foreground Brush tool and click inside the area of the photo you want to keep.**

 For this exercise, click repeatedly inside the little boy with the camera. Make sure you click each area except the camera strap dangling from his right arm. When you get close to the edge of his hat, decrease the brush size by pressing the left bracket key repeatedly until the brush is fairly small. You also want a fairly small brush at the edge of his hair. Make sure you click a couple of times at the bottom of his pants. When you're done defining the subject, your dialog box should look similar to Figure 11-25.

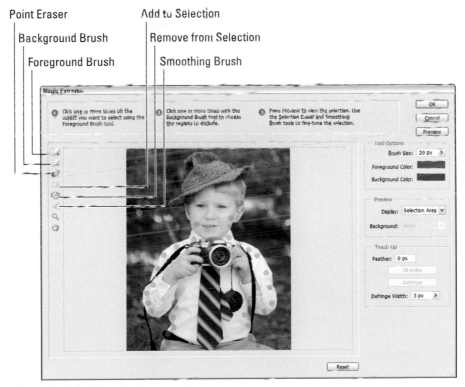

Figure 11-25: Defining the foreground.

6. Select the Background Brush tool and click inside the areas of the photo you want to discard.

Make sure you click several areas where the color is similar to the foreground. For example, the bright yellow colors by his left ear are close to the color of his hair. If you don't accurately define this area, it will be included as part of the selection. You'll also have to click inside the area between the camera strap and his body (see Figure 11-26). Decrease the brush size when working in small areas like this and click several times.

Use the Zoom tool to zoom in on small areas, such as the area between the camera strap and the boy's body.

If you add a point in error, select the Point Erase tool and erase the errant point.

Figure 11-26: Defining the background to remove from the photo.

7. Click Preview to view the extraction.

Yikes! There are some big holes in the middle of the image.

8. Select the Add to Selection tool and drag it over the areas you need to add to the selection.

9. Select the Zoom tool and zoom in on the edge of the extraction.

10. Press the spacebar to momentarily select the Hand tool.

11. Pan around the edge of the extraction and examine the edge.

You may find some areas where parts of the boy are missing or the edge is ragged.

12. Select the Smoothing Brush and drag it over any ragged edges.

The edge is restored.

13. **Click Fill Holes.**

 The Magic Extractor fills any holes in the extraction.

14. **Click Defringe.**

 The Magic Extractor cleans up the edges of the extraction.

15. **Click OK to complete the process.**

16. **In the Layers palette, click the eyeball for the duplicated layer.**

 The layer is hidden (see Figure 11-27).

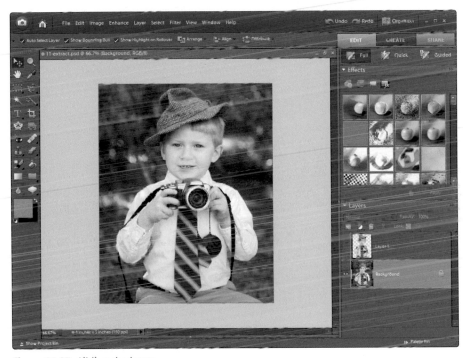

Figure 11-27: Hiding the layer.

17. **Select the Gradient tool.**

18. **Double-click the currently selected gradient from the tool options.**

 This opens the Gradient Editor dialog box (see Figure 11-28).

19. **Select the Violet, Orange preset.**

 It's the fifth icon from the right in the top row.

20. **Click OK.**

 The Violet, Orange preset is locked and loaded.

21. **In the Layers palette, select the background layer.**

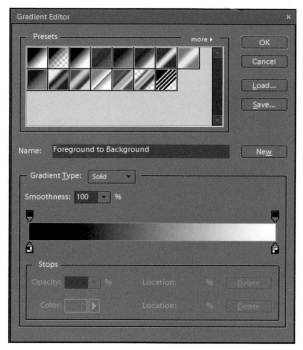

Figure 11-28: Editing the gradient.

22. **Hold the Shift key and drag from the top of the image to the bottom.**

 The background is replaced with the gradient. Holding the Shift key constrains the motion 90 degrees vertically when you drag from top to bottom, 180 degrees horizontally when you drag from left to right, and 45 degrees when you drag diagonally.

23. **Click the duplicated layer eyeball icon to reveal the layer.**

 The extracted image looks pretty good on the new background, but it can be improved.

24. **Ctrl+click the duplicated layer.**

 Photoshop Elements creates a selection around the extraction.

25. **Choose Select➪Modify➪Smooth.**

 The Smooth Selection dialog box appears.

26. **Type 2 in the Sample Radius text box and then click OK.**

 Photoshop Elements smooths the edges of the selection.

27. **Choose Select➪Modify➪Contract.**

 The Contract Selection dialog box appears.

28. **Type 2 in the Contract By text box and then click OK.**

 Photoshop Elements shrinks the selection by 2 pixels, which effectively removes any jagged edges.

29. **In the Layers palette, select the duplicated layer and press Ctrl+J.**

 Photoshop Elements creates a new layer based on the modified selection.

30. **Select the second layer and press Delete.**

 Photoshop Elements prompts you to confirm the deletion.

31. **Click OK.**

 Photoshop Elements deletes the layer.

32. **Choose Layer⇨Flatten Image.**

 Photoshop Elements flattens all layers to a single image, as shown in Figure 11-29.

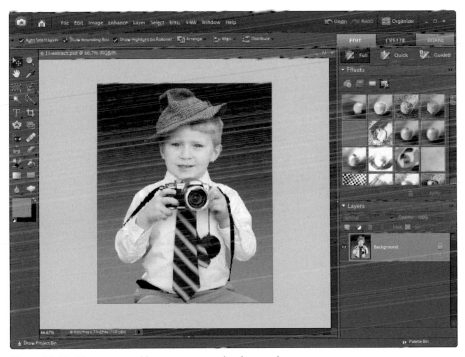

Figure 11-29: The extracted image on a new background.

Chapter 12

Adding Pizzazz with Special Effects

· ·

· ·

A fter you get an image into your computer and do some minimal editing, you may think that's all there is, but that would be an incorrect assumption. After you edit an image, you can do all sorts of things with it. You can add text, make the image look like a painting, make it look like a photo shot with an old-fashioned camera, and much more. Photoshop Elements has a treasure trove of filters. In addition, you can augment the powerhouse with third-party filters. The exercises in this chapter help you unleash your creative inner child and point you in the right direction for adding your own sense of style to images with special effects.

Adding Layer Styles

After you've edited an image to pixel perfection, you can take it to the next level by adding layer styles. As the name *layer styles* implies, you add the style to a layer other than the background. The following exercise introduces you to some of the cool things you can do with layer styles.

Exercise 12-1: Introducing Layer Styles

1. **Launch the Photoshop Elements Edit workspace.**

The easiest way to launch the Editor is to click the Photoshop Elements desktop icon and then click Edit. This opens the Edit workspace.

2. **Choose File⇨Open.**

The Open dialog box appears. Navigate to the image 12-layerStyles.psd and then click Open.

3. **In the Layers palette, select the background layer and press Ctrl+J.**

 Voilà! You've got a duplicate layer.

4. **In the Effects palette, click the Layer Styles icon.**

 It's the second icon from the left (see Figure 12-1).

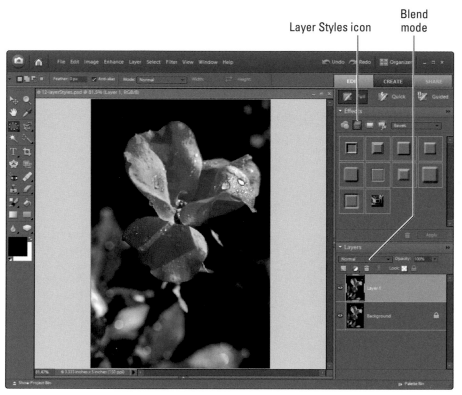

Layer Styles icon

Blend mode

Figure 12-1: You've got layer styles.

5. **Click the Layer Styles drop-down arrow to reveal the available style groups.**

 As you can see, there are lots of layer styles to explore.

6. **Select the Wow Plastic category.**

 The Effects palette refreshes and shows the available layer styles in this category.

7. **Click and drag the red icon in the bottom row and drop it on top of the image.**

 The image looks like it has been encased in opaque red plastic. Alternatively, you can click Apply in the Effects palette to apply the style to the layer.

8. **In the Layers palette, reduce the opacity to 60 percent.**

You lower the opacity by clicking the down arrow to the right of the word *Opacity* and then dragging the slider. Alternatively, you can pause the cursor over the word *Opacity* until you see a pointing finger with a dual-headed arrow. When you lower the opacity, the effect isn't quite as strong.

9. **Change the blend mode to Difference.**

To change the blend mode, click the down arrow to the right of the current blend mode, and then choose Difference from the drop-down menu. The plastic-fantastic flower takes on a purple hue (see Figure 12-2).

10. **Experiment with other blend modes and opacity settings to see the effect they have on the image.**

The previous exercise is the tip of the iceberg when it comes to layer styles. Experiment with the other layer style categories on the image supplied for the last exercise and your own images. When you find a style, opacity, and blend mode that you like, jot down the information for future reference.

Figure 12-2: Plastic flower — oh, baby, now you're such a drag.

Applying Effects with Filters

Photoshop Elements has lots of filters, more than you'll probably ever use. Some of the filters are menu commands, and others can be found in the Effects palette. The following exercise introduces you to some of the artistic filters.

Exercise 12-2: Adding a Touch of Pizzazz with Artistic Filters

1. **Launch the Photoshop Elements Edit workspace.**

2. **Choose File➪Open.**

The Open dialog box appears. Navigate to the image 12-filters.psd and then click Open.

3. **Choose Filters➪Artistic.**

 You'll see a wide variety of filters you can use to transform your image. However, when I'm modifying an image, I prefer to do my work on a separate layer. When you apply an artistic filter to a layer, you can lower the opacity to reveal the original image.

4. **Press Ctrl+J.**

 You've got a carbon copy of the original image on a new layer.

5. **In the Effects palette, click the Filters icon.**

 It's the first icon in the palette that looks like three photo filters arranged in a symmetrical pattern.

6. **Click the Filters drop-down arrow.**

 The Filters menu appears (see Figure 12-3).

Filters icon

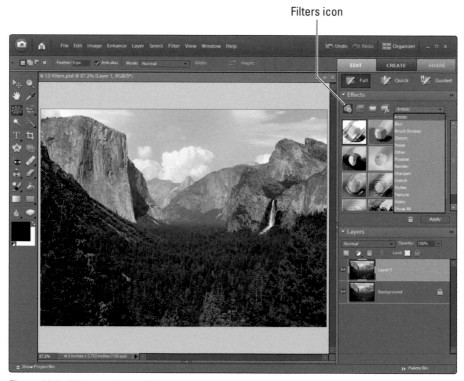

Figure 12-3: Filters, get your filters.

7. **Choose Artistic.**

 The Effects palette shows the available artistic filters.

8. **Select the Rough Pastels icon and drop it on the image.**

The Rough Pastels icon is the second icon in the third row. After you drop the icon on the image, the Rough Pastels dialog box appears (see Figure 12-4). As you can see, the filter does a good job of creating a reasonable facsimile of an artist using rough pastels on a canvas. Notice that there are lots of sliders you can use to vary the look. Experiment with them. If for some reason the artistic filter you selected isn't right for your image, you can select another style.

You can apply more than one artistic effect to an image. After applying one effect to an image, click the New Effect Layer icon in the lower-right corner of the dialog box. Click the new effect layer to select it, and then click a different icon. Try combining the Watercolor effect and then the Paint Daubs effect.

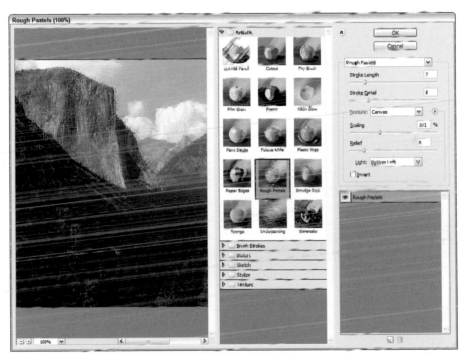

Figure 12-4: Rough pastels for hire.

9. **Click OK to close the Rough Pastels dialog box.**

The filter is applied to your image.

10. **In the Layers palette, lower the opacity to 85 percent.**

The underlying layer is revealed at low opacity, which reveals more detail.

Try using filters on your own images. The Sketch filters create effects similar to chalk or charcoal drawings. The Brush Strokes are good for creating painterly images.

Creating Black and White Photos

Most digital cameras have a menu command to convert an image to black and white. The resulting images don't look like the richly toned black-and-white images available from film cameras. This is because the camera simply desaturates the color. You can, however, create a great-looking black-and-white image from within Photoshop Elements by following the steps in this exercise.

Exercise 12-3: Creating a Black and White Photo

1. **Launch the Photoshop Elements Edit workspace.**

2. **Choose File➪Open.**

The Open dialog box appears. Navigate to the image 12-BW.psd and then click Open.

3. **Choose Enhance➪Convert to Black and White.**

The Convert to Black and White dialog box appears. The command has an uncanny way of selecting the proper preset for the photo you're converting (see Figure 12-5). For this image, it selected Scenic Landscape, which is spot on. Notice that you have a before-and-after window. This is useful when you fine-tune the conversion.

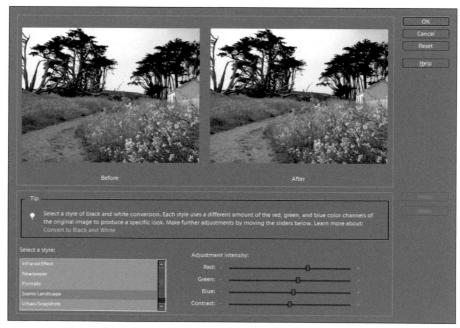

Figure 12-5: Converting an image to black and white.

4. **Drag the Adjustment Intensity sliders to fine-tune the conversion.**

 Notice the colors in the before window. For example, if you've got a lot of blue in the sky, you can darken the sky in the conversion by dragging the blue slider to the left. This image was shot on an overcast day, so there's only a small patch of blue. When you drag a slider, the after image updates in real time. Don't overdo any adjustment, however, because each hue in your image is composed of red, green, and blue. When you drag one slider, the predominant effect is on that color, but the change affects all hues in the image. You can also adjust the contrast. For this image, I

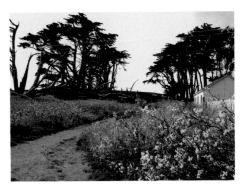

Figure 12-6: Black and white photos with pizzazz!

 increased the contrast, dragged the green slider a little to the left, and dragged the red slider a little to the right. The converted image is shown in Figure 12-6.

Experiment with the other black-and-white conversion styles. If your image has a lot of foliage and was shot on a sunny day, try the Infrared Effect style.

Using Photo Effects

If you want to tone an image or make it look like an antique photograph, or just plain get wacky, you'll love the photographic effects. As with all of the Photoshop Elements Effects groups, there are lots of Photo Effects. In the following exercise, you'll chisel the tip of the iceberg.

Exercise 12-4: Using Photographic Effects

1. **Launch the Photoshop Elements Edit workspace.**

2. **Choose File⇨Open.**

 The Open dialog box appears. Navigate to the image 12-photo.psd.

3. **In the Effects palette, click the Photo Effects icon.**

 It's the third from the left.

4. **Click the drop-down arrow to reveal the available photo effects.**

5. **Choose Frame.**

 The palette refreshes and displays three icons.

6. **Drag the Drop Shadow icon onto the photo.**

 Photoshop Elements does a bang-up job of creating a photo with a drop shadow (see Figure 12-7). Notice that Photoshop Elements took care of duplicating the layer for you. Photo Effects are no-brainers.

Photo Effects icon

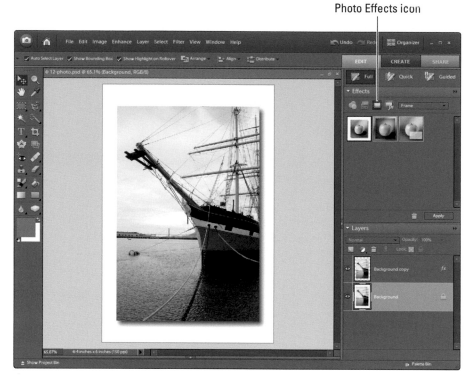

Figure 12-7: Creating a drop shadow frame.

7. **Choose Window➪Undo History.**

 The Undo History dialog box appears (see Figure 12-8). This is a great way to undo multiple steps, especially when you're working with Effects and you want to make some changes. I like the drop shadow frame, but I want to show you other Photo Effects, so I've chosen the quick-and-easy way to undo what Photoshop Elements has done. The Undo History dialog box shows the last 20 steps you've done.

 Figure 12-8: Undoing history, the Photoshop Elements way.

8. **Click Open.**

 The steps used to create the drop shadow frame are history. Hmmm, I guess that's why they call it Undo History.

9. **Close the Undo History dialog box.**

10. **Click the Photo Effects drop-down arrow and choose Monotone Color from the drop-down menu.**

 The Effects palette refreshes with a spiffy set of color apples.

11. **Drag the brown apple over the image.**

Photoshop Elements creates a new layer and you've got a beautiful sepia-tinted image (see Figure 12-9).

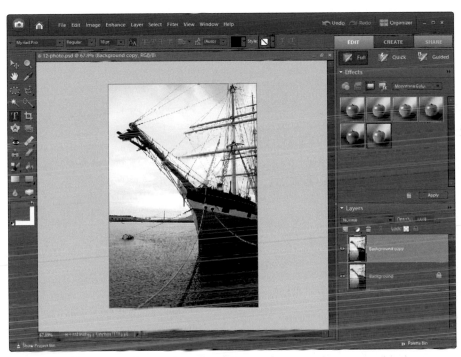

Figure 12-9: It's so easy when you use Photo Effects.

While you still have the photo open, experiment with the other Photo Effects. I'm sure you'll find several that you'll want to use on your own images.

Creating a Vignette

A *vignette* is a circular border around the center of interest in a photograph. Vignettes are effective when used with a portrait. The following exercises explore two ways to create a vignette in Photoshop Elements.

Exercise 12-5: Creating a Quick-and-Dirty Vignette

This technique uses a menu command to create a vignette around the borders of an image. The technique works best on a subject that is photographed against a light background.

1. **Launch the Photoshop Elements Edit workspace.**

2. **Choose File⇨Open.**

 The Open dialog box appears. Navigate to the image 12-vignette_01.psd and then click Open.

3. **Choose Filter⇨Correct Camera Distortion.**

 The Correct Camera Distortion dialog box appears (see Figure 12-10). The Correct Camera Distortion command is generally used to remove vignetting and barrel distortion that occurs with certain lenses. In this case, I'm going to use it to quickly add a vignette to a photo.

Figure 12-10: The Correct Camera Distortion dialog box.

4. **Click the Show Grid check box.**

 The grid is hidden. Without the grid, you can see the vignette better. The grid is used when you're correcting camera distortion.

5. **Drag the Vignette Amount slider toward darken.**

 The amount you darken the sides of the image is purely a matter of taste. The preview updates in real time. Release the mouse button when you see something you like.

6. **Click OK.**

Your quick-and-dirty vignette is served up pronto (see Figure 12-11).

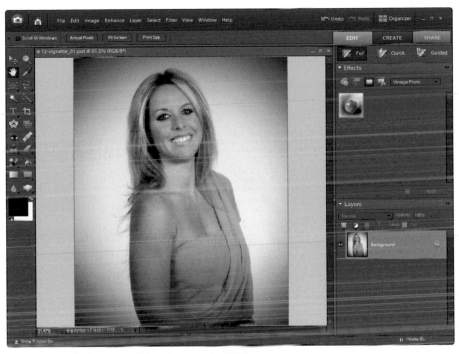

Figure 12-11: A vignette, quicker than you can blink an eye.

Exercise 12-6: Creating a Colorful Vignette

The previous exercise showed a quick-and-easy way to create a vignette, but it only comes in one flavor: black. The following exercise shows you how to create a colorful vignette with a gradual blend — can you say "Feather?" — to the subject.

1. **Launch the Photoshop Elements Edit workspace.**

2. **Choose File⇨Open.**

The Open dialog box appears. Navigate to the image 12-vignette_02.psd and then click Open.

3. **Select the Elliptical Marquee tool and create an oval selection around your subject.**

Remember, you can press the spacebar as you create the selection to move it. Get the selection as close to the center of the image as possible (see Figure 12-12).

Elliptical Marquee tool

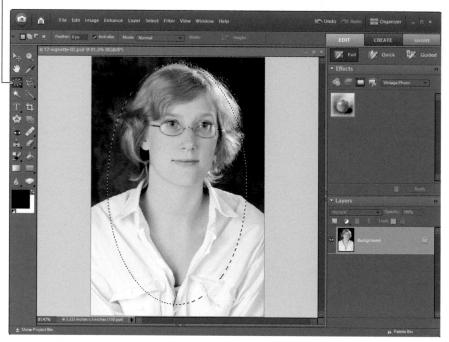

Figure 12-12: Defining the area of the vignette.

4. **Choose Select⇨Feather.**

 The Feather Selection dialog box appears.

5. **Type 25 in the Feather Radius text box.**

 This is the distance in pixels from the selection border where the selection will be blended with the surrounding pixels. The feather amount depends on the dimensions of the image to which you're applying the vignette. This image is relatively small; therefore, the small value. When you're working with a large, high-resolution image, you may end up needing a feather value of 125 pixels or greater.

6. **Choose Select⇨Inverse.**

 This inverts the selection. You fill the inverted selection with a color, which creates the vignette. Alternatively, you can press Ctrl+Shift+I to invert a selection.

7. **Choose Edit⇨Fill Selection.**

 The Fill Layer dialog box appears (see Figure 12-13).

8. **From the Use menu, choose Color.**

 The Choose a Color dialog box appears (see Figure 12-14).

Figure 12-13: Filling the selection.

Figure 12-14: A colorful vignette is a thing of beauty.

9. Move your cursor out of the dialog box.

The cursor becomes an eyedropper, which means you can click inside the image to select a color.

10. Click inside the young woman's hair until you select a color you like.

You can also modify the sampled color by moving the hollow circle inside the Choose a Color dialog box, and by moving the arrow to select a different hue. For this image, you can make the color a bit lighter and drag the hue slider closer to the red color.

11. Click OK to apply the fill to the selection.

If you're not satisfied with the vignette fill, press Ctrl+Z to undo the fill and repeat steps 7 through 10.

12. Choose Select⇨Deselect.

The selection exits stage right. Alternatively, you can press Ctrl+D to remove a selection. The portrait with vignette is shown in Figure 12-15.

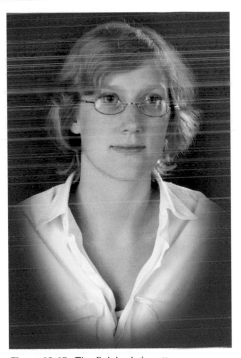

Figure 12-15: The finished vignette.

Repeat this exercise with the same photo using different feather values. Larger values create a smoother blend between the border of the vignette and the image. You can also lower the fill opacity in the Fill Layer dialog box to reveal some of the image instead of creating a solid color vignette. After you've experimented on this photo, use this technique on your favorite portraits.

Creating a Digital Polaroid Frame

Remember the old days when you got photos back from the drugstore, supermarket, or wherever you had your film processed? The images had a nice, neat white border around them. You can easily duplicate this effect by following the steps in this exercise.

Exercise 12-7: Creating a Digital Frame

1. **Launch the Photoshop Elements Edit workspace.**

2. **Choose File⇨Open.**

 The Open dialog box appears. Navigate to the image 12-BW.psd.

3. **Press Ctrl+J.**

 Photoshop Elements duplicates the layer.

4. **Choose Image⇨Transform⇨Free Transform.**

 The command's options appear below the menu bar (see Figure 12-16).

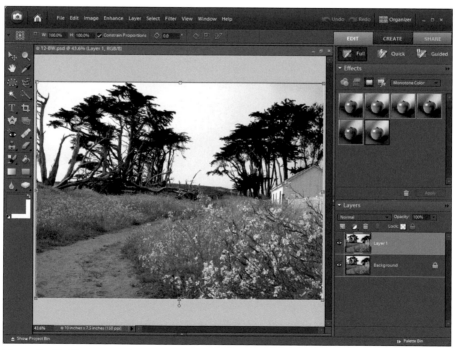

Figure 12-16: Please transform me, set me free.

5. **Type 85 in either the W or H text box and then press Enter.**

 The duplicated layer is now 85 percent smaller than its original dimensions.

6. **In the Layers palette, select the background layer.**

7. **Choose Edit⇨Fill Layer.**

 The Fill Layer dialog box appears (refer to Figure 12-13).

8. **Choose White from the Use list and then click OK.**

 The background layer is filled with white. But this image has some light areas around the edge, so I'm going to create a black line around the border of the image.

9. **Ctrl+click Layer 1.**

 It's a bird, it's a plane: No, it's an Army of Marching Ants, which means that Photoshop Elements has created a selection around the layer contents.

10. **Choose Edit⇨Stroke (Outline) Selection.**

 The Stroke dialog box appears (see Figure 12-17).

11. **Type 1 in the Width text field; in the Location section, click Inside.**

 This creates a stroke that is 1-pixel wide inside the image.

12. **Click the current color.**

 The Select Stroke Color dialog box appears (see Figure 12-18).

Figure 12-17: Stroking a selection.

Figure 12-18: Selecting the stroke color.

13. **Drag the dot to specify a dark gray color or solid black and then click OK.**

The stroke color is set. When you drag the dot, don't move it from the left side of the color well; otherwise, you'll have a tinted stroke. For this technique, black or gray is best.

14. **Click OK to close the Stroke dialog box and apply the stroke.**

15. **Choose Select⇨Deselect.**

Alternatively, you can press Ctrl+D to deselect a selection. The enhanced image is shown in Figure 12-19.

Figure 12-19: The frame technique adds a touch of class to a digital image.

Working with Text

Without text, this book would not be possible. In fact, the invention of text made it possible to record history for future generations. When you take photographs with your digital camera, you are recording an event in your life. You can add text to any image in Photoshop Elements. The following exercise introduces you to the Text tool.

Exercise 12-8: Introducing the Text Tool

1. **Launch the Photoshop Elements Edit workspace.**

2. **Choose File⇨New⇨Blank File.**

The New dialog box appears (see Figure 12-20).

Figure 12-20: Creating a new document.

3. **Type a name for the document.**

This step is optional. You can name a file when you save it.

4. **Choose US Paper from the Preset drop-down menu.**

The width and height change to dimensions you should know by heart.

5. **Accept the default color mode and choose White from the Background Contents menu.**

6. **Click OK.**

 A new document is hatched.

7. **Select the Text tool.**

 The tool options are displayed below the menu bar (see Figure 12-21).

Anti-aliasing Alignment options

Font Font Font Faux Wrap
family style size styles text

Figure 12-21: Specifying options for the text tool.

8. **Choose a font family from the Font Family drop-down menu.**

 For the purpose of this exercise, choose Garamond if you have it installed on your computer. If not, choose your favorite font.

 Type the first letter of the font family in the Font Family text box, and Photoshop Elements chooses the first font family that begins with that letter.

9. **Choose Bold from the Style drop-down menu.**

 Your other options are Normal, Bold-Italic, and Italic. If the font family you've chosen doesn't have styles, you can apply Adobe faux styles to the font. The faux styles are to the right of the two A capital letters. Move your cursor over the faux styles to see your options.

10. **Choose a font size.**

 You can choose one of the presets from the Font Size drop-down menu, or type a value in the Font Size text field. For this exercise, enter a value of **60**.

11. **Choose an alignment option from the Alignment drop-down menu.**

 For this exercise, choose Center Text.

12. **Click the color swatch and choose a color from the color picker.**

 For this exercise, choose a bright red.

13. **If desired, choose a style from the Style menu.**

 These are styles you can apply to your text, such as a bevel, emboss, and so on. Experiment with these when you finish the exercise. For this exercise, accept the default of No Style.

14. **Type your first name in the document.**

 The text is created on a new layer. A red circle with a diagonal line and a green check mark appear to the right of the tool options (see Figure 12-22).

Figure 12-22: Creating text.

15. **Click the check mark to commit the change.**

The text is part of the document. But you can still edit the text by double-clicking the layer. You can move the text with the Move tool.

16. **In the Layers palette, select the background layer and the text layer.**

You can select multiple layers by clicking the first layer and Ctrl+clicking the layers you want to add to the selection.

17. **Select the Move tool.**

The tool options appear beneath the menu bar.

18. **Choose Horizontal Centers from the Align drop-down menu (see Figure 12-23).**

Notice the other options you have available for aligning objects to the background layer.

19. **Double-click the text.**

The text is selected. At this point, you can change any text parameter by changing the text tool options.

20. **Position your cursor to the right of the last letter in your name, press the space-bar, and type your last name.**

Editing selected text is a breeze.

Move tool

Figure 12-23: Aligning the text to the background.

21. **Click the T with an arch beneath it.**

The Warp Text dialog box appears.

22. **Choose a style from the Style drop-down menu (see Figure 12-24).**

23. **Choose Arc.**

The dialog box refreshes. If you were warping the text to conform to an object in an image, you'd move the dialog box to the side and then change the bend parameter to match the curve of the object.

24. **For the purpose of this exercise, accept the default settings and click OK.**

You've got warped text.

25. **Click the green check mark on the tool options to commit the change.**

Figure 12-24: Warping perfectly straight text.

26. **In the Effects palette, click the Layer Styles icon and then choose Drop Shadows from the Layer Styles drop-down menu.**

The Effects palette refreshes to show the available drop shadow effects.

27. Drop one of the drop shadows on the text.

The drop shadow is applied to your text (see Figure 12-25). That's just the tip of the iceberg with text. Text can be used in collages and can be used to give an image a gallery-type effect. Figure 12-26 shows a classy font applied to an image that has been given a digital Polaroid border. If you have a high-resolution digital camera, you can create prints suitable for framing with their own border and title.

Figure 12-25: The ubiquitous drop shadow.

Pt. Reyes National Seashore

Figure 12-26: Adding a touch of class with text.

Creating a Fish-Eye Look

Fish-eye lenses enable photographers to photograph a 180-degree perspective. The resulting photo has some distortion, but looks very cool. Fish-eye lenses are also very expensive, and are not available for point-and-shoot digital cameras. You can, however, simulate a fish-eye look in Photoshop Elements.

Exercise 12-9: Creating a Fish-Eye Look

1. **Launch the Photoshop Elements Edit workspace.**

2. **Choose File⇨Open.**

The Open dialog box appears. Navigate to the image 12-fishEye.psd. Notice that this image is square. When you're using this technique on your images, crop them to square dimensions before doing the following steps.

3. **Select the Elliptical Marquee tool and create a round selection inside the image.**

Hold the Shift key to constrain the selection to a circle. Press the spacebar to move the selection while creating it (see Figure 12-27).

Elliptical Marquee tool

Figure 12-27: Creating a circular selection.

4. **Choose Filter⇨Distort ⇨Spherize.**

 The Spherize dialog box appears (see Figure 12-28).

5. **Accept the default value of 100 percent and click OK.**

 The center of the image bulges out and it actually looks like it was shot with a fish-eye lens.

6. **Choose Selection⇨Invert.**

 The Selection is inverted. Alternatively, you can press Ctrl+Shift+I to invert a selection.

7. **Choose Edit⇨Fill Selection.**

 The Fill Layer dialog box appears (refer to Figure 12-13).

8. **Choose Black from the Use drop-down menu.**

9. **Click OK to apply the fill.**

10. **Choose Select⇨Deselect.**

 The selection is added to the great selection junkyard in the sky. The fish-eyed image is shown in Figure 12-29.

Figure 12-28: Can you say fish?

Figure 12-29: Fish-eyed again!

Creating a Zoom Blur

Photographers with zoom lenses can create a very cool effect known as a *zoom blur*. They do this by zooming out during a long exposure. Unfortunately, digital point-and-shoot cameras can't do this. You can, however, mimic the effect in Photoshop Elements by doing the steps in the following exercise.

Exercise 12-10: Creating a Zoom Blur

1. **Launch the Photoshop Elements Edit workspace.**

2. **Choose File⇨Open.**

 The Open dialog box appears. Navigate to the image 12-zoom.psd.

3. **Select the Elliptical Marquee tool and create a selection around the car's grille.**

 Remember, you can press the spacebar to move the selection as you create it (see Figure 12-30).

Figure 12-30: Creating an oval selection.

4. **Choose Selection⇨Feather.**

 The Feather Selection dialog box appears.

5. **Type a value of 30 in the Feather Radius text field and then click OK.**

 The selection is feathered. This is a fairly small image. If you were feathering a selection for a larger image, you'd use a larger value.

6. **Choose Select⇨Inverse.**

 The selection is inverted. You'll be applying the blur from the car's grille outward.

7. **Choose Filter⇨Blur⇨Radial Blur.**

 The Radial Blur dialog box appears (see Figure 12-31).

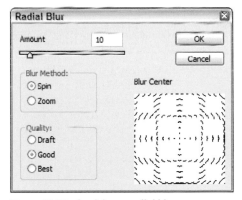

Figure 12-31: Applying a radial blur.

8. **Type a value of 40 in the Amount text field, choose the Zoom Blur method, and Best Quality.**

 When you create zoom blurs for your own images, experiment with different settings for this image. I opted for a value of 40. The Zoom Blur method mimics the zoom lens effect. Choosing the Best Quality option means it takes longer to render the blur, but the results look better.

9. **Click OK.**

 The zoom blur is applied to your image (see Figure 12-32).

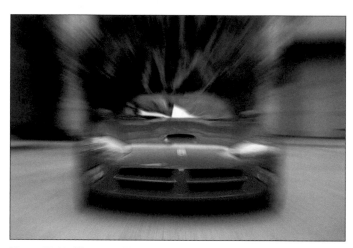

Figure 12-32: The zoom blur effect in live and living color.

Third-Party Filters

Photoshop Elements is an extremely popular image-editing application. Plug-in manufacturers recognize this and have created many plug-ins available for Photoshop Elements. You may wonder why you'd want to use third-party plug-ins. The answer is that they can do things that you can't do with the tools in Photoshop Elements. When you install a third-party filter plug-in, it becomes available on the Photoshop Elements Filter menu. The following exercises explore what you can accomplish with third-party plug-ins.

Open your Web browser and navigate to www.alienskin.com/downloads/. Download the Snap Art and Exposure 2 plug-ins. These plug-ins are fully functional for 30 days.

Exercise 12-11: Making Digital Images Look Like They Were Photographed on Film

Many photographers think digital images are too sterile. They don't have the rich, saturated colors of slide films like Kodachrome and Fuji Velvia, and they don't have grain. The folks at Alien Skin software created a plug-in that makes digital images look like they were shot with film.

1. **Install the Exposure 2 demo that you downloaded.**

 When you double-click the .exe file, follow the prompts to install the plug-in with Photoshop Elements.

2. **Launch the Photoshop Elements Edit workspace.**

3. **Choose File⇨Open.**

 The Open dialog box appears. Navigate to the image 12-exposure.psd.

4. **Choose Filter⇨Alien Skin Exposure 2 Demo⇨Color Film.**

 The Alien Skin Exposure 2 dialog box appears.

5. **Click the Settings tab and choose Films – Slide⇨Fuji Velvia 100F.**

 The image preview updates and the colors become richer and more saturated (see Figure 12-33). Notice that there are lots of presets for popular slide-and-print films. You can also modify the presets by changing the settings on the Color, Tone, Focus, and Grain tabs.

Figure 12-33: Choosing an Exposure 2 preset.

6. **Click OK.**

 The preset is applied to the image on a separate layer (see Figure 12-34). If the effect is too strong for your tastes, you can lower the opacity to let some of the underlying layer show through.

Experiment with the other color film presets and the black-and-white presets on this image and your own. Even if you decide not to keep the plug-in, it's fully functional for 30 days. You can use the filter on lots of images in that time.

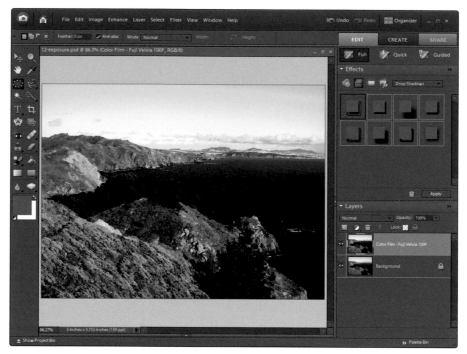

Figure 12-34: Using the Exposure 2 plug-in.

Exercise 12-12: Creating Art without Breaking a Sweat

In previous exercises, you explored the Photoshop Effects filters for creating painterly type photos. There are many third-party plug-ins that will create different effects. One of them is the Alien Skin Snap Art plug-in. The following exercise explores some of the plug-in's capabilities.

1. **Install the Exposure 2 demo that you downloaded.**

When double-clicking the .exe file, follow the prompts to install the plug-in with Photoshop Elements.

2. **Launch the Photoshop Elements Edit workspace.**

3. **Choose File⇨Open.**

The Open dialog box appears. Navigate to the image 12-snapart.psd.

4. **Choose Filter⇨Alien Skin Snap Art Demo⇨Oil Paint.**

The Alien Skin Snap Art Oil Paint dialog box appears (see Figure 12-35). Notice that there are lots of presets from which to choose, and you have more options than you find with the Elements Artistic filters. You can also modify a selected preset by changing settings on the Basic, Colors, Canvas, and Lighting tabs. When you make a modification, the preview updates in real time.

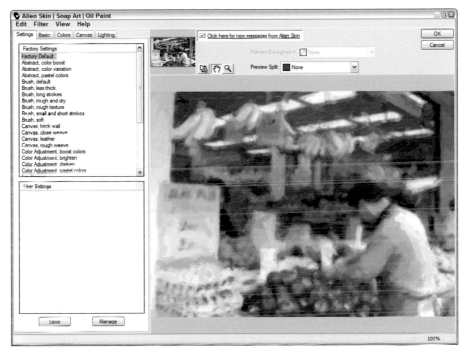

Figure 12-35: Choosing a Snap Art preset.

5. **Accept the default preset, choose a different one, or modify an existing preset.**

6. **Click OK to transform the digital photograph into a painterly image.**

 The effect is applied to your image. If you duplicate the background layer and apply the plug-in to it, you can vary the effect by lowering the opacity of the duplicated layer to let some of the original image show through.

Experiment with the other Snap Art presets on this image and your own. Even if you decide not to keep the plug-in, it's fully functional for 30 days.

To find other third-party plug-ins that work with Photoshop Elements, launch your Web browser and navigate to www.Google.com. Type **Photoshop Elements Plug-ins** in the Search text box. You'll find lots of resources available for Photoshop Elements plug-ins on the Web.

Part IV
The Part of Tens

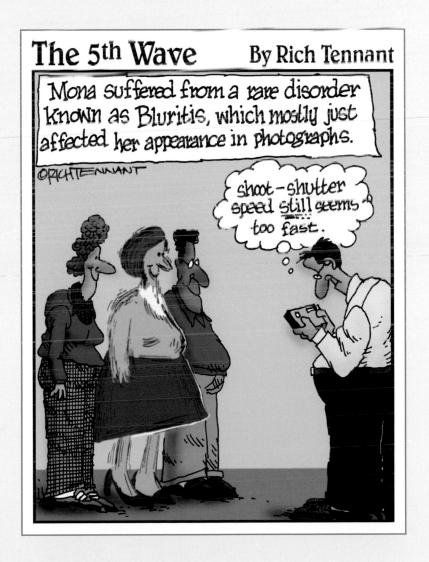

In this part . . .

This is the Part of Tens. Each chapter in this part has ten sections, which is why the publisher calls it the Part of Tens. The first chapter in this section features ten exercises that show you how to share your photos with a few close friends, and if you have a Web site (or a free Flickr account), the world. The second chapter in this section shows you ten Internet resources that are useful for digital photographers.

Chapter 13

To Share Your Photos

● ●

...ard drive filled to the brim with photos. If you've been sort-...
...getting rid of the losers, you've got a collection of some nice...
...ho has lots of friends or relatives, sharing your photos with...
...show off your talent. That's what the exercises in this chap-...

...a wonderful way to keep friends and relatives up-to-date...
...your life. Whether you're a college student snapping photos...
...m taking pictures of her son's soccer game, you can easily...
...otos by sending them as Photo Mail by following the steps in this exercise.

se 13-1: Sending Photos via E-Mail

1. **Launch the Organizer.**

The easiest way to launch the Organizer is to click the Photoshop Elements desk-top shortcut and then click the Organize icon.

2. **Select the photo you want to send.**

You can locate a photo using the Find command or by clicking the applicable key-word. (You *are* assigning keywords to your photos when you download them, aren't you?)

3. **Click Share.**

 The options for sharing photos are displayed (see Figure 13-1).

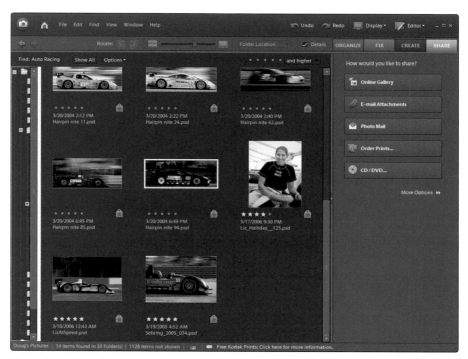

Figure 13-1: Show them you really care and share.

4. **Click Photo Mail.**

 The right pane of the Organizer updates to show the Photo Mail options.

5. **Drag a photo into the Items window.**

 I know I asked you to select a photo in the first step, and now you have to select it again and drop it in the window. However, if you don't select the photo before this step, you have to sift through your entire collection of photos. After you drag a photo into the Items window, the estimated size and download time are displayed (see Figure 13-2).

 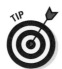

 You may be tempted to send lots of photos in one e-mail message. If you send more than two or three photos, the e-mail takes a long time to download, especially if your recipient has a slow Internet connection.

6. **Click Next.**

 The Organizer refreshes and shows you additional options (see Figure 13-3).

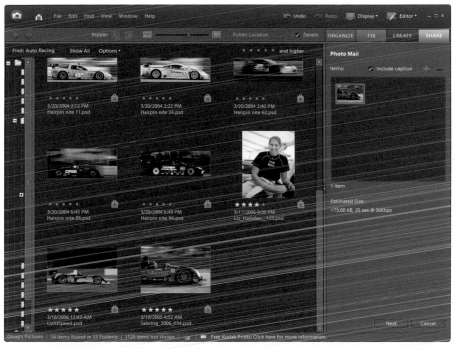

Figure 13-2: This photo will be sent by e-mail.

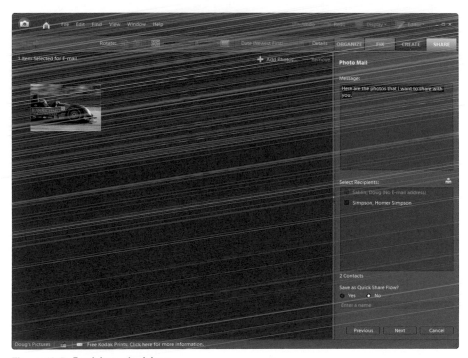

Figure 13-3: Decisions, decisions.

7. **Select a recipient from your recipient list.**

Photoshop Elements has a Contact Book. You can add people to your Contact Book by clicking the icon of the man to the right of the Select Recipients title. The Contact Book gives you the option of adding new contacts or importing contacts from vCard files, Microsoft Outlook, or Outlook Express. The Contact Book is easy to use, but a detailed exercise on how to populate the Contact Book is outside the scope of this book.

You can also access the Contact Book in the Organizer by choosing Edit⇨Contact Book.

8. **If you like, modify the message.**

You can delete the default message and type your own, or add to the default message.

9. **After selecting a recipient and modifying the message, click Next.**

The Stationery & Layouts Wizard appears (see Figure 13-4). The Stationery & Layouts Wizard lets you choose a frame from one of the categories. When you choose a frame, the preview changes.

Figure 13-4: Choosing a frame for your photos.

10. **Type a caption below the photo.**

To add a caption to the photo, click (Enter Caption Here) and then type your caption. Alternatively, you can select the default caption and the press Backspace to delete the caption.

11. **Click Next Step.**

The wizard refreshes. Now you have options to customize the layout by selecting a different background color, changing the photo size, changing the layout if you're sending multiple photos, changing the font family and font color, changing the border style and color, and deciding whether to include a drop shadow with the Photo Mail (see Figure 13-5).

Figure 13-5: Customizing the layout.

12. **Click Next.**

The photo is handed off to your default e-mail application with the recipient's e-mail address(es) already inserted in the To field, along with the Subject ("Here are the photos that I want to share with you.") and message.

13. **Click Send.**

The Photo Mail is sent into cyberspace at the speed of light. To cyberspace and beyond!

You can also send photos as e-mail attachments. Instead of clicking Photo Mail, click E-mail Attachments. Follow the prompts to specify image quality, recipients, and so on.

When you send photos using Photo Mail, your recipients can right-click the photo and then choose Save Picture As from the shortcut menu and save the image in the Windows *.BMP file format. If you send the photo as an e-mail attachment, your recipients can right-click the attachment and choose Save As from the shortcut menu.

Creating a Web Gallery

If you've got a Web site — and who doesn't these days? — you can create a Web gallery of your favorite images. Creating a Web gallery is a great way to share your images with a few friends, or, if your Web site gets a lot of hits, the world. The following exercise shows you how to create a Web gallery of your favorite photos.

Exercise 13-2: Creating a Web Gallery

1. **Launch the Organizer.**

The easiest way to launch the Organizer is to click the Photoshop Elements desktop shortcut and then click the Organize icon.

2. **Select the photos you want to include in your gallery.**

 You can locate specific photos using the Find command or by clicking the applicable keyword.

 If you're selecting photos that have several different keywords, create an Album and name it Web Gallery. Open the album and then select the photos.

3. **Click Share.**

 The options for sharing photos are displayed.

4. **Click Online Gallery.**

 The right pane of the Organizer refreshes, showing the photos you've selected (see Figure 13-6).

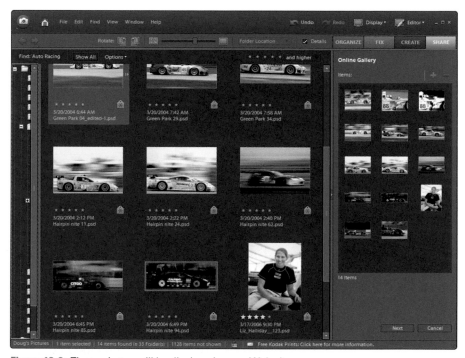

Figure 13-6: These photos will be displayed on my Web site.

5. **Click Next.**

 The Organizer refreshes. The photos you've selected for the gallery are displayed in the left pane, and the gallery templates are displayed in the right pane (see Figure 13-7). At this time, you can add photos by clicking Add Photos and following the prompts from the Add Photos dialog box. You can also remove a photo from the Web gallery by selecting it in the Items window and then clicking Remove.

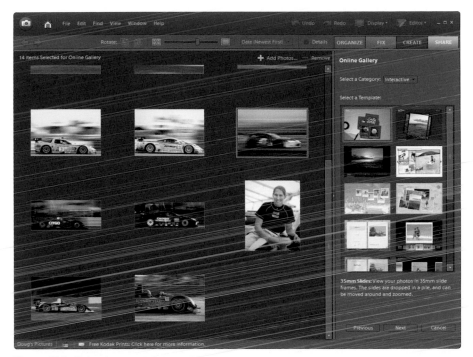

Figure 13-7: Selecting a template.

6. **Select a category from the drop-down list.**

 For the purpose of this exercise, stick with the default Interactive category.

7. **Choose a template.**

 For the purpose of this exercise, choose the Classic template. It's the first icon in the second row.

8. **Click Next.**

 Photoshop Elements displays a dialog box telling you the project is being built and shows you the progress. After the project is built, it is displayed (see Figure 13-8).

9. **Type a title and subtitle for the gallery in the applicable text fields. If desired, type your e-mail address in the E-mail Address text field.**

 The title you specify is displayed in your visitor's Web browser when the gallery is viewed from your Web site.

10. **If desired, change the background color and disable the option to show photo captions.**

 The default background color for this gallery is black. You can change it by clicking the color swatch and choosing the desired color from the color picker. If a photo has a caption, it is displayed under the photo if you accept the default Show Photo Captions option.

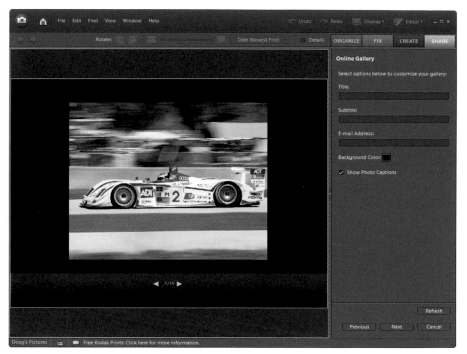

Figure 13-8: Adding the gallery title and subtitle.

11. Click Refresh.

Photoshop Elements rebuilds the gallery with your title, subtitle, and e-mail address. If you changed the background color, the new color is displayed as well. At this point, you can test the Web gallery by clicking the buttons to display the photos. If you don't like a photo, or want to change any other options, click Previous to display the previous gallery options and then make your changes.

12. Click Next.

The Organizer refreshes. At this stage, you need to name the gallery and specify the location in which the gallery will be saved.

13. Type a name for the gallery in the Gallery Name text field.

14. Accept the default location (your My Documents folder) or click Browse and navigate to a different location in which to save the file.

15. Click Next.

Photoshop builds the gallery and the Organizer refreshes. You have the option to share the gallery at the Photoshop Showcase, send the gallery to your Web site via FTP, or burn the gallery to a CD or DVD. You can choose one of these options and follow the prompts or click Done and upload the gallery by using an *FTP* client (software that's used to upload files to a Web server. See cuteFTP, at www.cuteftp.com/products/ftp_clients.aspx). After you click Done, the gallery is added to the Organizer.

Experiment with the different gallery templates. There are several unique templates from which to choose. Choose the template that best suits the style of your photographs.

To update the Web gallery, double-click its icon in the Organizer. The Organizer refreshes and enables you to go through each of the steps again. You can add or delete photos and change the other parameters for the gallery.

reating a Picture Package

An exercise in Chapter 10 shows you how to print a single photo from within the Edit workspace. You can, however, print multiple photos as a picture package from within the Organizer. When you print a picture package, you decide how many images will be printed on the page and what size they are, for example. The following exercise shows you how to create a picture package.

Exercise 12-3: Creating a Picture Package

1. **Launch the Organizer.**

2. **Select the photos you want to include in your picture package.**

 You can choose one photo or several. For this exercise, choose four photos.

3. **Choose File⇔Print.**

 The Print Photos dialog box appears (see Figure 13-9).

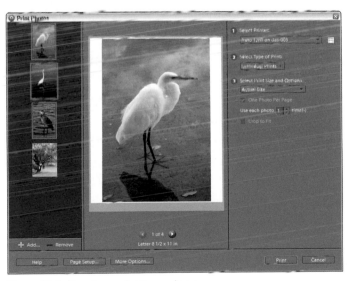

Figure 13-9: Creating a picture package.

4. **Select Picture Package from the Select Type of Print drop-down menu.**

 The Print Photos dialog box refreshes to show the Picture Package options.

5. **Choose an option from the Select a Layout drop-down menu.**

 As you can see, there are lots of layouts. For this exercise, choose Letter (4) 4.x 5. After you choose this option, the dialog box refreshes to show you the layout (see Figure 13-10).

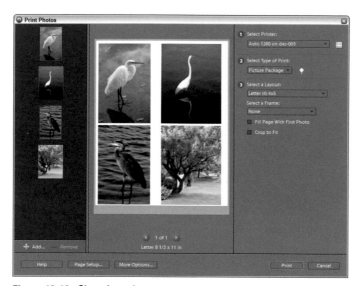

Figure 13-10: Choosing a layout.

6. **Click Page Setup.**

 The Page Setup dialog box appears. Refer to Chapter 10 for more information on setting up the page for printing.

7. **After setting up the page, click Print.**

 Photoshop Elements prints your picture package.

 Choose a single photo to print, and then choose Picture Package from the Print drop-down menu. Creating a picture package of a single photo is useful when you need to send the same photo to several people. Choose a template that creates a picture package of four 4 x 6 or 5 x 7 images.

Using Online Printing Services

Lots of online printing services are available to choose from. Each service has options for having prints made, creating items like coffee mugs with photos on them, and so on. With your purchase of Photoshop Elements 6.0, you're entitled to ten free Kodak prints from Adobe Photoshop Services. The following exercise gets you started.

Exercise 13-4: Using Online Printing Services

1. **Launch the Organizer.**

2. **Select the photos you want to print.**

You can find specific photos using the Find command or by clicking the applicable keyword.

3. **Click Share and then click Order Prints.**

The Adobe Photoshop Elements Preparing Files dialog box appears. After the files are prepared for printing, the Order Prints dialog box appears. The online service is Adobe Photoshop Services, which gets you Kodak prints through the Kodak Easy Share Gallery.

4. **Fill in your personal information, click Next, and then follow the prompts to order your prints.**

Adobe Photoshop Services is one of many online printing services. You might also want to try Shutterfly (www.shutterfly.com), which offers free prints when you create an account. When you use an online printer other than Adobe Photoshop Services, you prepare the images in Photoshop Elements and do the rest at the printer's Web site.

Creating a Slide Show

A slide show is another wonderful way to share your images. When you create a slide show of your image, you can add a soundtrack, pan and zoom each slide, specify transitions, and more. The end result is a professional-looking slide show you can share with friends and relatives.

Exercise 13-5: Creating a Slide Show

1. **Launch the Organizer.**

2. **Select the photos you want to include in your slide show.**

You can locate specific photos using the Find command or by clicking the applicable keyword. You can also use an album as the source for your slide show.

3. **Click Create and then click Slide Show.**

The Slide Show Preferences dialog box appears (see Figure 13-11).

4. **Set the slide show preferences.**

Most of the preferences are easy to understand. The Zoom and Pan option adds motion to your slide show. The Crop to Fit Slide option crops the slide to fit the screen, which means your photo loses

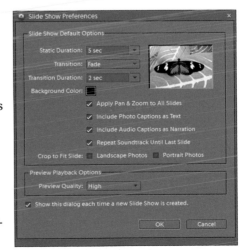

Figure 13-11: Setting slide show preferences.

information. I prefer to disable these options and see the full photo with a bit of background. The default transition is Fade, which fades one slide gradually into the next. You can choose a different transition from the drop-down list, if you like. You can also choose to open the Slide Show Preferences dialog box for each show you create.

5. **Click OK.**

 The Slide Show Editor appears (see Figure 13-12).

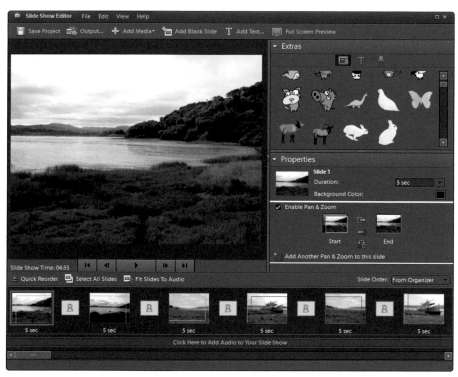

Figure 13-12: Editing the slide show.

6. **To add a title slide, click Blank Slide to add a blank slide to the show, click Add Text to add a title to your show, and if desired, drag a graphic to the title page.**

 After you create the title slide, drag it to the front of the show.

7. **To add a soundtrack to the show, click the audio track below the slide thumbnails.**

 This opens the Choose Your Audio Files dialog box, which enables you to navigate to a supported file and open it.

8. **If you add an audio track to the slide show, you can click the Fit Slides to Audio icon.**

 This trims the duration of each slide to fit the audio. If your audio is longer than the slide show, the duration of each slide increases.

...show Output dialog box appears. You have the following options:

- *Save As a File:* Save the slide show as a *.WMV movie or a PDF file. If you choose the PDF file format, the file size is smaller, but certain transitions and Pan & Zoom are supported.

- *Burn to Disc:* Burn the slide show to a CD or DVD.

- *Send to TV:* View the slide show on your TV using Windows XP Media Center. After the file is saved, you can find it by choosing Photoshop Elements from the More Programs menu on the Media Center start page.

12. **Click OK to create the slide show.**

 The Save Slide Show dialog box appears, prompting you for a location and file-name. After you supply this information, Photoshop Elements builds the slide show.

You can also save the slide show as a project, which enables you to edit it at a later date.

E-Mail a Photo to a Cell Phone

You're a photographer who has friends who use cell phones. You can send photos from Photoshop Elements to a mobile phone. How cool is that? The following exercise shows you how to send a photo to a friend's mobile phone.

Exercise 13-6: Sending a Photo to a Mobile Phone

1. **Launch the Organizer.**

 The easiest way to launch the Organizer is to click the Photoshop Elements desktop shortcut and then click the Organize icon.

2. **Select the photo you want to send to your friend's mobile phone.**

 You can locate specific photos using the Find command or by clicking the applicable keyword.

3. **Click Share.**

 The options for sharing a photo are listed.

4. **Click More Options.**

 Additional options for sharing photos are listed.

5. **Choose E-mail to Mobile Phone.**

 The Send to Mobile Phone dialog box appears (see Figure 13-13).

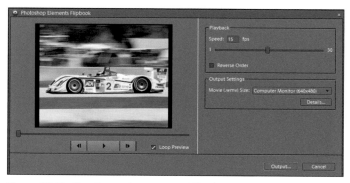

Figure 13-13: Sending a photo to a mobile phone.

6. **Select a recipient.**

 You must have your recipient's mobile phone e-mail address in her listing in your contact list.

 Mobile-phone carriers charge for sending text and photos. Some mobile-phone companies have text-messaging packages that include sending photos. Make sure your intended recipient has a text-messaging package or will not object to the charge for receiving the photo.

7. **Choose an option from the Maximum Size section.**

 The photo is scaled proportionately to the option you select. You can also enter a custom size. If you know the display size of your recipient's mobile device, you can size the image in the Edit workspace before sending it. If you like, you can also change the default message.

 E-mail your favorite images to your mobile phone. You can have a portable brag book anytime you want it. You can also set your favorite image as your phone's wallpaper.

8. **Click Next.**

 Your default e-mail application launches a e-mail message with the photo attached and the recipient's mobile phone e-mail in the To field. The Subject and Message fields are also filled in.

9. **Click Send.**

 The message and photo attachment are sent to your recipient's mobile phone.

2. **Select the photos you want to use for the flipbook.**

 You can locate specific photos using the Find command or by clicking the applicable keyword.

3. **Click Create.**

 The options for creating items with your photos are displayed.

4. **Click More Options.**

 More Options for creating photo objects are displayed.

5. **Select Flipbook.**

 The Photoshop Elements Flipbook dialog box is displayed (see Figure 13-14).

Figure 13-14: Creating a flipbook.

6. **Specify a playback speed.**

 The default playback speed of 15 fps (frames per second) is a compromise between file size and playback quality. Specify a higher frame rate if you're showing the flipbook on a TV, or a lower frame rate if you're sending the flipbook via e-mail.

7. **Click the Play button to preview the flipbook.**

 Alternatively, you can view the next or previous frame.

8. **Click the Reverse Order check box to reverse the order in which the photos are shown.**

9. **Choose an option from the Output settings drop-down menu.**

 The default option is for playing on a computer screen. If you're creating the flipbook for viewing on a North American set-top DVD player, choose DVD-NTSC. If you're creating a flipbook for viewing on a European set-top DVD player, choose DVD-PAL. If you're creating the flipbook for the Web or e-mail distribution, choose the applicable setting. If you're creating a VCD (video CD) for viewing on a North American set-top DVD player that plays VCDs, choose VCD-NTSC. If you're creating a flipbook for viewing on a European set-top DVD player that plays VCDs, choose VCD-PAL.

10. **Click Output.**

 The Save Flip Book as WMV dialog box appears.

11. **Type a name for your flipbook, and then click Save.**

 After you save a flipbook, it appears in the Organizer. Your next move depends on the format you used to publish the flipbook. If it's a DVD or VCD, you have to burn it to the appropriate media before viewing it on a television set. If you saved the flipbook for computer viewing, double-click it in the Organizer and it plays in another window.

Publishing a Photo Book

Creating a photo book is a wonderful way to display your best photos. Photo books also make great gifts for distant relatives. Create a book of photos of your children growing up and send it to your parents for a holiday gift. Better yet, create two and keep one for yourself. The following exercise shows you how to create a photo book.

Exercise 13-8: Publishing a Photo Book

1. **Launch the Organizer.**

 The easiest way to launch the Organizer is to click the Photoshop Elements desktop shortcut and then click the Organize icon.

2. **Select at least 21 photos.**

 Twenty pages is the minimum order for a photo book, and you need one page for the cover. If you accept the default option to let Photoshop Elements Auto-Fill the pages, choose at least 50 photos; otherwise, you end up with blank pages at the end of your book.

Figure 13-15: Creating a photo book.

4. **Accept the default title page photo, or rearrange the Project Bin.**

 Drag the photo you want to appear on the cover page and drop it in front of the current cover page photo. You can rearrange the other photos as well. The order in which the photos appear in the Project Bin is also the order they appear in the book.

5. **After rearranging the Project Bin, click Next.**

 The Layout options for the Photo Book appear (see Figure 13-16).

6. **Choose a theme.**

 Choose from the preset themes. When you choose a theme, a thumbnail of the page appears to the left of the Photo Book layout options.

Figure 13-16: Specifying layout options.

7. **Specify other layout options.**

 If you select Choose Photo Layout, you can choose the left and right page layout. If you accept the default option, Photoshop Elements auto-fills the pages with photos from the Project Bin. If desired, you can have photo captions printed on each page.

8. **Click Done.**

 Photoshop Elements creates the pages. If any of the images is a RAW file, the Camera Raw dialog box appears. Process the image and click Done. After you process the images, Photoshop Elements creates the pages of the book.

9. **Fine-tune the book using the Photo Book tools.**

 You can advance from page to page using the controls. You can resize images using the handles, drag them to different locations, rotate them, and so on.

10. **When you're satisfied with the layout of your book, click Order.**

 Photoshop Elements prepares the photo book for ordering, uploads them, and then launches Adobe Photoshop Services. Log in and follow the steps to order your book.

If you want complete control over the layout of your book, deselect the option to auto-fill the pages. Select the layout option for the left and right pages. When you click done, Photoshop Elements creates the book with blank pages. You can then drag photos from the Project Bin into each page. You can use the Photo Book tools to change the size of the photo. Right-click the page image for other options.

...wonderful gifts. If you've got friends or relatives on your holiday shopping list who use calendars (and who doesn't?) you can create a one-of-a-kind calendar using your photos. The following exercise shows you how to create a calendar using Photoshop Elements.

Exercise 13-9: Creating a Calendar

1. Click in the Organizer.

2. Select 12 photos.

 After all, there are 12 months in the year.

 Select 13 photos if you want a different picture on the cover of the calendar.

3. Click Create and then click Calendar.

 Photoshop Elements prepares the images and then launches Adobe Photoshop Services, which is online. If you're not logged in, you'll be prompted for sign-in information.

4. Click Next.

 Photoshop Elements uploads the files to Adobe Photoshop Services. After the photos have been uploaded, the window refreshes and displays a message telling you the photos have been successfully uploaded. Now you're ready to create the calendar.

5. Click Next.

 The Choose a Page Design for Your Calendar Web page appears. That's right, Toto, you're not in Photoshop Elements any more (see Figure 13-17).

6. Choose a design and then click Next.

 You want to let your photos do the talking. Instead of choosing a busy design that distracts the viewer's attention, I prefer the Simple White or White Drop Shadow designs because they don't distract the viewer's attention from the photos. After you click Next, Adobe Photoshop Services opens a window and gives you the option of auto-filling the calendar or laying it out page by page.

7. Choose an option for filling the pages.

 If you choose Page By Page, the page refreshes. The photos you uploaded are displayed in a row beneath a blank frame. Drag a photo into the frame. Your first step is to decide which photo is displayed on the calendar cover and to name the calendar (see Figure 13-18).

8. Click First Month.

 The page refreshes. Drag a photo into the frame, and, if desired, add a caption.

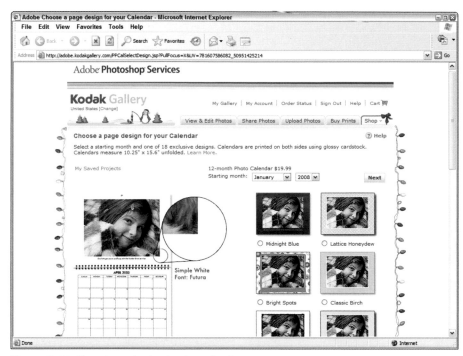

Figure 13-17: Choosing a design for the calendar.

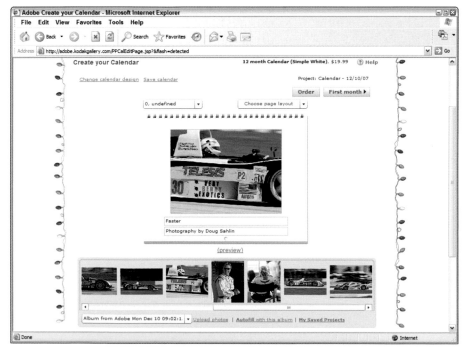

Figure 13-18: Designing the calendar.

...your credit card number, take out a second mort-
...your house — oops, that's right, you'll only need your credit card, you're just buying a calendar, not filling your car with gas.

Creating Photo Stamps

You send letters to friends and loved ones, right? One way to wow them is to send them a letter with a stamp that has a photo of a loved one or pet. It's easy to do, and the postage is the real deal, I guille. As of this writing, twenty 41-cent stamps cost $18.99 plus shipping. Yes, it is more expensive than regular postage, but you won't use them when you pay bills. They're for sending letters to special friends. The following exercise shows you how to create your own custom photo stamps.

Exercise 13-10: Creating PhotoStamps

1. **Launch the Organizer.**

2. **Select a photo for your PhotoStamp.**

 The photo must have a file size of less than 5 megabytes.

3. **Click Create⇒More Options⇒PhotoStamps.**

 Photoshop Elements prepares your file and the PhotoStamps dialog box appears.

4. **Click Upload My Photos.**

 A couple of dialog boxes whiz past — or shuffle past if you've got a slow Internet connection — and then a message appears telling you the upload was successful.

5. **Click Continue.**

 Your Image Gallery page at Stamps.com appears.

6. **Click the image.**

 The image details page appears (see Figure 13-19).

7. **Click PhotoStamps.**

 The Customize Your Photostamps page appears (see Figure 13-20). This page enables you to add a border to the stamp, move the image, zoom in, and so on.

8. **After you customize the stamp, click Continue.**

 The page refreshes and you're ready to check out. Cha-ching. Give them your credit card and shipping info. Stamps.com thanks you for your continued support.

Figure 13-19: She licks fur: Now she's going to be on a lickable or stickable stamp.

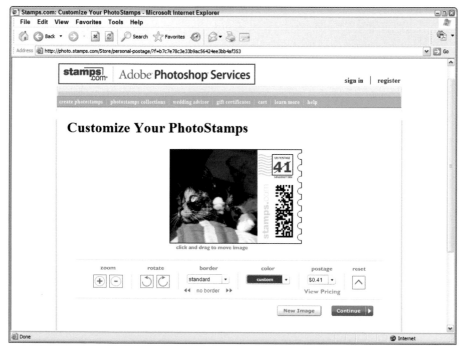

Figure 13-20: Customizing the stamp.

You can find almost anything you want on the Internet. Information and products concerning digital photography are no exception to that rule. The Internet has tons of sites devoted to digital photography. Some of them are awful, and others are great. This chapter explores ten sites worthy of digital photographers.

Exploring B&H Photo

B&H Photo has a huge camera and video store in New York City. For those of us who don't live within driving distance of New York City, the company has a wonderful online store. The following exercise explores the Web site.

Exercise 14-1: Exploring B&H Photo's Online Store

1. **Launch your favorite Web browser, type** www.bhphoto.com **in the Address field, and then press Enter.**

 The B&H Photo home page is displayed.

2. **Click Cameras & Photo Gear.**

 The Web site refreshes and displays the categories for camera and photo gear (see Figure 14-1). Click any category to see the available products. You can also search for a product by typing information in the site's Search text field.

3. **Spend a few minutes surfing the site.**

 If you see something you like but need more information, call the toll-free number (1-800-331-8506). The staff is knowledgeable, friendly, and helpful, and no one tries to upsell you.

Figure 14-1: Surfing for gear.

Surfing Shutterfly

There are plenty of online printing services around, but Shutterfly is one of the best known. It's reliable, it ships quickly, and it produces quality prints. These folks have created coffee table books, coffee mugs, and prints from my digital images, and I've been very pleased with the results. The following exercise explores the Shutterfly Web site.

Exercise 14-2: Surfing Shutterfly

1. **Launch your favorite Web browser, type** www.shutterfly.com **in the Address field, and then press Enter.**

The browser refreshes and displays the Shutterfly home page.

2. **To sign up for a Shutterfly account, click Sign In.**

The page refreshes. To sign up for a Shutterfly account, provide your e-mail address and a password. As of this writing, you get 15 free 4-x-6 prints when you create a new account.

Figure 11-2. Your Shutterfly albums and projects are saved for future use.

4. **Before you move on to the next exercise, click the Shutterfly Store link.**

 You can create some awesome gifts and mementos from your photos at the Shutterfly store.

Shutterfly automatically enhances prints by color correcting and sharpening them. If you've edited your prints in Photoshop Elements, you don't need to have your print enhanced. You can disable print enhancement (known as VividPics) when viewing uploaded images. You can disable image enhancement for your account by calling Shutterfly customer service and making the request to the friendly customer service representative.

Showing Your Images at Photo.net

Even the best photographers need inspiration. You can get inspiration and much more by looking at the lovely images at Photo.net. The following exercise explores the Web site.

Exercise 14-3: Strutting Your Stuff at Photo.net

1. **Launch your favorite Web browser, type** www.photo.net **in the Address field, and then press Enter.**

The site home page appears.

2. **To create a Photo.net account, click Sign In and then click the link to Sign Up.**

You can create a free account and upload up to six images. For $25 a year, you can create an account that lets you upload considerably more images. Figure 14-3 shows a portion of my portfolio at Photo.net. Note that some photographers post fine-art figure studies. The site screens all uploaded photos to make sure somebody doesn't try to sneak a pornographic photo into a portfolio. However, if artful photographs of the nude human body offend you, don't go to this site.

Figure 14-3: You can create a portfolio at Photo.net.

3. **While you're at the site, check out some of the forums.**

Members also post photos for critique. The site is a wonderful resource for learning about photography and getting inspiration from other photographers.

Exercise 14-4: Creating a Profile on Panoramio

1. **Launch your favorite Web browser, type** www.panoramio.com **in the Address field, and then press Enter.**

 The site home page appears.

2. **Click the Sign Up link.**

 The Sign Up page appears. Filling it out is a no-brainer, so I won't include an illustration of the page. All you need to do is enter your e-mail address, a user name, and a password, and click Sign Up. After you sign up, you're ready to start uploading photos. The account is free, and you can upload up to 2 gigabytes of photos.

3. **Sign in.**

 After you complete the initial sign-up process, all you need to do is enter your user name and password. The page refreshes and you're directed to your stuff (see Figure 14-4).

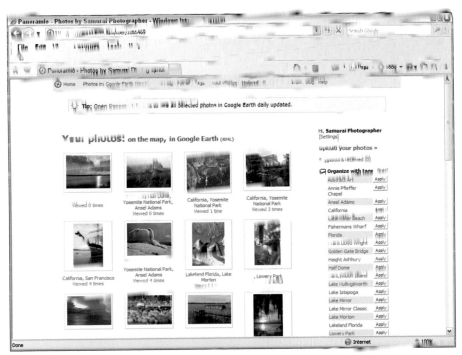

Figure 14-4: Panoramio is a place for my photo stuff.

4. **Click Upload Your Photos.**

 The Upload Your Photos page appears.

5. **Click Browse and navigate to the file you want to upload.**

 Panoramio automatically compresses the file. The original file cannot be larger than 5 megabytes.

6. **Select the photo and click Open.**

 The file is uploaded. Note that this site is busy on weekends. If there's a lot of traffic, it may take a while to upload your photo. After your photo is uploaded, a thumbnail appears in the Web page. Enter a name for the image.

7. **Click Map This Photo.**

 The Web page refreshes, and you're prompted to type the city or place. Don't type the state. If you know the longitude and latitude of the place, type the coordinates in the dialog box, separated by a comma.

8. **Type the city, place, or coordinate, and then click Search.**

 The page refreshes and lists the number of matches for the city or place.

9. **Select the appropriate city from the list.**

 A map appears with a marker in the center.

10. **Drag the marker to reposition it.**

 The map is a hybrid of high-resolution photos and an actual map. If you know the area well, you should easily be able to locate the exact spot. If necessary, zoom in (see Figure 14-5).

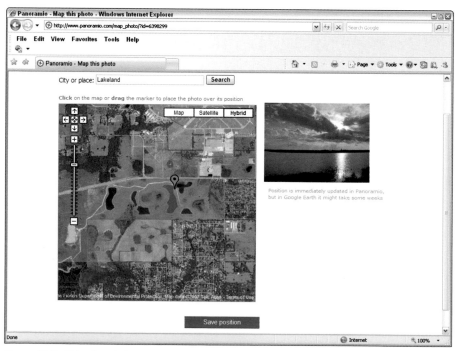

Figure 14-5: This photo's been mapped.

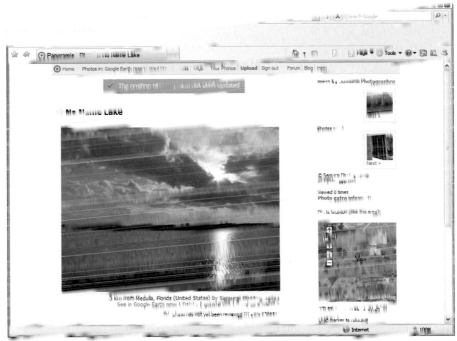

Figure 14-6: It's live for all to see.

You can also organize your photos with tags. Tags make it easier for other Panoramio users to find your photos. It's easy to create tags, and Panoramio has a Help link at the top of the site.

Searching for Video Tutorials at YouTube

Unless you've been incommunicado for the past year and a half, you know that YouTube is huge. Everybody and his little brother post videos on YouTube. In fact, even the future Big Brother posts videos on YouTube. Yep, I'm referring to the presidential candidates. A lot of what you find on YouTube is garbage, but there's also a lot of great stuff, including video tutorials on a wide range of subjects that include digital photography and Photoshop Elements.

Exercise 14-5: Finding Video Tutorials at YouTube

1. **Launch your favorite Web browser, type** www.youtube.com **in the Address field, and then press Enter.**

The site home page appears.

2. **Type Photoshop Elements Tutorials in the Search text box and then click Search.**

The Search Results page displays the videos that match your search criteria (see Figure 14-7).

Figure 14-7: Finding videos you want to play.

3. **Click the video to play it.**

If you think the information is useful, click on the Subscriber's name to view his other videos. If they're useful and he's a frequent contributor, you can subscribe to his videos. Figure 14-8 shows my channel on YouTube, which contains Photoshop tutorials. Notice that there are 185 subscribers to my videos.

4. **Before leaving the site, try typing different information in the Search text box.**

Try searching for videos on photography, digital photography, or any other subject that piques your curiosity. To create slide shows of some your own photographs, create a YouTube account, and then use Windows Movie Maker to create your slide show. To find out more about the YouTube community and how to create videos for YouTube, check out *YouTube For Dummies,* by Doug Sahlin and Chris Botello (Wiley Publishing).

Figure 14-8: A YouTube channel, chock full of videos

Discovering New Camera Gear at Digital Photography Review

When you're thinking about buying a new camera, it's best to read an authoritative report on available models before even going to the store. There are so many cameras to choose from that you can save a lot of time by first creating a list of cameras with the features you need and want. I always turn to one site when I need a report on a new camera: Digital Photography Review. The next exercise introduces you to the site.

Exercise 14-6: Searching for Camera Reviews at Digital Photography Review

1. **Launch your favorite Web browser, type** www.dpreview.com **in the Address field, and then press Enter.**

 The site home page appears. The home page lists news about camera revisions and the latest reviews.

2. **Click Reviews/Previews and select a review.**

 Alternatively, you can click Camera Database and select a camera manufacturer, which opens a page that shows all models reviewed by the site. Figure 14-9 shows the first review page for a new Olympus camera. The review is 32 pages long. The last page shows samples of images captured with the camera. Now that's an in-depth test if there ever was one!

Figure 14-9: An authoritative review of a new camera.

3. **While you're at the site, click some of the other links. You can find a wealth of information about digital cameras there.**

Fine-Tuning Your Landscape Photography Skills at the Luminous Landscape

Landscape photography is awe-inspiring. When you see beautiful photographs of breathtaking scenery, it makes you want to be there. But it's also possible to take bad photographs of gorgeous scenery. The following exercise introduces you to a Web site where you can find lots of useful information about landscape photography and how to improve your skills as a photographer.

Exercise 14-7: Exploring the Luminous Landscape Web Site

1. **Launch your favorite Web browser, type** www.luminous-landscape.com **in the Address field, and then press Enter.**

 The site home page appears (see Figure 14-10).

2. **Click Tutorials.**

 The page refreshes and you see each letter of the alphabet.

Figure 14-10: The Luminous Landscape home page.

3 Click a letter to see all tutorials that begin with that letter.

You can spend many days looking through the information on this site. If you're a
landscape photographer, bookmark the page and come back often.

Finding All the Digital News That's Fit to Print at Digital Outback Photo

Digital Outback Photo is run by a gentleman named Uwe Steinmueller and several other
contributors. On this Web site, you can find useful information about digital cameras and
photography. Some of it is free; some is not. The following exercise introduces you to
what you can expect to find at this resource.

Exercise 14-8: Visiting Digital Outback Photo

1. **Launch your favorite Web browser, type www.outbackphoto.com in the Address
 field, and then press Enter.**

 The site home page appears (see Figure 14-11).

Figure 14-11: A visit to Digital Outback Photo.

2. **Begin your exploration of this resource by clicking the News link.**

 The page refreshes and you see posts with the latest news from the site contributors. On the left side of the page are several links of interest. Check out their portfolios for some excellent examples of digital photography. You can also find information about cameras and photography gear, instructional tutorials, and much more. Spend some time at this site. Your visit is time well spent.

Looking at Fine Art Photography and More at Aperture

Aperture is a photography magazine that showcases the work of well-known photographers. In the magazine, you'll find excellent examples of cutting-edge photography and fine art photography. The companion Web site, which is the topic of the next exercise, is an interesting place for any photographer to visit.

Exercise 14-9: Exploring Aperture's Web Site

1. **Launch your favorite Web browser, type** www.aperture.org **in the Address field, and then press Enter.**

 The site home page appears (see Figure 14-12).

Figure 14-12: A click of the mouse button will put you at Aperture.

1. Begin your exploration by clicking the current issue link.

 Checking out a current issue gives you an idea of what the magazine is like. You can click links to see some of the articles and examples of fine art photography.

2. After you finish perusing the current issue, click the Photographer link under the Limited-Edition Photographs heading.

 The page refreshes and you see thumbnails of the photographs for sale, sorted by the photographer's name.

3. Click a thumbnail to see a larger version of the photograph and some information about it.

 The prices may shock you, but they're representative of what fine art photography sells for these days. The information may be an incentive to master your camera and make a bit of money selling your photographs at local art fairs.

Show Off Your Work Online at Flickr

Flickr is another Web site where photographers can post their work at no charge. At this site, you find photographs from photographers of varying talent. All you need to create an account is a few minutes and a Yahoo ID. The following exercise explores the Flickr site.

Exercise 14-10: Creating an Online Portfolio at Flickr

1. **Launch your favorite Web browser, type** www.flickr.com **in the Address field, and then press Enter.**

The site home page appears (see Figure 14-13).

Figure 14-13: Oh, Flickr, we're home!

2. **Click Create Your Account.**

The page refreshes and you're prompted to enter your Yahoo ID and password. If you don't have a Yahoo ID, click the link to sign up.

3. **Type your Yahoo ID and Password in the appropriate fields, click Sign In, and follow the prompts to create your account.**

After you create an account, the page refreshes (see Figure 14-14). This is my Flickr page. Of course, I've been busy writing this book, so I haven't had time to upload any photos yet. Notice that the nice folks at Flickr have taught me how to greet people in Turkish.

4. **Click Upload Photos.**

The page refreshes and you see three steps: Choose Photos, Upload, and Add Titles, Descriptions and Tags.

5. **Click Choose Photos.**

The Select Files to Upload to Flicker.com dialog box appears.

6. **Select the photos to upload and then click Open.**

The page refreshes and the Upload Photos to Flickr page appears (see Figure 14-15).

Figure 14-14: Each Flickr user has his own page.

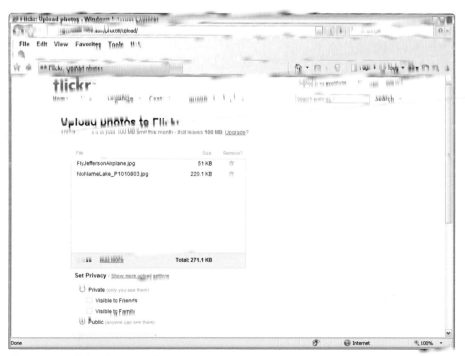

Figure 14-15: Uploading your photos.

7. **Choose viewing options.**

 If you're the shy, reclusive type, choose Private and make the photos visible to friends and family only. You can also send an invite for people to view your private stock. If you want your work seen by anyone, choose Public.

8. **Click Upload Photos.**

 The photos make the trip through cyberspace and you are notified when the upload is finished.

9. **Click Describe Your Photos.**

 The page refreshes showing thumbnails of the photos you've just uploaded.

10. **Enter a description and tags for each photo.**

 The description and tags make it easier for people to find your work on Flickr. Your description should describe the photo and any special effects you used. The tags should include the type of photo, the place where the photo was taken, and so on.

11. **After adding tags and a description to each photo, click Save This Batch.**

 The photos are added to your Flickr page (see Figure 14-16). Users can click on a photo thumbnail to view a larger rendition of the photo.

 There's a lot more to the Flickr site than just uploading photos. You can segregate your photos in sets, create stuff with your photos, and more. Enjoy exploring all this site has to offer.

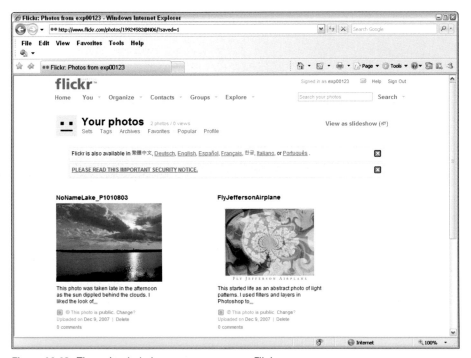

Figure 14-16: The uploaded photos appear on your Flickr page.

• G •

voyager

Christy M. Newman

Advisers to the Series

Mary Dunn Siedow
Director
North Carolina Literacy Resource Center
Raleigh, NC

Linda Thistlethwaite
Associate Director
The Central Illinois Adult Education Service Center
Western Illinois University
Macomb, IL

Reviewer

Sondra Luebke
Instructor, Adult Basic Education
Orange County Public Schools
Orange Technical Education Centers
Winter Park Tech
Winter Park, FL

New Readers Press

Acknowledgments

Fehler, Gene. "Winner" from CENTER FIELD GRASSES: POEMS FROM BASEBALL (c) 1991 Gene Fehler, by permission of McFarland & Company, Inc., Publishers, Jefferson NC 28640.

Hughes, Langston. "Dreams" from THE DREAM KEEPER AND OTHER POEMS by Langston Hughes. Copyright 1932 by Alfred A. Knopf, Inc., and renewed 1960 by Langston Hughes. Reprinted by permission of the publisher and Harold Ober Associates Incorporated.

Kaufman, Shirley. "The Arch" from WORDS ON THE PAGE, THE WORLD IN YOUR HANDS, BOOK ONE published by HarperCollins. Reprinted by permission of the author.

Marsh, Elizabeth. "Can't" from THE READING TEACHER, May 1981. Reprinted by permission of the International Reading Association.

Mosack, Dan. "My Best Friend" from TO OPEN YOUR MIND, Vol. 5, No. 1, Winter 1995. Reprinted by permission.

Toni, "A Special Friend." Reprinted by permission from NEED I SAY MORE, Vol. III, No. 2 (Summer 1990), a publication of the Publishing for Literacy Project, jointly sponsored by the Public Library of Brookline (MA) and the Adult Literacy Resource Institute of Roxbury Community College and the University of Massachusetts/Boston.

Voyager: Reading and Writing for Today's Adults™ Voyager 1
ISBN 978-1-56420-151-5

Copyright © 1999 New Readers Press
New Readers Press
Division of ProLiteracy Worldwide
1320 Jamesville Avenue, Syracuse, New York 13210
www.newreaderspress.com

Printed in the United States of America
9 8 7 6

All proceeds from the sale of New Readers Press materials
support literacy programs in the United States and worldwide.

Director of Acquisitions and Development: Christina Jagger
Content Editor: Mary Hutchison
Photography: David Revette Photography, Inc.
Developer: Learning Unlimited, Oak Park, IL
Developmental Editor: Sarah Conroy Williams
Cover Designer: Gerald Russell
Designer: Kimbrly Koennecke
Artist: Linda Alden
Illustrator: Cheri Bladholm

Distributed By:
Grass Roots Press
Toll Free: 1-888-303-3213
Fax: (780) 413-6582
Web Site: www.grassrootsbooks.net

ProLiteracy Worldwide and New Readers Press are not owned or sponsored by Voyager Expanded Learning, Inc.

This book has four units. Each unit is based on a theme that reflects our day-to-day lives. In *Voyager 1*, you will be exploring these themes:

- ▶ Hopes and Dreams
- ▶ Everyday Heroes
- ▶ Thrilling Moments
- ▶ Friendship

There are three lessons in each unit. Each lesson has the following features:

- ▶ **Before You Read:** a strategy to help you understand what you read
- ▶ **Key Words:** a preview of the harder words in the lesson
- ▶ **Reading:** a poem, story, biography, article, or journal written by adults, for adults
- ▶ **After You Read:** questions and activities about the reading
- ▶ **Think About It:** a reading skill that will help you understand what you read
- ▶ **Write About It:** an activity to improve your writing skills
- ▶ **Word Work:** strategies and skills to help you read and write better

We hope you enjoy exploring the themes and mastering the skills found in *Voyager 1*. We also invite you to continue your studies with the next book in our series, *Voyager 2*.

Student Interest Inventory

A. What is my educational goal?

B. What do I read?

Check this side **BEFORE** you do this book. Check this side **AFTER** you do this book.

a lot	a little	never	I read	a lot	a little	never
			• by myself			
			• at my job			
			• at school			
			• with my children			
			• other:			

I can read these now.	I need help to read these.	I don't care to read these.	I read or would like to read	I can read these now.	I need help to read these.	I don't care to read these.
			• signs or labels			
			• material for my job			
			• newspapers			
			• books to my children			
			• magazines			
			• instructions			
			• recipes			
			• notes and messages			
			• stories and poems			
			• the Bible			
			• other:			

			• at school			
			• for my children			
			• other			

I can do this now.	I need help to do this.	I don't care to do this.	I can or would like to	I can do this now,	I need help to do this	I don't care to do this
			• write dates and phone numbers			
			• write lists			
			• write notes and messages			
			• write letters			
			• write stories			
			• fill out forms			
			• fill out applications			
			• fill out money orders and checks			
			• other:			

I can do this now.	I need help to do this.	I don't care to do this.	When I write, I	I can do this now,	I need help to do this	I don't care to do this
			• print			
			• write in script			
			• write sentences			

▶ Skills Preview

Do as much of this preview as you can. Share your work with your instructor.

> Dear Student,
>
> This book will help you read better. This book has stories and poems for you to read. The stories and poems will give you a lot to think about. They will give you a lot to talk about.
>
> This book will help you understand what you read. You will also work on how to read new words.
>
> This book will also help you write better. And it will help you spell better.
>
> We hope you like this book.
>
> New Readers Press

Reading Skills

✓ Check __all__ the correct answers to each question. More than one answer is correct.

1. What will this book help you do?
 _____ a. read better
 _____ b. write better
 _____ c. spell better

2. What will you read in this book?
 _____ a. stories
 _____ b. books
 _____ c. poems

2. pit pot 4. cab cub

5. bud bug 6. clam clan 7. brick bring 8. trunk truck

B. Choose the right word. Write it on the line. Then read the sentences out loud.

1. Tess has a new _____.

 (jog, job)

2. She will work in a cake _____

 (chop, shop)

3. She will learn to make cakes by _____.

 (hand, hard)

4. Tess thinks her job will be _____.

 (fun, fan)

Skills Preview Answers

Reading Skills

A. 1. _✓_ a. read better

 ✓ b. write better

 ✓ c. spell better

 2. _✓_ a. stories

 _____ b. books

 ✓ c. poems

Phonics Skills

A. 1. hat 2. bell 3. pot 4. cab

 5. bug 6. clam 7. brick 8. truck

B. 1. job

 2. shop

 3. hand

 4. fun

Skills Chart

The questions in the Skills Preview assess students' familiarity with the following skills:

Question	Skill
Reading Skills	
1	Finding the main idea
2	Finding details
Phonics Skills	
A. 1 - 4	Short vowels
5 - 6	Ending consonants
7 - 8	Ending consonant blends and digraphs
B. 1	Ending consonants
2	Initial digraphs
3	Final blends
4	Short vowels

We all have hopes and dreams.

Our hopes and dreams say a lot about us. They say who we are. They say what we want in life.

Some dreams are big. It will take a lot of work to make these dreams come true.

Some dreams are not so big. It may not take much work to make these dreams come true.

Before you start Unit 1, think about your hopes and dreams. What do you want in life? How will you make your dreams come true?

Lesson 1

LEARNING GOALS

Strategy: Use your experience to help you understand what you read
Reading: Read a story
Skill: Sequence events
Writing: Make a list
Word Work: Short vowels (*a, e, i, o, u*)

Before You Read

"A Class of Hopes" is a story about adults who are learning to read better. Learning to read will help them make their dreams come true.

1. Talk about the things adults need to read.
 Why did you decide to improve your reading?
 What do you hope will happen when you can read better?

2. ✓ Check the sentences that are true for you. Write two more reasons why you want to learn to read better.

 I want to read

 _____ the newspaper.
 _____ for my job.
 _____ to help my children with their homework.

Key Words

- Jan <u>goes</u> to <u>school</u>.
- Ken wants to <u>learn</u> to read <u>better</u>.
- Ken hopes to read <u>stories</u> to his <u>son</u>.
- Brad wants to go to <u>college</u>.

Jan goes to school, too. She wants to read better. She hopes to work in a shop. She has to read to work in a shop.

Brad has a job. He cuts grass. But he wants a better job. He hopes to go to college, too. Brad has to read well to go to college.

Ken, Jan, and Brad all hope for better lives. They work hard. They know that they must learn to read better.

After You Read

Discuss these questions.

1. Why does Ken want to read better?
 Why does Jan want to read better?
 Why does Brad want to read better?
2. What are Ken, Jan, and Brad doing to make their dreams come true?
3. How will reading better help you? What changes will reading better make in your life?

Think About It: Sequencing Events

Sequence is the order in which things happen.

First your alarm clock rings.

Then you get up.

Last you get dressed.

Practice

A. Sequence Words Read the sequence words in the box.

First	Then	Last

B. Look at the pictures. Number them in order. Copy the word from the box under the right picture.

__1__

First

2. Then _____

3. Last _____

D. Read the sentences. Number them in order. Copy them in the right order.

_____ Jan learns to read better.

_____ Jan gets a job in a shop.

__1__ Jan hopes for a better life.

First <u>Jan hopes for a better</u>

life, _____

Then _____

Last _____

Write About It: Make a List

A. Brad's Plan In "A Class of Hopes," Ken, Jan, and Brad have special dreams. Brad wants a better job. He makes a plan. Brad's plan has five steps. Read his plan.

Brad's Plan

1. Learn to read and write better.
2. Take a GED class.
3. Get my GED.
4. Go to college.
5. Get a better job.

B. Brad's plan is a list. Each step has its own line. Recopy Brad's plan onto the lines below. Be sure each step starts on a new line.

Brad's Plan

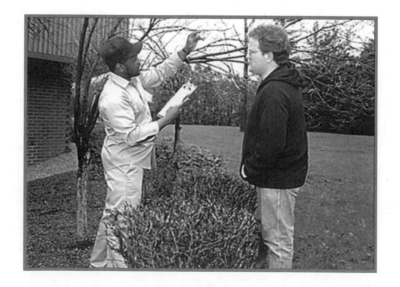

My Plan

_____ _____

_____ _____

3. Check your list. Be sure the steps are numbered in the
 right order. Then recopy your plan in the right order.

My Plan

_____ _____

_____ _____

_____ _____

_____ _____

Word Work: Short Vowels (*a, e, i, o, u*)

A. The words below have short vowel sounds. Read the words. Listen to the vowel sounds.

a	e	i	o	u
Jan	Ken	it	on	us
has	get	in	job	but
Brad	then	big	lot	much
plan	well	did	shop	must
class	better	this	college	Russ

B. Say the two words under each picture. Pick the word that says what you see. Then write it on the line.

pet pot

pin pan

map mop

cut cat

hat hut

bid bed

pen pin

nut net

b __ u d h __ m b ___ t l ___ ck

D. Word Families A word family is a group of words that share the same set of letters. Words in a family rhyme, too. Word families help you read many new words. Read the words. Write other words you know in each family on the lines.

-ad	-en	-id	-ot	-un
bad	den	hid	cot	bun
dad	hen	did	hot	fun
had	Ken	lid	jot	run
glad	then	slid	clot	stun
___	___	___	___	___
___	___	___	___	___
___	___	___	___	___

▶ **Update on "A Class of Dreams"** It is a few years later. Ken's son, Russ, is in school. He needs help with his homework. He asks Ken for help. What do you think happens?

Lesson 2

LEARNING GOALS

Strategy: Use what you know to understand what you read
Reading: Read a story
Skill: Identify cause and effect
Writing: Write a poem
Word Work: Initial consonant blends (*br, cl, gr, pl, st*)

Before You Read

"A New Life" is a story about a man who came to the U.S. from Mexico.
Before you read, answer these questions.

1. Think of a person who was born in another country.
Write about the person here.

Name: _____

Country: _____

Language: _____

2. Talk about why people move to new countries. ✓ Check the reasons
you think people come to the U.S. Write another reason.

_____ to get a better job _____ to get married

_____ to be with family _____ to feel more safe

_____ to be with friends _____

Key Words

- Sal is from <u>Mexico</u>.
- He learned <u>English</u>.
- Sal <u>missed</u> his <u>family</u>.
- He went to class at <u>night</u>.

Life in the U.S. was hard for Sal. He missed his family. He worked hard each day. He went to class at night. Sal learned English. He got a better job.

Now Sal has a new dream. He plans to visit his family in Mexico. He will give them gifts. He will tell them about his new life. Sal will be glad to see his family.

After You Read

Retell the story about Sal. Here are some ways to start.

1. Sal comes from . . .
2. Sal came to Texas because . . .
3. Each day Sal . . .
4. He learned . . .
5. Sal's new dream is . . .

Think About It: Identifying Cause and Effect

A **cause** is what makes something happen. An **effect** is what happens.

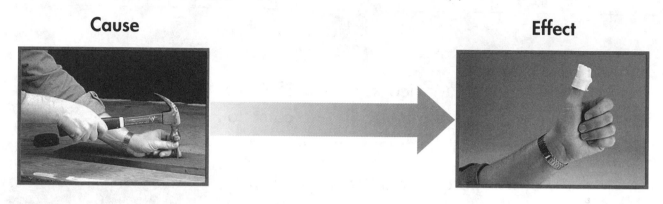

Cause Effect

Practice

A. Match Write the letter of the correct effect next to the cause.

Cause Effect

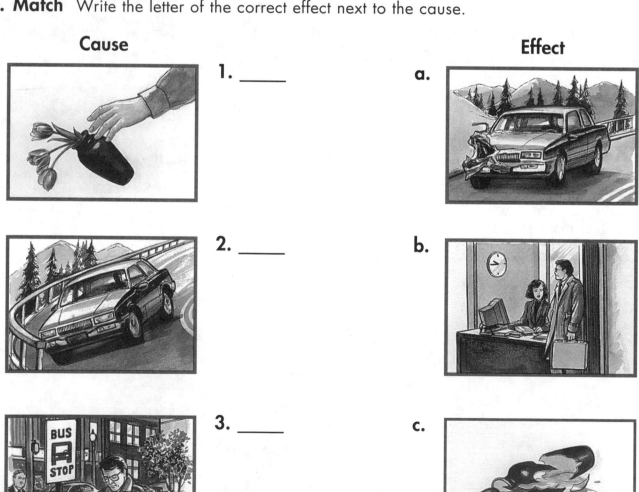

1. _____

2. _____

3. _____

a.

b.

c.

2.

Effect Sal calls his family on the phone.

Cause (1) _____ He misses his family
(2) _____ He works hard.

3.

Effect Sal went to class at night.

Cause (1) _____ He wanted a better job.
(2) _____ He wanted to visit his family.

C. Write a sentence that tells what is happening in the picture (effect). Then write a sentence that tells what you think made it happen (cause).

Effect _____

Cause _____

Write About It: Write a Poem

Sal's Poem

Sal wrote this poem in class. Read Sal's poem.

Sal
Mexican, brave, hardworking, hopeful
Son of Ben and Bella
Brother of Carmen, Victor, and Martin
Who feels glad to be here
Who likes sunny days
Who needs family, friends, and work
Who lives in Dallas, Texas
Castro

What details does the poem give about Sal? Discuss Sal's poem.

My Poem

A. Think about Sal's poem. Write a poem about yourself. Write a draft here.

Your first name: _____

Four words that tell about you: _____

Son or daughter of: _____

Brother, sister, or friend of: _____

Who feels: _____

Who likes: _____

Who needs: _____

Who lives in: _____

Your last name: _____

Who feels _____

Who likes _____

Who needs _____

Who lives in _____

Word Work: Initial Consonant Blends (*br, cl, gr, pl, st*)

A. Read the words in each list. Can you hear two sounds in the beginning blends?

br	cl	gr	pl	st
brave	clam	grab	plan	stop
bring	clip	grill	plant	star
broom	club	grin	plate	state
brush	class	grass	plug	story
brother	clock	grand	plum	stand

B. Read the two words under each picture. Pick the word that says what you see. Then write it on the line.

clock crock stop shop class grass groom broom

_____ _____ _____ _____

scar star plant grant crush brush plate late

_____ _____ _____ _____

_____ _____ _____ _____ _____

D. Pick the right word for each sentence. Write it on the line.

1. ____Sal____ came to the U.S. from Mexico.
 (Pal, Sal)

2. Sal went to _____ at night.
 (class, grass)

3. Sal lives in the _____ of Texas.
 (plate, state)

4. Sal _____ to visit his family.
 (clans, plans)

5. He will be _____ to see his family.
 (glad, grad)

▶ **Update on "A New Life"** Sal has worked hard. He knows English now. He has a better job. Now he can send money home. His brother wants to come to the U.S., too. He will live with Sal. What do you think will happen?

Lesson 3

LEARNING GOALS

Strategy: Picture what you read
Reading: Read a poem
Skill: Understand the main idea
Writing: Write a poem
Word Work: Final consonant blends (*ft, ld, mp, nt, st*)

Before You Read

Langston Hughes is a famous African American poet. In this lesson you will read his poem "Dreams." This poem tells us what life is like without hopes and dreams.

1. Why are your hopes and dreams important to you?

2. What can happen to people when they lose their hopes and dreams?

3. What feelings or pictures come to mind when you think about losing <u>your</u> hopes and dreams?

Key Words

- <u>Hold fast</u> means to hold on.
- The <u>broken-winged</u> bird cannot fly.
- No plants can grow in a <u>barren</u> field.

Poets often use words to create pictures, or images, that carry their message each stanza, or group of lines, has a different image of a life without dreams. I in the first stanza is:

> . . . if dreams die
> Life is a broken winged bird
> That cannot fly.

This is one image of a life without dreams.

Practice

1. What image of a life without dreams does Hughes use in the second stanza? Write it here.

2. Picture the "broken-winged bird" and the "barren field" in your mind. What other words can you think of to describe them?

3. "Dreams" tells us what happens if we let go of our dreams:

 - Life is a broken-winged bird that cannot fly.
 - Life is a barren field frozen with snow.

 What do you think happens if we hold on to our dreams?

In "Dreams," Langston Hughes tells us not to let hopes and dreams die.
As you read, what pictures do you see in your mind?

Dreams

Langston Hughes

Hold fast to dreams
For if dreams die
Life is a broken-winged bird
That cannot fly.

Hold fast to dreams
For when dreams go
Life is a barren field
Frozen with snow.

After You Read

Discuss these questions.

1. How do you feel after reading this poem?
2. Look at lines 1 and 5. What advice does Langston Hughes
 give in these lines?
3. Picture a "broken-winged bird." The poet says that a life
 without dreams is a broken-winged bird. What does he mean?
4. Picture a "barren field." The poet says that a life without
 dreams is a barren field. What does he mean?
5. Re-read the poem. This time, how does the poem make
 you feel?

Dreams

Hold fast to dreams
For if dreams die
Life is a broken-winged bird
That cannot fly.

Hold fast to dreams
For when dreams go
Life is a barren field
Frozen with snow.

Let Go

Let go of hate
For if hate dies
Life is a soaring bird
That owns the sky.

Let go of fear
For when fears pass
Life is a green field
Alive with grass.

A. Read the poem "Let Go" again. Think of words you can change in the poem.

B. Write your new poem below.

Let Go

Let go of _____

For if _____

Life is _____

That _____

Let go of _____

For when _____

Life is _____

That _____

Word Work: Final Consonant Blends (*ft, ld, mp, nt, st*)

A. Read the words in each list. Can you hear two sounds in the ending blends?

ft	ld	mp	nt	st
gift	old	lamp	cent	best
loft	hold	pump	pint	cost
lift	child	clump	went	fast
raft	field	stamp	grant	must

B. Read the two words under each picture. Pick the word that says what you see. Then write it on the line.

lamp land

chill child

best bent

gift girl

bump pump

field film

send cent

stamp stand

lamp	best	cold	gift	bump
ramp	test	hold	drift	pump
clamp	chest	sold	shift	plump
stamp	quest	scold	swift	clump

_____ _____ _____ _____ _____

D. Crossword Puzzle Fill in missing letters to complete the puzzle with words from the Word List.

WORD LIST

DARREN
BROKEN
CHEST
CLAMP
FAST
FIELD
HOLD
LEFT
NOW
OWN
STAMP
SWIFT
TENT
WENT
WINGED

Writing Skills Mini-Lesson: Sentences and Capitalization

When you write sentences, be sure they are complete. Be sure they are capitalized correctly. Follow these rules.

1. A sentence states a complete thought. It begins with a capital letter and ends with a period.

 I have a dream**.**

2. A question begins with a capital letter and ends with a question mark.

 What is your dream**?**

3. Always capitalize the word *I*. Capitalize people's names.

 Don **G**rant and **I** each have a dream.
 What is our dream?
 Don wants a new job, and so do **I**.

Practice

Rewrite each sentence. Capitalize the correct words. Write a period (.) or a question mark (?) at the end of each sentence.

1. don grant wants a better job

2. he wants to make more money, and so do i

3. how will don and i get new jobs

4. he and i will have to work hard to get them

Dreams

In this unit, we learned about some hopes and dreams.
Ken, Jan, and Brad want to read better. They go to class
to make their dreams come true. Sal wanted a better life.
He came to Texas to make this dream come true.

Dreams mean a lot to Ken, Jan, Brad, and Sal. They work
hard to make their dreams come true.

Choose the best answer to each question.

1. Which sentence best tells the main idea of "Dreams"?
 _____ (1) In this unit, we learned about some hopes and dreams.
 _____ (2) Ken, Jan, and Brad want to read better.
 _____ (3) Sal wanted a better life.

2. **Effect:** Ken, Jan, and Brad go to class.

 What is the cause?
 _____ (1) They want to read better.
 _____ (2) They want to have dreams.

3. **Effect:** Sal came to Texas.

 What is the cause?
 _____ (1) He learned English.
 _____ (2) He wanted a better life.

Word Work Review

Pick the right word. Write it on the line.

1. Ken goes to reading _____ .
(class, grass)

2. He _____ a son named Russ
(his, has)

3. Jan hopes to work in a _____ .
(stop, shop)

4. Brad dreams about a better _____ .
(jab, job)

5. Sal has a new _____ .
(plan, plant)

6. We need to _____ on to our dreams.
(host, hold)

7. Dreams can make us do our _____ .
(bent, best)

Write About It

▶ **Topic:** What is your dream? What are you doing to make it come true?

Prewrite Think about the topic questions. List some ideas.
Write Pick your best ideas. Write about your dream.
Revise Look at your sentences again. Change any words
 you want to change. Have someone read your writing.
 Can he or she understand it?
Edit Find and correct mistakes in your writing. See page 128.
Final Draft Make a final copy to keep and share.

Not all heroes are big and strong. Not all heroes fight in a war. Not all heroes save a life.

Most heroes are everyday heroes. They are like the people you see each day. They may not plan to be heroes. They may not think they are brave. But these heroes do things that are hard. They do hard things that must be done.

Heroes are brave. We admire this. We admire heroes.

Before you start Unit 2, think about heroes. What makes a person a hero? Who are some heroes you admire?

Lesson 4

Before You Read

"A Bus Ride" is about a woman who became a real-life hero. Before you read, answer these questions.

1. Look at the title of the reading on page 39. Look at the picture. What do you think the reading may be about? Write your prediction here.

2. Discuss what you know about the U.S. civil rights movement of the 1950s and 1960s.

3. Discuss the kinds of laws that were changed by the civil rights movement.

Key Words

- Alabama had an <u>unfair</u> <u>law</u>.
- Rosa Parks <u>paid</u> her <u>fare</u> to ride the bus.
- Rosa Parks was <u>arrested</u>.
- Now <u>people</u> can sit <u>anywhere</u> on a bus.
- <u>Cesar</u> <u>Chavez</u> formed a <u>union</u> for <u>farm</u> workers.

A Bus Ride

In 1955 Rosa Parks took a bus ride. That ride changed her life. It changed the law, too.

Alabama had an unfair law. The law said that white people could sit anywhere on a bus. But black people had to sit in the back of the bus.

One day Rosa Parks got on a bus. She paid her fare. She sat down. But a white man wanted her seat. Ms. Parks did not move. She did not think the law was fair.

ROSA PARKS

Rosa Parks broke the law. She was arrested. Many people heard about Ms. Parks. Black people were mad. They didn't ride the buses. They didn't ride for 381 days.

At last the law was changed. Now people can have any seat on the bus. Rosa Parks took a stand. She helped to change the way people live.

After You Read

A. Tell about Rosa Parks's bus ride. Here are some ways to start.
1. First Rosa Parks paid . . .
2. A white man wanted . . .
3. Ms. Parks did not . . .
4. She was . . .

B. Discuss why Rosa Parks is a hero.

Think About It: Making Predictions

When you **predict**, you try to figure out what a reading will be about.

To predict what a reading will be about, use these clues:

- the title
- pictures

On page 38 you made a prediction about the reading.
Copy it here.

How did your prediction match the reading? How did it not match?

Practice

A. Read each title and look at each picture. ✓ Check the prediction that can be made.

1.

 Title: Learning to Cook

 Prediction: (1) _____ The man will read a cook book.

 (2) _____ The man will learn to cook dinner.

2.

 Title: Mexico in May

 Prediction: (1) _____ They will take a trip to Mexico.

 (2) _____ They will take a trip to Dallas.

1. **Title.** Jun's New Job

Prediction: _____

2. **Title.** Brad Moves On

Prediction: _____

3. **Title:** Sal Takes a Trip

Prediction: _____

C. Look at the picture on page 42. Read the title. What do you think the article will be about? Write your prediction here

Prediction: _____

Write About It: Write About What You Read

A. Read this article about another real-life hero.

A Hero to Farm Workers

Cesar Chavez was an everyday hero. He was
a farm worker in California. He moved from farm
to farm. He worked very hard. But he made
almost no money. So he started a union.

The union is called the United Farm Workers.
The union helps farm workers get more money.

Cesar Chavez gave farm workers hope for
a better life. His work made him a hero.

CESAR CHAVEZ

B. Talk about Cesar Chavez and the United Farm Workers.

C. Write about Cesar Chavez in your own words. Here are some words
to help you start.

Cesar Chavez was _____

He worked _____

He started _____

He helped _____

He gave farm workers _____

I think he _____

A. The long a sounds like the *a* in *name*. Look at the words below. Most words with these letter combinations have a long *a* sound. Read the words.

a-e	ai	ay
date	paid	day
fare	wait	play
gave	rain	stay
brave	fair	today
plane	sail	maybe

B. Read the word pairs. Underline the word with the long *a* sound.

ran rain cup cape sail Sal plan plane

C. Read the word pairs. Underline the word with the long *a* sound.

1. hat hate tap tape made mad Jan Jane

2. rain ran pan pain pad paid main man

D. Look at the words you underlined in **C.** Talk about the patterns you see. Fill in the blanks in the patterns below.

1. Most words that end in a + consonant + silent _____ have a long *a* sound.

2. Most words with *ai* have a _____ a sound.

i-e and igh = Long i

E. The long i sounds like i in *ride*. Look at the words below. Most words with these letter combinations have a long i sound. Read the words.

i-e	i-e	igh
life	like	high
ride	time	might
white	alive	night
write	admire	tight

F. Read the word pairs. <u>Underline</u> the word with the long i sound. Then write it on the line.

1. ride rid _____

2. bite bit _____

3. sit sight _____

4. dim dime _____

5. fit fight _____

6. fine fin _____

7. spin spine _____

8. ripe rip _____

G. Look at the words you underlined. Talk about the patterns you see. Fill in the blanks in the patterns below.

1. Most words that end in i + consonant + silent _____ have a long i sound.

2. Most words with *igh* have a _____ i sound.

H. Sometimes *live* has a short i sound. Sometimes it has a long i sound. Read the sentences. ✓ Check the ones with a long i sound for *live*.

_____ **1.** Sal came to live in Texas.

_____ **2.** Sal lived in Mexico.

_____ **3.** Dreams can change lives.

_____ **4.** Rosa Parks lives in Alabama.

-ail	-ain	-ake	-ace	-ame
tail	main	make	face	came
mail	rain	rake	lace	name
nail	brain	shake	brace	blame
tail	grain	snake	grace	flame

| _____ | _____ | _____ | _____ | _____ |

-ice	-ine	-ite	-ight	-ind
mice	line	bite	night	bind
nice	line	kite	right	find
price	mine	unite	tight	kind
twice	shine	write	bright	grind

| _____ | _____ | _____ | _____ | _____ |

J. Practice Fill in the missing words in the sentences. Choose from the box.

admire	life	ride	right	white

1. Rosa Parks took a bus _____.

2. A _____ man wanted her seat.

3. She did not think it was _____.

4. The bus ride changed her _____.

5. Many people _____ Rosa Parks.

▶ **Update on "A Bus Ride"** Rosa Parks worked as a tailor until 1965.
Then she worked for a congressman. She retired in 1988. In honor of
the stand she took, she is called the "Mother of the Civil Rights Movement."

Lesson 5

LEARNING GOALS

Strategy: Picture what you read
Reading: Read a news article
Skill: Find details
Writing: Write about a person you interview
Word Work: long e and long y

Before You Read

"Neighbor Saves Family" is a news article about a house fire. Before you read the article, answer these questions.

1. Picture a house fire in your mind. Talk about the pictures that come to mind. What people do you see? What are they doing?

2. What words do you know that describe a hero? Write them here.

 _____ _____ _____

3. What everyday heroes do you know?

Key Words

- Steve Meehan helped his <u>neighbor</u>.
- He was <u>already</u> helping.
- The <u>cause</u> of the fire is not <u>known</u>.
- The family was in <u>danger</u>.
- Today Pete <u>retires</u> from his job.

actions in your mind

Neighbor Saves Family by Gene Miles

There was a house fire last night. The house was at 5 Beach Street. Steve Meehan, a neighbor, called 911. Then he ran to help Ms. Yee and her baby.

A fire fighter said, "We got to Beach Street fast. But Mr. Meehan was faster. He was already helping. He got Ms. Yee and her baby out the first-floor window. We made sure they were O.K. Then we put out the fire."

STEVE MEEHAN, Ms. YEE, FIRE FIGHTER

Ms. Yee and her baby are fine. "Steve is very brave," Ms. Yee said, "He saved our lives. He's our hero."

The cause of the fire is not known.

After You Read

A. Read the story out loud.

B. Discuss these questions

1. What did you picture in your mind as you read the article?
2. How did Steve get his neighbors out of the house?
3. Why did Ms. Yee call Steve a hero?
4. Steve's neighbors needed help. He did not stop to think about the danger. Do you think all heroes face danger? Are there other kinds of heroes?

Think About It: Finding Details

The facts in a news story are details. The facts give us important information. Can you remember details from "Neighbor Saves Family"?

A. ✓ Check **True** if the detail matches the story. Check **False** if it does not match.

True	False	
_____	___✓___	**1.** The house was at 9 Beach Street.
_____	_____	**2.** Steve Meehan called 911.
_____	_____	**3.** The Yee family got out the back door.
_____	_____	**4.** Fire fighters put the fire out.
_____	_____	**5.** Ms. Yee said Steve is a hero.

B. Complete each sentence. Use details from "Neighbor Saves Family."

1. There was a house fire at _____

2. Steve Meehan ran to help _____

3. He got them out the _____

4. The _____ made sure that the Yees were OK.

5. Ms. Yee and her baby are _____

6. Ms. Yee said that Steve is very _____

Fire Fighter Retires by Gene Miles

PETE GREELEY

Pete Greeley was a fire fighter for 25 years. He put out his last fire on Friday. Today he retires.

"Every fire can put people in danger," he said. "A family was in danger. We were lucky that the fire at 5 Beach Street was easy to put out."

Pete has won many prizes and medals. He is a brave man. But Pete doesn't think he is a hero. "I just do my job. I am a fire fighter," he said.

B. Complete each sentence. Use details from "Fire Fighter Retires."

1. _____ was a fire fighter for 25 years.

2. Pete put out his last fire _____

3. Pete retires _____

4. Pete has won many _____

5. Pete is a _____ man.

Write About It: Write About a Person You Interview

Reporters ask questions to get the facts right. These are some of the questions they ask.

Who? What? Where? When? Why?

Reporters ask	When they want to know
Who?	about people
What?	what happened
Where?	the place
When?	the time, day, week, month, or year
Why?	the cause

A. There are many facts in "Neighbor Saves Family." You have to ask questions to get the facts. Match the question to the correct answer.

b **1.** Who was a hero? **a.** The Yees had a house fire.

___ **2.** What happened? ✓ **b.** Steve Meehan

___ **3.** Where was the fire? **c.** It is not known.

___ **4.** When was the fire? **d.** at 5 Beach Street

___ **5.** Why did the fire start? **e.** last night

Who	What	Where	When	Why

Questions **My partner's answers**

1. _____ is your name? _____

2. _____ were you born? _____

3. _____ do you live? _____

4. _____ do you like to do? _____

5. _____ work do you do? _____

Now write your own question. Ask your partner this, too.

6. _____

C. Write about your partner. Use the facts you learned. Then read your writing aloud.

1. My partner's name is _____

2. _____ was born _____.
 (partner's name)

3. _____ lives _____

4. _____ likes to _____

5. _____ works _____

6. _____

Word Work: Long e and Long y

e, ee, and e-e – Long e

A. Long e sounds like e in be. Look at the words below. Most words with these letters have a long e sound. Read the words.

e	ee	e-e
be	need	Pete
he	week	Steve
me	green	these
she	street	complete

B. The Letters ea Look at the words below. The letters ea have three different sounds. Read the words.

ea as in each	**ea as in head**	**ea as in great**
easy	bread	break
reach	ahead	steak
year	already	greatly
dream	breakfast	outbreak

Tip When you see a new word with ea, first try ea as in each (long e). Then, if you don't hear a word you know, try ea as in head (short e). Last try ea as in great (long a).

C. Sometimes read has a long e sound. Sometimes it has a short e sound. The sound depends on the sentence. Read the sentences. ✓ Check the ones with a long e sound for read.

_____ **1.** Did you read the story in the newspaper?

_____ **2.** Steve read about the house fire.

_____ **3.** Ken reads to Russ every night.

_____ **4.** I read about the fire last night.

	y as in **any**
by	city
fly	many
why	story
myself	family

Practice

E. Finish the sentences. Use the words in the box.

easy
Why
bravery

1. _____ do we admire heroes?

2. We admire their _____.

3. It is not _____ to be a hero.

F. Read these words. Cross out the word in each row that does not have a long vowel sound. The first one is done for you.

1. we	weed	week	~~web~~
2. peek	pet	peel	Pete
3. bed	bee	he	by
4. feet	feel	fee	fed
5. heed	head	he	heel
6. flee	fly	fleet	flat

▶ **Update on "Neighbor Saves Family"** The Yee family is glad they are safe. Their house was saved, too. They have put smoke detectors in their house. They joined the Neighborhood Watch program with Steve Meehan. Now they all watch out for their neighborhood.

Lesson 6

LEARNING GOALS

Strategy: Use your experience to help you understand what you read
Reading: Read a poem
Skill: Make inferences
Writing: Write a paragraph
Word Work: Long a and long u

Before You Read

"Can't" is a poem about an everyday hero. This person was afraid to try something. Before you read the poem, answer these questions.

1. Have you ever been afraid to try something because you might fail? If so, what was it?

2. Did you ever do something just to prove you could? If so, what?

3. Do you agree that doing something hard can make a person a hero? Why or why not?

Key Words

- I once said I <u>couldn't</u> do it.
- I <u>screamed</u> it.
- I know you <u>can't</u>.
- I did <u>prove</u> them <u>wrong</u>.

As you read, think about what the poet might have been afraid to try.

Can't

E. M. Marsh

I once said I couldn't do it
I screamed it
I yelled it
I told everyone

Then
One day
Someone said
"I know you can't"

Then I did it
To prove them wrong

After You Read

A. Read the poem out loud.

B. Discuss these questions
 1. What happened in the first stanza?
 What might the poet have been afraid to try?
 How do you think the poet felt?
 2. What happened in the second stanza that made her change her mind?
 3. Why do you think the poet decided to do it?
 4. Who do you think it is harder to convince about things—yourself or other people? Why?

Think About It: Making Inferences

When you **Infer**, you use clues to figure out something not said.

Clue	**Inference**
	1. She has just come in from the rain.
	2. He has just built a dog house.

Practice

Answer the riddles. Use the words in the box.

toast	sea	tree	today

1. I am wet.
I am blue.
I have wave after wave.
I am the _____.

2. I am after yesterday.
I am before tomorrow.
I am now.
I am _____.

3. I am brown and dry.
I get buttered.
I used to be bread.
I am _____.

4. I am tall.
I give shade in summer.
I am bare in winter.
I am a _____.

to herself and to others that she could do it.

Think of something you have done that was hard for you. Finish these sentences. Or, if you prefer, write your own sentences.

I did a hard thing when _____

I did not _____

I wanted to _____

I decided that _____

It was _____

I felt _____

B. Copy your sentences into a paragraph.

Word Work: Long *o* and Long *u*

A. *o, oe, oa,* **and** *o-e* = **Long** *o* Long o sounds like the o in go

Look at the words below. When you see words with these letters, give them the long o sound. Read the words.

o	oe	oa	o-e
go	toe	goal	home
no	hoe	road	hope
hero	Joe	soap	broke
over	goes	toast	wrote

B. *u* **and** *u-e* = **Long** *u* Long *u* sounds like the *u* in *use* or the *u* in *June*.

Give the words below the sound of *u* as in *use*.

u	ue	u-e
menu	argue	cute
music	rescue	mule
union	statue	refuse
united	value	perfume

Give the words below the sound of *u* in *June*.

u	ue	u-e
flu	due	tune
duty	blue	rule
ruby	glue	include
super	true	produce

C. Practice Read these words. Cross out the word in each row that doesn't have a long vowel sound.

1.	rode	rope	road	rod
2.	cute	cube	cut	clue
3.	so	son	soap	spoke
4.	hop	hope	hoe	hero

boat	bone	more	old	-use
boat	bone	more	old	fuse
float	tone	tore	bold	excuse
gloat	alone	store	cold	misuse
throat	phone	before	gold	refuse

_____ _____ _____ _____ _____

E. More Practice Pick the word pair that rhymes with the underlined words. Finish the rhymes. ✓Check off the word pairs as you use them.

alone	phone	✓boat	float
blue	true	hoe	toe

1. She put on her <u>coat</u> as the ____*boat*____ began to ____*float*____.

2. There is a <u>tone</u> on the _____. But he is not _____.

3. The rent is <u>due</u>. It's _____. I feel _____.

4. <u>Joe</u> hurt his _____ on my garden _____.

F. Work with a partner. Pick a word family. Write a rhyming sentence here.

Writing Skills Mini-Lesson: Contractions

A **contraction** is formed when two words are combined into one. At least one letter is dropped. An **apostrophe** takes the place of the missing letter or letters.

can not ➡ can't is not ➡ isn't

Here are some other common contractions.

are not	➡	aren't	has not	➡	hasn't
was not	➡	wasn't	have not	➡	haven't
were not	➡	weren't	had not	➡	hadn't
do not	➡	don't	will not	➡	won't
does not	➡	doesn't	could not	➡	couldn't
did not	➡	didn't	would not	➡	wouldn't

Practice

A. Write the contraction.

1. did not ___didn't___ **4.** has not _____

2. do not _____ **5.** could not _____

3. is not _____ **6.** would not_____

B. Rewrite each sentence. Put the apostrophe (') in each contraction.

1. She thinks she cant do it.

2. Isnt it time for her to try?

3. She wont give up now.

Everyday Heroes

Heroes are people who do brave things. They do hard things that must be done. Rosa Parks was a hero. She took a stand in 1955, and an unfair law was changed. Cesar Chavez was a hero. He helped change farm workers' lives. Steve Meehan was a hero. He saved the Yee family.

Sometimes heroes do things no one thinks they can do. Sometimes heroes do things they didn't know they could do. This is what happened in the poem "Can't."

Think of the people you know. Maybe some of them are heroes, too.

Answer these questions. Write complete sentences.

1. What do we call people who do brave things?

2. In what year did Rosa Parks take a stand?

3. Who did Cesar Chavez help?

4. What kind of person do you think Steve Meehan is?

5. Why do you think the poet in "Can't" did what she did?

Word Work Review

Pick the right word. Write it on the line.

1. Rosa Parks's story is _____.
 (trunk, true)

2. Rosa Parks _____ the fare.
 (pad, paid)

3. She took a _____.
 (sat, seat)

4. Steve saw the _____.
 (fir, fire)

5. He _____ the Yees.
 (saved, said)

6. Cesar Chavez helped _____ workers.
 (farm, frame)

7. He helped workers get _____ pay.
 (more, move)

Write About It

▶ **Topic:** Think of someone you feel is a hero. What has this person done to make him or her a hero?

Prewrite Discuss the topic questions. List some ideas.
Write Pick your best ideas. Write a paragraph about your hero.
Revise Look at your writing again. Change any words you want to change. Have someone read your writing. Can he or she understand it?
Edit Find and correct mistakes in your writing. See page 128.
Final Draft Make a final copy to keep and share.

Thrilling moments are important to us. We love moments that make our lives exciting. We love to think about exciting moments. We love to talk about these moments, too.

We have different ideas about what's thrilling. Some of us are thrilled by winning a game or a race. Some of us are thrilled when good things happen to us at work. We are all thrilled when we reach a goal.

Before you start Unit 3, think about thrilling times in your life. Talk about them. What made those times special? What made them thrilling for you?

Lesson 7

LEARNING GOALS

Strategy: Use your experience to help you understand what you read
Reading: Read a story
Skill: Identify cause and effect
Writing: Write a story
Word Work: Digraphs (ch, sh, th, ph, wh)

Before You Read

In "The Promotion," Rich Marsh has a special success at work. It is a thrilling moment for him. Before you read "The Promotion," answer these questions.

1. Think of a special success you have had. Was it at home? At work? At school? What was thrilling about this success?

2. ✓ Check the sentences that are true for you. Write two more examples of your own.

 Things that have thrilled me:
 _____ winning a game or race
 _____ getting my first job
 _____ seeing my child for the first time

Key Words

- Rich works at <u>Alpha</u> <u>Company</u>.
- He puts <u>computer</u> <u>chips</u> on thin <u>boards</u>.
- Things were not <u>always</u> <u>good</u>.
- Each <u>Thursday</u> the <u>warehouse</u> sent 10 boxes of chips.
- Ms. Chin <u>thanked</u> me.

The Promotion

My name is Rich Marsh. I work for the Alpha Company. I put computer chips on thin boards. I like my job now. But things were not always good.

My work team had problems. Each Thursday the warehouse sent us 10 boxes of chips. Some weeks we needed more chips. Then we had to sit and wait. We call this waiting "down time."

Some weeks we needed fewer chips. But on Thursday we got 10 boxes anyway. Then we had to find some place to put them all.

Then I had an idea. I wanted to change the way boxes are sent. My boss, Ms. Chin, liked my idea. Now our team calls the warehouse when we are down to two boxes. We can call any day. We get 10 boxes the next day.

Now we get chips when we need them. We have no more down time. We have no more boxes in the way. We save time. Ms. Chin is glad. She thanked me for helping my team to work better. Then she made me team leader! I was thrilled!

After You Read

Discuss these questions.

1. What caused Rich to talk to Ms. Chin?
2. How does Rich feel about working for Alpha now? Why?

Think About It: Identifying Cause and Effect

In Lesson 2, you worked with cause and effect. A **cause** is what makes something happen. An **effect** is what happens.

Cause	Effect

Practice

A. Match Write the letter of the correct effect next to the cause.

Cause		Effect

1. _____

2. _____

3. _____

a.

b.

c.

_____ 1. Some weeks the team did not use all 10 boxes. But on Thursday 10 more boxes came.

a. The team had down time.

b. Rich's team changed the way it worked.

_____ 2. Some weeks the team needed more than 10 boxes.

c. The team ran out of space to store the boxes.

_____ 3. Rich had an idea.

C. Copy the sentence that tells the effect of each cause.

* The team gets 10 boxes the next day.
* Rich got a promotion.
* The team sat and waited.

1. Cause: The team ran out of chips

Effect: _____

2. Cause: The team calls the warehouse for more chips.

Effect: _____

3. Cause: Rich's idea worked well.

Effect: _____

Write About It · Write a Story

Wise old sayings are called **proverbs**. They often tell about a cause and an effect.

A. Match Write the letter of the words that complete each proverb. Then talk about what each proverb means.

 __b__ **1.** Haste **a.** killed the cat

 _____ **2.** Waste not, ✓ **b.** makes waste.

 _____ **3.** Curiosity **c.** gets the worm.

 _____ **4.** United we stand, **d.** want not.

 _____ **5.** The early bird **e.** divided we fall.

B. Here are more proverbs. Rewrite the proverbs in your own words. You may work with a partner. The first one is done for you.

 1. Proverb: A stitch in time saves nine.

 Rewrite: If _you fix a problem before it gets big,_

 then _you'll save yourself a lot of trouble._

 2. Proverb: An apple a day keeps the doctor away.

 Rewrite: If _____

 then _____

 3. Proverb: Absence makes the heart grow fonder.

 Rewrite: If _____

 then _____

2. April showers bring _____

3. A penny saved is _____ _____

D. Find or make up another proverb. Then rewrite it with a partner.

Proverb: _____

Rewrite: If _____

then _____ _____ _____ _____

F. Choose one of the proverbs on these pages, or think of one of your own. Write a story that tells how the proverb came true for you. Write a title for your story.

_____ _____ _____

The proverb _____

_____ _____ _____

came true for me when _____ _____ __

I learned that _____

_____ _____

Word Work: Digraphs (ch, sh, th, ph, wh)

A. Two letters that spell one sound are called a **digraph.** Read these words.
Do you hear one sound for each digraph?

ch	sh	th	th	ph	wh
change	shower	think	this	Alpha	when
cheer	shoe	thin	that	phone	what
children	fish	thing	father	nephew	whale
chin	ship	moth	than	Phil	why
reach	finish	bathtub	another	elephant	anywhere

B. Look at each picture. Find the word in the lists above. Write it on the line.

_____ _____ _____ _____

C. Use words from the lists above. Find words with *ch*, *sh*, *th*, *ph*, or *wh* for each group.

People	Animals	Question words	Things
nephew	fish	what	bathtub
_____	_____	_____	_____
_____	_____	_____	_____

ch	ph	sh	th	wh
-one	**-eat**	**-in**	**-en**	**-ine**
phone	cheat	shin	then	whine
shone	_____	_____	_____	_____
bone	_____	_____	_____	_____

E. Pick the right word for each sentence. Write it on the line.

1. Rich called a friend on the _____.

 (phone, shone)

2. He said, "I met _____ my boss today."

 (wish, with)

3. "Ms _____ liked my idea,"

 (Thin, Chin)

4. "_____ made me team leader!"

 (The, She)

▶ **Update on "The Promotion"** Rich's team works better now. And Rich has new ideas all the time. Last month Ms. Chin went to work at another Alpha plant. She wants Rich to work for her there. Rich likes these new and thrilling changes in his job.

Lesson 8

Before You Read

In "The Thrill of the Race," Phyllis Jones trains to run in the Boston Marathon. Before you read the story, discuss these questions.

1. What is a marathon? How is it different from other races?

2. Think of a marathon you have seen on TV or in real life. What do you remember about the runners? How did they look?

3. In a big marathon like the Boston Marathon, thousands of people run. Not every runner finishes the race. And only a few are winners. Why is it important for people to run when they know they probably won't win?

Key Words

- Phyllis ran in the <u>Boston</u> <u>Marathon</u>.
- Phyllis <u>stretched</u> each day.
- She <u>sprained</u> her <u>ankle</u>.
- The race was held on <u>Patriots'</u> Day.
- Her friends <u>screamed</u> and <u>cheered</u>.
- Phyllis <u>sprinted</u> for the finish line.

experience. How does it compare to what you already know about marathon runners?

The Thrill of the Race

Phyllis Jones is 35 years old. She has always liked to run. This year she wanted a new thrill. She wanted to run in the Boston Marathon.

Phyllis trained hard for the 26-mile race. She stretched. She worked out. She ran each day. At one point, she sprained her ankle. But she didn't give up. At last she was in shape for the marathon.

The race was held on Patriots' Day in April. More than 5,000 runners waited for the starting gun. When it fired, the runners took off. The crowd cheered.

Phyllis made a strong start. Her friends saw her run by. They screamed and cheered. But the finish line was far away. She was hot. Her legs began to get sore. She wanted to stop. But she made herself go on. Finally Phyllis saw the finish line. She sprinted for it.

Phyllis finished the Boston Marathon! She ran all 26 miles, and she did it in just over three hours. What a thrill!

After You Read

A. Retell Phyllis's story in your own words.

B. Discuss how Phyllis's experience compares with what you know about marathon runners.

Think About It: Sequencing Events

In Lesson 1, you worked with sequence. **Sequence** is the order in which things happen.

First it is time to get up.

Second it is time to go to work.

Then it is time for lunch.

Last it is time to go home.

Practice

A. Read the sentences. Number them in order. Then copy the correct sequence word next to each sentence.

First	Second	Then	Last

_____ _____ Phyllis finished in just over three hours.

_____ _____ Phyllis made a strong start in the race.

__1__ _____ Phyllis wanted to run in the Boston Marathon.

_____ _____ Phyllis trained hard for the race.

First	Second	Then	Last

Read the sentences. Number them in order. Then copy the correct sequence word next to each sentence.

__1__	__First__	Phyllis starts with a good breakfast.
_____	_____	she gets the sleep she needs at night.
_____	_____	she jogs or runs.
_____	_____	she does warm-up stretches.

C. Copy the sentences in order. Write a title for your paragraph.

Each day Phyllis works hard to stay fit. First _____

Write About It: Make a List

Phyllis's friends want to celebrate her thrilling run. They are planning a surprise party for her.

A. Unscramble the sentences to find out about the party. Write them on the lines.

Plans for Phyllis's Party

a to party surprise Phyllis for Come

ran the She Marathon

Joe's at party is The

there Be 7 Friday at p.m.

Come to a surprise party for Phyllis!

B. Here are Joe's plans for the party. Copy them onto the right lines below.

- when the bell rings, everyone hides.
- everyone jumps out and yells "Surprise!"
- everyone gets here by 7 o'clock.
- Joe lets Phyllis in.

First _everyone gets here by 7 o'clock._____

Second, _____

Then _____

Last _____

My Plans for a Party

_____ Clean the house. _____ _____

_____ Write a quest list.

_____ Plan a menu. _____ _____

_____ Make phone calls. _____ _____

D. Number your list in the order in which you would do the tasks. Copy your list in the right order on the lines below.

1. _____

2. _____

3. _____

4. _____

5. _____

6. _____

7. _____

8. _____

Word Work: Three-letter Initial Blends (scr, spl, spr, str, thr)

A You can hear three sounds in most three-letter blends. Listen to these words.

scr	spl	spr	str	thr
scrap	split	sprain	strain	three
scream	splash	spray	street	threw
screw	splice	spring	stretch	thrill
scrub	splendid	sprint	strong	thread
screen	splinter	sprout	strawberry	through

B. Look at the pictures. Find the word above. Write the word on the line.

_____split_____ _____ _____ _____

_____ _____ _____ _____

C. Cross out the word in each row that does not belong.

1. thread through thank threw

2. sting strong strain street

3. spray splash sprain sprout

4. scrub scream scrap scold

scr	spl	spr	str	thr

-ain	-int	-ead	-eam	-ew
sprain	splint	spread	stream	screw

__strain__ _____ _____ _____ _____

_____ _____ _____

E. Pick the right word for each sentence. Write it on the line.

1. Phyllis wanted a new _____ .
 (thrill, spill)

2. She became a _____ runner.
 (strong, throng)

3. She _____ her ankle.
 (sprained, drained)

4. The race was held in the _____ .
 (string, spring)

5. Phyllis's friends _____ and cheered.
 (screamed, dreamed)

6. Phyllis _____ for the finish line.
 (printed, sprinted)

▶ **Update on "The Thrill of the Race"** Phyllis still runs each day. She wants to keep fit. Some of her friends run with her now. They want to keep fit, too. What kinds of things do you do to keep fit?

Lesson 9

Before You Read

In the poem "Winner," Gene Fehler describes a thrilling moment that a boy and his father shared. Before you read the poem, discuss these questions.

1. Think of a baseball game you have played or seen. What thrilling moments do you remember?

2. Do you remember a time when someone was very proud of something you did? How did it make you feel?

Key Words

Here are some baseball terms that appear in the poem "Winner."

- **home plate:** where a batter stands to hit the ball
- **fast ball:** a pitch thrown at full speed
- **curve ball:** a pitch that curves unexpectedly before it reaches home plate
- **checked swing:** a swing of the bat that is started but not completed because the batter changes his or her mind
- **foul:** a baseball that is hit out of bounds or into foul territory
- **dying quail:** a softly hit ball that lands safely in front of the outfielder for a base hit
- **single:** a hit where the batter gets to first base safely
- **left-center:** just left of the middle of the outfield on a baseball field

Try to see what the poet is saying. What pictures do you see in your mind?

Winner

Gene Fehler

what I remember most
is my dad behind the rusted screen
back of home plate
"You can hit this guy!"
his voice not letting up
through four fast balls
(two misses swinging late,
two fouls on checked swings)

then the curve ball and the dying quail
into left-center,
the winning run sliding home,
my dad all smiles,
slapping backs in the bleachers
as if HIS single had won the game

After You Read

A. Read the poem aloud.

B. Discuss these questions.

1. What happens in this poem? Retell it in your own words.
2. What pictures came to mind as you read this poem?
 What words does the poet use to help you see those pictures?
3. Picture the boy's dad during this game. Who is more thrilled
 by the boy's hit—the boy or his dad? Why do you think so?

Think About It: Making Inferences

In Lesson 6, you worked with inferences. When you **infer**, you use clues to figure out something not said. What can you infer from the scenes below?

What's the occasion?

1. A new baby has been born.

2. They just got married.

Practice Read the lines from the poem. ✓ Check the inference that can be made.

1. what I remember most
is my dad behind the rusted screen

_____ (1) The boy's dad being at the game was most important.

_____ (2) The boy remembers the rusted screen best.

2. "You can hit this guy!"
his voice not letting up

_____ (1) The boy's dad is calm.

_____ (2) The boy's dad is excited.

3. then the curve ball and the dying quail . . .
the winning run sliding home

_____ (1) The boy slid into home plate.

_____ (2) The boy's hit won the game.

4. my dad . . . slapping backs in the bleachers
as if HIS single had won the game

_____ (1) The boy's dad was very proud of him.

_____ (2) The boy's dad won the game.

moment you have had. Write about it here.

My thrilling moment was _____

I was _____

What I remember most is _____

I felt _____

I can still see _____

I can still hear _____

I can still taste _____

I can still feel _____

B. Pick your best ideas and write a poem. Here are some ways to start

What I remember most _____

I was _____

I can still _____

I can still _____

It still makes me feel _____

Word Work: Three-letter Final Blends (*nch, nce, nge, rse, dge*)

A. In Lesson 8, you read words that begin with three-letter blends. You can find three-letter blends at the end of words, too. Read these words.

nch	nce	nge	rse	dge
inch	once	change	horse	edge
bench	tence	hinge	nurse	badge
branch	since	lunge	purse	fudge
lunch	prince	orange	course	bridge

B. Read the two words under each picture. Pick the word that says what you see. Then write it on the line.

fence finch hedge hinge purse prince badge bridge

_____ _____ _____ _____

C. Choose the right word to finish the sentences.

1. My dad and I had _____ at the ball game.
(lunch, lunge)

2. We sat on a _____ in the sun.
(badge, bench)

3. We had apples, _____, bread, and cheese.
(oranges, changes)

4. Then we had some _____.
(fence, fudge)

-ance	-ench	-inch	-inge	-edge
dance	bench	cinch	hinge	hedge
chance	clench	clinch	cringe	wedge
France	wrench	pinch	twinge	pledge

_____ _____ _____ _____ _____

E. Unscramble each word to finish the sentences. The underlined word is a rhyming clue.

(Fernac) **1.** Lee learned to <u>dance</u> when he was in _____.

(surpe) **2.** The <u>nurse</u> took her keys from the _____.

(odwog) **3.** He cut the <u>hedge</u> into a _____.

(chrewn) **4.** Fix the <u>bench</u> with this _____.

(grenic) **5.** The sound of the <u>hinge</u> made me _____.

F. Pick three words from the word families above. Scramble the letters and write the scrambled words here. Let a partner unscramble your words.

Your Scrambled Words **Partner's Real Words**

_____ _____

_____ _____

_____ _____

Writing Skills Mini-Lesson: Plurals

Plural means more than one. Most plurals are formed by adding -s or -es to a word. To make a word plural, follow these rules.

1. Add -s to most words.

 job + s = jobs game + s = games day + s = days

2. Add -es to words ending in s, x, z, ch, and sh.

 boss + es = bosses box + es = boxes wish + es = wishes

3. If a word ends in a consonant + y, change the y to i and add -es.

 city + es = cities company + es = companies

Practice

A. Write the plurals.

 1. car + s _____ **3.** party + es _____

 2. class + es _____ **4.** bench + es _____

B. Make each word plural. Write the plural word on the line.

 1. (idea) Rich Marsh has many good _____.

 2. (worker) He is one of the best _____ at Alpha.

 3. (boss) Someday he may be one of the _____.

 4. (stretch) Phyllis did many warm-up _____.

 5. (story) There are many _____ about baseball.

 6. (family) Friends and _____ come to see them play.

Reading Review

Thrilling Moments

Thrilling moments are an important part of our lives. Thrilling moments can make us feel good. They can make us feel strong. They can help us prove just what we can do.

In Unit 3, you read about three people who had thrilling moments. Rich Marsh helped his team at the Alpha Company work better. This made him feel good. Phyllis Jones ran in the Boston Marathon. She was thrilled when she finished the race. A boy hit a winning single. He and his father were thrilled.

We also like to think of thrilling moments in our own lives. We like to share these moments with others, too. We like to have some excitement in our lives.

Choose the best answer to each question.

1. Which sentence best tells the main idea of "Thrilling Moments"?

 _____ (1) Rich Marsh helped his team work better.

 _____ (2) We like to share these moments with others.

 (3) Thrilling moments are an important part of our lives.

2. Rich's idea helped his team save time. The team worked better. Which proverb best describes Rich's idea?

 _____ (1) Haste makes waste.

 _____ (2) A stitch in time saves nine.

 _____ (3) A friend in need is a friend indeed.

Word Work Review

Unscramble each word to finish the sentences.

1. (thllnirig) Most people like _____ moments.

2. (eedg) We like to sit on the _____ of our seats

3. (ceamrs) Some people _____ when they are thrilled.

4. (resha) Most people like to _____ their excitement.

5. (nepho) We may call our friends on the _____.

6. (ocne) We may tell the story more than _____.

7. (reeth) We may tell the story more than _____ times.

8. (ngecha) Thrilling moments can _____ our lives.

Write About It

▶ **Topic:** Think of a thrilling moment in your life. Why was it thrilling? Why was it important to you?

Prewrite Discuss the topic questions. List a few ideas.
Write Pick your best ideas. Write a paragraph about your thrilling moment.
Revise Look at your writing again. Change any words you want to change.
 Have someone read your writing. Can he or she understand it?
Edit Find and correct mistakes in your writing. See page 128.
Final Draft Make a final copy to keep and share.

What would we do without our friends? Friends share our lives. They help us when we are in trouble. They stay with us through good times and bad. Friends are a support we can lean on.

Friends make our lives richer, too. We laugh with our friends. Sometimes we cry with them, too. Friends teach us things we didn't know. And they let us teach them things we think are important.

Before you start Unit 4, think about the friends in your life. What do your friends add to your life? How do they make your life richer?

Lesson 10

Before You Read

In "The Arch," poet Shirley Kaufman uses the image of an arch to talk about friendship. Look at the picture of the arch on page 91. Then answer these questions.

1. Write a sentence that describes the arch.

2. Where do you see arches? How are they used?

3. Why do you think a poet might use the image of an arch

when talking about friendship?

Key Words

- Half the world leans on the other half.
- An arch stands on two feet.
- You help me stand up straight and tall.
- We need the love and laughter of our friends.

As you read "The Arch," think about arches and about friendship. In what ways is an arch like two friends?

The Arch

Shirley Kaufman

Half the world leans
on the other half
 to make it stand.

That's how an arch
stays up,
 two foot on land.

That's why I feel
so straight
 when you hold my hand.

After You Read

A. Read the poem aloud.

B. Discuss these questions.

1. In what ways is an arch like two friends?
2. An arch is both strong and beautiful. Is an arch a good image for friendship? Why or why not?
3. How do you feel after reading this poem?

Think About It: Understanding the Main Idea

In Lesson 3, you worked with main idea. The **main idea** of a poem is its most important message.

Read "The Arch" again. Each stanza, or group of lines, tells about different types of support:

- leaning on each other
- helping each other stay up
- holding each other's hands

Even though the word *friend* does not appear in the poem, the stanzas lead us to infer that the main idea of the poem is:

Friends support each other.

Practice

Read "Friends." Then answer the question.

Friends

We all need friends. We need their support. We need their advice. We need their love and laughter. We need friends because they help us get through life.

To have friends, we must also be a friend. It is as important to give support as it is to get it. It is as important to love as it is to be loved. We need to share with our friends. This helps us be all that we can be.

Which sentence best tells the main idea of "Friends"?

_____ (1) We need their advice and their love.
_____ (2) We need to give and get support.
_____ (3) We all need to share with our friends.

Smiles ▰▰▰▰▰

A smile's like a bridge
 spanning the air.

People smile at each other
 to show they care.

That's why I feel happy
 when your smile is there.

B. Think of something that is like something else. Finish the sentence below.

A _____ is like _____.

C. Write your own poem. On a separate paper, write some ideas about how the two things you wrote are similar. Then pick your best ideas and write a poem on the lines below. Give your poem a title.

Word Work: Special Vowel Combinations (*au, aw, oi, oy, oo, ou*)

A. Some words have vowel sounds that aren't long or short. Words with the letter combinations below usually have special vowel sounds. Read the words. Listen to the vowel sounds.

au as in **auto**	**aw** as in **saw**	**oi** as in **oil**	**oy** as in **boy**
fault	dawn	join	toy
taught	draw	noise	annoy
because	hawk	point	enjoy
daughter	awful	voice	employ

B. Use word pairs from the box to complete the sentences. The underlined word has a rhyming clue in it.

auto	daughter	enjoyed	toy
dawn	hawk	spoiled	voices

1. I <u>saw</u> a _____ in the sky at _____.

2. Many <u>noises</u> and loud _____ _____ the play.

3. He <u>taught</u> his _____ to drive the _____.

4. The <u>boy</u> _____ the new _____ I gave him.

C. The letters *oo* and *ou* can make more than one sound. Read these words. Listen to the vowel sounds.

oo as in **book**	**oo** as in **too**	**ou** as in **out**	**ou** as in **you**
cook	food	about	soup
foot	room	house	group
good	soon	proud	youth
took	school	sound	through

(soon, sound)

2. Will you finish reading that _____ tonight?

(book, boot)

3. Paula _____ in every _____.

(locked, looked) (room, root)

4. They ate all the _____ in the _____

(food, foot) (hound, house)

5. The _____ made hot _____ for the

(cook, cool) (soap, soup)

_____ .

(groan, group)

E. Word Families Read the words in these word families Write another word
you know for each family.

-aw	-oil	-ook	-ool	-ound
jaw	boil	book	cool	bound
paw	coil	hook	pool	found
saw	broil	look	tool	sound
claw	spoil	brook	stool	ground
_____	_____	_____	_____	_____

F. Work with a partner. Pick a word family. Use at least two of the words
to write a rhyming sentence.

Lesson 11

Before You Read

This lesson has three poems about friends. Think of a friend who is important to you. Answer these questions.

1. ✓ Check your choices. Add your own.

A friend is someone I can

_____ laugh with _____ talk to
_____ depend on _____ trust

2. Complete this sentence.

I know someone is a good friend when _____

Key Words

- My best friend is a <u>special</u> person.
- My friend shows me love and <u>appreciation</u>.
- We share trust and <u>honesty</u>.
- My friend <u>listens</u> and pays <u>attention</u> to what I say.
- My friend gives me a <u>generous</u> smile.

Boston. As you read, think about how the poet describes a special friend. Do you agree?

A Special Friend

Toni

a special friend's
a special blessing

a special friend's
someone to talk to,
someone to laugh with,
someone to hold on to

a special friend's
someone who shows you Love, appreciation
and honesty.

After You Read

A. Read the poem aloud.

B. Discuss these questions.
1. How does the poet describe a special friend?
2. Which quality listed in the poem do you feel is most important in a friend? Why do you feel this way?
3. What, if anything, would you add to the description?
4. As you read, did you picture someone you know? If you did, who was it?

Think About It: Finding Details

In Lesson 3, you practiced finding details. **Details** are the pieces of information you find in readings. Details often support the main idea of the reading.

Read "A Special Friend" once more. The main idea of the poem is this:

A special friend is a special blessing.

A. The poem has many details to support this main message. ✓Check each detail that you find in the poem.

A special friend is a special blessing because that person is someone

1. _____ to talk to
2. _____ you can laugh with
3. _____ you can hold on to
4. _____ you can fight with

5. _____ who shows you love
6. _____ who appreciates you
7. _____ who is honest
8. _____ who is in your family

Did you check details 1, 2, 3, 5, 6, and 7? If so,
you found the details in the poem.

B. You can organize details in a diagram like the one below to show how they relate to the main idea.

A. Read this poem. Think about the main idea. Look for details that support the main idea.

JC and Me ▰▰▰▰

Jonathan Cook comes from New York City.
I come from down on a farm.
Jonathan Cook has curly black hair
while mine is as straight as your arm.
Jonathan Cook loves to sing and to dance.
I like to watch and to see.
Jonathan lives with five sons and three dogs.
At home there's my girlfriend and me.

But we're as alike as two people can be,
my good friend JC and me.
We know what we want and we know where we'll go.
We talk and we trust and we laugh and we know
that our friendship will always be.

B. Read the poem aloud.

C. Answer these questions.

1. What is the main idea of "JC and Me"?
 _____ (1) They may have differences, but the two are best friends.
 _____ (2) The two friends are as alike as people can be.

2. List two details that show how the friends are different.

 _____ _____

3. List two details that show how the friends are alike.

 _____ _____

Write About It: Complete a Diagram

A. You have read two poems about friendship. Here is another poem. It was written by an adult literacy student in **Superior**, **Wisconsin**. As you read, notice the details. Guess who the poet's best friend is.

My Best Friend

Dan Mosack

Is she worth it?
Every day, same old thing.
Buy food, comb her hair.
Always having to be there
 for her.
Is she worth it?
Messy, all the time messy,
Always having to clean her
 messes.
Is she worth it?
Yeah, she's always there
 for me.
When I need to talk to someone,
She listens, paying close attention
 to what I say.

Is she worth it?
Come to think of it she's always
 been there for me.
Never been alone.
She goes almost everywhere I go.
Is she worth it?
A daily hug, a daily walk, a
 generous smile.
Warm and cuddly, honest and true.
Is she worth it?
You bet she's worth it.
Flopsy my English Springer and me
 are friends forever.

B. Answer these questions.

1. Who is the poet's best friend? _____

2. At what point in the poem did you guess that Dan's best friend
 is a dog? Put a star (*) by that place in the poem.

3. Find details in the poem that hint that Flopsy is a dog.
 Copy some of the details here.

 _____ _____

 _____ _____

of the diagram is Flopsy. Around Flopsy are the details.

- always there for me
- goes everywhere I go
- generous smile
- Flopsy
- listens, pays attention
- honest and true
- warm and cuddly

D. Think of your best friend, or a friend you feel is special. Think about why this person is special. What makes this person a good friend?

Write your friend's name in the center of the diagram. Fill in the rest of the diagram with details that show why this person is such a good friend.

Word Work: R-controlled Vowels (are, err, ire, ore, ure)

A. When a vowel is followed by r, the sound of the vowel changes slightly. Read the words below. Listen to the vowel sounds.

-are	-err	-ire	-ore	-ure
dare	hurry	hire	more	cure
fare	cherry	tire	sore	pure
scared	error	admire	shore	mature
share	merry	retire	restore	secure
careful	terror	firefly	before	unsure

B. Pick the right word for each sentence. Write it on the line.

1. We _____ for our friends.
 (dare, care)

2. Our friends _____ our lives.
 (scare, share)

3. We feel _____ our friends will help us.
 (cure, sure)

4. Friends _____ each other.
 (retire, admire)

5. Friends make our lives _____ complete.
 (more, store)

C. Cross out the word in each row that does not rhyme.

1. core	tore	chore	store	close
2. wire	bird	entire	spire	hire
3. clue	lure	cure	sure	pure
4. bare	spare	car	rare	flare
5. cherry	merry	ferry	cheery	berry

ACROSS

1. Toni's poem is about a _____ friend.
3. Things we have to do
6. Looks up to
9. What you do in a marathon
10. Give half to
11. Truthful
13. Fix like new
15. Opposite of left
16. Safe
19. They follow causes.

DOWN

1. Afraid
2. Hear
3. Auto
4. Have
5. Edge of the water
7. Like an adult; grown up
8. Opposite of poor
10. Place to buy things
12. All of us
13. Stop working
14. Great fear
16. Has faith in
17. Opposite of on

WORD LIST

ADMIRES
CAR
CHORES
EFFECTS
EVERYONE
HONEST
LISTEN
MATURE
OFF
OWN
RESTORE
RETIRE
RICH
RIGHT
RUN
SCARED
SECURE
SHARE
SHORE
SPECIAL
STORE
TERROR
TRUSTS

Lesson 12

LEARNING GOALS

Strategy: Picture what you read
Reading: Read a journal entry
Skill: Make predictions
Writing: Make a journal entry
Word Work: More R-controlled Vowels (ur, er, ear, our)

Before You Read

In this lesson, you will read some pages from Sofia's personal journal. Sofia comes from Turkey. She writes about her life in the journal. She writes about her thoughts, feelings, and what she is doing. Before you read her journal entries, answer these questions.

1. Look at the picture on page 105. What do you think Sofia will write about today? Make a prediction. Write it here.

2. Talk about keeping a journal. What kinds of things would you write? How would keeping a journal help you improve your reading and writing skills?

3. Many people lose touch with friends as years go by. What are some reasons people lose touch? List some reasons here.

Key Words

- My friend <u>arrived</u> from <u>Turkey</u>.
- We <u>laughed</u> and <u>cried</u> at the same time.
- <u>Kemal</u> is a <u>charming</u> <u>young</u> boy.
- We played <u>Turkish</u> <u>music</u>.
- What a joy to be <u>together</u> <u>again</u>.

In her journal, Sofia writes about a reunion with her old friend.
What pictures come to mind as you read?

Sofia's Journal

June 5

Dear Journal,

What a week I've had! On Monday, my old friend, Meral, arrived from Turkey! I had not seen her for many years. But I knew her right away. Her black hair and eyes still shine like the night. And who can forget her big smile?

She knew me right away, too. When she saw me, she yelled, "Sofia, you have not changed!" We ran into each other's arms. We laughed and cried at the same time. Everyone stared at us.

When I saw Meral last, she was a girl. Now she is a woman. Her son Kemal is with her. He is 10. He is a charming young boy. And so smart!

Last night I had a party for Meral and Kemal. I cooked Turkish food. We played Turkish music. We danced folk dances all night. We all ate and sang and danced. What a joy to be together again!

After You Read

A. Retell Sofia's story in your own words.

B. Discuss these questions.

1. What pictures came to mind as you read this journal entry?

2. How would you feel if you did not see a close friend for many years? How would you feel when you finally saw that person again?

Think About It: Making Predictions

In Lesson 4, you practiced predicting. When you **predict,** you try to figure out what will be in a reading. You can use the title and the pictures to help you predict.

You made a prediction about Sofia on page 104. Copy it here.

_____ _____

How did your prediction match the story? How did it not match?

Practice

A. Read each title and look at each picture. ✓ Check the prediction that can be made.

1. Title: You Never Know until You Try

Prediction: (1) _____ She will get fired.

(2) _____ She will apply for the job.

(3) _____ She will not try to get a job.

2. Title: Beating Fear

Prediction: (1) _____ He will be afraid to jump.

(2) _____ He will break his leg.

(3) _____ He will jump from the plane.

1. Title: Gold Medal Day

Prediction: _____

2. Title: A New Heart, a New Life

Prediction: _____

C. Look at the picture. Write your own title. Let a partner predict what may happen. Share your work.

Title: _____

Prediction: _____

Write About It: Make a Journal Entry

A. Sofia began writing in a journal when she was young. Here is a page she wrote a long time ago. How is this entry different from the entry on page 105? How is it similar?

My Journal ▰▰▰▰▰▰▰▰▰▰▰▰▰

May 12

Hello Journal,

My teacher gave me this journal today. She said it will make me feel better. It will help my writing, too. I have been very sad. I miss my friend, Meral, very much. Mother and Father wanted to move to the U.S. They want to be with the rest of our family. Meral had to stay with her family in Turkey.

Mother and Father like living here. I like it, too. I like my school. I like being near my Grandmother and Grandfather. But it would be better if Meral were here. We are so far away. I think I will not see her for a long time. I will write her a letter today.

Thank you, Journal, for being here today.

1. Sofia made a prediction in this journal entry. Copy it here.

Was her prediction correct? How can you tell?

2. Underline the part of this entry that you like best. Tell why you like it. Then rewrite that part in your own words.

Think about a change in a friendship you have had. Think about why it changed. Think about how you felt. Did you like the change? Did it make you happy or sad? Write a journal entry about that time.

(date)

Dear Journal,

Word Work: More R-controlled Vowels (ar, or, car, our)

A. ar: The letters ar can make different sounds in different words. Listen to the words. Then read the sentences.

arm The mark on his arm was a scar.

warm I warmed a quart of milk

marry She will marry Gary in January.

Write each word under the *ar* sound you hear. Then write a word of your own.

charm	quart	parent	award	part	vary

arm	**warm**	**marry**
_____	_____	_____
_____	_____	_____
_____	_____	_____

B. er: The letters *er* can make different sounds in different words. Listen to the words. Then read the sentences.

very The merit awards ceremony was very nice.

hero The hero in the series was superior.

her Her clerk was nervous.

Read the words in each list. On your own paper write three sentences, using as many words from the lists as you can.

very	**hero**	**her**
peril	here	term
stereo	zero	nerve
American	period	Germany

hear I h<u>ear</u> you, d<u>ear</u>, loud and cl<u>ear</u>.

wear The b<u>ear</u> will <u>tear</u> what I w<u>ear</u>.

heard P<u>ear</u>l heard the news <u>ear</u>ly.

Write each word under the *ear* sound you hear. Then write a word of your own.

appear	earth	swear	tear	learn	pear

hear	**wear**	**heard**
_____	_____	_____
_____	_____	_____
_____	_____	_____

D. our: The letters *our* can make different sounds in different words, too. Listen to the words. Then read the sentences.

our <u>Our</u> milk will s<u>our</u> in an h<u>our</u>.

four Y<u>our</u> friend will p<u>our</u> f<u>our</u> more.

journey The jungle j<u>our</u>ney took c<u>our</u>age

Read the words in each list. On your own paper write three sentences, using as many words from the lists as you can.

<u>our</u>	<u>four</u>	<u>journey</u>
flour	your	adjourn
scour	court	journal
hourly	mourn	courtesy

Writing Skills Mini-Lesson: Adding -ed and -ing

When adding -ed or -ing to a word, follow these rules.

1. **Add -ed or -ing to most words without changing anything.**

 warn + ed = warned enjoy + ed = enjoyed

 warn + ing = warning enjoy + ing = enjoying

2. **If a word ends in silent e, drop the e before adding -ed or -ing.**

 hope + ed = hoped change + ed = changed

 hope + ing = hoping change + ing = changing

3. **If a word ends with a short vowel followed by a consonant, double the consonant before adding -ed or -ing. Do not double w or x.**

 hop + ed = hopped plan + ed = planned

 hop + ing = hopping plan + ing = planning

Practice

A. Add -ed or -ing to each word. Write the word on the line.

 1. retire + ed = _____ **4.** run + ing = _____

 2. want + ed = _____ **5.** make + ing = _____

 3. hop + ed = _____ **6.** buy + ing = _____

B. Add -ed or -ing to finish the sentences.

 1. (stop + ed) My friend _____ by to see me.

 2. (smile + ing) My friend is _____ at me.

 3. (help + ing) My friend is always _____ me.

 4. (hug + ed) My friend _____ me today.

Reading Review

Friends

Friends are an important part of our lives. In Unit 4, you read some writers' ideas about friendship. One poet told how a friend's support makes her "feel so straight." Another wrote of what it takes to be a best friend. A third poet told why his dog is his best friend. Sofia wrote in her journal about seeing an old friend.

Think of the good friends In your life. Your friends may be in your family. They may be neighbors or people you work with. They may be near or far away. No matter where they are, one thing is true. Your friends play an important part in your life.

Answer these questions.

1. Which sentence best tells the main idea of "Friends"?
 _____ (1) Your friends may be In your family.
 _____ (2) Friends are an important part of our lives.
 _____ (3) Think of the good friends in your life.

2. ✓ Check two details that are In the reading.

 Friends may be
 _____ (1) in your family
 _____ (2) neighbors
 _____ (3) old or young

Word Work Review

Finish the sentences. Use a word in the box that rhymes with the underlined word.

about
bear
care
far
four
near
store
very

1. We <u>share</u> because we _____ .

2. A good <u>car</u> can take you _____ .

3. She got <u>more</u> food at the _____ .

4. The <u>berry</u> pie is _____ good.

5. I <u>fear</u> that the time is _____ .

6. I found <u>out</u> _____ the surprise.

7. I heard it from <u>your</u> _____ friends.

8. I gave my <u>pear</u> to the big black _____ .

Write About It

▶ **Topic:** Think of a special time you had with a friend. What happened? What made this time special?

Prewrite Discuss the topic questions. List some ideas.
Write Pick your best ideas. Write a paragraph about your special time.
Revise Look at your writing again. Change any words you want to change. Have someone read your writing. Can he or she understand it?
Edit Find and correct mistakes in your writing. See page 128.
Final Draft Make a final copy to keep and share.

Reading Skills

A. Read this story. Answer the questions.

Making a Change

Dee Harris changed her life. Dee is a single parent with two children. Dee did not have a job. Life was hard. Dee wanted a better life. She wanted a job, She also wanted to spend time with her children. She needed a job that let her do this.

First Dee went back to school. She learned to read and write better. She learned how to work with children It was hard. But Dee did it. Now she works in a day-care center. She likes her job. She can watch her own children at the center each day. Dee is glad that she changed her life.

1. Which sentence best tells the main idea of "Making a Change"?
 _____ (1) Dee is a single parent with two children.
 _____ (2) Dee Harris changed her life.

2. Which inference can you make about Dee?
 _____ (1) Dee did not really want a job.
 _____ (2) Dee cares a lot about her children.

3. Write the correct sequence word to put these sentences in order.

First	Then	Last

_____ Dee got a job in a day-care center.

_____ Dee wanted a better life.

_____ Dee went back to school.

B. Read this story. Answer the questions.

The Night Shift

Mike and Hector are next-door neighbors. They were good friends. In May Mike got a night job. He had to go to bed at 4 p.m. He slept all evening. He woke up at 11 p.m. and went to work.

Hector got home from work just when Mike went to sleep. Hector loved to listen to loud music. The music woke Mike up.

Mike told Hector the music was too loud. He asked Hector to turn it down. Hector felt bad. He said he would keep it down.

But the next night Hector forgot. He put on loud music. Mike woke up. He was mad. But he didn't know what to do.

Then Mike had an idea. He told Hector to get some headphones.

Now Hector can hear the music he wants. Mike can get the sleep he needs. They are friends again.

1. What caused Mike to get mad?
 _____ (1) Hector lived next door.
 _____ (2) Hector's loud music woke him up.
 _____ (3) Hector liked loud music.

2. How did Mike and Hector solve the problem?
 _____ (1) Mike got a new job.
 _____ (2) Hector got headphones.
 _____ (3) Hector turned the music off.

Write word pairs...
in each sentence is a rhyming clue.

| around | house | book | foot | clear | hear |

1. The <u>cook</u> dropped a _____ on his _____.

2. They won't <u>appear</u> until they _____ it is _____.

3. He was <u>proud</u> to show us _____ his _____.

Writing Skills Review

A. Copy the sentences. Add capital letters and punctuation marks.

 1. why dont steve and i help you move

 2. steve doesnt have time to help us

B. Add -s or -es, -ed or -ing to fit the sentences.

 1. (go, shop) Rosa and Ian were _____

 2. (hope, dress) Rosa was _____ to buy two

 _____.

 3. (hope, toy, baby) Jan _____ to find _____

 for two _____.

 4. (plan, have) Then they were _____ on

 _____ lunch.

Write About It

▶ **Topic:** Think about what you have learned in this book. What are you most proud of? Why?

Prewrite Think about the topic questions. List some ideas on another sheet of paper.

Write Pick your best ideas. Write a paragraph that tells why you are proud of what you learned.

I am most proud of learning _____

Revise Look at your paragraph again. Change any words you want to change. Have someone read your writing. Can he or she understand it?

Edit Find and correct mistakes in your writing. See page 128.

Final Draft Make a final copy to keep and share.

▶ **Now go back** and fill in the right side of the Student Interest Inventory on pages 6 and 7 in the front of this book.

Reading Skills

A. 1. (2) Dee Harris changed her life.
 2. (2) Dee cares a lot about her children.
 3. **Last** Dee got a job in a day-care center.
 First Dee wanted a better life.
 Then Dee went back to school.

B. 1. (2) Hector's loud music woke him up.
 2. (2) Hector got headphones.

Word Work Review

1. book, foot
2. hear, clear
3. around, house

Writing Skills Review

A. 1. Why don't Steve and I help you move?
 2. Steve doesn't have time to help us.

B. 1. going, shopping
 2. hoping, dresses
 3. hoped, toys, babies
 4. planning, having

Evaluation Chart

Circle any questions that you answered incorrectly. You may want to review the skill area for these questions. If so, refer to the lessons shown in the chart.

Reading Skills		
Question	Skill	Lesson
A. 1	Understanding the main idea	3, 10
2	Making inferences	6, 9
3	Sequencing events	1, 8
B. 1	Identifying cause and effect	2, 7
2	Finding details	5, 11
Word Work		
Question	Skill	Lesson
1	*oo*	10
2	*ear*	11
3	*ou*	10
Writing Skills		
Question	Skill	Unit
A. 1, 2	Capitalization, punctuation, contractions	1, 2
B. 1	Adding -*ing*	4
2	Adding -*ing*, -*es*	4, 3
3	Adding -*ed*, -*s*, -*ies*	4, 3
4	Adding -*ing*	4

Answer Key

Unit 1: Hopes and Dreams

▼ Lesson 1

After You Read (p. 13)

1. Ken wants to read to his son.
 Jon wants to work in a shop.
 Brad wants to go to college and get
 a better job.
2. They are going to school to learn
 to read better.

Think About It: Sequencing Events (p. 14)
Practice

B. 3, 2, 1
 Last, Then, First

C. 2, 1, 3
 2. Then Ken learns to read and write better.
 3. Last Ken reads stories to Russ.

D. 2, 3, 1
 Then Jan learns to read better.
 Last Jan gets a job in a shop.

Word Work: Short Vowels (p. 18)

B. pet, pin, mop, cut
 hat, bed, pen, nut

C. Word order may vary. Words should include:

ham	bat	lack
hem	bet	lick
him	bit	lock
hum	but	luck

▼ Lesson 2

After You Read (p. 21)

Wording may vary.
1. Sal comes from Mexico.
2. Sal came to Texas because he wanted
 a better life.
3. Each day Sal worked hard and went to class.
4. He learned to speak English.
5. Sal's new dream is to visit his family in
 Mexico.

**Think About It: Identifying Cause and Effect
(p. 22)**
Practice

A. 1. c
 2. a
 3. b

B. 2. (1) He misses his family.
 3. (1) He wanted a better job.

C. Sentences may be similar to these:
 Effect: Sal has finished school.
 Cause: Sal went to class and studied hard.

Word Work: Initial Consonant Blends (p. 26)

B. clock, drop, grass, broom
 star, plant, brush, plate

D. 2. class
 3. state
 4. plans
 5. glad

▼ Lesson 3

After You Read (p. 29)

Possible answers:
2. Do not give up your dreams.
3. A bird with broken wings cannot fly. It can be
 caught. Similarly, a person without dreams
 has no hope. He or she can get trapped in
 a bad situation.
4. Nothing grows in a barren field. Similarly,
 a person without dreams does not grow, nor
 does he or she help others to grow.

Think About It: Understanding the Main Idea (p. 30)
Practice

1. Life is a barren field frozen with snow.
2. Possible answers: crippled, torn, fractured,
 empty, bare, deserted
3. Possible answers: if we hold on to our dreams,
 life is a bird that can fly high in the sky; life is
 a field full of flowers and plants

Word Work: Final Consonant Blends (p. 32)

B. lamp, child, best, gift
 pump, field, cent, stamp

D. Crossword Puzzle

Practice

1. **D**on **G**rant wants a better job.
2. **H**e wants to make more money, and so do **I**.
3. **H**ow will **D**on and **I** get new jobs**?**
4. **H**e and **I** will have to work hard to get them**.**

▼ Unit 1 Review (p. 35)
Reading Review

1. (1) In this unit, we learned about some hopes and dreams.
2. (1) They want to read better.
3. (2) He wanted a better life.

Word Work Review

1. class
2. has
3. shop
4. job
5. plan
6. hold
7. best

Unit 2: Everyday Heroes

▼ Lesson 4
After You Read (p. 39)

A. Wording may vary.
1. First Rosa Parks paid her fare and sat down.
2. A white man wanted her seat.
3. Ms. Parks did not give her seat to the white man.
4. She was arrested.

Think About It: Making Predictions (p. 40)

Practice

A. 1. (2) The man will learn to cook dinner.
2. (1) They will take a trip to Mexico.

B. and C. Answers will vary.

Word Work: Long a and Long i (p. 43)

B. rain, cape, sail, plane

C. 1. tape, made, Jane
2. rain, pain, paid, main

D. 1. e 2. long

F. 1. ride 5. fight
2. bite 6. tine
3. sight 7. spine
4. dime 8. ripe

G. 1. e 2. long

H. 3.

I. 1. ride 4. life
2. white 5. admire
3. right

0. Because he saved their lives.

Think About It: Finding Details (p. 48)

A. 2. True
3. False
4. True
5. True

D. 1. a French ghost
2. Ms. Yee and her baby
3. first-floor window
4. fire fighters
5. OK, safe, or fine
6. brave

Practice

B. 1. Pete Greeley
2. Friday
3. today or after 25 years
4. prizes and medals
5. brave

Write About It: Write About a Person You Interview (p. 50)

A. 2. a
3. d
4. e
5. c

B. 1. What
2. Where or When
3. Where
4. What
5. What

Word Work: Long e and Long y (p. 52)

C. 1. and 3.

Practice

E. 1. Why
2. bravery
3. easy

F. 2. pet
3. bet
4. fed
5. head
6. flat

▼ Lesson 6
After You Read (p. 55)

Possible answers:

B. 1. The poet felt afraid or upset.
2. Someone agreed that the poet could not do something. This made the poet think twice.
3. She says she wanted to convince "them," but she also wanted to convince herself.

Think About It: Making Inferences (p. 56)
Practice
1. sea
2. help
3. toast
4. tree

Word Work: Long o and Long u (p. 58)
C. 1. rod
2. nut
3. son
4. hop
E. 2. phone, alone
3. true, blue
4. toe, hoe

▼ **Writing Skills Mini-Lesson: Contractions (p. 60)**
Practice
A. 2. don't
3. isn't
4. hasn't
5. couldn't
6. wouldn't
B. 1. She thinks she can't do it.
2. Isn't it time for her to try?
3. She won't give up now.

▼ **Unit 2 Review (p. 61)**
Reading Review
Possible answers:
1. We call them heroes.
2. Rosa Parks took a stand in 1955.
3. He helped farm workers.
4. He is brave.
5. Answers will vary.
Word Work Review
1. true
2. paid
3. seat
4. fire
5. saved
6. farm
7. more

Unit 3: Thrilling Moments

▼ **Lesson 7**
After You Read (p. 65)
1. His team had problems with the chips they needed. Rich had an idea to solve the problem.
2. He likes working for Alpha now. The problems with the computer chips are solved. His team works better now. Rich got a promotion.

Think About It: Identifying Cause and Effect, (p. 66)
Practice
A. 1. b
2. c
3. a
B. 1. c. The team ran out of space to store the boxes.
2. a. The team had down time.
3. b. Rich's team changed the way it worked.
C. 1. The team sat and waited.
2. The team gets 10 boxes the next day.
3. Rich got a promotion.

Write About It: Write a Story (p. 68)
A. 2. d; Waste not, want not.
3. a; Curiosity killed the cat.
4. e; United we stand, divided we fall.
5. c; The early bird gets the worm.
B. Answers will vary.
C. Possible answers:
1. the mice will play.
2. May flowers.
3. a penny earned.

Word Work: Digraphs (p. 70)
B. ship, chin, phone, whale
C. Possible answers:
People: children, father, Phil
Animals: moth, elephant, whale
Question words: when, why
Things: bathtub, shoe, ship, shower, phone
D. Possible words with digraphs include:
-eat: wheat
-in: chin, thin
-en: when
-ine: shine, thine
E. 1. phone
2. with
3. Chin
4. She

▼ **Lesson 8**
Think About It: Sequencing Events (p. 74)
Practice
A. **4 Last** Phyllis finished in just over three hours.
3 Then Phyllis made a strong start in the race.
1 First Phyllis wanted to run in the Boston Marathon.
2 Second Phyllis trained hard for the race.
B. **4 Last** she gets the sleep she needs at night.
3 Then she jogs or runs.
2 Second she does warm-up stretches.

The party is at Joe's.
Be there Friday at 7 p.m.

B. Second, when the bell rings, everyone hides.
Then Joe lets Phyllis in.
Last everyone jumps out and yells "Surprise!"

Word Work: Three-letter Initial Blends (p. 78)

B. screw, spray, strawberry
thread, street, three, spring

C. 1. thank
2. sting
3. splash
4. scold

D Possible words with three-letter blends include:
int: sprint
ead: thread
eam: scream
-ew: strew, threw

E. 1. thrill
2. strong
3. sprained
4. spring
5. screamed
6. sprinted

▼ Lesson 9

Think About It: Making Inferences (p. 82)
Practice
1. (1) The boy's dad being at the game was most important.
2. (2) The boy's dad is excited.
3. (2) The boy's hit won the game
4. (1) The boy's dad was very proud of him.

Word Work: Three-letter Final Blends (p. 84)
B. fence, hinge, purse, badge
C. 1. lunch
2. bench
3. oranges
4. fudge
E. 1. France
2. purse
3. wedge
4. wrench
5. cringe

▼ Writing Skills Mini-Lesson: Plurals (p. 86)
Practice
A. 1. cars
2. classes
3. parties
4. benches

5. stories
6. families

▼ Unit 3 Review (p. 87)
Reading Review
1. (3) Thrilling moments are an important part of our lives.
2. (2) A stitch in time saves nine.

Word Work Review
1. thrilling
2. edge
3. scream
4. share
5. phone
6. once
7. three
8. change

Unit 4: Friendship

▼ Lesson 10
Think About It: Understanding the Main Idea (p. 92)
Practice
(3) We all need to share with our friends.

Word Work: Special Vowel Combinations (p. 94)
B. 1. hawk, dawn
2. voices, spoiled
3. daughter, auto
4. enjoyed, toy
D. 1. sound
2. hook
3. looked, room
4. food, house
5. cook, soup, group

▼ Lesson 11
Think About It: Finding Details (p. 98)
Practice
C. 1. (1) They may have differences, but the two are best friends.
2. Possible answers: came from different places; different hair; like different things; live with different people
3. Possible answers: know what they want; know where they will go, talk, trust, laugh, know that their friendship will last

Write About It: Complete a Diagram (p. 100)
D. 1. Flopsy, an English Springer
 3. Possible answers: buy food; comb her hair; messy; cleaning up messes; daily walks; warm and cuddly

Word Work: R-controlled Vowels (p. 102)
B. 1. cure
 2. share
 3. sure
 4. admire
 5. more
C. 1. close
 2. bird
 3. clue
 4. car
 5. cheery
D. Crossword Puzzle

▼ **Lesson 12**
Think About It: Making Predictions (p. 106)
Practice
A. 1. (2) She will apply for the job.
 2. (3) He will jump from the plane.
B. Possible answers:
 1. She will win a gold medal with her dive.
 2. The patient will live with a new heart.

Write About It: Make a Journal Entry (p. 108)
A. 1. I think I will not see her for a long time.

Word Work: More R-controlled Vowels (p. 110)
A. arm warm marry
 charm quart parent
 part award vary
C. hear wear heard
 appear swear earth
 fear pear learn

▼ **Writing Skills Mini-Lesson: Adding -ed and -ing (p. 112)**
Practice
A. 1. retired
 2. wanted
 3. hopped
 4. running
 5. making
 6. buying
B. 1. stopped
 2. smiling
 3. helping
 4. hugged

▼ **Unit 4 Review (p.113)**
Reading Review
1. (2) Friends are an important part of our lives.
2. (1) in your family
 (2) neighbors
Word Work Review
1. care
2. far
3. store
4. very
5. near
6. about
7. four
8. bear

able
about
absence
adjourn
admire
advice
afraid
after
again
ahead
air
Alabama
alarm
alike
alive
all
almost
alone
alpha
already
also
always
American
animal
ankle
annoy
another
any
anywhere
appear
apple
apply
appreciate
appreciation
April
arch
argue
arm
arrest
arrive
ask
attention
auto
award
away
awful
back

badge
ball
bare
barren
baseball
bathtub
beach
bear
became
because
bee
been
boat
before
began
behind
being
bell
bench
bent
berry
beside
best
better
bind
bird
bite
black
blame
bleach
bleachers
blessing
blue
board
boat
boil
bold
bone
book
born
boss
bound
box
boy
brace
brain
bran

branch
brass
brave
bravery
bread
break
breakfast
bride
bridge
bright
bring
broil
broke
broken
brook
broom
brother
brown
brush
built
bump
butter
buy
California
call
calm
came
cannot
can't
cape
car
careful
cause
cent
center
ceremony
change
charm
cheat
check
cheer
cherry
chest
child
children
chill
chin

chip
chore
city
clam
clamp
clan
class
claw
clean
clear
clench
clerk
clinch
cling
clip
clock
close
club
clue
clump
coil
cold
college
comb
come
complete
computer
congressman
cook
cool
cost
could
couldn't
country
courage
course
court
courtesy
credit
cried
crock
crowd
crush
cry
cub
cuddly
cure

curiosity
curly
curve
cute
daily
dance
danger
dare
date
daughter
dawn
day
dear
decide
delight
depend
detector
didn't
die
difference
different
dime
dinner
dispute
divide
do
doctor
does
doesn't
done
door
doorway
down
drained
draw
dream
dress
drift
dry
due
duty
dying
each
early
earth
easy
edge

effect
elephant
employ
English
enjoy
error
even
every
everyday
everyone
everywhere
excite
excuse
eye
face
tail
fair
fall
family
far
fare
farm
fast
father
fault
fear
too
feel
feet
felt
fence
few
field
fifteen
fight
film
finally
find
fine
finish
fire
firefly
first
first-floor
fish
five
flame

flat grass hour like must penny
flee greatly hourly line my people
fleet green house list myself perfume
float grill how listen nail peril
flour grin hun live name period
flu grind idea look near person
fly groom important lose neat phone
foe ground inch loud need pictures
folk group include love neighbor pinch
fond grow instead lunch neighborhood pint
food grub into lunge nephew place
foot guest it's made nerve plan
forever guy I've maid nervous plane
forget hair jail mail nest plant
form half January main never plate
foul hand jaw make new play
found happen job many newspaper pleat
four happy jog marathon next pledge
fourth hard join mark nice plop
Friday hard-working journal marry night plug
friend haste journey mature nine plum
friendship hate joy may noise plump
from have jump maybe now point
frozen hawk June mean nurse pool
fudge head jungle medal o'clock pour
fuse hear just merit off preach
game heard keen merry oil price
garden heart keep menu OK prince
gave hedge kill mess old prize
GED held kind messy once problem
generous hello kite Mexico one produce
Germany help knew mice opening promotion
gift helps know might orange proud
girl her known mind other prove
girlfriend here lace mine our proverb
give hero lamp miss out pump
glad herself lance misuse outbreak pure
gloat hide land moment over purse
glue high language Monday own put
go hinge last money paid quail
goal hire late month pain qualities
goes hoe laugh more parent quart
gold hold laughter most part question
good home law moth party race
grab homework leader mother pass raft
grace honest lean mourn patriot rain
grad honesty learn move paw rake
grain honor left Mr. pay ramp
grand hook less Ms. pear reach
grandfather hope letter much pearl read
grandmother hopeful life mule peek refuse
grant horse lift music peel remember

restore	chore	spring	teach	trouble	why
retire	show	sprinkle	teacher	true	will
rice	shower	sprint	team	trust	window
rich	sigh	sprout	tear	try	wing
ride	sight	stamp	tell	tune	winner
right	since	stand	term	Turkey	winter
ring	single	star	terror	twice	wish
ripe	sister	stare	test	twinge	with
road	six	start	Texas	two	without
room	sky	state	than	unfair	woman
ruby	slap	statue	thank	union	won
rule	sleep	stay	that	unit	word
runner	slid	steak	their	unite	work
rust	slide	stereo	them	unsure	world
safe	slot	still	then	until	worm
said	smart	sting	there	update	worth
sail	smile	stitch	these	U.S.	would
same	smoke	stole	they	use	write
sang	snail	stool	thin	usually	wrong
save	snake	stop	thing	value	wrote
saw	snow	store	think	vary	yeah
say	soap	story	this	very	year
soar	soaring	straight	those	visit	yell
scare	sold	strain	thread	voice	yesterday
school	soldier	strawberry	three	wall	you'll
scold	some	stray	threw	wake	young
scour	someday	stream	thrill	walk	your
scrap	someone	street	throat	want	yourself
scream	sometimes	stretch	through	war	youth
screen	son	stride	throw	warehouse	zero
screw	soon	string	Thursday	warm	
scrub	sore	strong	tight	waste	
sea	sound	stub	time	watch	
seat	soup	stun	tint	wave	
secure	sour	summer	the	way	
see	space	sunny	toast	wear	
seem	span	super	today	weed	
seen	special	superior	toe	week	
send	spell	support	together	we'll	
sent	spent	sure	told	well	
series	spill	surprise	tomorrow	went	
shade	spin	swear	tone	we're	
shake	spine	swift	tonight	were	
shale	splash	swing	too	whale	
share	splendid	tailor	took	what	
shift	splice	take	tool	when	
shin	splinter	talk	tore	where	
shine	split	tall	town	while	
ship	spoil	tap	toy	whine	

Writing Skills Rules

Rules for Writing Sentences

1. A sentence states a complete thought. It begins with a capital letter and ends with a period.
 I have a dream.

2. A question begins with a capital letter and ends with a question mark.
 What is your dream?

3. Always capitalize the word *I*. Capitalize people's names.
 Don Grant and I each have a dream.

Rules for Contractions

When two words are combined into one and at least one letter is dropped, an apostrophe takes the place of the missing letter.

can not ➡ can't is not ➡ isn't

Rules for Adding *-s* or *-es* to Make Words Plural

1. Add *-s* to most words.
 job + s = jobs game + s = games day + s = days

2. Add *-es* to words ending in *s, x, z, ch*, and *sh*.
 boss + es = bosses box + es = boxes wish + es = wishes

3. If a word ends in a consonant + *y*, change the *y* to *i* and add *-es*.
 city + es = cities company + es = companies

Rules for Adding *-ed* and *-ing*

1. Add *-ed* or *-ing* to most words without changing anything.
 warn + ed = warned warn + ing = warning

2. If a word ends in silent *e*, drop the *e* and add *-ed* or *-ing*.
 hope + ed = hoped hope + ing = hoping

3. If a word ends with a short vowel followed by a consonant, double the consonant before adding *-ed* or *-ing*.
 plan + ed = planned plan + ing = planning

About this book

A succulent is a plant that stores water, usually in its leaves or stems, to use in dry weather. All cacti are succulents, but not all succulents are cacti. Only a cactus has areoles (see p. 9)

The beginning of this book shows just a few of the 2,000 known cacti and other succulents which you can keep and explains the care they need. The plants are divided into 'desert' cacti and 'forest' cacti, according to where they grow in the wild. There is also a section on other succulents. The last part of the book gives step-by-step directions of how to grow all the plants.

Cacti and succulents have strange shapes, unlike other plants. Don't be surprised if you start collecting them as a hobby !

Designer : Pat Butterworth
Consultant : Kevin de Groot
Cover illustration by Grahame Corbett
Additional illustrations :
Jane Wolsak pages 7, 18, 38
Artists' reference : The Smith Collection

LIBRARY OF CONGRESS CATALOG CARD NO. 80-82105
First American edition

Printed and bound in Italy by
Il Resto del Carlino, Bologna

ISBN 0-316-83207-3

Contents

Prickly Plant Book

Written by Sue Tarsky

Feature illustrations by Grahame Corbett

Activity Illustrations by Will Giles

LITTLE, BROWN AND CO.

Boston

How to use this book

Symbols
You will see symbols used on the step-by-step pages in this book. The symbols show you the kind of light plants need, when to water plants and when to feed them.

Shade If seedlings or plants need shade, you will see this.

Direct light Some seedlings and plants need full sunlight.

Indirect light This means good light that isn't full sunlight.

Hot, dark place If plants need to grow in a hot, dark place, you will see this.

Glochids These are tiny bristles that grow on *Opuntias*. They stick in your fingers easily.

Areoles These are small growths like side shoots found only on cacti. Wool, spines, flowers and new shoots grow from them.

Spines These may be thick and sharp or hair-like. They grow from areoles on cacti and from the bodies of some succulents.

Offshoots Branches that may grow from the sides of a stem after you take cuttings from it. You can use them as cuttings.

Rosette The circular shape in which some leaves grow.

Flower spike The way in which some flowers grow. The spike itself has no branches. The flowers on it have no stalks and grow in a spiral around the spike.

Watering This shows you when to water your plants.

Offset A plant that grows on a parent plant. You can cut it off to grow a new plant.

Plantlet A small plant that grows on the outer branches of a parent plant.

Variety A plant that is a little different from other plants in the same species.
Hybrid A plant that is the offspring of two different varieties or species.

Scion The top part of a plant that is used for grafting.
Rootstock or stock The bottom part of a plant that is used for grafting.
Shrub A plant with thick, woody branches that grow close to or below the compost level or ground. It lives for a long time.
Corm A short, fat stem with a bud. You can grow new plants from it.

Globular The rounded shape in which some succulents grow.
Cylindrical The upright shape in which some succulents grow.

English name, it is the name you'll see used in this book. If you want to know the Latin names for all the plants, look in the Index on p. 40. A cactus may have more than one common name, so if you want to find out more about it in other books, look up its Latin name. Some cacti even have more than one Latin name. The Index includes all known Latin names.

Be sure that:
1. you wear gloves when holding an adult cactus or wrap it in old newspapers.
2. you use tweezers to take out any spines that stick in your fingers.
3. you always clean up after doing a project.
4. you ask an adult to help you, wherever it's written in this book.

Monstrosa An unusual form in which a cactus sometimes grows. The cactus looks out of shape. The most common monstrosity is a 'cristate' form where the growing points divide all round a stem or just on one side.

Basic care

Your cacti and succulents are easy to care for. It's true that they don't need as much attention as most other plants you'll grow, but you can't just forget them and expect to have healthy plants and beautiful flowers. If you meet their few basic needs, your succulents will live for a long time.

Light
Most of your succulents need at least four hours of sun a day. If you keep them in a place where they can get light from a south-facing window, they should all do well. A west-facing window that gets afternoon sun is also good for succulents. Remember to turn the pots around so that your plants will grow straight up.

Direct light
Opuntias, the *Cereus* cacti and *Mammillarias* all grow well in full sun. So do succulents such as *Crassulas*, *Echeverias* and *Aloes*.

Little light
If your windows face east or north, choose plants that do not need as much light, such as 'forest' cacti. The Easter and Christmas cacti can grow in limited light.

Temperature
Succulents will all grow well in normal house temperatures. If you put any outdoors in the summer, remember to move them indoors in the autumn before the first frost. Most cacti have a resting period in the winter, when they need a cool temperature of about 40°F. If you have a room that isn't heated, put them in there for the winter.

Compost
You can make your own compost. Buy bags of good potting compost and coarse sand at a garden center Don't use beach sand – it has too much salt in it. Use an old cup to mix together equal amounts of the compost and sand. If you can, add some leaf mold to this mixture, especially for 'forest' cacti. When you fill the pots, don't pack the mixture too tightly. It needs fresh air in it.

Containers
Be sure your pots are clean. Clay pots dry out faster than plastic, so roots in clay pots are less likely to rot. A pot should be about 2.5cm wider than the width of your globular plants.

It should be about half as wide as the height of your cylindrical plants.

Cleaning
Wipe shiny stems or pads with a damp sponge once in a while, or use a fine spray to get rid of dust.

be at room temperature. The correct amount of water depends on the season, the plant you are watering, the kind of pot it's in and whether or not your home has central heating. Don't over-water or leave plants standing in water or they will rot.

In the growing season, water when the compost is dry or if the cacti look withered. You may have to water plants almost every day if they are in strong summer sun. Water winter-flowering plants while they are in bloom. In the resting period, water cacti about once a month, just enough to stop them from shrivelling or the compost and roots drying up. Spray them lightly about once

compost gets soggy – remember that compost below the surface may still be damp.

Plants in plastic pots need less water than plants in clay pots. Plants in small pots may need water more often than those in large pots. Your plants may need more water if the air is dry from central heating.

Water or spray plants in the morning or late afternoon, so that the sun doesn't dry up the water before the plants can absorb it. Never water in full sun. Never pour water on top of the stems or they may rot.

1. You can water succulents from the top with a watering can but don't water on top of the stems

2. Let extra water drain through into the saucer.

3. Empty the saucer.

4. Or, put your pots into a sink with a little water in it until the top of the compost is damp.

5. If it is very hot, spray the succulents with a fine spray every few days.

Feeding

When your plants are flowering, give them liquid tomato fertilizer about once a month as you water them.

`Desert´ cacti

Bunny Ears

Opuntia vestita

Opuntia tuna variegata

Opuntias are easy to grow, but they may not flower in a house. They grow best in direct sunlight.

Opuntia stems grow in sections. Each section is called a pad. There are many different species of *Opuntia,* and they grow in different shapes.

Opuntias have glochids instead of true spines (see p.2). Glochids stick in your fingers if you touch them. To take out glochids, cover them with a piece of sticky tape and then pull off the tape. Use tweezers to pull out glochids that are stuck in deeply.

Opuntias have a resting period in the winter, when they need a cool temperature (see p.4) and less water (see p.5). They need more water when they are growing in spring and summer.

You can use *Opuntias* for grafting (see pp. 35-37).

Grow new plants from cuttings (see p.32) or from seeds (see p.30). Cuttings and seedlings both grow quickly because *Opuntias* have strong roots.

Repot *Opuntias* in the spring (see p.31).

Peanut Cactus

These plants thrive in direct light. You can grow them all from seeds (see p.30). They all rest in winter.

The Peanut Cactus is easy to grow. Its spring flowers may bloom for a month. It needs warmth and plenty of water when it's growing. You can grow new plants from its shoots (see p.33).

The Old Man Cactus grows slowly and probably won't flower until it's 5m tall. It has spines that look like long white hairs which you can wash if you're careful not to break them. Like all cacti, it needs good drainage.

Cylindrical *Trichocereus* cacti are strong and easy to grow, so they make good stocks (see p.3). They grow quickly, so if you want to slow them down, keep them in small pots. They flower when they are five years old. You can grow new plants from stem cuttings (see p.32).

Oreocereus celsianus has long white hairs, too. It's easy to grow, but grows slowly. You can make new plants from seeds (see p.30). The seedlings develop slowly, too.

Old Man Cactus *Trichocereus terscheckii* Old Man of the Andes

need a lot of direct sunlight to grow well. The plant rests in winter, but needs air and plenty of water in summer. It rarely grows offsets, so grow new plants from seeds (see p.30), but be patient.

Cereus jamacaru is strong, and easy to grow. It needs good light. It grows branches that you can use as stem cuttings when they are about 10cm long (see p.33). You can also grow it from seeds (see p.00). It roots in winter.

The plant on this page is a monstrosa form (see p.0). You can grow new plants from cuttings or by grafting it (see p.36).

Golden Barrel Cactus

Cereus jamacaru monstrosa

Rat's Tail Cactus

The Rat's Tail Cactus is a popular plant that needs full sun. It hangs from tree branches or rocks in the wild, so you should grow it in a place where the long stems can hang down.

Don't let the stems touch the compost, or they may rot. If they do rot, graft the healthy ones on to a strong stock (see p.35). You can graft them even if they don't rot, to make a stronger plant.

The Rat's Tail Cactus rests in winter. It needs a temperature of 70°F in the spring, when it blooms. The plant doesn't flower until it's about five years old. The flowers may last a week or more. Water it well in spring and summer, but don't let it dry out in winter.

If you repot the Rat's Tail Cactus every spring, it will grow faster, but it only needs repotting when the plant grows too big for its pot (see p.31).

You can grow new Rat's Tail Cacti from seeds (see p.30) or stem cuttings (see p.32).

flowers that are on the sides of the stems. The flowers may last about a week, opening in the morning and closing at night. All *Echinocerei* plants flower easily at a young age.

There are two kinds of *Echinocerei*. Grow them both in direct sunlight. One kind branches from the bottoms of the stems and grows quickly. Because this kind of plant grows fast, the roots need room to spread, so don't keep these grow now or treat the branches as stem cuttings (see p.32) in the summer.

The other kind of *Echinocereus* cactus has one erect stem, usually with beautiful spines. This kind of plant grows slowly. It rests in the winter, too. Let it dry out before you water it each time in the summer. Grow new plants from seeds (see p.30).

You can wait until you see the areoles (see p.2) growing a lot of white hairs that look like wool in early spring, before you water the *Echinocerei* after their winter rest. This wool means that flower buds are growing. By waiting to water, you'll get as many flowers as possible. If you don't see any wool by April, the plants may not flower, so you should start watering anyway.

Rainbow Cactus *Echinocereus knippelianus* *Echinocereus blanckii*

Rebutias are quite small, globular cacti that are easy to grow if you give them good direct light. They are popular because they flower easily, even when they are about one year old.

The flowers grow in spring from the sides of the stems. The different species bloom in many different colours. The flowers last for a few days. If you watch closely, you can see them open in the morning and close in the evening.

Look for tiny red hairs in the areoles (see p. 2) at the bottom of a *Rebutia* plant in early spring. These hairs mean that the cactus is growing either new offsets or flower buds. When you see them, start to water the cactus a little after its winter rest. When the new growths are about 3mm long, they will be big enough for you to see if they are buds or offsets. Water more now. By waiting a while to water, you'll get as many flowers as possible. If the plant doesn't have buds by April, it may not flower, so you should start watering now anyway.

Repot *Rebutias* when their roots fill the pots they are growing in (see p. 31).

You can grow new plants from the offsets, which may have their own roots (see p. 33). You can also grow new plants from seeds, but the seedlings develop slowly (see p. 30). You can graft them so they grow more quickly (see p. 37).

Red Crown Cactus

Fire Crown Cactus

Some of them look like large [...]
Treat them all in the same way as *Rebutias*. *Lobivias* bloom freely in the summer. The brightly-colored flowers last a few days.

Echinopsis cacti rest in the winter, but need plenty of water in the summer. Grow them in direct light.

The flowers bloom on tubes that grow from the sides of the plants. The flowers open in the evening and bloom for about two days, so watch carefully or you may miss them.

If you want the *Echinopsis* cacti to grow quickly, repot them every spring (see p. 31). Otherwise, wait until they fill their pots.

them from seeds, the seedlings grow slowly (see p. 30). You can graft the seedlings for faster growth (see p. 37).

Orange Oak Cactus *Echinopsis* x 'Green Gold' *Echinopsis rhodotricha*

The *Parodias* are usually globular-shaped, but you may find some that are cylindrical (see p. 9). All *Parodias* are covered with many spines. Some have spines that are bent at the ends and look like little hooks.

These cacti are rather easy to grow. You can keep them in a sunny place, but they will also grow where there is some shade.

Parodias are popular cacti because they flower easily. They start flowering when they are about three years old. Different species flower at different times of the year. If you choose your species carefully, you can have *Parodias* in bloom from March to October, in a range of colors.

Parodias have a winter resting period (see pp. 4-5). If you grow any that flower late in the year, be sure you don't stop watering them too early.

As with all cacti, don't over-water *Parodias*. If you leave them in very damp compost for too long, they will rot where the roots start to grow at the bottoms of the plants (see p. 39).

Parodias all grow slowly. If you graft them on to fast-growing cacti with strong roots, they will grow more quickly (see p. 36).

You can propagate them from seeds (see p. 30). The seedlings grow slowly. You can graft these, too, for faster growth (see p. 37).

If you keep *Parodias* in small pots, they will grow better and give you more flowers. You can also grow a few *Parodias* together in a dish (see p. 18).

Golden Tom Thumb *Parodia chrysacanthion* *Parodia nivosa*

Notocacti are globular when they are young, but become cylindrical as they grow older.

Notocacti grow best in good light, but they can grow in a place that has some shade, too.

The Notocacti flower easily at an early age. Keep them dry during their winter rest from the end of November until early in March.

The flowers bloom in spring and early summer from near the tops of the plants. The larger flowers last only about a day, but the smaller ones last about one week.

from the bases of the plant to grow new plants (see p. 33). Or you can grow Notocacti from seeds (see p. 30). The seedlings develop easily.

Notocactus grossneri Silver Ball Cactus Goldfinger Cactus

Plaid Cactus

Gymnocalyciums aren't difficult cacti to grow. You can keep them in direct sunlight or in some shade. They rest in winter.

Some Gymnocalycium cacti need slightly different care than others.

The Plaid Cactus and its varieties such as *Gymnocalycium damsii* don't have the chemical they need to make food. Because of this, they must be grafted on to other cacti to live (see p.36). They also need a slightly warmer temperature in the winter than the other *Gymnocalycium* cacti.

All species are globular. They grow offsets from the areoles. You can use these offsets to grow new plants (see p.33). Or you can grow the cacti from seeds (see p.30).

Repot *Gymnocalyciums* every spring if you want them to grow quickly (see p.31). Otherwise, repot them when the plants fill their pots.

Most species flower easily at a young age. The flowers grow on tubes and may bloom for up to one week in the spring.

Gymnocalycium venturianum　　　Spider Cactus　　　*Gymnocalycium mihanovichii* var. *damsii*

Bishop's Cap Cactus

Sand Dollar Cactus

Try growing the *Astrophytum* cacti after you have grown easier cacti. They make interesting additions to your collection. *Astrophytums* not only have very strange shapes, but they also have odd white spots on their bodies.

They are rather globular-shaped at first, but will grow to be more cylindrical. These cacti grow slowly.

You can grow *Astrophytums* in a place where they get a lot of good light, or in a place that's lightly shaded. They need fresh air.

If you treat them carefully, beautiful flowers will bloom from the tops of the plants. The flowers close at night and open again in the morning. They may last for about five days.

The *Astrophytums* rest in the winter (see pp.1-5). Repot them in early spring if they fill the pots they are growing in (see p.31).

They do not usually grow offsets. The best way to propagate these plants is from seeds (see p.30).

A dish garden

You can make a dish garden for small cacti or succulents. Grow a few different species (see p. 3) in the same dish, or different varieties (see p. 3) of the same species.

Put down a layer of gravel at the bottom of the dish for good drainage. Use a wooden spoon to put in cactus compost (see p. 4) and then to make one hole in it for each cactus you want to plant. Put the cacti into the holes and gently firm the compost around the plants. You can add rocks, pebbles or even an object to the top of the compost.

The best way to water your dish garden is to put it into a sink so that water just covers the dish. When air bubbles stop rising, take out the dish. Put a stone under one end of the dish for about an hour to let extra water drain away.

gravel compost pebbles

Old Lady Cactus

flowers bloom ... tops of the plants in winter and spring. They bloom for a few days, closing at night and opening again in the morning.

The 'desert' *Mammillarias* grow and flower easily.

They grow best in a sunny place. They may be globular or cylindrical in shape. They are small plants, so you can keep them on a windowsill or grow a few together in a dish (see p. 18).

To get as many flowers as possible, start their winter rest a bit later than your other cacti and end it a bit sooner.

Mammillaria zeilmanniana

Pincushion Cactus *Mammillaria geminispina* *Mammillaria dumetorum*

'Forest' cacti

There are many hybrids and varieties of this plant, with differently-colored flowers. It is sold under a few botanical names (see p. 3).

Like all 'forest' cacti, it needs leaf mold in its compost, and shade and fresh air. Keep it in a shaded place where the stems can hang down.

To have flowers for Easter, put the plant in a cool, dark place at night from late January to early April. Leave it in its normal growing place during the day. Don't water or feed it. When you see flower buds, don't put it in the dark, feed it once a week, water and spray it. Keep the compost damp. The flowers bloom at the ends of the flat stems for about a week.

You can grow new plants from stem cuttings (see p. 3?).

There is also a Christmas Cactus with many varieties. To have flowers for Christmas, keep it in a dark place from late September to early December. It needs the same kind of care as the Easter Cactus. Both these plants need a temperature of at least 55°F while they rest. Both are easy to grow.

Easter Cactus

gacti, and need leaf mould in the compost and shade and fresh air. They are easy plants to grow. They can live in a winter temperature of 40°F but you'll get more flowers if it's warmer. Never let the plants dry out, even in winter. Feed them every two weeks when they flower in May and June.

You can grow new plants from stem cuttings (see p. 32) or seeds (see p. 30).

even when young. The open during the day.

Hybrids with yellow or white flowers don't bloom as easily as hybrids with red flowers, but they are strong-growing plants. Their flowers open in the evening.

Repot epiphytic cacti after they finish flowering (see p.31).

Epiphyllum x niobe Orchid Cactus

Other succulents

All these succulents grow well in a sunny place.

The *Faucarias* have pairs of leaves that grow in a criss-cross pattern, with one pair on top of another. The edges of the leaves are notched.

Give the plants plenty of water in summer and autumn when they grow, but keep them dry in winter while they rest.

The *Faucarias* have large flowers that look like daisies and bloom in the autumn.

Repot these succulents every three years in early spring (see p. 31).

Living Stones

Tiger's Jaws

Conophytum proximum

Painted Lady

You can propagate *Faucarias* easily from seeds (see p. 30). Keep the seedlings damp in their first winter. *Faucarias* can also be grown from cuttings. Cut off a leaf and a short piece of its stem and treat it as a stem cutting (see p. 32).

The tiny *Conophytums* look like the real stones they grow among in the wild. Give them fresh air and water them when the compost is dry in the summer. You'll see the leaves start to dry up in October. Keep them dry from October until May, when they rest. New leaves will grow through the old skins. You can peel off the old skins when they are brown.

The flowers, which look like daisies, bloom any time between August and October. If you grow *Conophytums* in small pots or pans, you'll get as many flowers as possible.

If you want the plants to grow fast, repot them every three years in July.

Propagate the tiny *Conophytums* from seeds or by division (see p. 33).

The tiny Living Stones also look like real stones. You can't see their stems, which stay under the compost.

Don't water the plants while they rest from mid-October to April. Be careful not to over-water, or they will swell up and rot. New leaves grow from between the old ones, which dry up. When the old ones have dried up, start watering again.

In September or October, flowers bloom from the openings between the leaves at the tops of the plants.

You can divide Living Stones to make new plants. Repot them every three years (see p. 31).

The *Echeverias* need good light for the coloring of the leaves, which form a rosette. They are very easy plants to grow, and can be kept outdoors in the summer. There are two kinds of *Echeverias*. One kind grows in a low rosette (Painted Lady). The other kind is a shrubby plant (see p. 3) with a long stem (*Echeveria gibbiflora*). This plant may lose its bottom leaves in winter. To help it look better, you can cut off the top of the stem with leaves, let it dry for two days, and repot it. The old stem will grow new shoots which you can use as offsets.

Water *Echeverias* well in summer. Don't get water on the waxy leaves, or it will mark them. They rest in winter.

The flowers grow on stems from the sides of the rosettes. Painted Lady blooms in June. *Echeveria gibbiflora* blooms in late autumn.

You can propagate these plants from offsets (see p. 33), seeds (see p. 30) or leaf cuttings (see p. 34).

Repot *Echeverias* every year (see p. 31).

Grow the Hearts Entangled in a place with good light and space for its long, thin stems to hang down.

Water it just a little in summer and even less in winter, when it rests.

The plant blooms easily. Its flowers are shaped like little lanterns.

You can grow new plants from stem cuttings (see p. 32) or by cutting off the small corms (see p. 3) on the stems and putting them in pots.

Pearl Plant Wart Plant Zebra haworthia

Haworthias are easy to grow. You can keep them in a sunny place or where there is some shade. Their roots do not grow very deep, so you can use a small pot, or shallow pan or dish for these plants.

Their thick, stiff leaves usually grow in a rosette (see p. 2). The leaves have white spots or markings on them, which form different patterns on different species (see p. 3).

Keep the compost damp in summer and almost dry in winter.

The flowers, which look like little bells, bloom on long stalks in summer.

You can repot *Haworthias* every spring (see p. 31).

Grow new plants from seeds (see p. 30) or whole leaf cuttings (see p. 34). You can also cut away the offsets of rosettes that grow from the bottoms of the plants (see p. 33) and pot them.

The Turkish Temple, a *Euphorbia,* is almost round when it is young, but becomes cylindrical as it gets older. The plant grows slowly.

The tiny, sweet smelling flowers bloom in summer.

See p. 25 for care of *Euphorbias*.

Turkish Temple

Euphorbias have strange shapes, like cacti, and may even have spines, but they are not cacti. They contain a white juice that can irritate, so if it gets on your hands, wash it off.

You can grow *Euphorbias* in full sun. Keep the Crown of Thorns in a dry room that has fresh air. Water it well from May to August but keep it just damp at other times. It can flower at any time of the year, even in winter. When it is in bloom, it needs a temperature of 55°F. Repot this plant every other spring (see p. 31). Take cuttings about 7.5cm long from shoots without flowers in July. Treat them as stem cuttings (see p. 28).

Water other *Euphorbias* well in summer and early autumn but keep them dry from then until early spring. Repot them every spring. You can grow new plants from seeds (see p. 30).

The shrubby (see p.) *Kalanchoes* are easy plants to grow. Give them full sun. Keep them well-watered in summer and just damp in winter, with a warm temperature. Grow new plants from seeds or stem cuttings. Repot them every spring. The Panda Plant probably won't bloom, but other *Kalanchoes* have clusters of tube-shaped flowers.

Panda Plant Crown of Thorns Milk-striped euphorbia

Burro's Tail

Chenille Plant

Ox-Tongue

Lilliput gasteria

Grow the *Sedums* for their flowers and unusual leaves. It's best to keep the slow-growing Burro's Tail in a place where the long, thin stems can hang down. A windowsill is a good spot, because this plant likes fresh air. If the sun is strong in summer, give the Burro's Tail some shade so it doesn't dry out. Don't let it get cold in winter, even though it rests then. Be careful not to over-water it. You can grow new plants from seeds (see p. 30), stem cuttings (see p. 32) or leaf cuttings (see p. 34). The star-shaped flowers bloom in summer, at the ends of the older stems.

The Chenille Plant needs the same kind of care as other *Echeverias* (see p. 23). This plant has short stems and leaves that form rosettes (see p. 2). The flowers are shaped like bells and bloom in sprays on long, arching stems.

Grow the *Gasterias* for their glossy, spotted leaves. These spots may be flat marks on the leaves or raised bumps. *Gasterias* are small and easy to grow. Water them well while they are growing in summer and keep them just damp in winter when they rest. Grow new plants from offsets (see p. 33), seeds or leaf cuttings. The tube-shaped flowers bloom in summer on long, bending stems. The stems may need staking to keep them upright when the plant is flowering.

The Ox-Tongue has leaves that grow in pairs, one above the other. They have gray bumps on them.

The leaves of the Lilliput gasteria grow in a spiral on a short stem. They have white spots on them.

Jelly Beans

Moonstones

Jelly Beans probably won't flower, but it's a pretty *Sedum* plant to keep because of its fleshy, colored leaves. It likes fresh air, so you can grow it on a sunny windowsill indoors from early spring until autumn. Like many other succulents, you can put it outdoors in the summer. Just be sure you bring it indoors before the first frost, because Jelly Beans is a tender plant and frost will kill it.

Propagate Jelly Beans from seeds (see p. 30) or stem cuttings (see p. 32). Although Jelly Beans is a *Sedum,* like Burro's Tail (see p. 26), its leaves are too small to use for leaf cuttings.

Moonstones is an easy succulent to grow. If you keep it outdoors in the summer, remember to bring it indoors before the first frost. The fleshy leaves turn slightly pink in the sun.

From spring until autumn, let the compost become almost dry between waterings. In the winter, water the plant just enough to stop the leaves from drying up. Moonstones needs a slightly warmer temperature in the winter — it should not be cooler than 50°F at night. You can grow new plants from leaf cuttings (see p. 34), seeds or stem cuttings. Repot the plants when they crowd the pots they are growing in (see p. 31).

If you grow *Crassulas* outdoors in the summer, you must bring them indoors before the first frost. You can grow small *Crassulas* in a dish garden (see p. 18). It will look like a scene of tiny trees.

You can keep almost any succulent outdoors in summer. Your plants may need more water than usual because the sun will dry it up quickly. Water in early morning or late afternoon. If the sun starts to burn the leaves, move your plants indoors. Bring them all indoors before the first frost.

Stapelias are difficult to grow, but they are worth trying for the large, weird flowers that bloom in the late summer and early autumn. Before they bloom, you will see large flower buds that look like balloons. After the flowers die, seed pods form that look like horns. Stapelias are better kept outdoors in the summer, because the flowers have an unpleasant smell that attracts flies.

Water the plants well in summer and a little in winter. Grow new plants from seeds (see p. 30) or cut off whole stems and treat them as stem cuttings (see p.32).

Agaves don't flower until they are quite old. They are grown for their sword-shaped leaves that form rosettes (see p. 2). Water Agaves well while they are growing in the summer but let them rest in winter. Repot them when they grow too big for their pots (see p. 31). The Agave victoriae-reginae needs a slightly warmer winter temperature than other Agaves and is the only one that doesn't grow offsets. You can grow new plants from seeds.

Agave victoriae-regi

Carrion Flower

Grow Aloes for their rosettes of thick leaves. The Hedgehog aloe has white bumps on its leaves. Water the plants well when they are outdoors in summer, but let the compost dry out between waterings from spring until autumn if they are indoors. Water just enough to stop them drying up in winter. *Aloes* don't need repotting often – add new compost to the pots. Grow new plants from offsets (see p. 33) or seeds. The flowers grow on a long spike (see p. 2).

Crassulas are grown for their thick leaves and tree-like shapes. They need good light when they are indoors. A good place to keep Crassulas is on a sunny windowsill.

Give them good drainage, as you need to water them all year. Keep them damp in winter. Grow new *Crassulas* from leaf cuttings laid flat on compost (see p. 34), stem cuttings (see p. 32) or from seeds (see p. 30).

Hedgehog aloe

Jade Plant

Sowing seeds

It's easy to grow cacti from seeds and it doesn't cost a lot. But it does take a long time, so you must be patient..A plant may take two years to really look like a cactus! The best time to sow seeds is in the spring. You can buy everything you need during your Easter holidays.

You will need
Old newspapers
Clean plastic seed pans or trays
Gravel for good drainage
Seeds, seed compost, sand, potting compost and fungicide from a garden center
Plastic bag
Elastic band
2 stakes
Plastic seed label
Old kitchen spoon

1. Put down a layer of gravel in one pan. Fill the pan up to 4cm from the top with seed compost so it is level. (It's a good idea to soak compost in fungicide first).

2. Sow seeds evenly over the top of the compost with your fingers. They don't have to be in rows. Cover them with a 2mm layer of sand.

3. Put the pan into a sink that has a little water in it. Water this way whenever the compost is dry until the seedlings are growing well.

4. Put two stakes into the pan at opposite ends. Put the pan into a plastic bag. Seal the end with an elastic band. The plastic must never touch the seedlings.

5. Put the pan and bag in a place with good indirect light. The temperature must be 70°F to 80°F for the seeds to grow.

6. Take off the bag when the seedlings grow spines. If you are growing more than one kind of species, take it off when the seedlings are large enough to handle, because not all species have spines.

7. When the seedlings are about 6mm across, fill another pan with potting compost. With the spoon, dig small holes in the compost about 3cm apart.

8. Hold a seedling gently with the fingers of one hand and lift it from underneath with the seed label. Put each seedling into a hole. Try not to harm the roots.

Repot an adult cactus when the roots fill the pot it's growing in. Most need repotting about every four years. You can add some new compost to the pot of a large plant if it doesn't need repotting. The best time to repot is in the spring, before watering. Look for pests on the roots (see pp. 36-38).

You will need
Clean pots about 6cm wide
Cactus compost with leaf mold (see p. 4)
Old kitchen spoon
Old newspapers
Gravel and crocks (pieces of broken clay pots)
Clean pots one size larger than adult cacti have been growing in

Seedlings Cover the drainage holes in the pots with crocks. Add a thick layer of gravel so that water can drain away without compost clogging the holes.

1. When the seedlings are about 2cm across (or 5cm high), fill each 6cm pot up to 2cm from the top with cactus compost (see p. 32).

2. Hold a seedling with one hand and dig up the roots and some compost with the spoon in your other hand.

3. Hold the seedling in place in a pot. Put it near the side so the roots can spread. The plant will grow faster.

4. Add compost around the seedlings to the same height as the old compost. Don't water for a few days.

Adult cacti Cover the drainage holes in the pot with crocks and add a thin layer of gravel for good drainage.

2. Put in enough compost so the compost ball around the roots will be about 2cm from the top when you put it in.

3. Tap the rim of the old pot upside down on a table top so the compost ball comes out in one piece.

4. Wrap newspaper around the cactus to protect your hands. Put the plant in its new pot. Put small plants near the side so the roots can spread. The plant will grow faster.

5. Fill in with more compost, to the same height on the cactus as the old compost.

6. Gently firm the compost around the edge of the pot and the plant. Don't water for about a week.

Stem cuttings

Any way you multiply your plants is called 'propagation'. The easiest way is to take cuttings. It doesn't harm adult plants. The best time to do this is in May or June. Keep your cuttings in a warm, shaded place. Don't over-water them. When you pot stem cuttings be sure they are the right way up!

You will need
Old newspapers
Plant for cuttings
Sharp knife
Old cup
Potting compost and coarse sand from a garden center
Clean pots about 6cm wide
Plastic seed labels
Watering can
Slightly larger pots for repotting.

1. Ask an adult to cut off a piece of a stem, straight across. If you are cutting off a piece of an *Opuntia* stem, it should be one whole segment cut off at a joint.

If you are taking off a piece of stem from a cactus with small joints, the cutting should be about three segments long.

2. Put the cutting in a warm, shady, dry place for as long as it takes to dry out completely.

3. You will see a hard, thick callous where you made the cut.

4. Using the cup, mix together an equal amount of potting compost and coarse sand.

5. Fill the 6cm pot up to 1.2cm from the top of the pot with sandy compost.

6. Stick the cuttings into the compost near the side of the pot. Use seed labels for support. Keep compost moist.

7. When the cuttings can stand up on their own, put each into its own slightly larger pot (see p. 31).

Offsets may grow on plants from under the compost or from the stems. If the plants' bulbous offsets have their own roots, don't cut them off until the roots are well-grown. Use division to propagate your cacti which look like stones. Propagate plants both these ways in the summer.

You will need
Old newspapers
Plants to propagate
Sharp knife
Clean pots about 6cm wide filled with potting compost
Clean pots about 6cm wide filled with sandy compost
(see p. 32)

Offsets at compost level
1. Ask an adult to cut away the offsets at their narrowest points when they're about 10cm long. The offsets may have their own roots.

2. Put each offset into its own pot of potting compost (see p. 31).

Offsets from stems
1. Ask an adult to cut away the offsets at their narrowest points.

2. Treat them in the same way as whole leaf cuttings (see p. 74).

Division
1. Carefully loosen the compost around the bottom of one of the plantlets with your fingers.

2. Tear away the plantlet with a small piece of its own stem

3. Put the plantlet into its own pot of potting compost (see p. 31).

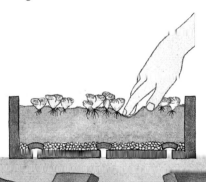
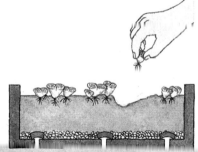

Leaf cuttings

You can propagate some succulents by planting one of their leaves upright in compost. Try this with *Sedums*, *Haworthias*, *Crassulas*, *Echeverias* and *Kalanchoes*. Propagate other succulents, such as *Gasterias*, by cutting up the leaves and putting the pieces flat on top of the compost.

You will need
Old newspapers
Plant for cuttings
Clean pots about 6cm wide
Watering can
Sharp knife

1. Pull off a leaf from a plant.

2. Let the leaf dry out for about two days in a warm, shady, dry place.

3. Fill a 6cm wide pot up to 1.2cm from the top with the sandy compost (see p. 32).

4. Stick the leaf into the compost near the side of the pot, just deep enough to stand up. Water the compost lightly every two days.

5. In about two weeks, the leaf will root and you will see a small leaf cluster growing on the leaf.

6. This cluster will grow into a rosette of branching leaves (see p. 2).

7. When the rosette grows as high as the first leaf, take them out of the pot they are in (see p. 31) and plant them near the side of a new 6cm pot of sandy compost.

8. When the original leaf is completely dried up, **ask an adult** to cut it off. Throw it away.

You can graft cacti. This is when you join together a scion and a stock (see p.3). Grafting doesn't from any of your plants – it just makes one new plant from the two you already have. Each keeps on looking the way it did before you grafted it. Be sure the cacti you use as your scion and stock are in the same family. Some scions grow better on certain stocks than on other stocks. You may want to look in a book to find out which cacti to graft.

Don't graft a strong scion on to a weak stock. The reason for grafting is to help slow or weak cacti to grow faster or stronger. It may also help some plants to flower faster. If just a part of a plant is sick, try grafting its healthy part on to a healthy stock to save it.

Always use healthy scions and stocks. A tip of a new shoot is a good scion to use. *Mammillarias*, *Rebutias* and *Gymnocalyciums* make good scions. Use a strong-growing cactus as your stock. The *Trichocereus* cacti make good stocks for cylindrical grafting. The scion and stock should be about the same size.

The best time to graft 'desert' cacti is from May to August. Once you graft them, keep them in a dry place that has a temperature of 70°F to 76°F.

You will need
Old newspapers
Sharp knife
Opuntia pad
Flat-stemmed cactus to use as scion (see p. 3)
Watering can

1. Ask an adult to make a cut along the curve of the top of an *Opuntia* pad.

2. Ask an adult to cut off a piece of the flat-stemmed cactus (see p. 36). Cut the bottom of the scion into a wedge shape.

3. Put the scion well down into the cut at the top of the *Opuntia* pad. Carefully pull off a spine from another cactus.

4. Push the spine through the pad and the scion to hold the scion in place. Put the plant in a **warm**, dry, shady place. Water.

5. In about two weeks, take out the spine. If the scion stays in place, it has grafted well.

Columnar grafting

After you graft a plant this way, you can cut off part of the scion to graft on to another stock if you wish. This will make new shoots from the first scion. You can use these shoots to grow new plants. You don't have to do this, but if you want to, steps 9, 10 and 11 show you how.

You will need
Old newspapers
Plant as rootstock
Plant as scion (see p. 3)
Sharp knife
Piece of cotton
2 elastic bands
Watering can
Clean pots about 6cm wide filled with sandy compost

1. Ask an adult to cut off the top of the rootstock, straight across (you can treat it as a stem cutting).

2. Ask an adult to cut off a scion. (The bottom of the scion should be about the same size as the top of the stock).

3. Ask an adult to shape the top of the stock and bottom of the scion and to cut off any spines.

4. Carefully press the scion down on to the stock. Try to line up the centres of the scion and stock.

5. Put the cotton on top of the scion to protect it.

6. Put elastic bands around the scion and the bottom of the pot to keep the scion firmly in place.

7. Put the plant in a warm, dry, shady place. Water slightly.

8. In two weeks, take off the bands. If the scion stays on, it has grafted. If not, put on the bands again.

9. If you wish, when the scion grows, you can **ask an adult** to cut it, leaving about 1.2cm on the stock.

10. Put the cut-off piece on to another cut stock and hold it in place with elastic bands.

11. Offshoots will grow around the scion left on the first stock. You can cut them off when they grow (see p. 33).

You will need
Old newspapers
Opuntia cactus
Sharp knife
Seedlings
Piece of cotton
2 elastic bands

1. Ask an adult to cut off the top of an *Opuntia* pad so the cactus is flat on top.

2. Ask an adult to cut off the roots of seedlings so that their bottoms are flat

3. Put the seedlings on top of the *Opuntia* pad.

4. Put the cotton on top of the seedlings to protect them.

5. Hold them in place with elastic bands (see p. 36).

6. In about three weeks, take off the bands. If the seedlings stay in place, they have grafted.

Pests and problems

If you give your cacti and other succulents the correct amounts of light, water, heat, fresh air and food, and grow them in clean containers filled with good cactus compost, they will be less likely to have pests or develop problems.

You can guard against insects by spraying your plants with a fungicide after you water them, especially in late summer and the autumn. **Ask an adult** to spray for you. A good time to spray is in the evening. Always be sure there is plenty of fresh air where the spray is used. You can buy good name-brand sprays at a garden center.

If one of your plants is attacked by pests or develops a problem, take it away from all your other plants until it is healthy again.

Scale insects Look for small, brown flat or rounded scales on the body of the plant, especially round the areoles. Wash with soapy water and rinse or use a small artist's brush dipped in methylated spirit.

Mealy bugs Look for a white cotton-like covering or pale brown spots on the body of the plant and roots. Use a small artist's brush dipped in methylated spirit. If the top of the plant doesn't have bugs, you can cut it off and use it as a cutting (see p. 32).

Too much water Stem rot. Look for a black mark at the bottom of the plant. Scrape away the mark and soft area behind it with an old clean spoon, or cut off the top of the plant with a sharp knife and pot it (see p. 31).

Too little water Look for withering or slow growth. Water the plant.

Red spider mites With a magnifying glass, look for tiny insects, or look for yellowish marks on the body of the plant.
Spray or cut off the top of the plant and use it as a cutting (see p. 32). (see p. 32)

Rootworms Look for fading color and slow growth. Take the plant out of its pot and look for swollen spots on the roots.
for swollen spots on the roots. Cut them off with a clean, sharp knife and don't repot for one week. Then use new compost in a clean pot.

Aphids (greenfly and blackfly) Look for small insects on the body of the plant. Spray.

Too little water and food Look for rings around the body of the plant. Feed it in the growing season and water

Too much heat or too little light Look for faded and weak new growth. Put the plant in better light and correct the temperature.

39

Index

Latin names are in *italic*.
Page numbers in *italic* refer to illustrations.

Folded FABRIC

squares
& more

JOYCE MORI

Love to
Quilt...

Located in Paducah, Kentucky, the American Quilter's Society (AQS) is dedicated to promoting the accomplishments of today's quilters. Through its publications and events, AQS strives to honor today's quiltmakers and their work and to inspire future creativity and innovation in quiltmaking.

EDITOR: SHELLEY HAWKINS
GRAPHIC DESIGN: AMY CHASE
COVER DESIGN: MICHAEL BUCKINGHAM
PHOTOGRAPHY: CHARLES R. LYNCH

Library of Congress Cataloging-in-Publication Data
Mori, Joyce
 Folded fabric squares and more / Joyce Mori.
 p. cm. -- (Love to quilt)
 ISBN 1-57432-814-X
 1. Patchwork--Patterns. 2. Quilting--Patterns. 3. Origami. I.
Title: Folded fabric squares and more. II. Title III. Series.

 TT835.M683 2003
 746.46'041--dc21
 2003002591

Additional copies of this book may be ordered from the American Quilter's Society, PO Box 3290, Paducah, KY 42002-3290; 800-626-5420 (orders only please); or online at www.AQSquilt.com. For all other inquiries, call 270-898-7903.

Copyright © 2003, Joyce Mori

ACKNOWLEDGMENTS

Thanks to the members of the Campus Club Quilters for test-ing the folding techniques. A special thanks to Pat Hill who tested directions, contributed several ideas for designs, found new uses for the techniques, and made samples for the Gallery. Sue Miltenberger was a wonderful help in testing directions. My daughter, Susan Marsh, drew several block designs, which are included. She is a new quilter and we enjoy sharing ideas and fabric.

As always, my husband, John, deserves special thanks for putting up with threads on the carpet and sometimes on his clothes. He claims I have taken over half the house with my quilts, but he lovingly accepts my quilting and contributes many suggestions to design and color.

Thanks to the American Quilter's Society for publishing this book and for having a great staff that is easy to work with.

CONTENTS

tural motifs on quilts and wearable art. I considered this use to be the main function for Prairie Points, until one day, as I drew a somewhat complex quilt design that contained many triangle pieces. I was not in the right frame of mind to make the series of templates needed to cut the patches or do the complex stitching the design would require.

As I studied the design, I tried to figure out a way to simplify the construction process. All of a sudden, it came to me that it would be easy to use Prairie Points in place of the small triangles. The final visual result would be the same, but the work involved would be significantly reduced. When I completed the quilt, I was pleased with how it looked. It had the appearance of a complex design but had not been difficult to piece (see WHIMSY, page 20)

Next, using pieces of paper, I tried different ways of folding a square, rectangle, triangle, circle, etc., to create other geometric elements. It felt like I was back in kindergarten again and having fun. As I expanded on the idea, I discovered that Prairie Points could be created from various types of fabric, such as lace, strip-pieced fabric, striped fabric, and print fabric. I also lined the fabric prior to folding to produce additional designs.

Fifteen fabric folding techniques are included, as well as five bonus techniques. The 15 techniques are used in a variety of designs for 11 quilt projects. Photographs and descriptions of blocks and block combinations are displayed in the Gallery on page 56, which offers inspiration for the many folded variations.

As I share my designs with you, I hope you enjoy sewing them and creating designs of your own. The folded fabric process is easy, fun, and creative. I am sure you will discover new and exciting ways to manipulate fabric pieces for innovative use in your quilts and wearable art.

idea of using folded fabrics instead of patches. This technique can eliminate the complexity of block assembly, without sacrificing the integrity of the design.

Figure 1 shows a block made with folded fabrics. Figure 2 shows a quarter of the block as a unit, containing a Prairie Point, a Folded Square, and a Line (bonus technique). There is no cutting required for the background. The folded pieces are simply cut out and placed on top. Figure 3 shows how complex the cutting and piecing of a single unit would be with traditional methods.

Figure 1

Figure 2 **Figure 3**

Figure 4 – Trim corners and seam allowances on lined motifs.

Figure 5 – Press the long seam allowance open for the points in a block to lie flat.

Figure 6 – Create a crisp edge with the help of a bias bar.

Please read the following information on pressing, sewing, and quilting before making the folded fabric pieces and quilt projects.

PRESSING

The following steps should be taken before pressing the folded motifs and completed blocks: Lined motifs need to have tips or corners cut off before turning them right side out. Seam allowances need to be trimmed to ⅛". Trimming reduces bulk so the motifs maintain sharp edges (Figure 4).

The back layer of a lined shape can be cut away when it is not used in the design. Cut the back layer to within ⅜" of the seam. The quilt, INTERSECTIONS, page 50, is an example where the linings of the quarter circles were cut away.

When pressing motifs such as Prairie Points or Lined Rectangles placed in a seam, press the seam allowances as if they were a continuation of the Prairie Point or other motif. This strategy allows the point to lie flat on the quilt surface. However, there may be instances when the seam allowances will be pressed open, as in SPRING PINWHEELS, page 23. The long seam allowance on the blocks in this quilt must be pressed open to allow each point to be pressed flat (Figure 5).

A bias bar is a helpful tool when pressing Lined Rectangles and Lined Triangles. After a Lined Rectangle has been cut to create a triangle, turn it right side out. Slip a ¼" bias bar inside the triangle against the long seam and press the seam to create a crisp edge (Figure 6). The bias bar is usually not needed against the shorter edge. If you do not have a bias bar, you can finger press the folded edges before pressing the triangle.

For another pressing strategy on lined motifs, you can turn them right side out with the main fabric side up. Put the tip of the iron

The raw edges of most folded fabric motifs are placed in the seam allowances of quilt blocks to hide them. Other motifs are sewn or appliquéd on the background. In some cases, the raw edges of the motifs are sewn into a seam and the folded edges are sewn down on the block. The folded edge of the motif might be sewn to the background in just one spot (Figure 7) or along the entire edge.

Figure 7 – Folded fabric edge sewn to the background.

The intended use of the quilt may determine the stitching method. The tips of Prairie Points can be secured with buttons or beads on a wall quilt. However, this would not be suitable for a bed quilt on which the buttons or beads might be uncomfortable. Likewise, on a wall quilt, motifs can be less strongly secured because the quilt will not be cleaned frequently. Consider the purpose of the quilt when deciding how to attach the motifs.

SEWING MOTIFS TO THE BLOCKS

After you create folded fabric motifs, place them on a block and pin them in the seam allowance. To prevent shifting, machine baste the motifs ⅛" from the edge of the block before enclosing them in a seam. Figure 8 shows the basting stitch as it appears in the block assembly diagrams of the quilt projects. Once you familiarize yourself with the sewing concepts, you will probably omit the machine basting step for most elements and will simply use pins to secure the motifs prior to sewing the seams of the blocks.

Figure 8 – Basting stitch

The edges, points, etc., of the motifs can be sewn to the quilt surface by hand or machine. I find sewing them by hand is quick and relaxing, and folded fabrics make a good portable project. With hand sewing, you can also add a button or bead as a decorative element when you secure the flaps.

Figure 9 – Allow space between folded fabric and seam intersections to reduce bulk.

Figure 10 – Place sashing between units to reduce bulk.

When machine sewing items to the background, I use monofilament thread so the stitch is nearly invisible. A contrasting thread could be used, however, to highlight the stitched line. To secure the folded fabric to the block, you can sew in place for a few stitches at the tip of the folded fabric, just as you would hand stitch, or you can top stitch close to the folded edges of the fabric. Your choice of fabrics and the final design effect will determine which method you use.

For TRIANGLES AND ARCS, page 76, the border design was secured by machine after the main portion of the quilt had been quilted. I used invisible thread, and the stitching served both to secure the border pieces, and provide machine quilting in the border.

REDUCING FABRIC BULK

When placing motifs such as Flat Prairie Points in areas where there is a convergence of seam lines, place them ¼" to ⅜" away from the seam intersection (Figure 9). This reduces bulk and makes pressing the seams much easier.

Another strategy to reduce the bulk created by intersecting seams is to place narrow sashing between units. Figure 10 shows four Folded Square Kite units placed together. The multiple layers of fabric at the center would be bulky. However, by placing a narrow sashing between the units, the bulk is reduced, but the integrity of the design is maintained.

OTHER OPTIONS

At the time you secure the edge of an item such as a Prairie Point to the quilt block, you may want to add a decorative element like rickrack or piping. Slip the rickrack or piping under the edge of the motif and stitch it in place as you secure the point to the quilt block (see CURVING PINWHEELS, page 41). If you do not want to sew the edges or points in place, you can use a ½"-wide square of fusible bonding web, which is simply

design elements on the quilt. Be creative.

QUILTING

The projects can be quilted by hand or machine. I have come to prefer machine quilting for the speed it provides. Select the method you prefer based on the amount of time you have to quilt and the use of the project.

The majority of the project quilts are machine quilted with invisible thread. For each project, the outline of the blocks was quilted in the ditch. For the larger projects, additional quilting was done close to the edges of motifs in the blocks for emphasis.

One benefit of quilting projects with folded fabric is that the quilting can serve to secure the points, flaps, or folded edges of the motifs to the background of the quilt. This method eliminates the step of sewing the folded fabric to the background after it has been sewn in the seam allowances. It also provides a more stable attachment of the motif to the quilt because the stitching will go through the quilt top, batting, and backing.

I use a thin batting, usually low-loft polyester. Occasionally, I use cotton flannel for batting. It helps reduce the bulk that can be caused by layers of fabric in the quilt top. The layers can be basted with thread or with spray basting products. Spray basting is quick and easy. It has allowed me to hand quilt without a frame. It can also be used for machine quilting.

Figure 11 – Secure a folded fabric tip or edge with fusible bonding web.

PRACTICE FOLDING

This section includes 15 fabric folding techniques. You may want to practice the techniques with paper or scrap fabric before making the quilt projects.

When making the quilts in the projects, refer to each specific project for the fabric choices and cutting sizes used. The measurements given in this section are examples. I use a rotary cutter and acrylic ruler for most of my cutting.

PRAIRIE POINT

1. Cut a 4" square of fabric. Fold the square in half diagonally, wrong sides together.

2. Fold the resulting triangle in half diagonally and press.

3. Place the base of the triangle in the seam of a block. The tip can be sewn to keep it flat against the block, if you like.

FLAT PRAIRIE POINT

1. Make a Prairie Point from a 4" square as previously described. Cut two 2½" x 4½" rectangles of the same fabric. On the right side of a rectangle, center the Prairie Point on the long edge and pin.

and sew along the edge with a ¼" seam allowance.

3. Open the rectangles. Flatten the Prairie Point against the seam to form a kite shape, and press.

POINTED TAB

1. Cut a 4½" square of fabric. Fold the square in half, right sides together.

2. Sew across the top from the raw edges to the fold with a ¼" seam allowance. Trim the seam allowance to ⅛".

3. Turn the square right side out, carefully pushing the corner out. Lay the unit right side down on a table with the seam at the top and the long, open edge to the right. Open the unit from the right side and move the seams to the left. Center the seam on the wrong side. Press the unit flat to form a Pointed Tab.

LINED SQUARE

1. Cut a 3" square of fabric and a 3" square of lining fabric. Scraps or muslin can be used for the lining because it will not be seen.

2. With a rotary cutter, make a cut along the diagonal in the lining square, leaving at least ¾" from the corners uncut.

trim to ⅛" →

3. Place the two squares right sides together and sew around the outside, ¼" from the edge. Trim the seam allowance to ⅛".

4. Turn the square right side out through the slit. Use the blunt end of a bamboo skewer, or something similar, to carefully push the corners out. Press the square and place it cut side down on a block. Sew along the edges of the square to secure the shape and hide the lining.

LINED RECTANGLE

1. This technique allows you to make odd-sized triangles. Cut two 3½" x 4½" rectangles of the same fabric and place them right sides together. Draw a diagonal line from corner to corner on the top rectangle. Sew ¼" from the line on each side.

raw edge →

↑ raw edge

2. Cut on the drawn line and turn the resulting triangles right side out and press.

Lined Rectangle

3. Place the raw edges of the triangle in the seam allowance of a block. The folded edge does not have to be sewn unless you use a large rectangle.

the fold and sew the tip to hold it in place.

1. Cut two 2½" x 4½" rectangles, each from a different fabric. Place the rectangles right sides together and sew around the outside with a ¼" seam allowance.

2. On the main fabric, draw a diagonal line inside the seam lines from corner to corner of the stitching line. Cut the rectangle in half on the line through the seam lines. Trim the seam allowance to ⅛".

Lined Rectangle
Variation

3. Turn the resulting triangles right side out and press. Place the raw edges of the triangle in the seams of a block. The tip can be sewn to keep it flat against the block.

LINED TRIANGLE

1. Cut two 4½" squares, each from a different fabric. Place the squares right sides together and sew around the outside with a ¼" seam allowance.

2. Cut the squares in half diagonally. Trim the seam allowance to ⅛".

raw edge

3. Turn the resulting triangles right side out and press flat. Fold the triangle in half as shown and press this fold to mark it.

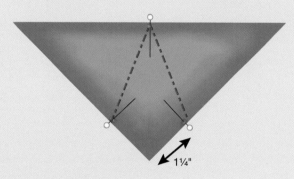

1¼"

4. Open the triangle and place a pin on each side, 1¼" away from the tip as shown and in the fold mark at the center of the triangle base.

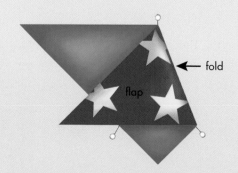

fold

flap

5. Make a fold in the fabric between the center base pin and the 1¼" pin to create a flap.

6. Fold the flap back on itself at the center of the base and press. Repeat step 5 and this step for the other side. The folds should touch. Press.

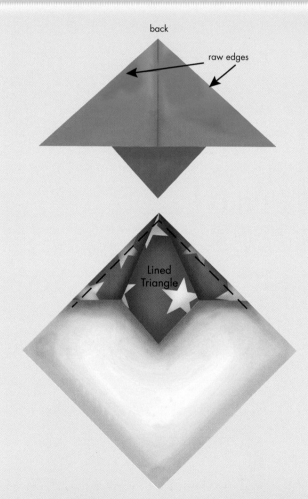

back

raw edges

Lined Triangle

7. Turn the motif over and place the raw edges on the corner of a block and pin. With an ⅛" seam allowance, baste the raw edges to the block. The center kite shape is a loose flap. You will need to sew it down to secure it after the block is complete.

angles right side out and press flat.

2. Fold and press the tip of the triangle as shown, stopping at least ½" away from the raw edge so the tip will not be caught in the seam. The tip should be tacked down to preserve the fold of the fabric.

LINED CIRCLE

template

1. Trace the 4" circle, page 61, on paper. Shapes such as hexagons and ovals can also be used with this technique. Cut the paper circle on the traced line. Cut two 4½" squares, each from a different fabric. Place the squares right sides together and lay the paper circle on top of the squares. Pin the paper to the fabrics.

template

2. Sew the circles together, through the paper, with an ⅛" seam allowance. Use a short stitch length, about 10 to 12 stitches per inch. Trim the fabric to leave an ⅛" seam allowance. Remove the paper.

3. Fold the circle in half and cut on the fold. Turn each half right side out. Use your fingers to push the seam in place and press. To create quarter circles, cut each half circle in half again.

Quarter
Circle

Half Circle

Leave a scant ⅜" between the curve and the raw edge so the edge is not caught in the seam allowances. The rolled edge must be sewn on the curve to preserve the curve.

FOLDED SQUARE

4. When sewing the Lined Circles to a block, insert the raw edges in a seam for the half circle, and two adjacent seams for the quarter circle.

LINED CIRCLE VARIATION

1. Follow steps 1–3 in the Lined Circle technique, page 15, to make a half circle. Mark the center of the half circle with a pin.

scant
⅜"

raw edge

2. Roll the two seamed edges toward the center so the lining is visible, and press.

1. Cut a 4½" square of fabric. Fold the fabric in half diagonally, wrong sides together, and press.

raw edge →

Folded Square

↑
raw edge

2. The raw edges of the resulting triangle are sewn into the seams of a block.

diagonally, wrong sides together, and press.

1. Cut a 4½" square on the straight grain of fabric so the diagonal fold will be on the bias. Fold the fabric in half diagonally, wrong sides together, and press.

2. Open the square and place it right side down. Fold two opposite corners to the diagonal fold of the square and press.

Folded Square Variation

Folded Square Kite

2. The bias edge can be rolled back to create the curve. The rolled edge must be sewn on the curve to preserve the curve.

3. Turn the shape over and place it on a 4½" square of fabric. When the square is sewn into the block seams, the narrow tip of the kite will be blunt rather than pointed.

FOLDED BIAS SQUARE

1. Cut a 4½" square of fabric on the bias.

2. Fold the square in half. Because the fold is on the bias, the fabric can be easily manipulated.

3. Fold the bias edge back to create a curve. The folded edge must be sewn on the curve to preserve the curve.

SQUARE IN A SQUARE

1. Cut two 4½" squares, each from a different fabric. With right sides together, sew three edges of the squares with a ¼" seam allowance, forming a pouch.

2. Trim the allowance to ⅛" and turn the square right side out. Press. Cut the square, parallel to the unsewn edge, 2¼" from the seamed edge.

3. Open the pouch and pull the two side seamed edges together, wrong sides touching, and pin. Baste along the raw edge with a ⅛" seam allowance. Press the shape flat to form a square.

5. Sew along the long edge of the triangles with a ¼" seam allowance, catching the Square in a Square in the seam. Be careful not to catch the top layer of the square in the seam.

4. Cut a 4⅞" square. Cut this square in half diagonally to make two half-square triangles. Center the raw edge seam of the shape from step 3 between the long edges of the half-square triangles.

WHIMSY

Quilt size: 4⅛" x 4⅛"

Finished block size: 13½"

borders	1¼	2 strips 4" x 42" for top and bottom 2 strips 4" x 49" for sides
blocks		36 A squares 3⅞", cut in half diagonally 9 F rectangles 3½" x 6½" 9 G rectangles 2" x 3½"
Assorted prints	2¼	36 A squares 3⅞", cut in half diagonally 18 C rectangles 1¼" x 6½" 9 D squares 2 18 E rectangles 2" x 6½" 18 G rectangles 2" x 3½" 176 H squares 3" (Prairie Point) 4 I squares 3" (Folded Square)
Assorted black and white striped	⅝	9 B squares 3½" 18 D squares 2" 18 E rectangles 2" x 6½" 9 F rectangles 3½" x 6½"
Batting		52" x 52"
Backing	3¼	52" x 52"
Binding	½	6 strips 2½" x 40"

PRAIRIE POINT, page 10. Fold all of the H squares with this technique.

FOLDED SQUARE, page 16. Fold all of the I squares with this technique.

BLOCK ASSEMBLY

– – – folded fabric basting

QUILT ASSEMBLY

ASSEMBLY

Use a ¼" seam allowance for piecing, unless otherwise stated.

1. Refer to the block assembly diagram and arrange the black, print, and striped pieces as shown. Before joining the pieces, place the Prairie Points on the black pieces as shown. Note that the black G piece requires a not in seam. Make nine blocks.

2. Rotate the blocks as desired and sew them together in three rows of three blocks. The quilt photographed, page 20, contains a different center block; however, the blocks in this pattern are all the same.

3. Refer to the quilt assembly diagram and sew the black borders to the top and bottom of the quilt, then to the sides, trimming each strip to size after sewing. Pin 17 Prairie Points (H) to each border and a Folded Square (I) to each corner of the quilt. Baste the shapes in place with an ⅛" seam allowance.

4. The folded edges of the Prairie Points and Folded Squares are sewn with an invisible hand stitch. Polymer clay buttons were also hand sewn as an embellishment. Layer the quilt top, batting, and backing. Baste and quilt the layers. WHIMSY was hand quilted in the ditch around each piece. Bind and label your quilt.

Finished block size: 4"

FOLDING

PRAIRIE POINT, page 10. Fold all of the B squares with this technique.

FOLDED SQUARE, page 16. Fold all of the D squares with this technique.

MATERIALS

Yardage is based on 40"-wide fabric.

Fabric	Yards	Cutting
Yellow	⅜	36 A squares 2½"
Light blue	½	64 A squares 2½"
Medium-dark blue	¼	36 D squares 2" (Prairie Point)
Medium blue	⅜	64 B squares 2" (Prairie Point)
Dark blue sashing borders	½	4 A squares 2½" 16 D squares 2½" (Folded Square) 2 strips 1½" x 26" for top and bottom 2 strips 1½" x 28" for sides
Yellow and blue print sashing	⅜	20 C rectangles 2½" x 4½"
Batting		30" x 30"
Backing	1	30" x 30"
Binding	⅜	4 strips 2½" x 40"

ASSEMBLY

Use a ¼" seam allowance for piecing.

1. Refer to the block assembly diagram, page 25, and sew medium-dark blue Prairie Points (B) in the seams of the 2½" yellow squares (A) as shown. Note that the Prairie Points do not meet at the center of the block. See page 6 for pressing the seam allowances. Make nine yellow blocks. Make 16 light blue Pinwheel blocks in the same manner.

the seams in the next step.

3. Arrange seven rows of Pinwheel blocks, sashing units, and 2½" squares as shown in the quilt assembly diagram. Sew the pieces into rows, then sew the rows together.

4. Sew the borders to the top and bottom of the quilt, then to the sides, trimming each strip to size after sewing.

5. If desired, attach the Prairie Point tips to the quilt with fusible web. Layer the quilt top, batting, and backing. Baste and quilt the layers, then bind and label your quilt.

BLOCK ASSEMBLY SASHING ASSEMBLY

folded fabric basting

QUILT ASSEMBLY

TRIANGLES AND STARS

Quilt size: 38" x 38"

Finished block size: 10"

Fabric	Yards	Cutting
Dark pink	½	18 A squares 4⅞", cut in half diagonally
borders		4 G squares 3" (Square in a Square)
Light blue	½	18 A squares 4⅞", cut in half diagonally
Yellow print	⅜	32 B squares 3" (Prairie Point)
Maroon	1 fat quarter	4 B squares 3" (Prairie Point)
		4 F squares 2" (Lined Square)
borders		4 G squares 3" (Square in a Square)
Gold	⅜	16 C rectangles 2½" x 4½"
borders		2 strips 2½" x 40" for top and bottom
Gold print	½	20 C rectangles 2½" x 4½"
borders		2 strips 2½" x 40" for sides
Medium green	1 fat quarter	16 D squares 2½" (Folded Square)
		4 E squares 2½"
Dark green	1 fat quarter	20 D squares 2½" (Folded Square)
		5 E squares 2½"
Light green	6" x 10" scrap	3 F squares 2" (Lined Square)
Lining	6" x 12" scrap	9 F squares 2" (Lined Square)
Black	½	
sashing		6 black strips 1½" x 10½"
		4 black strips 1½" x 32½"
		2 black strips 1½" x 34½"
Batting		42" x 42"
Backing	1½	42" x 42"
Binding	⅜	5 strips 2½" x 40"

all of the B squares with this technique.

FOLDED SQUARE, page 10. Fold all of the D squares with this technique.

LINED SQUARE, page 11. Fold all of the F squares with this technique.

SQUARE IN A SQUARE, page 18. Fold all of the G squares with this technique. Note that the measurement for cutting with the size of piece is as follows: Cut 1½" instead of 2¼" away from the seam line.

Top stitch F on E after the block is assembled.

BLOCK ASSEMBLY

– – – folded fabric basting

QUILT ASSEMBLY

ASSEMBLY

Use a ¼" seam allowance for piecing.

1. Refer to the block assembly diagram and arrange the pieces as shown, basting the folded fabric pieces in place. Note that there are two different block colorations. Refer to the quilt photograph on page 26 for color placement. Sew your blocks. Top stitch the F squares on the E pieces.

2. Refer to the quilt assembly diagram and arrange three rows of three blocks. Sew the 10½" sashing strips between the blocks in each row. Then sew the 32½" sashing strips between the rows and to the top and bottom of the quilt center. Sew the 34½" sashing strips to the sides.

3. The gold borders have mitered corners under the Square in a Square (G) pieces. Sew the borders to the quilt top, leaving the miter seam open. Place the Squares in a Square in the miters and complete the seams.

4. Sew the tips of the Prairie Points and the corners of the Squares in a Square with an invisible hand stitch. Layer the quilt top, batting, and backing. Baste and quilt the layers, then bind and label your quilt.

FOLDING

FLAT PRAIRIE POINT, page 10. Fold all of the B squares with this technique.

LINED RECTANGLE VARIATION, page 13. Fold all of the C rectangles with this technique. Cut half of the rectangles diagonally from left to right, and the other half diagonally from right to left. This creates mirror-image units.

LINED TRIANGLE, page 13. Fold all of the D squares with this technique. The folds on each side of the triangle are 1¾" from the tip.

PRAIRIE POINT, page 10. Fold all of the E squares with this technique.

MATERIALS

Yardage is based on 40"-wide fabric.

Fabric	Yards	Cutting
Cream	1	20 A squares 6"
Medium green print	¾	16 A squares 6"
Dark green print	½	16 B squares 5" (Flat Prairie Point)
Red and blue print	1	32 B squares 5" (Flat Prairie Point) 8 E squares 2½" (Prairie Point)
Royal blue print	½	4 B squares 5" (Flat Prairie Point) 8 C rectangles 3" x 5" (Lined Rectangle Variation) 2 D squares 6½" (Lined Triangle)
Lining	½	8 C rectangles 3" x 5" (Lined Rectangle Variation) 2 D squares 6½" (Lined Triangle)
Batting		37" x 37"
Backing	1⅛	37" x 37"
Binding	⅜	4 strips 2½" x 40"

ASSEMBLY

Use a ¼" seam allowance for piecing.

1. This quilt consists of nine four-patch blocks. Refer to the block assembly diagrams, page 31, and make four corner blocks, four side blocks, and one center block. The B pieces are sewn in the seam allowances between the A pieces. Note that the points of the B pieces do not meet at the center of the block. They are spaced about ¼" from the seam intersection. Press the seams of the background squares open for the B pieces to lie flat. Once the center block is sewn, the E pieces are inserted under the B pieces.

CORNER BLOCK ASSEMBLY

SIDE BLOCK ASSEMBLY

CENTER BLOCK ASSEMBLY

––– folded fabric basting

2. Refer to the quilt assembly diagram and arrange three rows of three blocks as shown. Join the blocks and rows, sewing the dark green Flat Prairie Points (B) in the seam allowances. Refer to the quilt assembly diagram for the placement of the B pieces.

3. Trim the edges of the quilt top. Baste the C and D pieces along the edges of the quilt. They will be sewn in place when the binding is added.

4. In this quilt, the tips of all the folded fabric motifs are sewn with an invisible hand stitch. Layer the quilt top, batting, and backing. Baste and quilt the layers. STARS ALL AROUND has hand quilted motifs in the cream blocks and hand quilting around each Flat Prairie Point. Bind and label your quilt.

QUILT ASSEMBLY

WINDMILLS

Quilt size: 26" x 26"

Finished block size: 11"

Fabric	Yards	Cutting
Gold	⅜	8 A squares 6⅜", cut in half diagonally
Light blue print	⅜	8 A squares 6⅜", cut in half diagonally
Light brown print	1 fat quarter	8 B squares 4½" (Lined Triangle Option)
Dark brown print	1 fat quarter	8 B squares 4½" (Lined Triangle Option)
Medium green borders	¼	8 B squares 4½" (Lined Triangle Option) 4 D rectangles 2¾" x 4½" (Lined Rectangle)
Dark green borders	¼	8 B squares 4½" (Lined Triangle Option) 4 F squares 2½" (Folded Square Variation) 4 D rectangles 2¾" x 4½" (Lined Rectangle)
Blue-violet borders	⅜	4 C strips 2½" x 22½"
Blue-violet print borders	6" x 6" scrap	4 E squares 2½"
Batting		30" x 30"
Backing	1	30" x 30"
Binding	⅜	4 strips 2½" x 40"

LINED TRIANGLE OPTION, page 15. Fold all of the B squares with this technique.

LINED RECTANGLE, page 12. Fold all of the D rectangles with this technique. Cut half of the rectangles diagonally from left to right, and the other half diagonally from right to left. This creates mirror-image units.

FOLDED SQUARE VARIATION, page 17. Fold all of the F squares with this technique.

BLOCK ASSEMBLY

– – – folded fabric basting

ASSEMBLY

* *

Use a ¼" seam allowance for piecing.

1. Refer to the block assembly diagram and make four Windmill blocks. Place the brown Lined Triangles (B) ½" away from the intersection of the four gold triangles (A). Center the green Lined Triangles (B) along the long edge of the light blue triangles (A). Note that the folded tips of the Lined Triangles do not touch the seam allowance. This keeps the tips from being down in the seams. Sew the four blocks together as shown.

2. Refer to the quilt assembly diagram and assemble four borders. The Lined Rectangles (D) are placed on each end of the blue-violet strips (C). Sew two of these border strips to the top and bottom of the quilt top. The Folded Squares (F) are placed on the blue-violet squares (E). Sew this unit to each end of the remaining border strips. Sew these strips to the sides of the quilt.

3. Sew the curved edges of the Folded Squares with matching thread. Sew the folded tips of the green Lined Triangles with an invisible hand stitch, and the edges of the brown Lined Triangles with matching thread. Layer the quilt top, batting, and backing. Baste and quilt the layers, then bind and label your quilt.

QUILT ASSEMBLY

FOLDING

MATERIALS

Yardage is based on 40"-wide fabric.

Fabric	Yards	Cutting
Dark blue print	½	4 A squares 3" 16 D rectangles 3" x 5½"
Dark red print	½	4 A squares 3" 16 B rectangles 3" x 5½"
Red-navy print borders	1 fat quarter	1 A square 3" 4 B rectangles 3" x 5½" 4 A squares 3"
Beige	1½	36 C squares 5½" 36 E rectangles 3" x 4" (Pointed Tab)
Medium blue print	¾	20 D squares 5½" (Folded Square Kite)
Light red-blue print	¾	16 D squares 5½" (Folded Square Kite)
Dark navy sashing borders	⅞	6 strips 1¼" x 13" 2 strips 1¼" x 39½" 4 strips 3" x 39½"
Batting		48" x 48"
Backing	3	48" x 48"
Binding	½	6 strips 2½" x 40"

FOLDED SQUARE KITE, page 17. Fold all of the D squares with this technique.

POINTED TAB, page 11. Fold all of the E rectangles with this technique.

are sewn in the seams of the beige squares (C). The Pointed Tabs (E) are sewn in the seams of the 3 x 5½" rectangles (B).

2. Refer to the quilt assembly diagram and arrange three rows of three blocks as shown. Join the blocks with the 13" sashing strips, then the three rows of blocks with the 39½" sashing strips.

3. Sew the top and bottom borders to the quilt top. Sew an A piece to each end of the side borders. Sew the side borders to the quilt.

4. Top stitch the edges of the folded fabric with invisible thread. Layer the quilt top, batting, and backing. Baste and quilt the layers. In FOURTH OF JULY, the tips of the Pointed Tabs were sewn in place while quilting the stars in the ditch. Bind and label your quilt.

BLOCK ASSEMBLY

– – – folded fabric basting

QUILT ASSEMBLY

COUNTRY CHARM

Quilt size: 51" x 51"

Finished block size: 10"

Fabric	Yards	Cutting
Cream	⅞	
Block 1		10 A squares 5⅞", cut in half diagonally
Block 2		8 A squares 5⅞", cut in half diagonally
Light beige print	⅝	
Block 1		10 A squares 5⅞", cut in half diagonally
Block 2		8 A squares 5⅞", cut in half diagonally
Light beige floral	1 fat quarter	
borders		8 strips 1½" x 10½"
Green	¼	
Block 1		20 B squares 2½" (Folded Square)
borders		2 strips 1½" x 30½" for top and bottom
		2 strips 1½" x 32½" for sides
Medium brown #1	⅜	
Block 1		20 E squares 3" (Folded Square)
borders		4 strips 1½" x 10½"
Medium brown #2	⅜	
Block 2		16 E squares 3" (Folded Square)
Dark brown print #1	⅜	
Block 1		20 C squares 3½" (Prairie Point)
Dark brown print #2	⅜	
Block 2		16 C squares 3½" (Prairie Point)
Dark red #1	½	
Block 1		20 D squares 4" (Prairie Point)
Dark red #2	½	
Block 2		16 D squares 4" (Prairie Point)
borders		4 squares 1½"
		4 rectangles 1½" x 2½"
Batting		38" x 38"
Backing	1¼	38" x 38"
Binding	⅜	4 strips 2½" x 40"

FOLDED SQUARE, page 16. Fold all of the B and E squares with this technique.

PRAIRIE POINT, page 10. Fold all of the C and D squares with this technique. The C pieces are placed under the E pieces in the blocks.

BLOCK 1 ASSEMBLY

BLOCK 2 ASSEMBLY

– – – folded fabric basting

ASSEMBLY

Use a ¼" seam allowance for piecing.

1. Refer to the block assembly diagrams and make five of Block 1 and four of Block 2.

2. In this quilt, the tips of the Prairie Points are sewn on the blocks with an invisible hand stitch. The folded edges of the E pieces are top stitched with matching thread to hold the C pieces in place.

3. Refer to the quilt assembly diagram and sew three rows of three blocks together. Sew the green borders to the top and bottom of the quilt top, then to the sides.

4. Construct the outer borders by sewing a medium brown #1 border strip between two light beige floral border strips. Make four borders. Sew a red 1½" square on each end of two of the borders. Sew these borders to the top and bottom of the quilt. On the remaining two borders, sew a red 1½" x 2½" rectangle on each side. Sew these border to the sides of the quilt.

5. Layer the quilt top, batting, and backing. Baste and quilt the layers, then bind and label your quilt.

QUILT ASSEMBLY

The quilt photographed includes several shades of green and peach. The directions have been simplified to group the greens, peaches, and lilacs as light fabrics.

Quilt size: 55" x 55"

Finished block size: 10"

FOLDING

PRAIRIE POINT, page 10. Fold all of the B and H squares with this technique.

FOLDED SQUARE VARIATION, page 17. Fold all of the D and F squares with this technique.

FOLDED SQUARE, page 16. Fold all of the I squares with this technique.

MATERIALS

Yardage is based on 40"-wide fabric. For a scrap look, several different light, medium, and dark fabrics can be used in this quilt.

Fabric	Yards	Cutting
Assorted lights	1	8 A squares 5⅞", cut in half diagonally
		8 C squares 5½"
		12 E squares 3"
borders		6 G strips 3" x 10½"
Assorted mediums	1	16 B squares 4½" (Prairie Point)
		8 C squares 5½"
		4 E squares 3"
borders		6 G strips 3" x 10½"
		4 E squares 3"
Assorted darks	⅜	8 A squares 5⅞", cut in half diagonally
Bright print	1	16 D squares 5½"
		(Folded Square Variation)
		8 F squares 3" (Folded Square Variation)
borders		20 H squares 3½" (Prairie Point)
		4 I squares 3" (Folded Square)
Large, black rickrack	6⅛	
Batting		39" x 39"
Backing	1¼	39" x 39"
Binding	½	5 strips 2½" x 40"

ASSEMBLY

Use a ¼" seam allowance for piecing.

1. Refer to the block assembly diagrams, page 43, and make four corner blocks, four side blocks, and one center block.

2. Refer to the quilt assembly diagram and arrange three rows of three blocks as shown. Sew the rows together.

CORNER BLOCK ASSEMBLY SIDE BLOCK ASSEMBLY CENTER BLOCK ASSEMBLY

– – – folded fabric basting

3. Construct the borders by sewing three 3" x 10½" strips (G) together for each side of the quilt. Center five Prairie Points (H) along each pieced strip and baste them along the edge of the quilt. They will be sewn in place when the binding is added. Sew two of these borders to the sides of the quilt.

4. Baste a Folded Square (I) to a medium 3" square (E) to form a corner unit. Make four units. Refer to the quilt assembly diagram and sew a corner unit to each end of the remaining borders. Sew these borders to the top and bottom of the quilt.

5. Place the rickrack under the Prairie Points and Folded Squares. Sew these pieces to the background of the quilt along the folded edges of the fabric. Sew the Folded Squares along the curved edges with matching or invisible thread. Layer the quilt top, batting, and backing. Baste and quilt the layers, then bind and label your quilt.

QUILT ASSEMBLY

NOVA

Quilt size: 40" x 40"

Finished block size: 12"

Fabric	Yards	Cutting
Cream	¼	8 A templates
Light brown	1¼	32 A templates 18 C squares 4⅜", cut in half diagonally
Medium brown	1	32 A templates
Dark brown borders	¾	32 B rectangles 3" x 5½" (Lined Rectangle Variation) 4 D rectangles 3½" x 5½" (Lined Rectangle Variation, Option) 2 strips 2½" x 36½" for sides 2 strips 2½" x 40½" for top and bottom
Red borders	¾	32 B rectangles 3" x 5½" (Lined Rectangle Variation) 4 D rectangles 3½" x 5½" (Lined Rectangle Variation, Option) 4 E squares 2½" (Folded Square)
Batting		44" x 44"
Backing	1¾	44" x 44"
Binding	½	5 strips 2½" x 40"

LINED RECTANGLE VARIATION, page 13. Fold all of the B rectangles with this technique. Cut the rectangles diagonally as shown in step 2 of the technique on page 13.

LINED RECTANGLE VARIATION (OPTION), page 13. Fold all of the D rectangles with this technique. Cut the rectangles diagonally as shown above. Fold the tip of the triangles back after they have been sewn in the block.

FOLDED SQUARE, page 16. Fold all of the E squares with this technique.

BLOCK 1 ASSEMBLY

– – – folded fabric basting

BLOCK 2 ASSEMBLY

ASSEMBLY

Use a ¼" seam allowance for piecing.

1. Refer to the block assembly diagram and make eight of Block 1, varying the colors of the pieces as shown in the quilt photograph, page 11. The B pieces are placed about 1¼" away from the intersection of the A pieces when sewn in the blocks. Make one of Block 2 containing the D pieces, which are placed about 1⅛" away from the intersection of the A pieces.

2. Refer to the quilt assembly diagram and arrange three rows of three blocks. Sew the blocks and rows together.

3. Add the borders to the sides of the quilt, then to the top and bottom. Sew a Folded Square (E) to each corner of the quilt.

4. Sew the tips of the folded fabric in place with an invisible hand stitch. Layer the quilt top, batting, and backing. Baste and quilt the layers, then bind and label your quilt.

QUILT ASSEMBLY

FOLDING

PRAIRIE POINT, page 10. Fold all of the D and G squares with this technique.

FOLDED SQUARE VARIATION, page 17. Fold all of the E squares with this technique.

LINED QUARTER CIRCLE VARIATION, page 16. Fold all of the H pieces with this technique.

MATERIALS

Yardage is based on 40"-wide fabric. For a scrap look, several different blue and black fabrics were used in this quilt. Templates are on pages 61 and 62.

Fabric	Yards	Cutting
Assorted black prints	1	18 A squares 2⅞", cut in half diagonally 36 C and 36 Cr templates 24 G squares 3" (Prairie Point)
Light blue	½	18 A squares 2⅞", cut in half diagonally 16 F squares 4½"
Assorted medium blue	¾	72 B squares 2" (Prairie Point) 36 E squares 3" (Folded Square Variation) 4 H templates (Lined Quarter Circle Variation)
Gold	½	36 B squares 2" (Prairie Point) 4 H templates (Lined Quarter Circle Variation)
Beige	1	36 D templates 20 F squares 4½"
Black borders	¼	2 strips 1½" x 36½" for top and bottom 2 strips 1½" x 38½" for sides
Batting		42" x 42"
Backing	1½	42" x 42"
Binding	½	5 strips 2½" x 40"

CORNER BLOCK ASSEMBLY

SIDE BLOCK ASSEMBLY

CENTER BLOCK ASSEMBLY

– – – folded fabric basting

ASSEMBLY

Use a ¼" seam allowance for piecing

1. Refer to the block assembly diagrams and make four corner blocks, four side blocks, and one center block.

2. Refer to the quilt assembly diagram and arrange three rows of three blocks as shown. Sew the rows together.

3. Sew the top and bottom borders to the quilt, then sew the side borders.

4. Sew the tips of the Prairie Points in place with an invisible hand stitch. Sew the folded edges of the Lined Circles and Folded Squares with matching thread. Layer the quilt top, batting, and backing. Baste and quilt the layers, then bind and label your quilt.

QUILT ASSEMBLY

INTERSECTIONS

Quilt size: 33" x 33"

Finished block size: 9"

Fabric	Yards	Cutting
Gold print	1⅛	9 A squares 3½" *36 C squares 3½" (Folded Bias Square)
Light gold borders	1	36 A squares 3½" 40 A squares 3½"
Green borders	1	*20 C squares 3½" (Folded Bias Square) 5 D templates *36 C squares 3½" (Folded Bias Square) 4 E squares 3½" (Folded Square Variation)
Red	⅞	*16 C squares 3½" (Folded Bias Square) 4 D templates (Lined Quarter Circle)
Cream	1 fat quarter	36 B rectangles 1¾" x 3½"
Lining	⅛ yard of scraps	9 D templates (Lined Quarter Circle)
Batting		37" x 37"
Backing	1⅛	37" x 37"
Binding	½	4 strips 2½" x 40"

* Cut squares on the bias.

ASSEMBLY

• •

Use a ¼" seam allowance for piecing

1 Refer to the block assembly diagram to make nine blocks, vary-
 ing the colors of the pieces as shown in the quilt photograph,

technique. Do not press the curve until you construct a block.

LINED QUARTER CIRCLE, page 15. Fold all of the D pieces with this technique. To reduce fabric bulk, cut the lining away ⅜" from the seam after pressing the quarter circle.

FOLDED SQUARE VARIATION, page 17. Fold all of the E squares with this technique.

BLOCK ASSEMBLY

– – – folded fabric basting

page 50. Before sewing the D and C pieces together press the B piece in half lengthwise. The B piece is smaller than a full background in order to reduce fabric bulk in the block. Unfold this piece and place the folded edges of the C pieces on the pressed line. Baste the outer edges of the C pieces to the D pieces. Sew the blocks together.

2. Fold the Bias Squares (C) to create a curve and top stitch the curve with invisible thread. Top stitch the curves of the Lined Circles (D) as well.

3. Refer to the quilt assembly diagram and arrange three rows of three blocks. Sew the blocks and rows together.

4. To construct the borders, sew a Folded Bias Square (C) to a 3½" gold square (A). Sew nine of these units together for a border. Make four borders. Sew two of the borders to the sides of the quilt.

5. Sew a Folded Square (E) to a 3½" gold square (A) to make a corner unit. Make four units. Sew a unit on each side of the remaining two borders. Sew the borders to the top and bottom of the quilt.

6. Layer the quilt top, batting, and backing. Baste and quilt the layers, then bind and label your quilt.

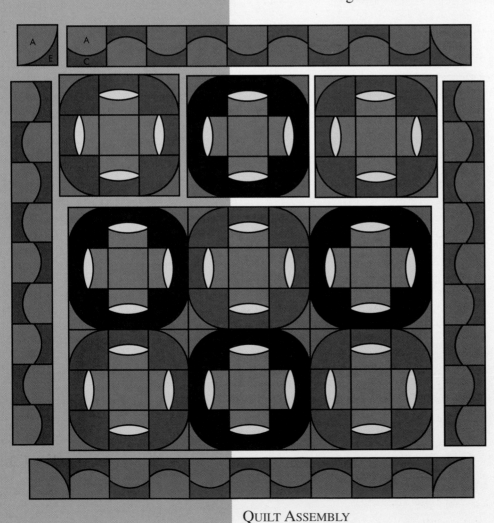

QUILT ASSEMBLY

LINE

1. Cut a 4½" square of fabric. Fold the square, wrong sides together, on the diagonal.

seam

¾"

excess triangle

2. Sew ¾" away from the folded edge. Trim the seam to ¼" on the pointed side of the triangle. Press the piece with the fold flat so the seam is in the center.

3. This piece will fit on the diagonal of a 4½" block.

LINED TRIANGLE VARIATION

1. Cut two 4½" squares, each from a different fabric. Place the squares right sides together and sew around the outside with a ¼" seam allowance.

2. Cut the square in half as shown. Trim the seam allowance to ⅛".

3. Place the squares right sides together and sew around the edges with a ¼" seam allowance. Trim the allowance to ⅛".

raw edge

3. Turn the resulting rectangles right side out. Press. Fold two corners of the rectangle as shown and press.

WINDOW SQUARE

1. Cut two 4½" squares, each from a different fabric. Make a small cut in the fabric that will be the window frame of the motif rather than the center. This cut should be in the middle of the square as shown.

4. Turn the square right side out through the cut and press. Place the square right side up and mark the center with a pin. The square with a cut should be on the bottom.

5. Fold each corner of the square to the center pin and press.

6. Fold the tip of each corner back on itself to the edge of the square so the bottom fabric shows. When securing

TRIANGLE ON A

1. Cut two 4" squares, each from a different fabric. Place the squares right sides together and sew around two sequential edges with a ¼" seam allowance. Trim the seam allowance to ⅛".

2. Turn the square right side out and press. Fold the tip of the square as shown and press.

3. Place the motif in a block so the raw edges will be in the seam.

1 Cut a 2" x 4½" rectangle of fabric. Fold two corners of the rectangle to the wrong side of the fabric as shown and press.

raw edge

raw edge

2. The resulting shape is a parallelogram. The folded side is placed down and the raw edges are placed in the seams of a block.

GALLERY

As you have tried some or all of the techniques and projects in this book, you have most likely realized the potential for applying these folding strategies to your own quilt ideas. This section features more possibilities for the folded motif. Techniques are listed with the photos to show their numerous applications in block designs.

Spring colors are found in this group of blocks. The green print half oval shapes are Lined Circles, page 15 (substitute an oval for the circle in the technique). The blue print triangles are the same technique with a diamond shape substituted for the circle. At the center of each block are two Folded Square Variations, page 17.

This block requires no curved piecing. The half and quarter circles are created with the Lined Circle, page 15.

These two ideas for using folded shapes on border sections are by Pat Hill of West Hills, California. Both designs use the Lined Rectangle Variation, page 13. On the top version, she folded the tip of the rectangle into the seam and an entirely new shape was created.

This striking block was designed and made by Pat Hill. She used the Lined Triangle Option, page 15, for the fuchsia and purple triangles. She chose to catch the tip of the triangles in the seam.

Pat Hill also created this block, featuring a lovely floral fabric. On a square of the floral fabric, she placed a Lined Rectangle, page 12 (substitute a square for the rectangle in the technique), in each corner. The lining was pressed to the front in each corner.

My daughter, Susan Marsh, of West Allis, Wisconsin, designed these sailboat blocks, which are a wonderful idea for a child's quilt. The blue base of the boat is a Lined Circle, page 15 (substitute an oval for the circle in the technique). The sails of the boat are the Lined Rectangle Variation, page 13. Each rectangle is a different size to provide variety.

Susan Marsh also designed these butterflies. The Lined Rectangle Variation, page 13, was used for the wings. The antennae were satin stitched on the background of the block.

This colorful set of flowers is made of reproduction fabrics from the 1930s. The flowers are Lined Triangles, page 13. A button is sewn in the center of the flower shape. The stylized leaves are Parallelograms, page 55.

Pat Hill made this Puzzle Box block from reproduction fabrics. She used quarter Lined Circles, page 15, for the solid green, yellow, rose, and blue units in the corners of the print blocks.

11 (substitute a rectangle for the square in the technique), and green and red print Lined Rectangles, page 12, are also used. The top right block has red Tabs and light green print Folded Squares, page 16. The bottom left block has beige Tabs and Lined Circles, page 15 (substitute an oval for the circle in the technique). The bottom right block features red and green Tabs and Triangle on a Square, page 55, in the corner. In this case, the tip of the square was not folded back.

These soft spring colors make a beautiful four-block grouping. The light green and lilac squares are Lined Squares, page 11. They are added after the blocks have been pieced. The peach triangles at the corners are Folded Squares, page 16. The rose and blue print triangles with the tips folded back are Lined Triangle Options, page 15.

Christmas colors are used in this four-block grouping, which features a hidden star in the beige background. The red elements are Folded Square Kites, page 17, and the beige motifs in the center are Lined Triangles, page 13. The use of narrow sashing reduces the fabric bulk at seam intersections and is an important element in the total design of this grouping.

Sampler block designs can be effectively sewn with the techniques described in this book. The top left block features rust print Pointed Tabs, page 11 (substitute a rectangle for the square in the technique), and lilac Parallelograms, page 55, with a center Lined Square, page 11. The top right block features a strip-pieced Folded Square Kite, page 17, of rust and gold print. The lilac shape is a Flat Prairie Point, page 10. The bottom left block features lilac Lined Squares and purple and print Pointed Tabs along the edges. The bottom right block has lilac and purple print Folded Square Kites, as well as a Line, page 53, sewn on the diagonal of each square.

The traditional Log Cabin block is given a new look with the green and yellow Pointed Tabs, page 11 (substitute a rectangle for the square in the technique). The green/rose print triangles are Folded Squares, page 16.

This four-block grouping features a wonderful assortment of bright, wild colors. The smaller print triangles are Prairie Points, page 10, and the black and white stripe triangles and yellow triangles are Folded Squares, page 16. Although this design looks complex, it is easy to complete.

6" circle

4" circle

Use the 4" circle for the Lined Circle technique, page 15, in the Practice Folding section. Use the 6" circle for the H patch in SOPHISTICATED STARS, page 47, and for the D patch in INTERSECTIONS, page 50.

The circles have an ⅛" seam allowance.

A

NOVA

C & Cr

SOPHISTICATED
STARS

D

SOPHISTICATED
STARS

Joyce Mori learned to quilt from her mother around age 10, using cardboard templates and doing hand piecing. She made her first full-size quilt, a Grandmother's Flower Garden, as a teenager. When Joyce had a daughter, she left her profession to be a full-time mother. When her daughter began school, Joyce needed something to help fill her time. It seemed natural to her to combine her interest in quilting with her doctorate in Native American technologies.

Joyce received a National Quilting Association grant to study the use of Native American designs by quilters. This study directly led to Joyce writing five books. She has now written over a dozen books and 70 articles on quilting subjects.

Quilting appeals to Joyce for the aspects of encouraging creativity, playing with color combinations, learning new techniques, observing all the wonderful quilts made by quilters, and enjoying non-harmful sensory overload. However, learning is the major factor that has kept her quilting for so long.

Joyce says there are always new techniques to learn and new patterns to try. With the new knowledge comes the chance to apply that to Joyce's own style and designs. She says quilting does not have to be boring or repetitive because there are so many facets of the hobby to explore.

OTHER AQS BOOKS

This is only a small selection of the books available from the American Quilter's Society. AQS books are known worldwide for timely topics, clear writing, beautiful color photos, and accurate illustrations and patterns. The following books are available from your local bookseller, quilt shop, or public library.

#6296 us$25.95

#6212 us$25.95

#6210 us$24.95

#6293 us$24.95

#6213 us$24.95

#6076 us$21.95

#6074 us$21.95

#5755 us$21.95

#6079 us$21.95

LOOK for these books nationally, CALL or VISIT our website at www.AQSquilt.com

1-800-626-5420

Creative
Beginnings
in Machine Embroidery
INNOVATIVE IDEAS FOR EXPERT RESULTS

Patty Albin

C&T PUBLISHING

Text © 2006 Patty Albin

Artwork © 2006 C&T Publishing, Inc.

Publisher: Amy Marson

Editorial Director: Gailen Runge

Acquisitions Editor: Jan Grigsby

Editor: Lynn Koolish

Technical Editors: Carolyn Aune, Wendy Mathson

Copyeditor/Proofreader: Wordfirm, Inc.

Cover Designer: Christina D. Jarumay

Design Director/Book Designer: Christina D. Jarumay

Illustrator: Kirstie L. Peterson

Production Assistant: Matt Allen

Photography: Luke Mulks

Published by C&T Publishing, Inc., P.O. Box 1456, Lafayette, CA 94549

Attention Teachers: C&T Publishing, Inc., encourages you to use
this book as a text for teaching. Contact us at 800-284-1114 or
www.ctpub.com for more information about the C&T Teachers Program.

We take great care to ensure that the information included in our books
is accurate and presented in good faith, but no warranty is provided nor
results guaranteed. Having no control over the choices of materials or
procedures used, neither the author nor C&T Publishing, Inc., shall have
any liability to any person or entity with respect to any loss or damage
caused directly or indirectly by the information contained in this book.
For your convenience, we post an up-to-date listing of corrections on
our website (www.ctpub.com). If a correction is not already noted,
please contact our customer service department at ctinfo@ctpub.com or
at P.O. Box 1456, Lafayette, CA 94549.

Trademark (™) and registered trademark (®) names are used through-
out this book. Rather than use the symbols with every occurrence of a
trademark or registered trademark name, we are using the names only in
the editorial fashion and to the benefit of the owner, with no intention
of infringement.

Library of Congress Cataloging-in-Publication Data

Albin, Patty

 Creative beginnings in machine embroidery : innovative ideas for
expert results / Patty Albin.

 p. cm.

 Includes index.

 ISBN-13: 978-1-57120-327-4 (paper trade)

 ISBN-10: 1-57120-327-3 (paper trade)

 1. Embroidery, Machine. I. Title.

 TT772.A42 2006

 677'.77--dc22

 2005025328

Printed in China

10 9 8 7 6 5 4 3 2 1

DEDICATION

This book is dedicated to my husband, Chuck.

I am eternally grateful for your constant

support and encouragement of my dreams.

You are the guiding light that enriches my life.

You are my best friend,

my life's companion, my hero.

ACKNOWLEDGMENTS

My daughter, Lindsey—You are the constant joy in my
life. I love you with all my heart.

Faun Lee—you are always there when I need you. I just
realized another book is finished! That means another
road trip and more margaritas! Yee-ha!

Without the support of many people, this book would
not have been possible:

Mom and Dad—Betty and Mike Barnisin—thank you
for giving me wings.

Everyone at C&T—you are a joy to work with and
you all make me look *so* good.

Terry Smith and Viking Distributing Company—thank you.

Gwen Woodard—you worked tirelessly and always with-
out complaint to help with the samples and embroideries.

Thank you to everyone who allowed me to use their
quilts for photography—especially after I called at the
last minute.

Karen Hinrichs—thanks for answering my technical
questions and offering creative energy—you did a great
job digitizing the title!

Sue Hausmann—thank you for all your support.

Contents

INTRODUCTION

Embroidery; im-'brói-dar-ē· noun a decorative design made with hand or machine needlework
Embroider; im-'broi-dar· the process by which the decorative design is made, either by hand or machine needlework

Congratulations! You own an embroidery machine. Now what?

Well, you finally did it! You now own an embroidery machine and are very excited about the creative possibilities. Don't know where to start? This book will show you the basics of using your embroidery machine so you understand how it works and what you can do with it.

And even if you've been embroidering for a while, I'll bet there are techniques in this book that will be new to you and that you'll be able to put to good use. In addition to learning how embroidery machines work, you'll also read about and have a chance to practice useful techniques with some of the most commonly used tools and supplies. You'll learn how to start and finish your embroideries, and you'll see lots of examples of what you can do with embroideries to incorporate them into a variety of items, including quilts, home décor items, garments, accessories, and more.

Although most embroidery machines work in a similar manner, each machine is a little different, so this book will not tell you how to use your specific brand of machine (that's what your machine instruction manual is for), but rather how to understand embroidery machines in general so you can experience success.

Copyright

The issue of copyrights often comes up in a discussion of embroidery (and if it doesn't, it should). So, before we get started, there are a few things you need to know.

When you use embroidery designs that have been created by someone else—regardless of whether they are designs you purchased, designs that came with your embroidery machine, or designs that are built into your machine— you have purchased the license to use these designs. They are for your use only.

- You cannot copy the designs and give them to your friends.

- You cannot use designs that a friend copied and gave to you.

- You cannot borrow and use the designs purchased by someone else, even if you are using the original card or CD.

- You cannot sell items using the purchased designs unless the packaging specifically indicates that this is allowed.

Even if you alter a design, if you didn't create it in the first place, it's protected by copyright. You wouldn't want someone copying *your* work, would you?

Getting Started

As I travel and teach around the country, the most common comment I hear from embroidery machine owners is that they are afraid they will break their machine. You do need to treat your machine with respect, but unless you do something drastic to it, you won't break it. Rest assured that you have nothing to be afraid of.

To get your creative juices flowing, there are two galleries in this book. The first is to give you inspiration about how you can creatively use embroideries. The second gallery shows what you can do when you become more comfortable with your machine and software to manipulate designs.

In between, each chapter has basic information you need to know about machine embroidery. You'll also find helpful tips (Patty's Pointers), to do lists to prepare you for embroidery, and exercises to learn specific skills. By the end of the book, you'll be familiar with your embroidery machine and the materials used for machine embroidery.

At the back of the book is a list of resources to help you locate items mentioned in the book if you can't find them locally.

So, take a look, get inspired, and set up your machine so you can begin your creative journey.

Baltimore In Blue, 62″ × 80″, made by Betty Barnes, quilted by Z.J. Humback, embroidery designs from *The Golden Age of Baltimore (1st, 2nd, and 3rd ed.)* by Bob Decker

■ Betty had a stack of fabric that she really liked and decided to stitch out designs to match the colors of the fabric. This fabric worked well with the designs and resulted in a fun and beautiful quilt. Don't be afraid to buck convention and choose your own colors. Matching embroidery colors to fabric you like ensures that the colors you use will look wonderful.

Trip to the Orient, 13″ × 16″, made by Gwen Woodard, embroidery design from *Exotic Garden* by Husqvarna Viking/Inspira

■ During some inclement weather in Kenai, Alaska, Gwen created this miniature Trip Around the World quilt top. It sat on a shelf as an unfinished quilt top for over a decade. Recently, she got the idea to use her embroidery machine to add the embroidery on top of the pieced patches. She gave this quilt top new life, and now it's finished. Think of all the ways you can combine embroidery and piecing.

Chicken Strips, 49″ × 58″, made by Betty Barnes, quilted by Christina Fairley, embroidery designs from *French Hens* by Amazing Designs (discontinued), quilt design based on *Chicken Print* from *Folk Art Quilts* by Christina Meynink, published by Quilters Mountain (formerly Chitra Publications)

■ Some quilts are made because they are just plain fun, and this is one of those quilts. The combination of funny-looking chickens and chicken wire fabric make it fun and whimsical. You don't always need a reason or an occasion to make a quilt — you can make one just because it's fun. And remember to include fun-looking embroideries too!

Black and White and Red All Over, 41″ × 41″, made by Betty Barnes, embroidery designs by Husqvarna Viking

■ About ten years ago there was a revival of redwork hand-embroidery designs, but at the time no commercial redwork machine-embroidery designs were available. Undaunted, Betty found some designs that had a final color of black, which was used as the outline of the design. She color-stepped (see page 45) through the design and didn't stitch any of the colors *until* she got to the last color, which was the outline that she stitched in red. When looking at embroidery designs, remember that you can use just the parts you want.

Fan Flair, 28″ × 28″, made by Patty Albin, embroidery design from the book *Machine Embroidery Makes the Quilt* by Patty Albin

■ After seeing a photo of an antique Drunkard's Path quilt in a magazine, I realized that I could make the curved portion of the block by using the *Quarter Doily* design from my first book. I stitched out the doilies using 100% cotton thread on a water-soluble stabilizer. After rinsing the stabilizer away, I sewed the doilies onto the fabric squares and assembled the quilt. No curved piecing in this quilt, machine embroideries to the rescue!

Mini Fan Flair, 13½″ × 13½″, made by Patty Albin embroidery design from the book *Machine Embroidery Makes the Quilt* by Patty Albin

■ This quilt was based on the larger quilt *Fan Flair* and was created as a color alternative. The same embroideries on different fabrics with different block placements gave the quilt a completely different feel. I have fun experimenting.

Curly Vanilla, 13˝ x 18˝, made by Terry White, embroidery designs from *Art Nouveau*, designed by Terry White for Husqvarna Viking

■ To make this creative quilt, Terry cut a piece of old hand-embroidered linen into segments. After fusing cotton fabrics to it and adding a variety of stitches, she had something really special, but it still needed that extra bit of pizzazz. She added an embroidered leaf and buttons and beads. Combining antique handwork with today's high-tech sewing machines marries the creative spirit of yesterday's sewer with that of today's quilter. Don't be afraid to combine the traditional and contemporary in your next quilt.

Vintage Alphabet, 30˝ x 33˝, embroideries stitched by Ellen Banry, quilt assembled by Gwen Woodard, quilted by Patty Albin, embroidery designs from *Vintage Alphabet* and *Italian Romance* by Husqvarna Viking

■ Choosing the thread colors for this quilt was fun since we were trying to achieve a romantic look; we selected soft colors that matched the binding fabric. The stripe in the border is actually a very long embroidery that was stitched over and over again, then assembled with mitered corners. This is an example of a quilt that uses embroideries as the quilt blocks.

■ Linda combined her embroidery with her love of painting on fabric to create this wonderful quilt. She used designs and painting techniques from her DVD, and embellished the machine embroidery with inks. She even used the embroidery design as the quilting pattern. Look at your machine embroidery designs to see if you might be able to add the dimension of painting to your embroidery projects.

■ This quilt was made using a variety of techniques from various sources. The posy embroidery design and the fabric painting techniques are from Linda Visnaw's DVD. I have also become a fan of beading and thread painting, and when I saw Terry White's DVDs *Beading by Machine* and *Designing By Thread. The Basics,* I knew I had to incorporate all these fun things into one quilt. Using instructional videos like Linda's and Terry's can make creative embellishing easy!

Playful Posy, 14″ × 12″, made by Patty Albin, designs from the DVD *Threads and Inks Together— Creating Synergy by Linda Visnaw*

■ Like *Tumbling Buds* by Linda Visnaw (above), I used embroidery designs that are just an outline, then painted them using Tsukineko fabric inks. The designs from my first book, *Machine Embroidery Makes the Quilt,* were my starting point. I enlarged the center block and kept the other pieces their original size. After the designs were stitched out and the blocks assembled, I used the fabric inks to embellish the bluework designs. This is an easy technique for embellishing traditional embroideries and is a great way to combine machine embroidery and embellishment in a quilt.

Painted Bluework, 18″ × 12″, made by Patty Albin, embroidery design from the book *Machine Embroidery Makes the Quilt* by Patty Albin

Heirloom Wall Quilt, 10½" × 12½",
made by Cynthia Scott, embroidery
designs from *Janome Flower Collection*
by Janome

■ The inspiration for this little wall quilt came from a greeting card Cynthia received many years ago. She replicated the embossed feel of the card using embroidered trapunto hearts and a rose embroidery. Heirloom and decorative stitches create a windowpane effect that completes the quilt. Don't overlook the embroidery designs that come with your embroidery machine—even simple designs such as this rose, combined with beautiful stitching, can be used to create an elegant quilt.

Beautiful Baltimore, 32" × 32",
made by Patty Albin, embroidery
designs from *Beautiful Baltimore* by
Patty Albin for Husqvarna Viking

■ I used the designs from my embroidery card *Beautiful Baltimore* to create this Baltimore Album-style quilt. Embroidered quilt blocks that resemble their larger, traditional counterparts are created by combining smaller designs within larger wreath designs and bows. You can use many types of machine embroideries to create smaller, embroidered versions of larger quilts. (See pages 39–40 for precision hooping to place swags.)

Mola Nouveau, 14½" x 6¼",
made by Patty Albin, embroidery
design from *Mola Nouveau* by
Laura's Sewing Studio

■ This little quilt combines an original traditional handmade mola on the left with a machine-embroidered mola of a similar design on the right. Handmade molas are beautiful but can be expensive and hard to find. By using machine embroidery, stitching out these designs can be fast and easy while still allowing you to appreciate the traditional design elements in this style of quilt.

Church and Hmong, 16" x 8",
made by Patty Albin, embroidery
designs from *Hmong's the Way* by
Laura's Sewing Studio

■ After purchasing a small Hmong quilt top at a quilt show, I saw that the embroidery card *Hmong's the Way* had a similar design. As I did with *Mola Nouveau* (above), I combined the original handmade quilt top on the left and the machine embroidered design on the right to show that machine embroidery can do a great job of mimicking handwork of this nature. The designs in this collection still have the storytelling elements that are so important in Hmong quilts. Like the design collection *Mola Nouveau*, these designs honor the traditional needlework of these native peoples.

Old World Santas, 46¼″ × 52″, made by Betty Barnes, embroidery designs from *Large Santas of the Old World* by Cactus Punch

■ Betty always wanted to make a quilt using Victorian Santa designs, and she thought this collection was perfect. She decided to follow the exact colors that the guide recommended, and as a result the colors worked beautifully together and all Betty had to do was collect the thread. You can always follow your own instincts when it comes to selecting thread colors, but if a design uses many colors, it might be easier to follow the creator's color suggestions.

The Twelve Days of Christmas, 52″ × 66″, made by Betty Barnes, quilted by Sandi Freuhling, embroidery designs from *The Twelve Days of Christmas Design Pack* by Cactus Punch

■ Betty created a special gift that said "holiday," not "Christmas." When making your own holiday gifts, think about using nontraditional images for a unique gift.

Several different types of embroidery machines are available. The most common are sewing machines with an embroidery unit that you attach. It can be a little awkward, but you can do some regular sewing with the embroidery unit attached. There are also machines that have the embroidery unit built right in, and it becomes available at the touch of a button.

Dedicated embroidery machines are available for home use; however, these machines don't have regular sewing capabilities.

The information in this book is applicable to all these types of embroidery machines. Throughout the book, you'll be using your machine with the embroidery unit attached unless otherwise specified.

Instruction Manual

Sewing machines come with lots of papers these days—instruction manuals, accessory guides, advertising, and more. Sort through everything to find your instruction manual(s) and any other quick-start guides or similar materials. Many machines have a separate manual and instructions for the embroidery unit, so be sure to find those as well.

Keep your machine instruction manual handy.

The Embroidery Unit

Some sewing machines come with the embroidery unit permanently attached; other machines come with an embroidery unit that you attach or plug in to the sewing machine when you want to do embroidery.

Machine with removable embroidery unit

The embroidery arm and clip assembly move the embroidery hoop.

Whether it is built in or attached, the embroidery unit is basically an arm that moves a hoop. The **arm** itself moves back and forth, and a **clip assembly** that holds the hoop moves up and down along the length of the arm. The needle actually stays in the center position and just moves up and down. Once the hoop is attached, the information

from the embroidery design tells the arm how to move the hoop to create the design.

Before you attach or remove the embroidery unit to the machine, check the machine instruction manual to see if you need to turn off the machine first.

Attaching the embroidery unit

Your machine and embroidery unit are pieces of electronic equipment, so you need to handle them carefully. Never hold the embroidery unit by the arm. The success of your design depends on the proper operation of this arm. If your machine has a button you can push to park the arm in the proper position for storage, by all means use it. With some machines, you have to manually position the arm so you can properly put it away. If this is the case with your machine, do so carefully so as not to force or jam the arm. Each machine is different, so be sure to check your machine instruction manual to learn how to attach the embroidery unit to the machine, remove it, and safely put it away.

Hoops

There's a hoop for just about every size of design: small hoops for small designs; mega-size hoops to accommodate long, large designs; and every size in between. Check your machine instruction manual to learn how to attach and remove the hoop from your machine. You'll read more about using the hoops starting on page 36.

Hoops are available in all shapes and sizes for machine embroidery.

Embroidery Feet

Most embroidery machines come with a presser foot designed especially for embroidery. Some feet have an arm or extension that allows them to move up and down with the needle. Check your machine instruction manual to find out which foot to use and how to put it on the machine.

Machine embroidery feet

Feed Dog Drop

The feed dogs are the teeth that move the fabric as you sew. For embroidery, the feed dogs need to be disengaged or in the lowered position. Check your machine instruction manual to find out whether you need to lower the feed dogs or whether the machine does it automatically.

card, memory card, CD, floppy disk, or **USB embroidery stick,** or by transferring designs from your computer using a cable designed specifically for this purpose. You'll need to read your machine instruction manual to find out how to load designs into your machine.

There are many ways to load embroidery designs.

Essential Accessories

Surge Protector

A **surge protector** is an essential accessory for an expensive piece of electronic equipment such as your embroidery machine. During electrical storms, or when the electricity is restored after a blackout or brownout, there is usually a spike in the voltage of electricity passing through the wires. This surge of energy can damage electrical equipment such as TVs, stereos, computers, and *sewing machines.* By using a surge protector for your sewing machine, you protect it.

Surge protectors vary in price and—as with anything else— quality. Look carefully when you go to buy one. Some plug strips may masquerade as surge protectors. Purchase a *good* surge protector to make sure you have something that will

The higher the number of joules, the more severe the surge it can protect against. As a minimum, look for *Surge Protection Performance—Maximum Energy 1,000 Joules,* or something similar. Check your budget and decide how much you can spend on this, and purchase accordingly. Surge protectors range in price from $15 to $50 or more.

Surge protectors are an inexpensive way to protect your expensive embroidery machine from damage.

A plug strip can easily masquerade as a surge protector. The bottom strip in this photo is NOT a surge protector and will not protect your machine from electrical surges.

Battery Backup

I see more and more **battery backups** in classes when I teach. As I talk to the machine owners, I realize they have made a wise choice. The battery backup provides two functions:

- Powerful surge protection

- Continuous electricity to get you to a point where you can safely power down your sewing machine should the power fail

Should the electricity fail while you are embroidering, the battery will kick in and provide power, allowing you to get to a convenient point where you can stop. Some backup units provide up to an hour or longer of power. This can be invaluable if you are in the middle of an embroidery when power is lost.

If having a backup like this is important to you, look at different models, comparing price, battery backup time, and joule surge protection. Just one more piece of insurance for peace of mind. Prices for these backups range anywhere from $50 to over $100.

Battery backups provide temporary power to your embroidery machine so you can continue to embroider until you get to a convenient stopping point.

To do

Get out your machine instruction manual and read through it so you are familiar with all the parts of your machine. In particular be sure to do the following:

- Attach and remove the embroidery unit (do you need to turn the machine off beforehand?).

- Remove the normal sewing foot and attach the embroidery foot.

- If needed, find out how to drop the feed dogs on your machine.

- Check out what size hoops you have. Are there any clips for larger-size hoops? Attach and remove the hoops from the embroidery unit.

- Find out how you load embroidery designs into your machine. What type of disk, stick, or media card does your machine use? Do you have any embroidery designs or alphabets built into your machine?

- Check out surge protectors and battery backups.

I know you've heard a million times about using the right tool for the job, but as in any other pursuit, having the right tools is essential for achieving excellent machine embroidery results.

Scissors

Curved and Double-Curved

Embroidery scissors are absolutely essential when you are embroidering. Although you can use any short-bladed sharp-tipped scissor, there are scissors made especially for machine embroidery. They have a slight curve to the blade so you can get the tip *under* the threads you need to trim. Do yourself a favor and invest in a good pair—and then hide them from everyone. To the untrained eye, some curved scissors look just like fingernail scissors.

The slight curve of machine embroidery scissors makes snipping threads easy.

Double-curved scissors are designed specifically for cutting threads, or anything else, in an embroidery hoop. The curve on the handle helps get the blades over the height of the machine embroidery hoop while keeping the tips of the scissors level with the fabric.

Double-curved scissors make it easy to snip threads while the embroidery is still in a hoop.

Snips

Snips are made for cutting threads. The blades are small and short, and when it comes to cutting threads—and only threads—snips are another choice you have in specialty scissors.

Thread snips come in handy for trimming thread.

Appliqué (Duck-Bill) Scissors

You may be familiar with this kind of scissors from traditional appliqué, but don't discount them for appliqué done with machine embroidery. They will help you trim away excess fabric for this special kind of machine embroidery as well.

Duckbill appliqué scissors are great for machine-embroidered appliqué.

Seam Ripper

If you sew, you probably already have a **seam ripper**. Yes, chances are that at least once while stitching embroidery you'll have to remove or un-sew some threads. (I've done it more than I care to admit.) Choose a seam ripper that has a slender point so you can get it under the bobbin threads and easily cut them—then you can give a slight tug on the top thread, and the stitches will be removed. With embroidery, you may have some tiny stitches to remove; this is where you will be thankful you invested in a small seam ripper.

Seam rippers: they aren't just for seams.

Iron

I can't stress enough the importance of a good iron. While the fabric is being embroidered, it sometimes distorts. Even if the embroidery process does not distort the fabric, removing the stabilizer can make the fabric or embroidery appear less than flat. In addition to using the best stabilization and removing that stabilizer carefully, you will need to iron your embroideries when done. A good iron will correct fabric and design distortion but will not scorch the fabric or design thread.

A good iron is invaluable.

Patty's Pointer

I almost always use steam when I press my embroideries. I find that irons with high-temperature steam (usually steam-generator irons) do a better job of pressing than traditional irons do. No matter what type of iron you use, test the iron on a practice embroidery so you know the proper temperature setting for your iron.

completely removable. To make sure that your marks can be removed safely, test it on a piece of scrap fabric or in a hidden place. Remember that heat can set any type of marker, so iron the embroidery only after you have washed out the marks.

Ink Markers

There are two different kinds of temporary ink markers: water-erasable and air-erasable.

Water-erasable means that these marks will disappear only if they are washed with cool, clear water. Use this marker if you are going to mark many pieces of fabric, or if you are going to mark your fabric today and embroider tomorrow or next week or next month. These marks stay until you are ready to remove them.

Many embroiderers like the **air-erasable** markers because the marks disappear within a few hours and your garment or fabric appears to have only the embroidery, no purple placement marks. When you use this type of marker, don't mark on a Friday planning to embroider on Monday, or the marks will be gone. Be careful, though, as the chemicals from this ink are still in the fabric even though the marks have become invisible. This ink should be washed out in a timely manner.

but in time they will disappear with washing and

Bobbins

When machine embroidering, make sure you have plenty of filled **bobbins** on hand. You may need to purchase extra bobbins and fill them with the bobbin thread of your choice (see pages 22–23). There are also prefilled generic bobbins that you can purchase for your machine (see page 23).

To do

Gather up the notions that you plan to use for embroidery.

- Do your scissors need to be replaced or sharpened?

- Do you have a good seam ripper with a narrow point?

- Do you have a good iron? If it produces steam, make sure it doesn't leak or spit.

- Do you have fresh marking tools?

- Do you have plenty of bobbins wound with bobbin thread?

Patty's Pointer

Over the years I have used both water-erasable and air-erasable markers and recommend both. I would suggest a few precautions, though, since I have heard from a few quilters regarding problems that these markers have caused.

- To remove the marks, always rinse in cool, clear water first, and then wash with warmer water and soap if desired. Both soap and warm water may cause the marks to set and be permanent, so be sure the marks are completely removed before using soap or warm water.

- Always start with a fresh pen, using something that you've had in your sewing basket since the dawn of time is not a good idea.

- Always rinse your fabric before ironing it. Never iron your fabric with *any kind* of marker on it or you run the risk of the marks becoming permanent.

Threads, Stabilizers, *and* Needles

Threads

Threads are essential to machine embroidery; they bring your embroidery to life. The color, sparkle, sheen, weight, and so on are what make the same embroidery design appear so different when stitched out in different threads. That is one of the creative aspects of embroidery. Even when a design is preprogrammed, when different people stitch out the same embroidery it will look different due to their different thread choices.

While a discussion of thread choices alone can fill a book, let's look at the most common threads for embroidery. This doesn't mean you can't use whatever thread your heart desires. In fact, I encourage you to do so. But for now, and until you have a few embroideries under your belt, these are the easiest threads to work with.

Embroidery threads are available in a variety of fibers, weights, spool sizes, and colors.

Kathy's Pointer

Most sewing machines have two types of spool pins: horizontal and vertical. There are many opinions about which is better to use. The bottom line is that if you are having a difficult time with a particular thread, here are a few things to do:

1. Make sure you are using the right type and size needle for the thread.

2. Flip the spool over so the thread is coming off the spool from the other side.

3. Switch the orientation of the spool from horizontal to vertical, or from vertical to horizontal.

4. When using slick threads such as monofilament or some metallics, you must use them in a vertical position.

Embroidery Threads

When it comes to thread, size does matter. Most embroidery designs are created to be stitched out with 40-weight rayon thread or a thread of similar size. For thread, the *larger* the number, the *finer* the thread. The *smaller* the number, the *heavier* the thread. So a 60-weight cotton will be finer than a 12-weight cotton. And a 30-weight rayon is heftier than a 40-weight rayon. Thread weight is also affected by the number of plies, or strands of thread, that are twisted together to form the final product. Check the spool or packaging to find the thread size or weight. If you want to learn more about thread and thread sizing, check out the websites of the thread manufacturers listed in Resources on page 62.

Check the spool for the thread size or thread weight.

That being said, keep in mind that a 40-weight *rayon* may not stitch the same way as a 40-weight *cotton*. According to an industry expert, 40-weight is the same thickness whether you are talking cotton or rayon, but because they are different *fibers*, they may look different and stitch differently.

If you use a thread that is finer or thinner than a 40-weight, the stitches in the design may not look as full as when stitched with a thread that is heavier. The result might look okay or it might look sparse. If you use a thread that is larger or thicker, the embroidery may look full or dense, and, depending on the design, it might even look dimensional. However, it may also look too dense and feel too stiff.

12-weight 30-weight

60-weight

These embroideries are all stitched with cotton thread, but the different weights change the look.

project, by all means, stitch on this. Investment of time, thread, and fabric will pay off big in the long run because you won't have any surprises when you stitch out the designs on your project. You'll know that the fabric, stabilizer, needles, and thread are all working together as you intend.

Rayon Thread

Rayon is best suited for decorative uses. It has a sheen to it and is a bit finer (thinner) than traditional quilting threads (50/3 cotton). Rayon is a decorative thread, so it's best not to use it if the embroidery is stitched into something that will endure hard use or will be laundered frequently. A 40-weight rayon is commonly used in embroidery, but other weights are available. Check the spool to make sure you are buying the weight you want.

Cotton Thread

Cotton thread, when stitched out in an embroidery design, can produce an entirely different look than that of rayon. A 60/2 cotton produces a lovely, flat embroidery with a matte finish. A 50/3 or heavier weight cotton can produce a different look altogether. *Fern Flair* and *Mini Fern Flair* on page 7 were stitched using 50/3 cotton thread.

Cotton Rayon

An embroidery stitched with cotton looks different than one stitched with rayon.

Polyester Thread

Polyester is being used more and more in embroideries, and the color selection is growing in leaps and bounds. For hard wear, consider polyester, as it is more colorfast than rayon. Since polyester is a synthetic fiber, you may find that the thread has a bit of stretch to it. Keep this in mind as you are embroidering, as it may cause a problem with stitch quality and thread breakage. A 40-weight polyester thread is similar in thickness to a 40-weight rayon thread but will have a different look.

Patty's Pointer

When I'm stitching an embroidery that will be used in a quilt that has a very traditional look to it, I prefer cotton thread, with its matte finish. I find it is a better choice for traditional quilts and their embroideries. To me, rayon's shiny appearance doesn't suit traditional quilts.

Metallic Thread

Using metallics in embroideries is fun and creates beautiful results. Basically, there are two different kinds of metallic thread. One is a flat, ribbonlike film that is metallicized on both sides. It has a bright, reflective quality and works best in embroideries that have longer stitches. Shorter stitches don't show off the thread's reflective nature and may cause abrasion to the thread.

The other type of metallic thread has a nylon or polyester core with the metallic wrapped around it.

When using metallic thread make sure you use a large needle such as a size 12 or 14 embroidery, top-stitch, or metallic. Reduce the speed on your machine and loosen the upper thread tension. Stitch a test sample with your thread of choice so you can make sure the tension, speed, and needle are all correct for your project.

Patty's Pointer

If you have old thread that you are still using—and by that I mean old—save it or no on wooden spools—get rid of it. Thread made today is of better quality than older thread. Don't cut corners by using cheap thread, because it is just that, cheap thread.

Bobbin Thread

Cotton Thread

A 60-weight cotton thread can be used in the bobbin as well as for machine embroidery. Some brands even print *Embroidery Thread* right on the spool of this weight of thread. It is my first choice for bobbin thread.

Polyester and Nylon Lingerie Thread

Both 60-weight polyester and 70-weight nylon lingerie threads work well in the bobbin and add very little bulk to the embroidery. If you've done many embroideries, you know that winding bobbins can be time consuming. Over time you come to realize that with a thinner thread, such as a 70-weight nylon lingerie thread, more of it can be wound on the bobbin, which translates into fewer bobbin changes.

Patty's Pointer

So, if there are fewer bobbin changes, it sounds like thinner thread (either thread you wind yourself or on pre-wound bobbins) saves you even more time in the long run. Yes, and maybe no. Yes, for all the reasons I previously stated. No, because the thinner thread *sometimes* fools the bobbin thread tension mechanism on *some* machines and stitches out as if there is **no** tension on the bobbin thread. Use thinner thread with this knowledge and always check to see how it reacts in your machine.

different colors. However, be aware that the generic bobbins can be problematic, because they are just that—generic. If you are going to be doing a lot of embroidery, buy a few different types of pre-wound bobbins and try them out before you buy any in a larger quantity. If you do have problems with your machine or aren't happy with the quality of embroidery, the bobbin may be the culprit if you are using pre-wounds.

Generic pre-wound bobbins

you should see about two-thirds top thread and one-third bobbin thread. Threads should not be loose, and should appear secured.

Embroidery with proper tension—notice how the top thread is pulled to the back.

Embroidery with improper tension—notice the loops of thread and how much has been pulled to the back so there is very little bobbin thread visible.

Some machines adjust the top tension automatically; on other machines you need to adjust it manually. If your machine does not have automatic thread tension, you may want to lower the top tension to help ensure that the top thread will be pulled to the back of the fabric and none of the bobbin thread will be seen on top. See your machine instruction manual for suggested tension, but the best way to find out is to do some test embroideries and see what looks best.

If you are using a very lightweight thread for your bobbin, you may need to adjust the bobbin tension as well.

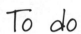

Stabilizers are available in a variety of types and weights.

To do

Gather up all your threads and take stock of what you have.

• Do you have 40-weight rayon thread in a variety of colors?

• Do you have 40-weight polyester thread in a variety of colors?

• Do you have 50/3 or 60/2 cotton thread in a variety of colors?

• Do you have different bobbin threads to try?

• Do you have any specialty threads you'd like to try, such as metallics?

Plan on having a nice assortment on hand to use as you work through the practice exercises later in the book.

Stabilizers

Wow! There are lots of different stabilizers out there, and each one is for a specific purpose. Basically, though, you can divide them into three different categories: tear-away or cut-away, water-soluble, and heat-removable. No, air-removable stabilizers haven't been invented yet, but you can dream, can't you?

Cut-Away Stabilizer

A **cut-away stabilizer** is just that—stabilizer that needs to be cut away because it doesn't tear. This stabilizer can be used for projects in which the stabilizer can be left in without having an adverse effect (shadowing, bulk, and so on) on the finished embroidery. It is available in different weights. Select the weight that is appropriate for your fabric.

Cut-away stabilizers work when you do not have to remove the stabilizer from the finished embroidery.

Tear-Away Stabilizer

For quilters, **tear-away stabilizer** is by far the most common. Use a lightweight stabilizer for lighter-weight fabrics. Heavier fabrics require a heavier type of stabilization, so look for a regular or heavy tear-away. If you have only lightweight tear-away, use two layers for heavier fabrics.

For common quilting broadcloth, such as that found in quilt shops, a layer of regular-weight stabilizer should do the job.

torn away after the embroidery is complete. Use sticky stabilizer when you need an extra level of stabilization. In some cases, you can use iron-on stabilizer instead of a sticky stabilizer (see below).

Sticky Stabilizer

Sticky stabilizer is actually a tear-away stabilizer that has a sticky adhesive side. The sticky side is protected by a smooth paper covering the adhesive. A sticky stabilizer is used when you want to embroider on a fabric or item that you can't or don't want to hoop, such as leather or velvet. Some fabrics when hooped develop hoop burn—marks left after the hoop is removed. These fabrics are perfect candidates for a sticky stabilizer.

To use a sticky stabilizer, hoop the stabilizer with the stabilizer facing down and the paper-covered sticky side up. Use a pin or needle to score the protective paper covering and remove it to expose the sticky side of the stabilizer.

Use a pin or needle to score the protective paper, then peel it away.

Carefully position the item to be embroidered, then press it onto the stabilizer. Now you can embroider without worrying that your fabric will shift in the hoop.

Sticky stabilizer allows you to embroider without clamping your fabric in the hoop.

Spray Adhesive

Spray adhesives for fabric are temporary sprays that disappear from the fabric within a week or so, leaving no stain or residue. To use, hold the can about 8" away from the fabric, and spray lightly. Use some sort of guard to avoid getting the adhesive on the hoop and tabletop. And **never** spray near your embroidery machine or computer.

Be sure to use a product that is designed specifically for use with fabrics. Some spray adhesives designed for general craft use are permanent and can discolor fabric over time.

Using a cardboard frame is an easy way to prevent spray adhesive from getting on the hoop.

A tear-away stabilizer used with a temporary spray adhesive creates a sticky stabilizer.

Water-Soluble Stabilizer

Water-soluble stabilizers can be used underneath the fabric to stabilize embroidery, just like tear-away or sticky stabilizers. The benefit of using water-soluble stabilizer is that you can cut away most of it and then rinse away the rest; you don't have to tear and pick out the little bits of stabilizer like you do with a tear-away. As with tear-away stabilizers, water-soluble stabilizers come in several weights. If you have the lightest-weight stabilizer you may need to use two or three layers, depending on the stabilizer and its thickness.

Water-soluble stabilizer saves time when it comes to removal.

On the rare occasion when you are embroidering on something with a nap—such as a knit, terry cloth, fleece, or the new Minkee Blankie by Benartex—you will need to place a water-soluble stabilizer *on top* of the fabric. This prevents the stitches from sinking into the fabric by compressing the nap or pile of the fabric so the machine will stitch the embroidery as if the fabric were smooth.

Keep in mind that if you are using fabric with a pile or nap, chances are good that it shouldn't be hooped in the hoop at all, but rather pressed on top of a sticky stabilizer. You can place the water-soluble stabilizer on top of the fabric, pin or baste the layers in place, and embroider as usual. You can also use a heat-removable stabilizer (see page 27) for this purpose if your fabric will not be damaged by the heat of the iron.

For nicer embroidery, use a water-soluble stabilizer on top of fabric with a nap to trick the machine into thinking the fabric is smooth. Remember, only use it on fabrics that you can get wet.

in airtight plastic (such as in a large zipper-type plastic bag) so they don't become dry and brittle over time.

Try several different products and see what works best for you.

Liquid Stabilizer

Using a **liquid stabilizer** such as Perfect Sew directly on the fabric to make it stiff prevents the fabric from shifting, and may eliminate the need for additional stabilizer. Use liquid stabilizers only on fabric that can be washed after embroidering to remove the stiffness.

Apply the stabilizer by thoroughly saturating the fabric and allowing it to air dry before pressing it to remove any wrinkles. You can speed the drying process with a hair dryer, but never iron the fabric while it is still wet.

Saturate thoroughly, especially where you plan on placing the embroidery.

or likely to be adversely affected by the heat of the iron.

To remove this type of stabilizer, iron in circular motions to melt the stabilizer into little peppercorn-sized balls that you can brush away.

Applying heat in a circular motion creates residue of stabilizer that you can just brush away or pick off.

To do

Gather up all the stabilizers you have.

• Do you have any sampler packs that you got with your machine or from your sewing machine dealer?

• For all the stabilizers you have, read the manufacturer's instructions and become familiar with each kind.

• If you don't have any stabilizers, or want to try some different ones, purchase a small quantity of several different types and/or brands. Some manufacturers sell samples of all their stabilizers. If you want to try a liquid stabilizer, get a small bottle of Perfect Sew.

• Be sure you have at least two types of stabilizers— a tear-away stabilizer and a water-soluble type.

Needles

At last count, there were well over a dozen different *kinds* of needles for home sewing machines. And those needles come in a variety of different sizes.

When stocking up on needles, keep in mind how important it is to change your needle often. Needles are inexpensive, so be sure to have plenty on hand. A sharp needle will penetrate the fabric and embroidery smoothly. With repeated use, a needle—just like anything sharp, such as your sewing scissors or kitchen knives—gets dull. A dull needle can damage the embroidery threads as it penetrates the design or damage the fabric. Either way, a dull needle is bad news. Change it.

When you are embroidering with a sticky stabilizer or a stabilizer on which you have used a temporary adhesive spray, the needle will eventually develop a buildup of the adhesive material on the shaft. When this happens, you will most likely experience thread breakage since the delivery system along the front of the needle is now obstructed by something sticky. The thread will get caught on this and shred and break.

If the buildup occurs quickly, you can clean the needle by using silicone or a commercially available product called Sewers Aid by Dritz. Place a drop on a piece of scrap fabric or a piece of cotton batting. Rub the fabric along the shaft of the needle until the gum is gone. Don't overdo the liquid, as it may transfer to the embroidery and stain it.

Needle Sizes

Unlike thread, when it comes to needles, the larger the number, the larger (and stronger) the needle. Needle sizes are often written as 75/11 or 90/14.

Needle Sizes	
EUROPEAN	**AMERICAN**
60	8
65	9
70	10
75	11
80	12
90	14
100	16
110	18
120	19

Embroidery Needles

Embroidery needles are created to do exactly what they say they do—embroider. Since embroidery thread is usually fine or made of a fiber such as rayon that might shred, the eye of the embroidery needle is smooth. This helps prevent the thread from breaking or shredding when it passes through the eye to be stitched into the embroidery design.

These needles come in a variety of sizes, from 65/9 to 90/14. I recommend starting with the 75/11, and if you find the needle breaking or the thread shredding, move up to a 90/14. While the embroidery needle is the most common choice for cotton broadcloth, you can also use this needle to embroider on a heavy woven fabric such as a canvas tote bag.

Quilting Needles

A **quilting needle** is designed to easily penetrate many layers of fabric and batting. Although this is a type of needle many quilters use, it is not the best choice for embroidery. You can use a quilting needle if you don't have an embroidery needle, as it is very sharp, but keep in mind that you may encounter problems because it doesn't have a smooth eye like an embroidery needle. It is best to use a quilting needle for the use for which it was intended—quilting. Quilting needles come in two sizes, 75/11 and 90/14.

allows jeans thread to pass through it while you have on a heavy woven fabric. The eye is not smooth, so you may experience some thread shredding. This kind of needle is sometimes used for machine embroidery because the stronger shaft allows the needle to penetrate dense embroideries and embroideries on heavy fabric. These needles come in a range of sizes, from 70/10 to 110/18; be sure to use the smallest size that will work for your project so that the holes made by the needle are not too big.

Microtex or Sharps Needles

Microtex or sharps needles are made for sewing on tightly woven and microfiber fabrics. This type of needle is very sharp, and when the machine takes a stitch the needle will split the thread rather than pushing it to the side the way a universal needle does, so you get a smooth-edge finish to your stitches. These needles are available in sizes 60/8 to 90/14.

A needle with a rounded point pushes the thread aside (Universal).

A very sharp needle splits the thread (Embroidery, Jeans, Sharps).

and synthetic threads.

Universal Needles

Universal needles are made to accommodate all kinds of threads and fabrics. You can use them on wovens, knits, or heavy fabrics. In a pinch, you can use them for embroidery, but for best results on woven fabric, I recommend embroidery or jeans/denim needles. Universal needles are available in sizes ranging from 60/8 to 120/19.

Patty's Pointer

If you find that your thread is shredding or your needles are breaking, one of the first questions to ask yourself is, "What needle do I have in the machine?" Many headaches can be relieved by simply using the right tool for the job at hand. Or, in this instance, the right size and kind of needle for the thread and fabric being used.

To do

Take stock of the needles you have.

- Buy the sizes and types of needles you need or want to try.

- Throw away old needles and those that you can't identify. Unless needles are in a pack, they probably aren't new and should be thrown away.

Needles should generally be thrown away after about 100,000 stitches. You can check your embroidery designs to see how many stitches they contain.

Embroidery Designs

esigns come in all shapes and sizes. You can buy any kind of design that your heart desires. Many designs are available in collections, and for one price you get a whole slew of beautiful things that you can stitch out on your machine. Some companies offer single designs from a collection, which is okay if you really don't want to buy *everything* in that particular collection. You will pay relatively more for the convenience of getting just one design, though. Designs are available from many sources, most commonly from sewing machine stores and through the Internet.

If you buy embroidery designs made just for your brand of machine, you'll get them in the format you need. Otherwise, when you buy embroidery designs you'll need to know what format your machine uses. The format is indicated by a three-letter code, such as hus, pcs, art, and so on. Ask your machine dealer or check your machine instruction manual to find out what format your machine uses. Most embroidery designs come in all the formats needed for most machines.

Patty's Pointer

For my money, I choose to purchase *collections* of designs because the value is better per design. Even though I may not have any intention of using most of the designs right away, having them in my library is comforting because I know they will be there when I finally do need them.

Transferring Designs

There are a number of ways to transfer designs to embroidery machines. You will need to consult your machine instruction manual to find out how to transfer designs to your machine. For the next section, you will need to transfer a few designs to the medium that is specific to your machine. If you have designs built into your machine, you can use them if you like.

Embroidery Design Information

When you load a design into your machine, you may have all the design information displayed on the machine screen. The available information may include thread colors, size of design, and position in the hoop, or it may just display the design number from the card, and it is up to you to know that after it stitches out the first color, the second color is green and the third color is blue. Design information may come printed on the design package, as an insert, or as a PDF file on a CD.

Printed design information

On-screen design information

Embroidery Size

The size of an embroidery design is usually given in millimeters (as are hoop sizes). This information helps you select the appropriate hoop size and embroidery placement. When you use a hoop that is size-appropriate for the design, you won't waste stabilizer.

Match the hoop size to the design size.

Look at the sizes of hoops that came with your machine and any other sizes you may have since purchased. For example, if you own a hoop that is 100mm × 100mm (or about 4 inches × 4 inches), you are limited to stitching out designs measuring 100mm × 100mm or less. The same is true for each different size hoop.

Number of Stitches

The more stitches the design contains, the longer it takes to stitch it out. Lots of stitches also mean lots of thread. Don't be surprised if a design has over 20,000 stitches. Larger designs have more stitches, and with hoops growing ever larger, don't be surprised to see designs over 100,000 stitches!

Thread Colors

Embroidery designs generally include a list of thread colors used in the design so you can make sure you have the right colors of thread. Gather them before you start to stitch out the embroidery and arrange them in the order the embroidery suggests. If you'd rather use different colors, get those ready instead.

Patty's Pointer

If you have a thread holder, or can make one like I did, number the spaces under the spindles to indicate the thread order. You'll always know what color is next for your embroidery.

A piece of scrap wood, some nails, and a felt tip pen keep my thread colors in order. It may not be pretty, but it does the job!

Manipulating a Design

Most embroidery machines allow you to do some easy manipulations of designs. These manipulations not only allow you to position an embroidery the way you want it to appear, they also give you ways to make the embroidery look a little different each time you use it.

There are several ways you can manipulate an embroidery design with your embroidery machine.

Rotating

When you **rotate** a design, you turn the entire design. If you think of a circle, one complete revolution would be 360°. If you take a design and rotate it 90° you've turned it one quarter of the way around the circle; 180° is halfway around the circle, and 270° is three-quarters of the way around. Just think of how the earth *rotates* on its axis.

Patty's Pointer

If you want to embroider a design on the left side of your shirt or jacket, you would hoop it in your hoop like this.

The bulk of the shirt is within the head of the machine and could affect the design by prohibiting the free movement of the hoop.

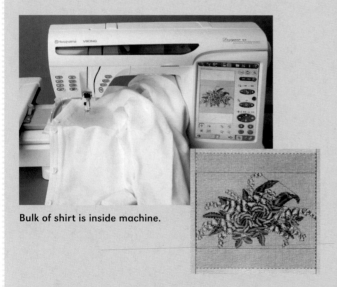

Bulk of shirt is inside machine.

But if the shirt is hooped upside down, the bulk of the shirt is on the *outside* of the machine and allows the hoop to move unhindered.

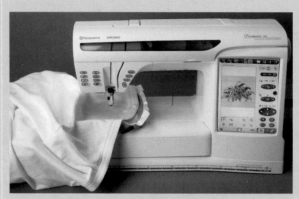

Hoop shirt upside down to place bulk outside machine.

All you have to do now is *rotate* the design 180°. This will allow you to stitch the design in the proper direction and in the position on the shirt that you desire.

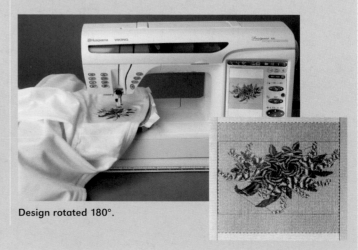

Design rotated 180°.

Rotation is always referred to by degrees in a circle.

Mirror Imaging

A **mirror image** is the reverse of a design; if you look at a design in a mirror it will look backward, or mirror imaged. You can mirror image a design side to side.

EMBROIDERY YЯƎbIOЯ8MƎ

Mirror imaged side to side

You can mirror an image top to bottom

EMBROIDERY
EWBBOIDEBA

Mirror imaged top to bottom

EMBROIDERY
LWBBOIDEBA YЯƎbIOЯ8MƎ

| | |
| Top to bottom | Then side to side |

Mirror imaged top to bottom *and* then side to side

These functions come in handy when you are embroidering a design such as non-directional flowers. They can be mirrored *and* rotated, giving them different orientations for different looks.

Stitch Density

Stitch density is exactly that—how dense, or close, the stitches are within a particular design. Proper stitch density is a sign of a well-digitized embroidery. A design that is very dense may be very stiff when it is stitched out and not nice to touch. If it is not dense enough, it will have

| Light | Medium | Heavy |

Enlarging and Reducing

Embroidery machines allow you to **enlarge** and **reduce** designs. Some machines simply make the design bigger or smaller without changing the number of stitches. Other machines change the number of stitches to maintain the same stitch density. If your machine does not adjust for density, you are generally safe if you enlarge or reduce by up to 20%; any more than that and you will adversely affect the density. If your machine does take density into account when enlarging or reducing, you can enlarge or reduce by a greater percentage. Be aware that it may take the machine some time to make the necessary adjustments to the design.

With 4,875 stitches on the left and 8,526 stitches on the right, the stitch *density* remains the same as the size of the design changes.

Appliqué and Trimming

Some embroideries have special instructions in addition to the stitching. For embroideries that include appliqué, the embroidery is designed to stop and allow you to trim the excess fabric before a decorative stitch or a satin stitch is used to couch the appliqué.

Use your appliqué scissors to ensure that you don't cut your base fabric.

Embroideries can also be designed to have a chenille effect. For this effect to work properly, you must follow the special instructions that direct you to cut the bobbin thread when finished.

Follow specific instructions for special embroidery effects.

Read all instructions before you begin to stitch so your embroideries will look exactly as they should when done.

MANIPULATION EXERCISE

1. Load an embroidery design into the machine or bring up a built-in design.

2. Experiment with rotating and mirroring the design. Consult your machine instruction manual to find out how to perform each of these functions. Try combining mirroring and rotating.

3. Experiment with enlarging and reducing a design. Does your machine adjust the stitch density? Consult your machine instruction manual to be sure.

Whether you've been machine embroidering for years or days, one thing is certain: preparation is essential to ensure success. Taking shortcuts or skipping some of these important steps could mean that some of your embroidery stitch-outs may not look the way you would like them to. Take the time for proper preparation and it will pay off in the long run.

Preparing the Fabric

Ironing the Fabric

Make sure you iron your fabric. Stitching on wrinkled fabric is a recipe for disaster since it increases the chances that you will stitch a pucker into your embroidery.

Stabilizing the Fabric

Using a liquid stabilizer, such as Perfect Sew, on your fabric makes it stiff and less likely to shift in the hoop during embroidery.

With Perfect Sew Without Perfect Sew

When fabric shifts, it can cause puckers and distortion in an embroidery design. Using a liquid stabilizer is not a required step for machine embroidery, but it is something that you can do to increase the chances of ending up with a beautiful embroidery. If you decide to use a liquid stabilizer, test it on a portion of the fabric and make sure you can rinse it out completely without any adverse effects on the embroidery or fabric.

To use a liquid stabilizer, saturate the fabric and let it *air* dry. If you iron the fabric dry, the wet stabilizer may build up on the hot soleplate of the iron. You can use spray starch but it won't make the fabric stiff the way Perfect Sew does. If you do use starch or sizing, again make sure the fabric is dry when you iron it, or the starch will build up on the soleplate of your iron and cause flaking of the starch. Scorching can also occur if the fabric is not dry before you iron it. Always remember: before using any products or stabilizers, test them first so you know that they can be removed safely and completely.

Once your fabric has had a chance to air dry, iron the fabric so it is perfectly flat. This eliminates the possibility of stitching over wrinkles.

Patty's Pointer

When it comes to machine embroidery, there is nothing as certain as uncertainty. What I mean by that is that there are *many* factors that contribute to the successful way an embroidery stitches. All things being equal, it might come down to the quality of fabric on which you are embroidering. But I've found over the years that there are things you can do to throw the odds in your favor and that will help you stitch quality embroideries. Buying and using quality materials is just one.

To do

1. Purchase about 1 yard of medium-weight woven white or light colored solid cotton fabric.

2. Select a hoop that will accommodate an embroidery design that measures about 100mm x 100mm, give or take 15mm.

3. Measure the width of your chosen hoop, add 6" to that width, and if you can cut the fabric from selvage to selvage in strips the width you calculated.

4. If you want to treat the fabric with a liquid stabilizer, do this now (see page 35). Saturate the fabric, let it air dry, and press it with an iron. It is easier to prepare fabric with this type of stabilizer in smaller strips or pieces of fabric than it is with yardage. Set aside the pieces.

5. Cut all but one of the fabric strips into pieces that extend about 3" beyond all edges of the hoop. Set these aside to use in the rest of the exercises in this book or for your own practice exercises. (The full-length strip will be used in the final exercise.)

Hooping

Hoops have an inner and outer ring. (I like to call them innies and outies.) Look at the sides, top, and bottom of both parts of the hoop. Somewhere on the hoop are marks called **placement guides** that indicate the center points of the hoop. The placement guides help you make sure the inner hoop is inserted properly into the outer hoop and enable you to properly align your fabric in the hoop.

Look for the placement guides on your hoops.

To better see the placement guides, you might want to take a permanent marker and mark the notches.

Some hoops have only one way to place the inner hoop into the outer hoop. If you get into the habit of always making sure the placement guides are properly aligned, your hoops will fit together snugly and the fabric will be held taut. Otherwise, the quality of the stitched embroidery design may be affected.

Basic Hooping

When embroidering, I find it easier to deal with smaller pieces of fabric than with yardage. Plain and simple, smaller pieces are just easier to hoop, maneuver, iron, and trim. To make sure the fabric will fit into the hoop, measure the width of your hoop from outside edge to outside edge and add about 3" in both directions. If you are embroidering quilt blocks, you can cut your fabric a little larger than the quilt block and trim it to size after embroidering.

Measure and cut fabric to fit hoop.

If you need to work on a larger piece of fabric or a complete garment or home décor item, see the tips on page 32 for positioning. You can also rotate and mirror your designs to help with placement (see pages 32–33).

To hoop your fabric, loosen the screw on the outer hoop so you can remove the inner hoop. Place the outer hoop on a stable work surface. Place the fabric on the stabilizer face up. Then center the fabric and stabilizer on top of the hoop.

Position the inner hoop and press firmly so the inner hoop is now within the outer hoop.

Center fabric and stabilizer. Press inner hoop into outer hoop

Notice that when you hoop this way, the fabric lies flat against the work surface and will be flat against the bed of the machine. If you hoop upside down, the fabric will not be flat against the machine, and the embroidery will not stitch out cleanly.

If you are experiencing difficulty in hooping the fabric and stabilizer, you might need to loosen the screw on the outer hoop a bit more. When the inner hoop is in place, tighten the screw. This is important for two reasons: it prevents the inner hoop from popping out of the outer hoop during embroidery, and it holds the fabric tight to prevent shifting during the embroidery process. Be careful not to overtighten the screw on the hoop, as you run the risk of damaging it.

When your fabric is hooped, make sure it is taut. If the fabric has a lot of give, your design may not stitch out straight or may have puckers. After the fabric and stabilizer are in the hoop, give a slight tug in the direction of the grain of the fabric, keeping your hands directly opposite each other. Don't pull too tightly, or you will pop the inner hoop out of the outer hoop.

Give a slight tug on fabric in both directions to take slack out of fabric. Do not stretch fabric.

The fabric on the top is hooped properly—it is absolutely square, and the lines on the fabric are absolutely square. The fabric on the bottom is not hooped properly. The wiggly lines show how distorted the fabric is in the hoop. If you embroider on fabric this distorted, your final product will be wavy and distorted as well.

After everything is properly positioned, make sure the screw is tight enough to keep the fabric and stabilizer secure.

Fabric just right—lines on fabric are straight and parallel to side of hoop

Fabric stretched and distorted—lines on fabric are wavy and not parallel to side of hoop

Different Size Hoops

Different size hoops require different hooping methods. Most hoops have a screw that is used to tighten the outer hoop around the inner hoop so it doesn't loosen and pop out during the embroidery process.

Some hoops are spring-type and some are so large they require extra clips to hold the fabric taut.

Clips aid stability of fabric in a mega-size hoop.

With other hoops you merely place the fabric in the hoop, then close and clamp, or replace the inner spring on the fabric. This keeps the fabric tight enough within the hoop to embroider beautifully.

Hoops like these offer different ways of hooping your fabric.

Attaching the Hoop

After the fabric is hooped, you need to attach it to the embroidery arm. Do so with care. Remember, you are connecting two critical components for embroidery, the arm and the hoop. On most machines you will hear a click when the hoop is completely inserted and secure. The hoop should attach easily. But if yours has a tight fit on the clip, attach and remove it with care. Check your machine instruction manual for instructions on proper hoop insertion.

Remove and attach hoops with care.

choose some stabilizers that are sticky or water-soluble, or even a heavier tear-away.

1. On a piece of the cut fabric (see To do, page 36), draw a grid of parallel lines about ½" apart.

2. Cut a piece of tear-away-type stabilizer about the same size as or bigger than the square of fabric you just prepared. Place it under the fabric you want to hoop.

3. Hoop the fabric and stabilizer as described on pages 36–37, making sure the fabric is taut but not distorted. Check the lines you drew to make sure they are straight and square.

4. If the fabric is not smooth and even, take it out of the hoop and try again until you are comfortable with the hooping process.

5. Insert the hoop into the embroidery arm and make sure it clicks into place.

Precision Hooping

Generally, when stitching out embroideries, especially for quilts, it's easier when the design is stitched on a piece of fabric larger than necessary, trimmed down to size, and then incorporated into the quilt in some way. But on occasion you may need to precision hoop a design so it is in an exact, particular spot. To do this, you need to know where to place the fabric in the hoop so you can stitch out the design exactly where you want it.

The trick to precision hooping is to mark your fabric so you know where the exact center of the design needs to be, and then use those guidelines to precisely hoop the fabric.

Even when you get the fabric placed precisely in the hoop, the starting needle position may not be in the exact right place. Remember when I said that when stitching a machine embroidery, the needle stays in the center position? This means that if the needle isn't exactly where the placement lines cross, you need to move the *hoop* to make it line up.

machine. The border on the quilt *Beautiful Baltimore* (see page 10) and the scalloped swag on the *Scalloped Pillowcase* were made using precision hooping so the swags would be stitched precisely where they needed to be.

Scalloped Pillowcase, 2" × 20" (scalloped edging), made by Gwen Woodard, embroidery design from *Beautiful Baltimore* designed by Patty Albin for Husqvarna Viking

Placement Preview

Some machines have a **placement preview** function that allows you to see the outer boundaries of where an embroidery will stitch. This is another tool you can use to make sure that your embroidery will stitch out exactly where you want it. Check your machine instruction manual to find out whether your machine has this function and if so, how to use it.

1. With a pen or marker that will remove completely (see page 19), draw perpendicular *placement lines* on a piece of the prepared fabric (see page 38).

Draw placement lines.

2. Place the fabric and a piece of tear-away stabilizer in the hoop so that the drawn lines on the fabric match the placement guides on the hoop.

Match the lines on the fabric to the placement guides on the hoop.

3. Press the inner hoop into place. Tighten the outer hoop to hold the fabric securely, and make sure the fabric is taut but not distorted.

Properly hooped and secured fabric and stabilizer

4. Repeat this process until you are comfortable with it and can get the fabric lined up perfectly. If you suffer from hoop creep, read Patty's Pointer on page 38.

5. Carefully attach the hoop to the embroidery arm.

6. Call up an embroidery design on your machine so you have access to the placement adjustment functions.

7. Use the placement adjustment to move the hoop away from you, toward you, to the right, and to the left. Now use the placement adjustment to make sure the needle is positioned *exactly* over the intersection of the placement lines.

Hoop and needle in correct position

8. If your machine has a placement or perimeter preview, use it to see the outer boundaries of where the embroidery will stitch.

that this is something so simple that time shouldn't be wasted discussing it, think again. Success or failure could result from properly or improperly winding a bobbin or choosing proper or improper bobbin thread.

A bobbin will hold more 60- or 70-weight thread than thicker 40- or 50-weight thread. But sometimes the very thin threads fool the bobbin tension and the bobbin thread tension will be off. If this is an issue with your machine, try using thread that is a bit thicker, such as a 60-weight cotton. (See pages 22–23 for more on bobbin thread.)

Prepare for a day of embroidering by having plenty of bobbins wound and ready to go.

To do

- Get your bobbins ready.

- Wind bobbins with 60/2 cotton thread or your bobbin thread of choice.

Stitching the Design

Are you ready to start embroidering? There are just a few more things you need to know. Look for a quick checklist at the end of this chapter that you can use until all these things become second nature.

Unobstructed Space

Make sure the area around your machine, and especially around the embroidery arm and hoop, is free of obstructions. Should your hoop bump into a lamp, a pile of fabric, or a wall, it may be enough to knock the arm out of calibration, compromising the integrity of the design. Adverse effects can include the outline being slightly off, gaps between colors, or the design not stitching where you want it.

Starting to Stitch

You have the design and threads selected, the fabric prepared and hooped, and the hoop attached to the embroidery unit.

Before you take that first stitch, hold the top thread between your thumb and forefinger to prevent the tail from getting tangled in the next few stitches.

Hold the thread tail when starting an embroidery.

To begin stitching your design, press the foot pedal or press the button that makes your embroidery machine begin embroidering. Every machine is different, so consult your machine instruction manual. Some machines automatically stop to allow you to trim the thread tails, but others do not. Either way, the thread tail must be trimmed. If yours doesn't automatically stop after about 5 or 6 stitches, stop the machine, trim the thread tail, and then continue on with the first color.

Trimming threads now prevents them from being stitched over later, making trimming more difficult.

Patty's Pointer

Many of the new machines have a built-in thread cutter that cuts both the top thread and the bobbin thread with the touch of a button. If your machine does not have this option, you probably will have a bobbin tail that is long enough to get tangled underneath the embroidery. To prevent this tangling, let the machine take just one stitch, then use the top thread to pull up the bobbin thread. Hold both threads while the machine takes the first few stitches, then trim both the top and bobbin tails.

the actual embroidery. If your machine has this, get into the habit of basting as it is one more measure to ensure secure stitching and a stable fabric. However, if you are embroidering on something that would show the needle holes from the basting stitches, such as leather, skip this step. When the embroidery is finished, remove the stitches with a seam ripper.

Basting around an embroidery design

Jump Stitches

As the embroidery is stitched out, you will see the needle jump from one area to another, leaving a long stitch. This is called a **jump stitch**. Jump stitches are very common in designs with many colors. Another time you may see jump stitches is when the same color thread appears in more than one area of the design.

Untrimmed jump stitches

trim them all when you are finished. You are wasting time by doing this, you are really making *more* work for yourself. Once those jump stitches have been stitched on, you may not be able to remove the entire thread. Out come the tweezers and the pointy scissors for some very tedious trimming.

Trim as you go. Trimming jump stitches between color changes saves tedious trimming after you are finished with the design.

Changing Threads

Once the machine finishes stitching color number 1 it will stop. This allows you to change the thread to color number 2. This also allows you to clip any jump stitches that may have been stitched in color number 1. After clipping, you are ready to stitch out the next color.

THREAD EXERCISE

For this exercise you'll be stitching out an embroidery design multiple times on one fabric to see how different threads affect the look of the embroidery.

1. Choose an embroidery design that will fit in a hoop that is about 100mm × 100mm, or about 4″ by 4″. Select a design that has only a few color changes. I suggest you choose a design that is directional in nature—one that has a definite up, down, right, and left. Many embroidery machines come with a variety of designs to get you started. You can use one of these designs or one that you have purchased separately. Transfer it to your machine or use a built-in embroidery design.

2. Select threads for the embroidery. Choose different kinds of threads (rayon, cotton, polyester, and so on) and different weights (40- and 50-weight). Remember, if you don't like the colors of the design, just pick your own.

3. Hoop a piece of prepared fabric (see page 36) with a stabilizer. Thread the machine with the first kind of thread you are going to use. Use the same type and weight of thread within each embroidery.

4. Embroider on a light-colored fabric such as muslin, so you can mark with a permanent pen right on the fabric which threads, needles, stabilizers, and so on you used for that particular embroidery test.

Record notes on each test embroidery and save them for later reference.

5. When the first color has finished stitching, trim the jump stitches, if any. Continue on to the next color. Remember to hold the thread tail in your hand as before. Continue stitching through this color and the rest of the colors of your embroidery, trimming threads and jump stitches as before.

For the next round in this exercise, choose another cut piece of fabric and a different set of threads (different weight or fiber). Stitch out the embroidery again. If you'd like, choose more threads and stitch again. You can do this as many times as you'd like. Make sure you mark each fabric with the kind of threads you used, including manufacturer, weight, and fiber.

Set these samples aside for now; the process of removing the tear-away stabilizer will be discussed in depth on starting on page 50.

Patty's Pointer

You should definitely try using a water-soluble stabilizer in these exercises. There are many different kinds on the market, and at some point you will need to use one. By testing one now, you will have on hand a water-soluble stabilizer you've tested and liked. I would suggest that you stitch out two identical designs—a "before" and "after" so you can see and feel the fabric before you wash out the stabilizer and then once you've removed it. Be sure to mark your samples with a permanent marker so you'll know which is which, and the stabilizer brand used.

Creative Beginnings in Machine Embroidery

1. Select the same embroidery design and threads from the Thread Exercise.

2. Hoop a piece of prepared fabric (see page 36) with a stabilizer and stitch out the design.

3. If you need to make any additional modifications to your machine to stitch out successfully with any of those stabilizers, indicate that on the sample.

4. Make sure you identify all the supplies, including the brand and name of the stabilizer as well as the thread manufacturer, weight, and fiber.

For the next round in this exercise, use another piece of prepared fabric and choose a *different* stabilizer. Stitch out the embroidery again. Make sure you mark the fabric with the kind of thread and stabilizer used. Let these stand as a guide for you. The process of stabilizer removal will be discussed in depth in the next chapter.

Color Stepping

Color stepping is the process by which you advance through the colors of a design without stitching them out. If you are stitching a design that has the same color in a different thread order, you can color step to that color and stitch it out without changing thread.

If you want to stitch out only part of a design, you can color step through the colors to get to the point where the machine is stitching only that part of the design you want.

The original design is on the left, and by color stepping through the design you get just the part of the design that you want.

Another good use of color stepping is when the final color is an outline, and that is the only part you want to stitch. Betty Barnes' quilt *Black and White and Red All Over* (page 6) is a perfect example of this. She color stepped through the design to stitch out just the outline of the design.

Skipped Stitches or Broken Threads

Sometimes while the embroidery design is stitching, the thread will break or the bobbin thread will run out and continue to stitch, leaving gaps within the design. Have no fear, since your machine has been designed to deal with just this situation.

Your machine has a **stitch advance** or **stitch back-up** function. The beauty of this function is that not only can you advance stitches within the design, you can also back up within the design.

Stop the machine as soon as you notice that the embroidery thread has broken or you're out of bobbin thread, and you see a gap in the stitching. You will need to back up the embroidery. Back up to the point where, when you start again, you will stitch over the last few stitches. This ensures that there is no gap in the stitches when you begin again.

COLOR SETTING AND STITCH ADVANCE EXERCISE

1. Find the color advance button on your machine (consult the machine instruction manual as needed).

2. Load an embroidery design or pick a built-in design.

3. Hoop a piece of prepared fabric (see page 36) with a piece of stabilizer.

4. Advance through the different colors of the design.

5. When you have done this successfully, return to color number 1.

6. Now find the stitch advance on your machine (consult the machine instruction manual as needed).

7. Start the embroidery design, then stop it. Use your stitch advance function to advance a few stitches, then use it to back up a few stitches.

Now you'll know how to use this function when you need it.

COMBINING ELEMENTS EXERCISE

Many embroidery machines will allow you to copy and combine embroidery designs on the embroidery machine screen. Here's an exercise that will let you practice your precision hooping and stitch out a monogram.

1. Use a piece of prepared fabric (see page 36) and draw 2 intersecting lines on it. These will be your guidelines for centering both the designs.

2. Find a symmetrical embroidery design that is a wreath or some other circular design.

3. Select it and follow the steps from the previous exercises to stitch it out. Use precision hooping (pages 39–40) and the machine placement adjustment function to make sure your design is centered. Do not remove the fabric from the hoop.

4. Now use your machine instruction manual to find out how to load a letter that you will stitch out in the middle of your circular design.

5. Again use the placement adjustment function and the placement preview function (page 39) to make sure the letter will fit within your circle. Enlarge or reduce it as necessary (page 33).

6. Stitch out the letter.

Combining 2 designs

Centering guidelines

Creative Beginnings in Machine Embroidery

1. Trace the full-size design onto your template using a removable marker or the special template marker that came with it. To get the full-size design you can print the design from your computer, or trace it from the booklet it came with. Be sure the design you are working with is the size you intend to use. When tracing the design from these sources, align the center point and horizontal and vertical positioning marks on the paper or page with those on the template.

Hoop template and design printout

If you have no computer or booklet, hoop up a piece of muslin on which you have drawn a horizontal and vertical line. Use the center guides on the hoop to connect both centers vertically and horizontally with drawn lines on the muslin. Stitch out the design, noting where the center starting point is. Then, cut out the design from the fabric so you can still see the placement lines you've drawn on the fabric. Use this embroidery to trace the design onto the template as described in the previous paragraph, aligning the placement lines on the fabric to those on the template.

2. Place the marked template onto the garment, positioning the design exactly where you want it. Use a marker that will disappear completely, and mark the center of the design as well as the horizontal and vertical positioning lines on the garment.

on the garment with the marks on the hoop and press onto the stabilizer.

Garment properly hooped, design in original orientation

4. Attach the hoop to the embroidery arm. Load the design into your machine. If you have hooped your garment upside down, **rotate** the design 180° so it appears upside down on your machine's information screen.

5. Look at the needle. Is it in the center? If so — congratulations! If not, use your positioning buttons to move the hoop so the center point on the garment aligns perfectly with the needle.

6. If you are embroidering on a knit, such as this sweater, remember to use a ball point or universal needle—otherwise you may wind up with holes in the fabric around the embroidery!

7. You are now ready to begin embroidering!

Design rotated 180° and stitched out

STITCHING IN A LINE EXERCISE

In this exercise you will be unhooping and re-hooping the fabric at the end of each design.

1. Find a simple embroidery design, or plan to use just a portion of a design. Trace the design onto the template that came with your hoop. If you don't have one, you can trace the design right onto template plastic, marking the midpoint and the vertical and horizontal center of the design. (See page 47.)

2. Prepare a strip of fabric 3″ wider than your hoop and about 18″ long. Draw a straight line down the center of the strip. This will be your guideline for stitching a row of designs.

Straight guideline

3. Start at one end of the fabric, aligning the vertical center line on the fabric with the top and bottom center marks on the hoop, and hoop the fabric for the first embroidery.

4. Use the placement adjustment function or positioning buttons (page 59) to make sure the design is centered on the vertically drawn line.

5. Stitch out the design.

6. Remove the fabric from the hoop. Use the template for placement and align the center line of the design with the drawn line on the fabric.

Place design precisely where you want it.

7. Mark the center point of the design and the horizontal line of the embroidery. Make this large enough to reach from one side of your hoop to the other.

8. Re-hoop the fabric, aligning the vertical and horizontal lines on the fabric to your placement marks on your hoop. Use the placement adjustment function or positioning buttons and placement

preview (if your machine has this function) to make sure the design will stitch out in the correct place.

Use template to mark placement of next design.

9. Stitch the design. Continue to stitch out more designs in a line, following the previous instructions, until you feel comfortable with the process.

A straight line of designs

Storing Your Samples

Now that you have a sampling of tests and examples, keep them all together. This will help you later when you are trying to decide on a thread or a stabilizer. An expandable file, a notebook, or a flat pizza box are all good places to store these samples. All your tests are together and each one is marked with the materials you used.

EMBROIDERY CHECKLIST

✓ Clear obstructions from the embroidery area, especially around the hoop.

✓ Select and transfer the embroidery design to the machine.

✓ Prepare the fabric with liquid stabilizer (optional).

✓ Put a new needle in the machine. ✓ Iron the fabric.

✓ Select a stabilizer. ✓ Hoop the fabric and stabilizer.

✓ Choose and organize the threads. ✓ Fill bobbins.

E ven though your embroidery machine has stopped, you aren't quite finished. Avoid the temptation to immediately remove the hoop from the arm and the fabric from the hoop. There are a few checks you need to do first.

Make Sure All the Colors Are Stitched

If you have a list of all the colors of the design, make sure they have all been stitched. There have been more times than I care to admit that I've removed the fabric from the hoop, only to discover that the last color hadn't stitched yet. Some machines have a pop-up window on their screen that indicates that the embroidery is finished. Others depend on you knowing that the last color is done. If this is the case with your machine, get in the habit of checking the colors before proceeding.

All colors stitched

Make Sure No Stitches Were Skipped

Sometimes stitches may have been skipped within the design. For example, when the thread breaks or the bobbin thread runs out, sometimes the stitching continues, as discussed in the previous chapter. If the needle isn't backed up and those missing stitches stitched, there will be a gap within the embroidery design.

Yellow flower centers missing. Forgetting to stitch the last color will affect the look of the embroidery.

Gaps in the design

Check to make sure there are no gaps in the embroidery before you remove the fabric from the hoop. Chances are good that you can go back and stitch those missing stitches using color stepping and stitch advance (see pages 45–46). However, if you've removed the fabric from the hoop, you've most likely missed your chance.

Remove the Hoop

After you've checked your embroidery to ensure that all colors have been stitched, there are no gaps in the stitches, and the embroidery needs no more attention at this time, remove the hoop. Carefully remove the fabric from the hoop. Now it is time to remove the stabilizer from the embroidery.

Patty's Pointer

If you plan on stitching more embroideries, have a second hoop with fabric and stabilizer ready to attach to the machine after the embroidery is finished and you've removed the hoop from the arm. This saves time, especially if you have lots of embroideries to stitch. And if you have to precision hoop (see page 39) more than one piece of fabric, spending time hooping while the other hoop is on the machine will save you time in the long run.

Extra hoop is ready to attach.

Remove the Stabilizer

Once you have removed the fabric from the hoop, you will have to remove the stabilizer from the design and fabric.

Tear-Away Stabilizer

If you used a tear-away, be careful when removing the stabilizer so as not to compromise the stitches in the design.

A very dense design will perforate the stabilizer and make it easy to tear. But with designs that are more open, such as the one pictured here, great care must be taken when removing the stabilizer since the pulling and tearing motion puts stress on the stitches, which could damage them.

An open design requires careful stabilizer removal.

If you've used two layers of lightweight stabilizer, tear one layer, then the other. With the finger and thumb of one hand, hold the embroidered stitches while tearing away the stabilizer with the other.

Carefully tearing away your stabilizer ensures that your embroidered stitches remain intact.

However, if tearing away the stabilizer concerns you or if you are afraid you are going to tear your stitches, consider a different stabilizer, such as a water-soluble.

Creative Beginnings in Machine Embroidery

process may take several washings and lots of water. If there's still stabilizer residue (and you'll know this because the fabric will be sticky when wet or stiff when dry), try using warm water. Remember to remove any markings with cold water before using warm water (see page 19).

Cut away excess water-soluble stabilizer before washing.

Press your embroideries from the back to protect the threads on the front.

Patty's Pointer

When you are using water-soluble stabilizer, I suggest that you first cut or tear away (if you can without damaging the stitches) the excess stabilizer. That way there will be less dissolved stabilizer in the fabric once you have begun to rinse it out. If you find that the stabilizer is being stubborn and refusing to leave completely, try much warmer water, as this does a very good job of accelerating the dissolving process.

Look at Your Work

After you have stitched out an embroidery design, take a careful look at it. How does it look? You should ask this every time you stitch an embroidery design. It is only by asking this question that you are able to critique your own work and make the next project better. If you like the way your embroidery looks, then your choices of thread and needle were correct.

If you don't, you need to ask some other questions. Did the fabric pucker? If it did, what can you do differently next time? Use a liquid stabilizer? A stiffer tear-away-type stabilizer? What about something that is sticky that won't allow the fabric to shift?

STABILIZER REMOVAL EXERCISE

1. Take one of the designs you stitched out earlier using tear-away stabilizer. With your thumb and forefinger, hold the embroidery while you use the other hand to tear away what you don't need. Afterward, look at the front of the embroidery. Do the stitches appear damaged or are they undisturbed? Hint: Undisturbed is the right answer.

2. Take one of the designs you stitched out earlier using water-soluble stabilizer. Tear or cut away as much stabilizer as you can from the stitched embroidery. To remove the remaining stabilizer, rinse the embroidery in cold water, especially if you have marked the fabric with a water-soluble pen. If the fabric still feels sticky when wet, try using warmer water and continue rinsing out the fabric. Once the fabric and embroidery are dry, feel the fabric. If it is stiff, repeat the rinsing process again. Lay flat to air dry. Press when completely dry.

A Word About Software

It's amazing how much you can do with just an embroidery machine, but embroidery software allows you to be more creative than you ever thought possible. To get some ideas, take a look at Gallery II on pages 54–61. It takes a little time to learn to use the software, but you can relax—you don't need to be a computer whiz.

Embroidery software

What Embroidery Software Can Do for You

Change Designs

Embroidery programs made by different companies provide basically the same functions. For example, you can move designs or parts of designs, copy them from one place and paste them in another, and dramatically change the size of a design and have the software automatically adjust the density. Embroidery software also makes it easy to add words to an embroidery design. In short, you are able to take a design that thousands of people own and modify or change it to make it your own. You can customize the design at your own whim and make it look like something

that no one else has. Some embroidery machines can do some of this within the machine. But for those that can't, embroidery software offers you these functions.

In this example, the design on the left is the original design. In the design in the center, the large flowers were removed and small flowers were copied and added to make a complete circle. In the design on the right, the color stops were removed so that the flowers in the design would stitch in the same color. One design with many looks— that's what software can do for you. Instead of purchasing more designs for different projects, you can simply modify the same design over and over to give it different looks for your different projects.

| Original | Edited | Edited again |

Customize your embroideries for unique looks.

In this example, the design on the left is the original. In the center design, the original design was edited so that only one flower and one leaf remain. In the design on the right, the edited design was duplicated, rotated, and mirrored for a new look.

| Original | Edited | Edited again |

One original design—many looks

Leather Needlebook, 4½″ × 7½″, made by Patty Albin, embroidery design from the book *Machine Embroidery Makes the Quilt* by Patty Albin

The first holder I made disappeared at a sewing show. Not ready to lose another, I embroidered my autograph on the back of the second one. There is no way to remove the embroidered signature, but I'm still keeping a closer eye on this one!

Lindsey's Fleece Blanket, made by Patty Albin, original embroidery design

A "blank" is a plain item that has been purchased so that it can be embellished in some way. This was a very inexpensive fleece blanket on which I embroidered a name. I made

an embroidery design. The embroidery designs you buy are already digitized. But it is now easier than ever to digitize your own designs. Software is available that automatically digitizes designs, or you can use a program that allows you to control every aspect of the finished design. If this is something that appeals to you, check out some of the digitizing programs available. (See Gallery II, pages 54, 56, 58, 59 and 60, for examples.)

Cross Stitch

You can create your own cross-stitch embroideries using software. You can either plot your own design or let the cross-stitch software create the embroidery design from a scanned photo. (See Gallery II, pages 56 and 57, for examples.)

Save Money

I purchased a particular flower design years ago. I've used this design in at least a half dozen different projects since then, yet with the software I've manipulated the design to make it look like a different embroidery design each time it is used. Eliminating color stops, combining designs, resizing the design, eliminating parts of it, and moving the leaves and buds within the design make it look like new. I really got my money's worth on that one!

Many designs can be created from a single embroidery design.

Gallery II

H ere's a chance to see just how creative you can be when you use the different types of embroidery software. The examples range from completely original designs to purchased designs that have been modified. Isn't the range of possibilities astounding?

Morning Glory, 16″ × 14″, made by Gwen Woodard, hummingbird design from *Hummingbirds* by Vermillion Stitchery, original morning glory design

■ Gwen was inspired by an embossed greeting card when she made this quilt. She used an autodigitizing software program to create the leaf and flower design, and with some additional trapunto quilting gave it texture. She used a hummingbird embroidery design but selected thread colors that she liked rather than the colors in the original design. The combination of the two elements created a unique little quilt. Keep your eyes open, as you may find inspiration in the most unexpected places.

Dragonfly, 5½″ × 4″ × 1½″, made by Gwen Woodard, embroidery design created using Husqvarna Viking 3-D embroidery software

■ Gwen used a 3-D digitizing program and an image of a dragonfly to create one big embroidery design that filled her entire embroidery hoop. After the embroidery was stitched out, she used the embroidery as her fabric to make a modified version of *Patty's Pretty Purse* pattern. What embroideries can you stitch out to create your own fabric?

■ Inspired by a pair of pants I saw in an ad, I knew I could make a pair of my own for a fraction of the price. I used embroidery software to modify a flower design to create a narrower look that would fit nicely on the pant leg; I wanted the final version to look like a stripe from a distance. I removed and moved some of the original design elements, then copied the design four times to create one long embroidery that I could stitch out in a very long hoop. I opened the inside pant leg seam from ankle to ankle on a purchased pair of jeans, and embroidered the design on the outside seam from ankle to hip. By using my embroidery machine I made my own version of very expensive pants. What can you embellish to wear?

Floral Wreath Design, CD holder 5¾″ × 5½″, tote bag 14″ × 19″, purse 7½″ × 5½″, made by Patty Albin, embroidery designs modified from the book *Machine Embroidery Makes the Quilt* by Patty Albin using embroidery computer software

■ I used my embroidery software to create this wreath from an arc of flowers. This is one of my favorite designs and I use and reuse it often.

For the CD holder and purse, I used a sticky type of stabilizer to embroider on the suede, because hooping suede (and other leathers) leaves marks (see page 25 for more on using sticky stabilizers.) For the CD holder I topstitched the embroidered suede onto a purchased CD holder and trimmed the extra suede with a small rotary cutter. For the purse, I sewed the embroidered fabric into a simple rectangle, then inserted a zipper and used cording as a shoulder strap. I added a bit of sparkle with the beaded fringe on the bottom to complement the metallic thread I used in the embroidery.

To use the same design on a tote bag, I stitched the embroidery designs onto fabric similar to that of the tote bag, then topstitched the embroidered fabric to the bag. This is a great way to personalize all those tote bags you get at trade shows and quilt festivals.

Appli Fill Sampler, 17" x 17", made by Bonnie Coleman, original embroidery designs

■ Bonnie wanted to show how the sheen and light-reflective quality of rayon thread make it a good choice for machine embroidery. When she created these designs in her embroidery software, she used the broad areas of the designs to show off different stitch patterns, giving the appearance of different textures. Starting with the designs in the Electric Quilt 5 (EQ5) block library, she digitized the designs using her embroidery software. With copyright-free blocks in the EQ5 library as the basis, you can create your own embroideries using machine-embroidery software.

Alaskan Cross-Stitch, 30" x 24", made by Jeanne Laurie, embroidery designs created using a machine-embroidery cross-stitch program

■ Using purchased clip art, Jeanne turned wildlife images and a cabin into cross-stitch embroideries that she stitched out on her machine. She bought a collection of clip art, so now she has that many *more* potential embroideries. All she has to do is convert them to machine-embroidery designs using her cross-stitch program. *Remember, unless the clip art is specifically copyright-free, get permission from the original designer before converting and using the design.*

■ This quilt is a celebration of the Sisters Outdoor Quilt Show. Cathy used her computer software to create all of the embroidery designs for the lettering and decorative shapes.

Each little quilt is a cross-stitch design that Cathy created in her cross-stitch software. After each quilt was stitched out, it was bound to look like a miniature quilt.

For the outer border, Cathy scanned into her computer all the posters that Dennis McGregor created for the annual show (receiving permission first!) The images were printed on pre-treated fabric sheets and fused to the quilt.

No wonder this quilt is a best-of-show award winner!

■ The shirt was inspired by a sweater I saw Sue Hausmann wearing, and I knew I had to make something similar for myself. I used my software to arrange the shoes and purse to stitch on a purchased shirt. For some added glitz, I embellished the purse with Swarovski crystals.

Then I just had to have a purse to go with the shirt. I went back to my computer and modified the original group of designs so they would fit on a small rectangular purse.

Thinking that my shirt and its matching purse were just the cutest outfit I ever saw, I had to commemorate it with a small quilt that used the same designs. So I used '50s-era-looking fabric and the embroideries to create this small quilt that turns heads wherever it is hung. If you really like a design or collection of designs, keep using them! That's why you bought them!

Saddle Shoes and Poodle Purses, Shirt, Purse 9" x 6", Quilt 12" x 15", made by Patty Albin, embroidery designs from *Steppin' Out With Accessories* by Cactus Punch

Scalloped Box-Pleat Valance, 32" x 47", made by Pamela M. Damour, embroidery design by Katie Bartz

■ As a successful home décor designer, Pam makes window treatments, pillows, and slipcovers for her many clients. Katie digitized an embroidery design to match the valence, and Pam stitched the embroidery multiple times, elevating the valence from everyday to spectacularly stylish. Think about how you can incorporate embroideries into your home decorating projects.

Monogrammed Neckroll Pillow, 14" x 6", made by Pamela M. Damour, embroidery design from *Special Occasion Monograms* by Katie Bartz

■ As Pam and Katie developed this pillow for their book *Pillow Talk*, they wanted something interesting to add to it. This pillow not only sports a beautiful monogram designed and digitized by Katie, it also incorporates lovely shirred welting. A large monogram can take an item from ordinary to extraordinary. Another great example of using embroidery on home décor projects.

Welcome the Sun of Summer, 24" × 30",
made by Gwen Woodard, embroidery designs
from the collections *Words From Japan* and
Fashion by Husqvarna Viking

■ While Gwen was looking through a home decorating
catalog, a framed print caught her eye. Feeling inspired,
she used some blocks from a previous quilt and added a
cheesecloth overlay to make the piece look like an old
scroll. The Japanese characters were enlarged using an
embroidery software resizing program. She also used the
software to edit the palm frond and the branch. Though the
quilt is quite simple, it has an air of elegance. Before you
throw out your junk mail, take another look. It might not be
junk after all.

Appliqué Bouquet 11" × 12½", made by Gwen
Woodard, original embroidery design

■ Gwen designed *Appliqué Bouquet* as a class
sample to teach a variety of stitches and
appliqué methods. She digitized the leaves
and stems from a hand-drawn image using her
digitizing software, then applied the fused
appliqué shapes. She used her computer soft-
ware and embroidery machine to complement
the traditional appliqué. How can you combine
traditional and high-tech sewing techniques?

Happy Hour, 14″ × 12″, made by Patty Albin, original embroidery designs created using clip art

■ I had wanted to make this quilt for months, but the search for the perfect martini fabric never panned out. So at the suggestion of my husband, Chuck, I used a piece of copyright-free clip art that I turned into an embroidery design. After I digitized the design, all I had to do was add the words. Make statements in your quilts using your embroidery machine, and listen to your husband.

Route 66 board book, 8″ × 8″, made by Patty Albin, embroidery designs from *Design Pack AM02* by Cactus Punch, beading technique from the DVD *Beading on the Sewing Machine* by Terry White, blank board book from C&T Publishing

■ Feeling inspired by the book *The Art of Fabric Books* by Jan Bode Smiley, I wanted to combine quilting and machine embroidery in a blank board book similar to those scrapbookers use. I created the lettering using my computer software and resized the embroidery designs so they would fit into the small appliqué scene. After the embroidery was done, I used my machine to add the beaded embellishment and the words. It's easy to incorporate machine embroidery into scrapbooking and altered books.

Leather Accessories, trifold needle wallet 6″ × 5″, checkbook cover 6¾″ × 3½″, notepad cover 3″ × 4½″, made by Patty Albin, embroidery designs modified from *Beautiful Baltimore* by Patty Albin for Husqvarna Viking

■ All these leather accessories were made by topstitching the embroidered leather onto premade items, then trimming the leather to size. To embroider, I used a sticky type of stabilizer so I wouldn't have hoop marks on the leather. (See page 25 for more on using sticky stabilizers.)

For the needle wallet, I placed the embroidery design exactly where it needed to be and stitched everything out in one mega-size hoop. For the checkbook cover, I added my signature on the back before topstitching the embroidered leather to a premade checkbook cover. The notepad covers went together so fast I could make one from start to finish in about twenty minutes.

All these personalized items are perfect to give as gifts around the holidays. Or you can make a few and put them aside for when you need them. Your embroidery machine makes making gifts fun and fast.

Mom and Dad card, embroidered
pansy design from the book
*Machine Embroidery Makes the
Quilt* by Patty Albin

Snowman card and Mom Tag,
embroidery designs from *Holiday Happiness*
by Shelly Benton for Inspira

Thank-you card, embroidered fruit design
#04 from *Beautiful Baltimore* by Patty Albin
for Husqvarna Viking, Thank You lettering
created in 3D Embroidery software by
Husqvarna Viking

■ Embroidery can be found on
a variety of materials: cottons,
canvas, mesh, netting, leather,
and now, paper. It's an easy
way to make your own cards,
stationery, and other paper
products.

Embroidery on paper samples, assorted
sizes, made by Patty Albin

Butterfly Tag, embroidered butterfly
design from *Beautiful Baltimore* by
Patty Albin for Husqvarna Viking

Back

Front

Life's Journey, 10″ x 10″ x ¾″, made by
Patty Albin, embroidered lettering created
using 3D Embroidery software by Husqvarna
Viking, fruit embroidery design #04 from
Beautiful Baltimore by Patty Albin for
Husqvarna Viking

■ I created this collage on a base of
a 10″ x 10″ canvas. I used molding
paste and acrylic paints, transparen-
cies of quotes and images, a photo,
decorative fibers, pattern tissue,
stamps, Swarovski crystals, ephemera,
and, of course, machine embroideries.
White fabric was painted then adhered
by PPA glue. All sides of this canvas are
decorated, including the back, making it
a two-sided piece of dimensional art.
You really should try this!

RESOURCE GUIDE

At the time of publication, the following suppliers offered the listed products and services. While it is impossible to mention all available suppliers, I've listed some of my favorites and those with designs or patterns mentioned in this book.

SEWING MACHINES

To find a dealer near you, consult your local phone book or visit the company's website.

Bernina of America
www.berninausa.com
630-978-2500

Brother
www.brother-usa.com/HomeSewing/
800-284-4357

Husqvarna Viking
www.husqvarnaviking.com
800-358-0001
info@husqvarnaviking.com

Janome
www.janome.com

Pfaff
www.pfaffusa.com

Singer
www.singerco.com
800-4-Singer

EMBROIDERY DESIGNS

Many of the designs shown in this book can be purchased from your local sewing machine dealer. To locate one near you, consult your phone book or visit the manufacturer's website. Some embroidery designs can be purchased directly from websites.

Cactus Punch
www.cactuspunch.com
800-487-6972

Decker Design Studio
www.deckerdesignstudio.com

EZ Sew Designs
www.ezsew.com

Karen's Keepsakes
karenh@kanoskeep.com

Laura's Sewing Studio
www.laurassewingstudio.com
866-844-8895

Martha Pullen
www.marthapullen.com
800-547-4176 ext. 2

Pollard's Sew Creative
www.pollardsewcreative.com
626-335-2770

Scrigby's Embroidery Designs
www.Scrigbys.com

Sew Artfully Yours,
Designs by Cindy Losekamp
www.sewartfullyyours.com
812-637-0697
888-202-5855
info@sewingart.com

THREAD

Maderia
www.madeirausa.com

Mettler
www.amefird.com/mettler.htm
800-847-3235

Robison-Anton
www.robison-anton.com
201-941-0500

Sulky of America
www.sulky.com
800-874-4115

Superior Threads
www.superiorthreads.com
800-499-1777

STABILIZERS

Stabilizers can be purchased online and at retail outlets that sell fabrics and/or sewing machines.

SOFTWARE

Embroidery software is available from sewing machine manufacturers as well as from the following companies:

Autodigitizing
www.autodigitizing.com

Buzz Tools
www.buzztools.com
fax: 800-850-2844

EQ5
www.electricquilt.com
800-356-4219

OESD
www.oesd.com
888-223-6943

Origins
www.originssoftware.com
866-678-7638

BOOKS, PATTERNS, INSTRUCTIONAL VIDEOS, AND NOTIONS

Damour Designs
Home décor patterns
www.pamdamour.com
518-297-2699
decor8me@aol.com

"Mynd's Eye"
Gwen Woodard
Scalloped Pillowcase pattern
115 N. Willow
Kenai, AK 99611-7702
Woodard@acsalaska.net

ScrapSMART
Vinyl accessories that you can easily add machine embroideries to
www.scrapsmart.com
800-424-1011

Linda Visnaw
Threads and Inks Together DVD
928-453-1942
lmvdesign@citlink.net

Terry White
Taire Daire Productions—
Instructional videos
www.threadpaint.com
rscwhite@adelphia.net

Kandi Corp
Swarovski crystals, L'Orna Hotfix applicator
www.L-Orna.com

MACHINE EMBROIDERY SUPPLIES

Viking Distributing Company, Inc.

Stabilizers, design cards, threads, software, instructional videos, Sylvia Design sewing cabinets, Laurastar ironing products, Perfect Sew

685 Market Street
Medford, OR 97504

800-428-2804

may not be currently available because fabric manufacturers keep most fabrics in print for only a short time.

FOR MORE INFORMATION

Ask for a free catalog:
C&T Publishing, Inc.
P.O. Box 1456
Lafayette, CA 94549
800-284-1114
www.ctpub.com
ctinfo@ctpub.com

Also by Patty Albin

ABOUT THE AUTHOR

Photo cred. Chuck Humbert

Patty Albin has been an avid quilter for more than twenty-five years and has always loved the traditional look of quilts. With the advent of twenty-first-century sewing machines and the creative opportunities that pre-programmed machine embroideries offer, she's become passionate about incorporating these designs into her quilts, as well as showing others how to do so.

Formerly, Patty owned a quilt shop and was an associate editor of *Quiltmaker* magazine. Currently, she is an AQS Certified Quilt Appraiser and is the Director of Education for Viking Distributing Company in Medford, Oregon. Patty designed the *Beautiful Baltimore* embroidery collection for Husqvarna Viking.

Great Titles
from C&T PUBLISHING